EXPLORING THE INVISIBLE

EXPLORING

Lynn Gamwell

THE INVISIBLE

Art, Science, and the Spiritual

PRINCETON UNIVERSITY PRESS

PRINCETON AND OXFORD

To the memory of two scientific explorers, Charles Darwin and Albert Einstein.
Illuminating the invisible, inspiring the imagination.

FRONT JACKET: Color study, from M.-E. Chevreul, *De la loi du contraste simultané des couleurs* (On the law of simultaneous contrast of colors) (Paris: Pitois-Levrault, 1839) (detail of plate 58).

CASING: "Radiolaria," in Ernst Haeckel's entry, *Report on the Scientific Results of the Voyage of HMS* Challenger *during the Years 1873–76* (Edinburgh, 1880–95), 18: pl. 7 (color added). Special Collections, Glenn G. Bartle Library, Binghamton University, State University of New York. Photo: Chris Focht.

SPINE: "Cynthia," drawn by Ernst Haeckel for the *Challenger* and reprinted in *Kunstformen der Natur* (Art forms in nature) (detail of plate 68).

BACK JACKET: Stanton Macdonald-Wright, *Conception Synchromy*, 1914 (detail of plate 144).

FRONTISPIECE: Caspar David Friedrich, *Wanderer above a Sea of Fog*, c. 1818 (detail of plate 2); and "Siphonophorae: Anthemodes ordinata," in Ernst Haeckel's entry, *Report on the Scientific Results of the Voyage of HMS* Challenger *during the Years 1873–76* (detail of plate 73).

Published by Princeton University Press, 41 William Street, Princeton, New Jersey 08540
In the United Kingdom: Princeton University Press, 3 Market Place, Woodstock, Oxfordshire OX20 1SY
www.pupress.princeton.edu

Publication of this book has been aided by a grant from the Millard Meiss Publication Fund of the College Art Association.

MM

Designed by Joel Avirom
Design assistants: Jason Snyder and Meghan Day Healey
Composed by Matt Mayerchak
Printed by Butler & Tanner Limited
Printed and bound in the United Kingdom
10 9 8 7 6 5 4 3 2 1

Library of Congress Cataloging-in-Publication Data
Gamwell, Lynn, 1943–
 Exploring the invisible: art, science, and the spiritual / Lynn Gamwell.
 p. cm.
 Includes bibliographical references and index.
 ISBN 0-691-08972-8 (cloth: alk. paper)
 1. Art and science. 2. Spirituality in art. 3. Art, Abstract. I. Title.

N72.S3 G36 2002
700'.1'05—dc21 2002025106

CONTENTS

Foreword
Science as the Artist's Muse

Neil deGrasse Tyson

In the late 1880s, when Vincent van Gogh was painting in the south of France, classical physics was in its prime years, the industrial revolution was in high gear, Lord Rosse's giant reflector telescope was exploring the sky, and heavier-than-air flight was being actively researched. Vincent could have called one of his most famous paintings from that period *Tranquil Landscape*, or *Village in the Valley*, or *Evening Air*. But no, he called it *The Starry Night*.

In many ways, science and art are profoundly similar. The best of each rises up from the depths of human creativity, nurtured by an individual's commitment to and passion for the discipline. In common parlance, we are equally likely to hear (or say ourselves) "She's got it down to a science" or "He's raised it to an art." In other ways, however, science and art are profoundly different. The most important scientific theories of all time, those that came from the minds of undeniably great scientists, would all have been discovered eventually by one or more other scientists. In some cases, important theories or discoveries have been rushed to publication out of fear of being scooped by someone else. In art, however, Cézanne didn't have to rush-paint his *Mont Sainte-Victoire* out of fear that somebody else was going to create the identical landscape. And if Claude Debussy had never been born, nothing remotely approximating his famous "Prelude to the Afternoon of a Faun" would ever have been written by anybody, anywhere, at any time.

If art indeed imitates life, then art is an expression of the beauty, the tragedy, and the complexity of the human condition. Central to imitating the human condition is the need to explore our sense of place and purpose in the world. If the discoveries of science were detached from this calling, then one would never expect science to inspire creativity in the artist, or more specifically, one would never expect art to reach for scientific themes. Other than the occasional portrayal of a comet or an evening moon, art before the nineteenth century rarely tapped science for its themes. Only after the industrial revolution did science begin to touch people's daily lives. Today, we fully expect to be living differently (longer, better, healthier, stronger) this year than last, simply due to the advancing frontier of science.

For most of the twentieth century, the public image of the scientist was of the wild-haired, lab coat–wearing, test-tube–holding, unkempt, and antisocial variety. But what was even more alienating than these stereotypes was that scientists typically labored in the confines of laboratories and rarely communicated their work to the public, unless the results had direct implications for national health or defense. And even then, the results were only occasionally communicated by the scientists themselves. True, the great physicists Galileo, Newton, Laplace, Faraday, Eddington, Jeans, and Einstein all wrote popular accounts of their works. But the popularization of science differed greatly by country, with the result that some artists knew a lot about new discoveries, while others remained ignorant of them.

In today's global culture of science it is expected (and even common) for scientists to communicate discoveries to the public through magazines, books, television, and public talks. During any given week, dozens of science programs appear on PBS and on cable TV channels, while multiple science news stories make headlines in the daily newspapers.

This dramatic increase in science popularization has infused the arts. In recent years, I saw the Tony Award–winning play *Copenhagen* on Broadway, where the audience was transfixed by this retelling of important episodes in the history of particle physics and quantum mechanics as they related to the making of the first atomic bomb. At the same time, I noted that Brian Green's book *The Elegant Universe* (1999) about the search for a theory of everything—the ultimate explanation of all physical events in the universe—was high on the bestseller list. A few months later, I attended a dance performance titled *Elements*, featuring four dancers personifying Earth, Air, Fire, and Water, which was inspired by modern themes of geology and geophysics. Then I attended another dance performance, entitled *Strings*, which was inspired by the string theory of particle physics and by the major tenets of the Big Bang theory of the origin of the universe. In addition, two more science-inspired plays have recently raised their curtains. *QED* explores the life of the celebrated physicist Richard Feynman, and *Proof* explores the relationships between mathematical genius, mental derangement, and falling in love. On a related theme, the film *A Beautiful Mind*—based on the life of John Forbes Nash Jr., the mathematical genius who won a Nobel Prize in economics and suffered from schizophrenia—won four Academy Awards, including Best Picture.

We have evolved from a culture in which science touched only a select few to a global, diverse culture in which science touches everyone. Caught in the transition were those pioneering artists who, during the past two hundred years, sought cosmic themes at a time when the science was there but accessible expositions of its discoveries were not available to all. Today the public has embraced science as never before—not as something cold and distant but as something warm and nearby. From the mysteries of cosmic origins to the mapping of the human genome to the stellar origin of the chemical elements of life itself, people are beginning to feel that scientific discoveries made by members of our own species belong to us all. People see, perhaps for the first time, that they are no longer bystanders in the scientific enterprise but willing and vicarious participants.

In *Exploring the Invisible: Art, Science, and the Spiritual*, Lynn Gamwell traces and documents the resonant evolution of art and science through the last two centuries in as thorough an exposition as I have ever seen. As the twenty-first century takes shape, I assert that we are entering an era in which artistic inspiration comes, as never before, from the discoveries of modern science. Just as religious and mythological sources had thoroughly influenced art before and during the Renaissance, so countless artists are now being moved by the need to capture the complexities and mysteries of the physical universe on film, in dance, and on canvas. The theories and discoveries of modern science will, I predict, prove limitless in their potential to inspire human emotion and unbridled wonder. Artists can now count among their many muses the secrets of the universe.

The most beautiful experience we can have is the mysterious.
It is the fundamental emotion that stands at the cradle of true art and science.
Albert Einstein, "What I Believe," 1930

MYSTERY HAS SHROUDED abstract art since it emerged in the late nineteenth century. Where did it come from? How did shape, color, and line—in and of themselves—come to be the vocabulary of the modern painter? I propose that two catalysts contributed to the precipitation of abstract art: the scientific worldview that developed after the publication in 1859 of Charles Darwin's *On the Origin of Species by Means of Natural Selection* and the secular concepts of the spiritual that developed thereafter.[1] Darwin forever changed our sense of the universe; what had been static and eternal was now seen as constantly evolving. In the Enlightenment, Isaac Newton had cast the universe as a vast, immobile volume of space—the ether—in which the stars and planets move slowly and precisely, like a great clock, and Carolus Linnaeus organized the plants and animals of the natural world into a great "chain of being." This metaphor, inherited from Aristotle, positioned all entities in order of ascending complexity, from mineral, plant, and animal to man and, ultimately, God.

This picture altered dramatically after Darwin presented overwhelming evidence that the links in the chain of being are not rigid but changeable over time. Bitter public debates erupted over the biblical and the Darwinian accounts of creation, and a new journalism emerged to meet the general public's burgeoning fascination with science and its implications. Superbly illustrated science periodicals, books, and displays at public fairs brought science literacy to the general public and aesthetic inspiration to artists.[2] Within decades, most educated people of the West had adopted a scientific worldview.

This radical shift has long been recognized for its impact on science and culture; the purpose of this book is to demonstrate its infiltration into the visual arts and the resulting emergence of abstract art as part of the first wave of modern art in the late nineteenth century. By the 1870s painters were thinking of themselves as organisms responding to light; Monet's landscapes became as fluctuating as the light falling on his retina. New high-powered microscopes were opening windows into hitherto invisible realms, and by the end of the century Art Nouveau and Jugendstil designers were working in biomorphic styles that captured the new evolutionary concept of life on the cellular level.

1. Map of the universe, computer simulation, 2002. Virgo Super-computing Consortium, Computing Centre of the Max Planck Society, Garching, Germany, and Parallel Computing Centre, Edinburgh.

This computer simulation of the structure of the universe is based on calculations of how clouds of hydrogen and helium, as well as invisible dark matter, have evolved in the expanding universe. By comparing such computer simulations with observations of the real universe, the Virgo Consortium, an international team of astrophysicists and computer programmers, hopes to gain insight into how fluctuations in primordial clouds of gas evolved into today's galaxies and larger structures, such as the supercluster of galaxies shown here.

As artists in Munich and Moscow were creating the earliest abstract art, based in the new biology, the foundations of physics began to crumble. In the 1890s more windows were flung open into even smaller invisible worlds when X rays were discovered. In the first decade of the twentieth century, scientists realized that the basic building blocks of Newton's clock—atoms—are not solid but mainly empty space and that they are not eternal but transmutable. In the 1920s the public grappled with the concept that the universe itself is in flux; indeed, that the universe is expanding. During the 1920s and '30s, as Albert Einstein's space-time cosmology was replacing Newton's absolute space and time, artists in the second great wave of abstract art expressed the new quantum universe in geometric art and steel-and-glass architecture.

Modern art also responded to the new secular concepts of the spiritual that were formulated in the nineteenth century during major changes in religious beliefs. It would be too simple to describe this as a battle between science and religion because neither is a single-minded monolith, and there has been an ongoing dialogue between scientists and theologians. These important debates are outside the scope of this book, but a central thread woven into the fabric of modern art is the reformulation of theological questions in secular terms as artists and scientists have searched for new ways to understand the human condition during the first secular, scientific age in human history.[3]

I have organized this book around the history of modern science, tracing the major questions that have driven scientists and discussing related developments in the art world as the concerns of artists have intersected with—and been inspired by—those of scientists. My goal has been to begin with science and then, with this as background, to explore how artists have created symbols that express the modern scientific understanding of the natural world and the human condition. I begin the book in the early nineteenth century because the French Revolution was the political starting point for the rise of modern science and secularism. Before 1789 astronomy, physics, and natural history had been gentlemen's pursuits, but as democratic reforms swept the West, chimney sweeps, seamstresses, and bankers also began to be attracted to the antiauthoritarian outlook underlying the scientific method, in which there were no preordained natural laws. When Darwin released *Origin of Species* in 1859, the burgeoning middle class was already primed to embrace a scientific worldview in which the truths of nature are determined by experiments that can be observed by all people equally. The French Revolution was also the spiritual starting point for modern art and science because it inspired the passionate quest for freedom and individualism that lies at the heart of psychology—the new science of the mind—and in the soul of Romanticism. The Romantic artists, philosophers, and scientists who took up the banner of liberty, equality, and fraternity also wrote the first creeds of the secular age—pantheism and positivism—variations of which are held to this day.

Historians of modern art have tended to focus on Paris as the art capital of the West. Following in the steps of trailblazers who have looked elsewhere, I argue that the core style of modernism—abstract art—originated and was sustained in the nation that led the world in science from the late nineteenth century to 1939—Germany—and in nations with a Germanic culture, especially Austria and Russia.[4] The conceptual basis for both the art and the science, from Kant to Einstein, was provided by the philosophy of German Idealism—a powerful vision of the unity of nature. The destruction of German culture and the diaspora of intellectuals

during World War II effectively ended German Idealism as a living tradition in the minds and hearts of artists and scientists; now a dead language, like Latin, it survives today in academia.

After 1945 the world center of science—and with it, avant-garde art—shifted to the United States. The subsequent history of the interface between the arts and sciences has been shaped by the disunity and diversity of American culture and by its tradition of utilitarianism. With the beginning of the nuclear age in 1945, the American public tended to be suspicious of science, and many new discoveries were greeted not with wonder but with dread. After the Cold War, the society of science was increasingly organized into interdisciplinary teams of scientists from around the world. Today it is common for research scientists, coming from diverse cultural backgrounds, to stress the disunity of the sciences and to be wary of the kind of overview—*Weltanschauung*—that guided German science for a century. As the immediacy of a nuclear threat has faded, the popularization of science has expanded,[5] and younger generations of artists have begun to look again to science for inspiration. Citizens of today's global culture routinely learn of extraordinary breakthroughs as astronomers look back in time at the early universe through telescopes positioned high above the earth's atmosphere, and surgeons implant a life-saving tube, thinner than a human hair, into a patient's artery. But this renewed wonder is tempered by ethical and social concerns also raised by discoveries, as artists, scientists, and the public grapple with troubling questions about cloning, bioterrorism, stem cell research, genetically modified crops, and euthanasia. And every educated person in the world lives with the uneasy awareness that at any moment the sleeping nuclear giant could be awakened.

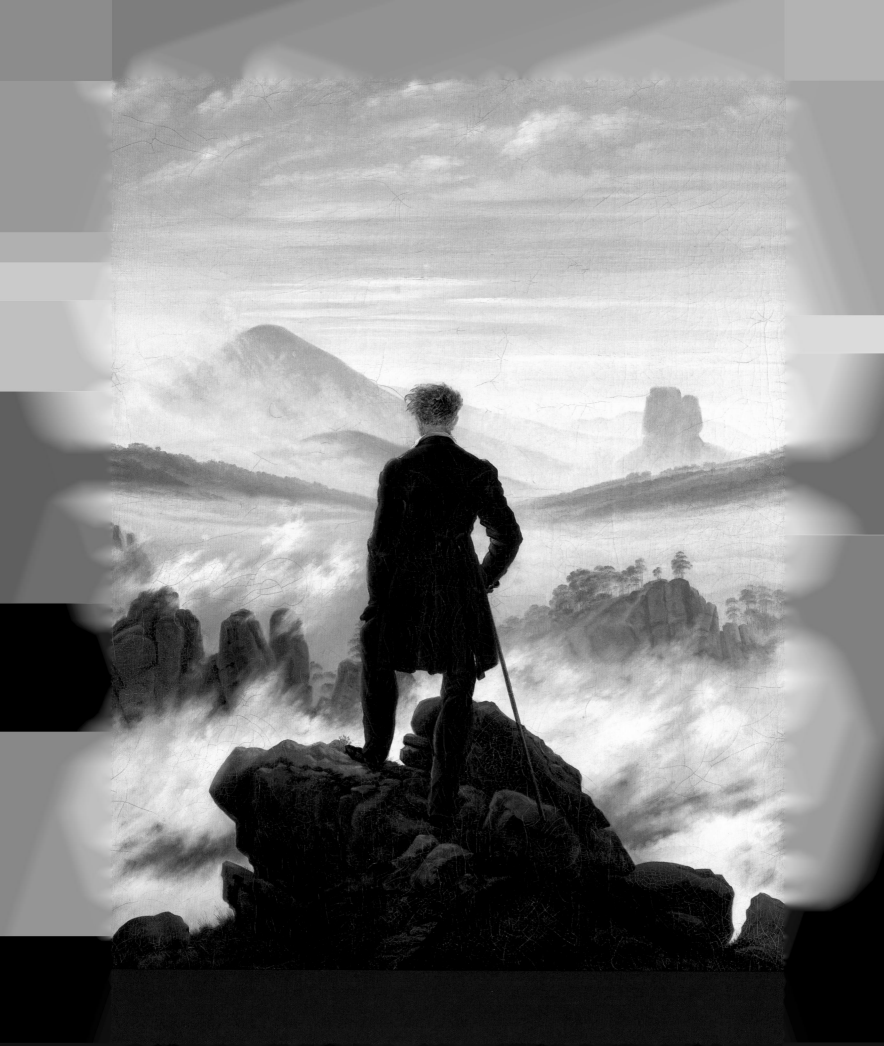

ART IN PURSUIT OF THE ABSOLUTE: ROMANTICISM

Nature is visible spirit, and spirit is invisible nature.

Friedrich Schelling,
Ideas for a Philosophy of Nature, 1797

SOMETIME ABOUT 1818, the German artist Caspar David Friedrich finished a large oil on canvas whose apparent subject is seen only from the back. Titled *Wanderer above a Sea of Fog* (plate 2), it shows a man poised on a rocky outcropping. His posture tells us that his mood is pensive, perhaps troubled, as he gazes over mist-shrouded rocks toward a great, unreachable void. The subject is as much the feeling the painting evokes as it is the fog and jagged peaks.

Friedrich, who made the concept of the sublime a central concern of the Romantic movement, was among those artists who placed their trust in intuition and emotion, valuing the subjective experience over the rationalism that had powered the Enlightenment. This attitude did not, however, divide the artists from the scientists of their day but made them soul mates. In early-nineteenth-century Germany, some of the loudest cries against Enlightenment reason came not from artists' studios but from natural philosophers' studies and scientists' laboratories.

The Enlightenment culminated at the close of the eighteenth century with Immanuel Kant's critiques of the foundations of human knowledge in his grand Teutonic system— German Idealism.[1] Kant declared that the human mind has a spatial and temporal scaffolding that it uses to organize, for example, the colors of flowers and the chirping of birds into one's experience of the natural world over time. Although Kant never doubted that the flowers and birds existed out there in the commonsense world, he concluded that, in a strict philosophical sense, one knows the natural world as a mental construction made out of colors, sounds, and other sensations. The second-generation Idealists—the natural philosophers and scientists known as the Naturphilosophen (nature philosophers)—rejected Kant's limits on knowledge and revived a mystical, pantheist desire to intuit the essence and totality of birds and flowers by becoming one with nature.

Romanticism occurred at a time of transition from speculative philosophy to experimental science. Philosophers who collected specimens and did laboratory experiments (as the Idealists did), were called natural philosophers; as the balance shifted in the early nineteenth century to a more experimental approach, a new breed of researchers came to be called natural

2. Caspar David Friedrich (German, 1774–1880), *Wanderer above a Sea of Fog*, c. 1818. Oil on canvas, 38 x 30 in. (94.8 x 74.8 cm). Hamburger Kunsthalle, Hamburg.

scientists. Thus modern science evolved from philosophy, and pivotal questions that have driven scientific research are philosophical in origin. For the Naturphilosophen and the natural scientists, everything depicted in a painting such as *Wanderer above a Sea of Fog*—the fog, the Alpine rocks, the void, and the wanderer's deepest feelings—can be known immediately and directly and is therefore the subject of science.

The Union of Pantheism and Natural Philosophy

The pantheistic reverence for nature is based in the experience of wonder in the face of natural phenomena, and it entails an immediate feeling of unity of the self with the universe. The creed has a complex history that began in ancient cosmology and became associated with Judeo-Christian mysticism. When it reappeared in the nineteenth century as a form of second-generation German Idealism, pantheism was expressed by German artists beginning with Romantics such as Friedrich, and mystical pantheism remained a strong current in German thought, forming the philosophical underpinnings of abstract art in late-nineteenth-century Jugendstil and in art by the Blaue Reiter group in the early twentieth century. The common theme in all pantheist creeds is the assertion that nature is a unity and that this unity is divine.

One of the oldest philosophical questions in Western culture was posed anew in the Romantic period and became central to modern science: How many kinds of things are there? The ancient Greek philosopher Pythagoras identified only one, a primordial substance, a "monad" (from the Greek word for "one"). Since mankind and the universe are both constructed from this substance, Pythagoras reasoned that man is a microcosm of the universe and animated by a common spirit, a World Soul, which is divine and eternal. Forces in nature exist in complementary, antagonistic pairs such as male and female, limited and unlimited, which are balanced in the living, dynamic cosmos. Followers of Pythagoras, such as Plato, taught that one can attain knowledge of the cosmos through philosophical reflection.

The idea that the universe is ordered by one spiritual principle inspired a desire to unite with the World Soul, and there is a long association of monism with mysticism in the Medieval and Renaissance eras. In the seventeenth century, the deification of nature began to be articulated into a pantheist creed within the Judeo-Christian tradition. Protestantism, with its declaration that the worshiper communicates with God directly, unmediated by saints or priests, produced the Lutheran mystic Jakob Böhme, who had a vision that nature is entirely a manifestation of a divine spirit—"the Abyss"—the ground of all things. Jewish mysticism, which encourages meditation on sacred writings (the Kabbalah), provided the intellectual setting for the Dutch philosopher Baruch Spinoza, who proclaimed that everything is a manifestation of one substance, a monad called God/Nature—"the One."

But when Enlightenment natural philosophers asked how many things constituted their clockwork universe, they answered: "There are two—mind and matter." In Newton's mechanical worldview everything is made of matter, which is inert and does not move unless acted upon by a force, such as gravity. Matter in motion follows strictly deterministic laws of cause and effect. In order to make room for free will and creative thought in this billiard-ball universe, the seventeenth-century French philosopher René Descartes posited that the human

One and the same principle supports the continuity of the inorganic and organic worlds, binding the whole into a general organism. From the earliest times philosophers have proclaimed that there is a common soul in nature, and today physicists reaffirm this unity when they assert that the universe is formed and permeated by the ether.

Friedrich Schelling,
On the World Soul, 1798

3. "The first organisms—groups of monads," in Camille Flammarion, *Le Monde avant la création de l'homme* (The world before the creation of man)(Paris: Flammarion, 1886), fig. 53.

soul (the mind) is not material but spiritual; it exists outside the body and is independent of it. Thus a philosophical chasm opened, separating man's subjective mental experience from the material world, including his own body and everyday objects.

The pantheism adopted by Romantic artists and scientists developed out of attempts to close the gap. Kant tried to solve the problem by arguing that a man's sensations (colors, sounds, smells) reflect properties of real flowers and birds but still the flora and fauna "in-itself" remained beyond the borders of perception. Determined to know the tantalizingly imperceptible natural world "in-itself," the Naturphilosophen revived the ancient Pythagorean doctrine of cosmic unity and proclaimed that mind and matter are not distinct substances but are one. According to Friedrich Schelling,[2] everything that exists is made of one basic building block (a monad) that is infused with mind (a World Soul) (plate 3). Schelling contended that nature (matter) and spirit (mind) are an inseparable unity because they each sprang from the same ground of being—the Absolute. Schelling's concept of the Absolute is essentially a secular version of Pythagoras's World Soul, Böhme's Abyss, and Spinoza's God/Nature—the One. Knowledge of and union with the Absolute became a spiritual goal central to artists in Germanic culture, from Friedrich to Wassily Kandinsky and Kazimir Malevich, and—after the influx of Germans, Austrians, and Russians to American shores—to Mark Rothko and Barnett Newman.

The whole of philosophy depends, consequently, upon the demonstration of the parallelism that exists between the activities of Nature and Spirit.... Galvanism [electricity] is the principle of life. There is no other vital force than galvanic polarity.

Lorenz Oken, *Handbook of Nature Philosophy*, 1843

Schelling's themes were echoed in the laboratories of the day. The Danish physicist Hans Christian Ørsted, who in 1820 performed a key experiment that led to the discovery of electromagnetism, held that all material objects are embodiments of ideas.[3] The German naturalist Lorenz Oken undertook to demonstrate that the structures of mind and matter are

analogous, and physicists hailed Newton's ether as a unifying substance in the cosmos.[4] The intellectual stage was set for Romanticism. The deification of nature by second-generation German Idealists is expressed in the work of Romantic painters, who through popular sources became familiar with pantheist concepts such as those expressed by the poet-scientist Johann Wolfgang von Goethe, who authored not only *Faust* (1808 [part I]; 1832 [part II]) but also *The Metamorphosis of Plants* (1790), in which he proclaimed that all plants are variations of one basic type. Like Goethe, the German Romantic painters viewed nature both with reverence and with a naturalist's eye.[5]

Philipp Otto Runge, an early Romantic painter whose career was very brief, learned of Böhme's writings while in Dresden from 1801 to 1803 and introduced them to Friedrich after their meeting in 1802. Friedrich also read pantheist writings by Goethe and by the Lutheran theologian Daniel Schleiermacher, whom he knew. In search of a form of Protestantism that could coexist with science, Schleiermacher espoused a pantheist interpretation of religion in his influential *On Religion: Speeches to Its Cultured Despisers* (1799).

Friedrich developed his style of painting a deified landscape while working on his four-painting cycle *Times of Day* in 1803–4, during which he also wrote four poems expressing his belief in the presence of God in nature. From 1810, during the struggle against Napoleonic forces in his native Dresden, Friedrich began including Gothic architectural elements in his paintings because of their association with German nationalism; sensing the decline of religious authority in his era, he depicted the churches in ruins. In *Abbey in Oakwood* (1890; Schloss Charlottenburg, Berlin), monks carry a coffin past a decrepit tower. Before Romantic pantheism, religious painting done in the West from the Renaissance on had generally depicted God as a personal deity or as a clearly identified symbol. For example, in *Trinity* (1428; San Lorenzo, Florence), the Italian painter Masaccio portrayed the divine tripartite deity: God-the-father above with arms outstretched, God-the-son crucified on the cross, and between them God-the-spirit symbolized as a dove. But in pantheism, the deity is shown not as a person or symbol but as a natural object, such as Friedrich's Alpine fog.

Like Schelling's concept of the Absolute, the German philosopher G. W. F. Hegel's view of Absolute Spirit is similarly a secular reformulation of traditional Pythagorean and pantheist notions—that one can attain higher mental levels through philosophical reflection or meditation. In Hegel's terms, a dialectical, mental process can move one beyond everyday perception of the natural world to self-consciousness, culminating in knowledge of Absolute Spirit. One senses the search for an Absolute in German Romantic landscapes such as Friedrich's *The Polar Sea* of 1823–24 (plate 4). Friedrich chose this subject during the first decade of intense arctic exploration by the British Navy in search of a route from Europe to Asia over the top of North America—a Northwest Passage. Imaginations were fired by expedition reports of impassable ice fields and raging gales, such as Captain William Parry's *Journal of a Voyage of Discovery of a North-West Passage* (1821). The British expeditions were widely reported in European newspapers, and Friedrich may even have known the 1822 German translation of Parry's *Voyage*.[6] He included an arctic vessel, whose silhouette echoes the spires of a cathedral, being crushed by sheets of ice. Friedrich placed the viewer in the midst of the frozen ruin, gazing beyond it into infinite distance, with precarious towers of ice fading into the void. In *The Polar Sea*, he achieved that blend of natural science and pantheist mysticism so typical of Romanticism.

4. Caspar David Friedrich, *The Polar Sea*, 1823–24. Oil on canvas, 38 x 49⅞ in. (96.5 x 127 cm). Hamburger Kunsthalle, Hamburg.

The skies of Romantic landscape painting offered the perfect place to synthesize science and the spiritual. Filled with air, light, and impalpable clouds, the sky suggested the ethereal realm of the spiritual. The atmosphere had been brought to public attention in 1782 when two Frenchmen, the Montgolfier brothers, lit a fire under a large cloth bag with a hole in the bottom; as the bag filled with hot air it slowly ascended, beginning the balloon age. Within a year inventors were including barometers and thermometers in the gondolas, along with instruments to collect air at various altitudes, and the new science of meteorology was also launched. In the first decade of the nineteenth century the British naturalist Luke Howard formulated a theory of cloud formation in terms of temperature, altitude, and air currents.[7] He classified four types of clouds: *nimbus*—dark gray clouds that precipitate rain, sleet, or snow; *stratus*—foglike bands; *cumulus*—white, fluffy flat-bottomed clouds with multiple rounded tops, formed by ascending air masses; and *cirrus*—high-altitude clouds composed of white fleecy patches (plate 5). When Goethe read the 1815 translation of Howard's study of clouds, it seemed to him that science had discovered the order of the heavens. In admiration for Howard, Goethe proclaimed: "He grips what cannot be held, cannot be reached. He is the first to hold it fast."[8] Goethe was inspired to write his series of "Cloud Poems" and to give Howard's classification a spiritual interpretation in his scientific treatise "The Shape of the Clouds According to Howard" (1820). Levels of clouds—from low nimbus to high cirrus—were, according to Goethe, linked to ascending spirituality, culminating in the highest cirrus clouds.

Inspired by Goethe's poems in honor of Howard, the Dresden doctor and amateur painter Carl Gustav Carus, a close friend of Friedrich, declared that "the sky in all its clarity, as

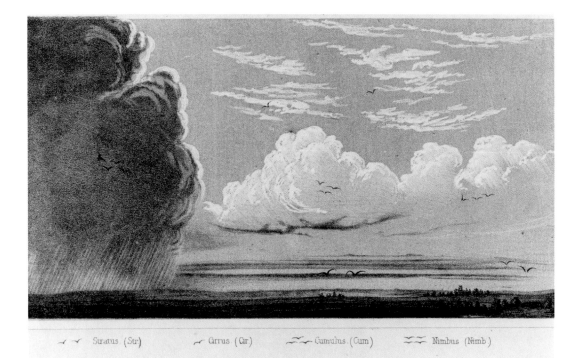

Stratus (Str.) Cirrus (Cir.) Cumulus.(Cum) Nimbus (Nimb)

ABOVE

5. Primary forms of clouds, in Luke Howard, *Essay on the Modifications of Clouds* (1803; 3rd ed., London: John Churchill and Sons, 1865), opp. 12. Mandeville Special Collections Library, University of California, San Diego. Hill Meteorology Collection.

OPPOSITE

6. Johan Christian Dahl (Norwegian, 1788–1857), *A Cloud and Landscape Study by Moonlight*, 1822. Oil on paper mounted on thick paper, 6¼ x 7⁵⁄₁₆ in. (15.8 x 18.6 cm). Fine Arts Museums of San Francisco. Museum Purchase, Magnin Endowment Income Fund, 1992.128.

the quintessence of air and light, is the real image of the infinite . . . the most essential and most glorious part of the whole landscape."[9] Goethe admired the landscapes of Carus, to whom he commented "how profoundly you comprehend the organic world, how keenly and accurately you depict it."[10] In the painter's *Monument in Memory of Goethe* (c. 1832; Hamburger Kunsthalle, Hamburg), two angels kneel before a harp on a coffin, which symbolically holds the remains of Goethe, who died in 1832. Light streams through the lofty cirrus clouds and falls upon the somber scene, which is set in the high Alps. Carus's fellow Dresden resident the Norwegian painter Johan Christian Dahl filled *A Cloud and Landscape Study by Moonlight* (plate 6) with lofty cirrus clouds. Dahl too used clouds to suggest spiritual ascension from the earthbound trees upward toward the moonlight and into the black abyss. The fog and clouds in Friedrich's *Wanderer* evoke a pantheist spiritual presence, but they also locate the contemplative man in the natural world; he has climbed above the valley fog and ascends—spiritually and physically—toward the cirrus clouds.

Thus German Romantic landscape painting expressed a pantheist union of spirit and body (mind and matter) in keeping with the monism that emerged on German soil in the early nineteenth century. As experimental science began to separate from speculative philosophy, debates echoed in artistic and intellectual circles between the two great traditions of German Idealism: the attempted resolution of the Enlightenment mind-matter dualism (Kant) and the beginning of modern monism (Schelling and the Naturphilosophen). Both were based in a scientific outlook that was strictly deterministic. Descartes's and Kant's matter and Schelling's monads are billiard balls that follow scientific laws of cause and effect. Both traditions produced a major worldview, one made of matter (the atomic version of Newton's clockwork universe) and one of monads (Einstein's mass-energy universe).

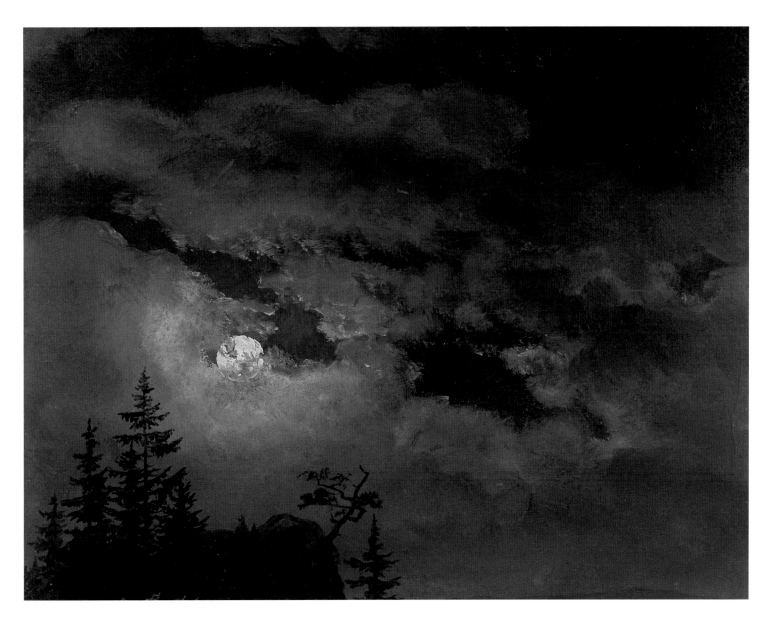

Kant and Schelling differed in where they placed man's mind (his soul, spirit, will, morals, creativity). Kant maintained that morality and creativity do not follow causal, scientific laws; they exist in a unique realm distinct from physics: so-called metaphysics (ethics, aesthetics, and religion)[11] where the rules are written by God or some other nonscientist. Schelling, on the other hand, declared that the mind is within the province of science. Both dualism and monism, and many related Idealist doctrines, were debated throughout the nineteenth century, and their influence was felt wherever there was German culture. Like any fluid ideas in a live intellectual climate, the philosophical concepts often intermingled, and for the purpose of this book it is not important to keep them all straight. Suffice it to say that in the end, Schelling won out. By 1900 there was no desire so intimate, no ecstasy so ephemeral, no guilt so unspeakable that it was outside the domain of psychology, the new science of the mind.

Yet the noble impulse
mounts always higher!
A heavenly, light compulsion
brings release.
A pile unravels into flakes
Tripping like tiny lambs,
combed lightly into clusters
So at last what comes lightly
into being down below
Above grows into the Father's
lap and hand.

Johann Wolfgang von Goethe,
"Cirrus," c. 1820

Schelling's vision of the unity of mind and matter is seen nowhere more clearly in Romantic-era science than in research on the mind in terms of electricity and magnetism—animal magnetism. The late-eighteenth-century Viennese physician who began the scientific investigation of the unconscious mind has gone down in history as an explorer who made a great discovery but mistook what he had found.[12] In 1774 Franz Anton Mesmer was treating a twenty-seven-year-old patient, Fräulein Österlin, who complained of severe physical pain and paralysis for which no organic cause could be found. Physicians of the era were just beginning to use electricity and magnetism therapeutically; in 1771 the Italian anatomist Luigi Galvani had determined that animal muscles moved when stimulated by electricity, and suspecting a link between electricity and magnetism, some English physicians had begun treating ailments with magnets. Mesmer, after placing magnets on the woman's legs and stomach, ordered her to drink a solution containing iron. Within an hour she reported feeling a powerful force flowing through her body and her symptoms disappeared. Mesmer mistakenly believed he had found a therapeutic magnetic force that flowed from doctor to patient—"animal magnetism"—but, in fact, he had discovered the power of suggestion.[13]

To earn his medical degree, Mesmer had written his doctoral thesis on a universal fluid, *gravitatio universalis*, which he hypothesized transmits forces from the motion of the planets to the human body. After Fräulein Österlin's cure, Mesmer was convinced that this fluid was, instead, magnetism and that his discovery would revolutionize not only medicine but also astronomy, chemistry, and the natural sciences. He proclaimed that animal magnetism is a physical fluid that fills the universe, connecting the celestial bodies, humankind, and all earthly creatures; disease results from an imbalance in the positive and negative forces in the fluid, and health is restored when the opposing forces are balanced. The role of the physician (who collects the healing fluid within himself just as a Leyden jar collects static electricity) is to channel animal magnetism to the patient, a process he named "mesmerism."

In 1778 Mesmer left Vienna for Paris, the medical capital of Europe, to announce his discovery, and he soon had a large, lucrative practice in high society. Mesmer was egocentric enough to believe that French scientists would eagerly adopt his theory, but instead they suspected fraud and convinced King Louis XVI to appoint a scientific commission to investigate him. The commission—which included the chemist Antoine Lavoisier and electricity expert Benjamin Franklin, who was in Paris as American ambassador—concluded in 1784 that there was no evidence for the existence of a magnetic fluid. They acknowledged that there was possible benefit from the treatment but astutely ascribed its therapeutic effect to the patient's imagination. In the end, mesmerism was officially disclaimed by the French Académie des Sciences, the Royal Society of Medicine, and the faculty of medicine at the University of Paris. Mesmer left Paris after the commission's findings were announced and died a bitter man in 1815.

But interest in mysterious mental states had been aroused in France, and Mesmer's followers continued his methods; one of them discovered a powerful new technique. The marquis de Puységur, a well-educated, wealthy layman, was magnetizing an ill subject and accidentally put him into a trance. He found that in the trance the subject was very open to his suggestions and,

indeed, would obey his commands. Puységur was also astounded to hear the entranced subject report information that the patient did not know when awake. Puységur recognized the similarity of the trance to somnambulism (sleepwalking) and named it "magnetic sleep"; in 1843 the British scientist James Braid gave it its modern name, *hypnotism* (from the Greek for "sleep").[14]

Since practicing mesmerism was forbidden to French physicians, hypnotism was also disallowed, but many insightful lay healers continued using hypnotism in the early nineteenth century. Because it developed outside the French scientific establishment, the field of hypnotic therapy was unregulated and hence defenseless against medical quacks and stage performers who hypnotized people for entertainment. With the rise of Romanticism after 1789, there was interest among French intellectuals in the bizarre mental states revealed under hypnosis, which was made all the more alluring by its shady reputation.[15]

As interest in Mesmer's and Puységur's work spread throughout Europe in the first decade of the nineteenth century, the German government also launched an inquiry into the matter. It concluded that the doctrine was plausible and should be investigated, and professorships in mesmerism were established at the University of Berlin and the University of Bonn in 1816. Schelling and his colleagues in Naturphilosophie enthusiastically studied mesmerism because its universal magnetic fluid, if it existed after all, could (like Newton's ether) be the agent of the World Soul, pervading the universe and connecting all its parts into a whole. Because a person under hypnosis has exceptional lucidity and intuitive powers, Schelling and Hegel also believed that magnetic sleep offered an avenue whereby one could reach the highest level of understanding—knowledge of Absolute Spirit.

In this atmosphere of great interest in mysterious mental phenomena, Carus formulated the first systematic theory of the unconscious mind. Carus, who was medical director of a maternity clinic in Dresden, held that the human ovum has a soul—or, in scientific language, is permeated with consciousness—and that the unconscious mind develops as the fetus grows. At birth the individual becomes conscious, but returns regularly to an unconscious state in sleep. The unconscious mind is dynamic, actively transforming into memories the thoughts and feelings that enter its realm from consciousness.[16] Carus began his book *Psyche, on the History of the Development of the Soul* (1846) with these prophetic words: "The key to the knowledge of the nature of the soul's conscious life lies in the unconscious. This explains the difficulty, if not the impossibility, of getting a real comprehension of the soul's secret. If it were an absolute impossibility to find the unconscious in the conscious, then man should despair of ever getting a knowledge of his soul, that is a knowledge of himself. But if this impossibility is only apparent, then the first task of a science of the soul is to state how the spirit of man is able to descend into these depths."[17]

In his paintings and writings, Friedrich manifested a strong interest in plumbing "the secrets of the soul" described by his friend Carus. To communicate "the unconscious in the conscious," Friedrich painted figures who convey a feeling of psychological aloneness and remoteness that is communicated by their physical isolation, as in *Wanderer* (plate 2) and *Monk by the Sea* (plate 270). The inner journey of these figures is also implied by the physical pilgrimage that has brought the wanderer to the mountaintop and the monk to the shores of the sea, from which "the spirit of man is able to descend into these depths."

A timeless, limitless, perfect unity underlies all our feeling and thought, underlies every form of existence and every part of our self. We know this through a deep, inner awareness for which we can give no explanation or proof, because it is itself the source of all knowledge, proof, and explanation. Depending on our degree of personal development, this awareness in us may be obscure or clear.

Carl Gustav Carus, *Nine Letters on Landscape Painting*, 1815–24

When Carus and Goethe were in Weimar in 1821 they discovered their shared interest in the interconnections of art, science, and the spiritual and they became close friends. Self-taught as an artist, Carus painted landscapes with the eye of a naturalist, the mind of a psychologist, and the heart of a Romantic. In *View through a Window with a Comet* (plate 7) he commented on man's quest for spiritual fulfillment in a secular, mechanistic universe by placing the viewer in the realm of science with a globe and telescope, looking at the sky through Gothic spires that suggest a spiritual realm. Linking science and the spiritual is the comet. Before Newton, comets had been viewed superstitiously as unpredictable omens of divine action. But it seemed to a friend of Newton, the British astronomer Edmond Halley, that gravity

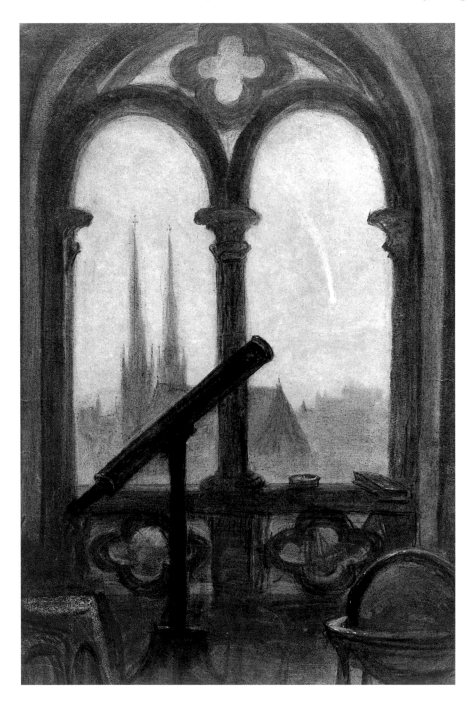

7. Carl Gustav Carus (German, 1789–1869), *View through a Window with a Comet*, c. 1851. Charcoal on paper, 17¼ x 10¾ in. (43.8 x 27.3 cm). Kupferstich-Kabinett, Staatliche Kunstsammlungen, Dresden.

must control the motion of comets (from the Greek for "long-haired" [stars]). After studying the records of the dates when comets appeared and their paths across the sky, Halley noticed that a comet with the same path was recorded at regular intervals of approximately seventy years: 1456, 1531, 1607, and 1678. He hypothesized that these were all appearances of the same comet, which traveled in an ellipse like a planet, but a very, very long ellipse. He predicted that the comet would appear again, traveling in the same path, in 1758. No one thought much about it, but when "Halley's comet" returned as predicted, it confirmed his theory. When the comet returned to the skies of Dresden in 1832, it was awaited with a telescope as a reminder of the awesome power of Newton's law of gravity.

The interest in the unconscious realm within German Romanticism culminated in Eduard von Hartmann's classic compendium of all known types of unconscious mental activity, *Philosophy of the Unconscious* (1869).[18] The book's great popularity among Western intellectuals suggests how common discussions of the unconscious mind had become in the West by the mid-nineteenth century.

ROMANTICISM IN BRITAIN AND AMERICA

In England the philosopher and poet Samuel Taylor Coleridge embraced another aspect of German Idealism in his pursuit of a poetic pantheism that he practiced along with fellow poet William Wordsworth. Kant divided his study of human reason into several realms, including reasoning about mathematics, as well as judgments about ethics and aesthetics. He defined the aesthetic realm as autonomous and declared that the truth of an aesthetic judgment, such as "The sunset is beautiful," is independent of logical or moral criteria. Such aesthetic knowledge is neither deductive nor inductive but an immediate, subjective intuition. For Coleridge and a host of other Romantic poets, Kant's description fit their view of the artistic imagination. The artist creatively intuits the essence of nature, which for pantheists like Coleridge and Wordsworth was divine. The artist-poet then reveals the sacred truth in his creation.

Kant also analyzed a central Romantic concept—the sublime. The modern notion of the sublime had been defined a half century earlier, in 1757, by Edmund Burke as the experience of the infinite in nature, such as the number of stars in the heavens, which, according to Burke, is a boundless and indistinct quantity.[19] Kant disagreed with Burke's suggestion that the experience of the sublime is enhanced by a fear of the unknown and stressed that the sublime is a satisfying, exhilarating experience of grandeur. Kant linked the sublime directly to the pantheist notion of an awesome transcendent universe. The sublime is occasioned, according to Kant, when one is confronted with something extremely vast, such as the heavens, or something overwhelmingly powerful, such as universal gravitation. In such situations, man has an aesthetic experience of nature during which, according to Kant, he is overwhelmed by the concept of vastness or power. Thus the experience of the sublime is thrilling, not terrifying. Kant believed in the existence of a God, but he dismissed the whole field of theology as inept reasoning. For him the proof of God's existence was

Two things fill the mind with ever new and increasing admiration and awe, the more often and steadily reflection is occupied with them: the starry heaven above me and the moral law within me. *Neither of them need I seek and merely suspect as if shrouded in obscurity or rapture beyond my own horizon; I see them before me and connect them immediately with my existence.*

Immanuel Kant,
Critique of Practical Reason, 1788

not intellectual but experienced by every man in his moral instinct and in his intuition that nature is a manifestation of cosmic order. The aesthetic experience of the sublime and the beautiful that occurs when one looks at a landscape, according to Kant, depends on this intuition of God's presence in nature.

This pantheist concept of the sublime was embodied in a pair of paintings on the theme of the biblical flood by the British artist J. M. W. Turner: *Shade and Darkness—The Evening of the Deluge*, and *Light and Color (Goethe's Theory)—The Morning after the Deluge—Moses Writing the Book of Genesis* (plates 8 and 9).[20] Turner painted the sea in swirling brushstrokes to communicate terror before the powerful storm, and thick impasto to produce a feeling of calm afterward.

Turner based his choice of color on Goethe's book, *Theory of Colors* (1810; English translation, 1840), in which the poet had set out to prove that Newton had been wrong about light and color. In a famous series of experiments in the 1660s, Newton had let a ray of light enter a darkened room through a hole in a window shade and pass through a prism of glass onto a screen (plate 10). Different parts of the light were refracted to different extents, so that the beams that

8. J. M. W. Turner (English, 1775–1851), *Shade and Darkness— The Evening of the Deluge*, 1843. Oil on canvas, 31½ x 31¼ in. (78.7 x 78.1 cm). Tate, London.

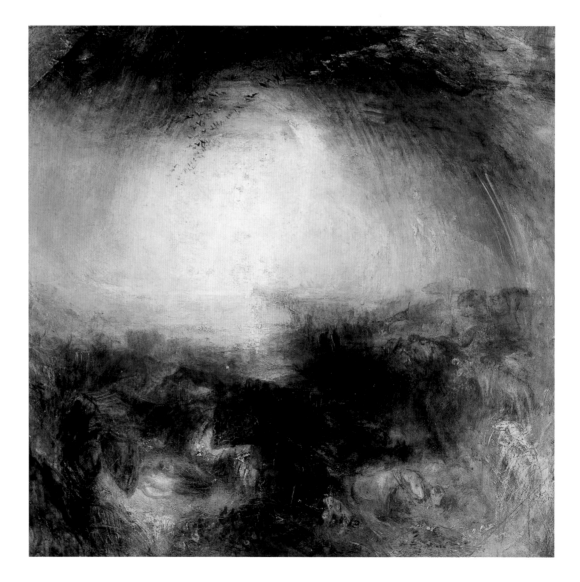

fell on the screen were in a band of colors of the rainbow—red, orange, yellow, green, blue, violet—a spectrum. Goethe set up his own experiment with a prism and got a different result; he observed that light traveling through a prism does not separate into a spectrum, as Newton had claimed, but produces fringes of colored light at the edges of a black-and-white pattern. Using this as his premise, Goethe formulated his theory that the color of a surface is caused by a pattern of black and white lines and spots; different colors result from different ratios of the black and white elements.[21] If Goethe had not had a great reputation as an artist, his color theory would have been tossed into the dustbin of science along with countless other laboratory mistakes and false hypotheses, but instead gallons of ink have been spilled trying to make sense of it.[22] As the German physiologist Hermann von Helmholtz pointed out in 1853, Goethe failed to produce a spectrum because of simple errors in how the poet performed his experiment.[23] To produce a spectrum a narrow beam of light must be directed into a prism. Goethe allowed light to flood through a window onto his prism, and this does not produce a spectrum, or rather it produces thousands of overlapping spectra, which blend to white light. Failing to produce a spectrum, Goethe put the prism up to his eye and looked through it, as one looks through a lens, at a pattern

9. J. M. W. Turner, *Light and Color (Goethe's Theory)—The Morning after the Deluge—Moses Writing the Book of Genesis*, 1843. Oil on canvas, 31½ x 31½ in. (78.7 x 78.7 cm). Tate, Liverpool.

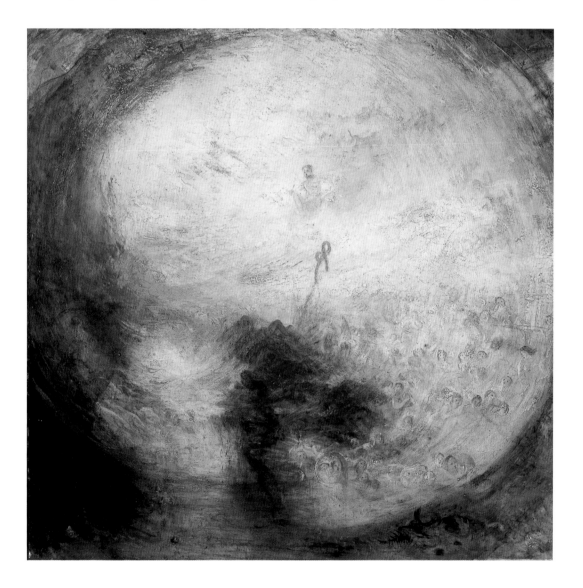

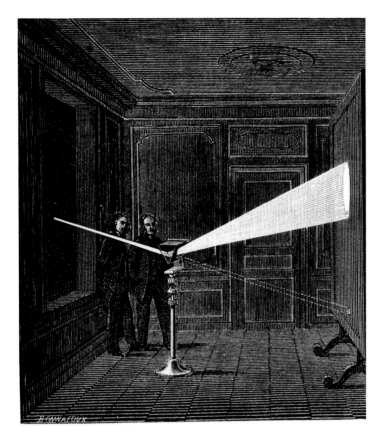

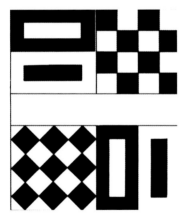

of black and white shapes (plate 11). He saw chromatic distortion at the edges of the black-and-white pattern, which produced a rainbowlike outline of all the edges. Such chromatic distortion was well known to lens grinders, but Goethe was evidently unaware of this and cried "Eureka"—Newton was wrong and he was right. The viciousness of the poet's attack on the towering genius of the Enlightenment—calling Newton's color theory "incredibly impudent," "mere twaddle," and a "ludicrous explanation"[24]—makes one suspect that there was more than science going on. When Goethe published his theory in 1810, the artist's role as a recorder of the natural world was being challenged as physicists were beginning to describe color as a property not of surfaces but of light. Perhaps Goethe felt called upon to stop the tide, as Helmholtz insightfully noted, "We must look upon his theory as a forlorn hope, a desperate attempt to rescue from the attacks of science the belief in the direct truth of our senses."[25]

Turner's application of Goethe's method for objectively recording colored surfaces resulted, ironically, in two extremely abstract paintings. The pair hover on the border of total non-representation, remaining figurative only by virtue of the smallest of details, such as the animals lined up two-by-two to board Noah's ark in the lower part of *Shade and Darkness* and the small figure of Moses in the center of *Light and Color*. In his book Goethe taught that there are only two fundamental colors, black and white, and that the eye perceives a color when looking at a pattern of tiny black and white specks too small to be discerned by the naked eye as distinct units. Goethe's description of color in terms of abstract black-and-white patterns may have encouraged Turner's inclinations toward radical abstraction.

In an imaginative rethinking of Goethe's color theory, Turner transformed how, according to the poet, one perceives colored surfaces—seeing first black-and-white patterns, which then leads to seeing color—into a metaphor for the deluge. The viewer first sees only the shade and darkness of the impending doom *(The Evening)*. Then the pattern (the circle within the square) is transformed, and *The Morning* glows with light and color. The circular forms in the two paintings have shimmering edges, like the flicker one sees at the edge of a black-and-white pattern (in *The Evening*) and like the sparkles and flashes of colored light that one sees when there is chromatic distortion (in *The Morning*).

Like the German Romantic painters, John Constable was inspired by Luke Howard's description of clouds; the artist owned Thomas Forester's *Researches about Atmospheric Phenomena* (1812), which begins with a summary of Howard's classification of clouds.[26] In 1821–22 Constable did a series of cloud sketches in oil, and he declared: "I have done a great deal of skying, for I am determined to conquer all difficulties. . . . The sky is the source of light in Nature, and governs everything."[27] Like a naturalist, he recorded the day, time, location, and weather conditions; plate 12 shows a stormy sky filled with nimbus clouds.

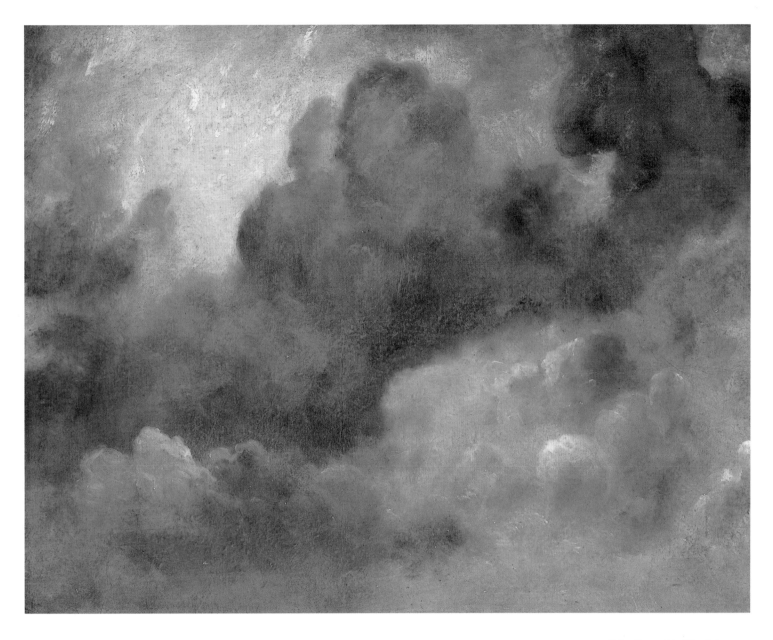

On the shores of Walden Pond near Concord, Massachusetts, an American variety of pantheism was bred by the New England Transcendentalists, a group of writers led by Ralph Waldo Emerson and Henry David Thoreau who flourished between the 1830s and the 1860s. Emerson derived the term Transcendentalist from Kant, according to whom space and time are transcendental (a priori) preconditions for experiencing the world. In other words, from birth an infant sees flowers and trees as part of a landscape (the spatial world) that stays there day after day (the continuity of time) because the child was born with a brain that thinks spatially and temporally. Emerson gave Transcendentalism the vaguer meaning of anything that is intuitive: "What is popularly called Transcendentalism among us, is Idealism . . . whatever belongs to the class of intuitive thought, is popularly called at the present day Transcendental."[28] Emerson was a clergyman ordained as a Unitarian, a Protestant sect that is pantheist in the sense that it asserts the unity (as opposed to the trinity) of the deity and the manifestation of God in nature.

12. John Constable (English, 1776–1837), *Cloud Study*, 1822. Oil on paper laid on board, 19 x 23 in. (47.6 x 57.5 cm). Tate, London.

The leader of the Hudson River School of painting, Thomas Cole, together with his student Frederic Edwin Church, was the artistic spokesman for pantheism in America. Cole's description of Niagara Falls, which he painted (plate 13), expresses his spiritual union with this divine natural splendor: "In gazing on it we feel that a great void had been filled in our minds—our conceptions expand—we become part of what we behold!"[29] American Romantic landscape painters shared their German and British colleagues' symbolic association of luminous skies with a divine presence;[30] Cole heightens the drama of his scene with a band of rain-filled nimbus clouds at the horizon, valley fog creeping in from the left, with the reassuring presence of wispy cirrus as the viewer looks toward the highest heavens.

The most widely read early-nineteenth-century scientist to extol the harmony of nature and the great chain of being was the German naturalist Alexander von Humboldt. From 1799 to 1804 he led an expedition to South America, during which he climbed the nineteen-thousand-foot

Standing on the bare ground,—my head bathed by the blithe air, and uplifted into infinite space,—all means of egotism vanish. . . . I am nothing. I see all. The currents of the Universal Being circulate through me; I am part and parcel of God.

Ralph Waldo Emerson,
Nature, 1836

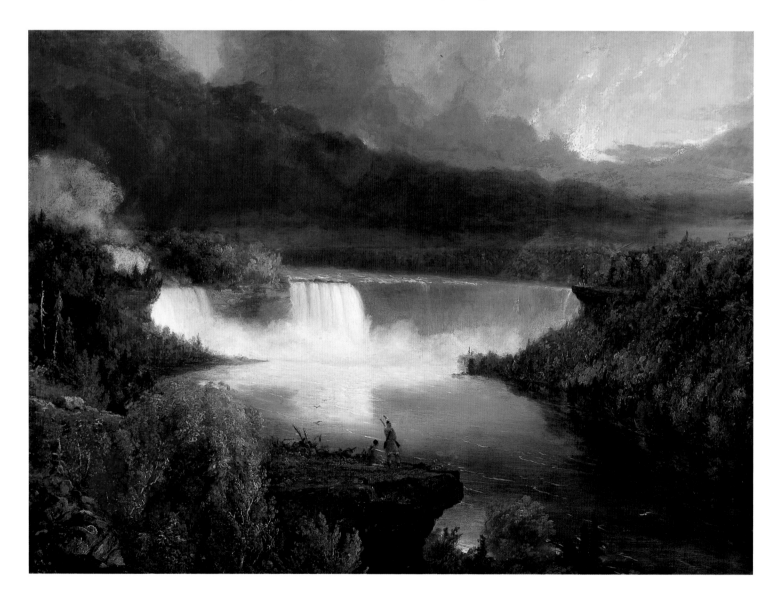

CHAPTER I

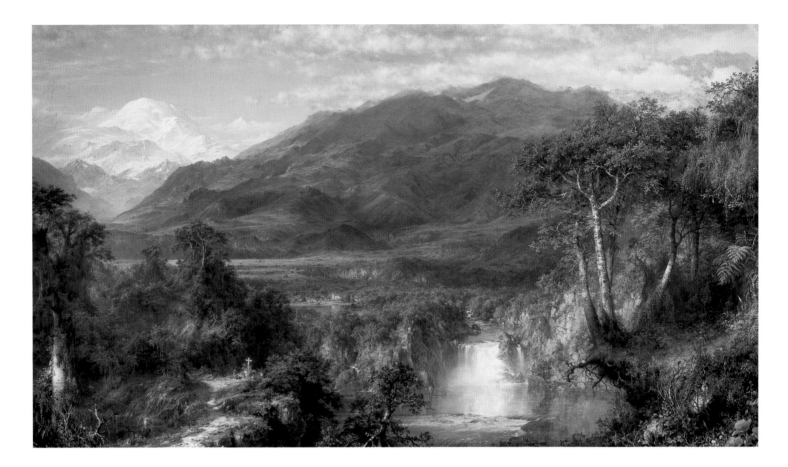

Chimborazo volcano in Ecuador, setting a new world record for altitude, and collected sixty thousand plant and animal specimens. In 1845 he released the first volume of his popular and hugely influential compendium on nature, *Cosmos*. In the introduction Humboldt stated that his goal was to describe nature as "a unity in diversity of phenomena; a harmony, blending together all created things, however dissimilar in form and attributes; one great whole (τὸ πᾶυ) animated by the breath of life."[31] Coming from the world of natural science, in which artists commonly documented expeditions, Humboldt encouraged landscapists to learn botany, to develop their skills of observation, and to sketch *en plein air*, dismissing as "morbid sentimentality" the idea that scientific knowledge of nature diminishes aesthetic pleasure.

Soon after Cole painted his great panorama of Niagara, Church began reading Humboldt's pantheist description of nature. Following Humboldt's injunction, the artist traveled to South America and in 1859 completed his grand vision of the harmony of nature, *Heart of the Andes* (plate 14).[32] The painting presents an encyclopedic overview of natural science, from glacial peaks to tropical vegetation, and the artist painstakingly painted an array of flora and fauna, each suited to its climate, in precise detail. When a young Charles Darwin set sail on the *Beagle* in 1831, he packed his copy of Humboldt's *Personal Narrative* (1814–29), a description of his South American voyage. The next year in the jungles of Brazil, Darwin wrote in his diary, "Humboldt's glorious descriptions are and will forever be unparalleled."[33] But by the time Darwin returned to London in 1836, he had come to the unsettling conclusion that nature is more like a battlefield than a peaceable kingdom. Once Darwin's views became widely

OPPOSITE
13. Thomas Cole (American, 1801–1848), *Distant View of Niagara Falls*, 1830. Oil on panel, 18⅞ x 23⅞ in. (48 x 60.7 cm). The Art Institute of Chicago. Friends of American Art Collection, 1946.396.

ABOVE
14. Frederic Edwin Church (American, 1826–1900), *Heart of the Andes*, 1859. Oil on canvas, 5 ft. 6⅛ in. x 9 ft. 11¼ in. (1.68 x 3.29 m). The Metropolitan Museum of Art, New York. Bequest of Margaret E. Dows, 1909 (09.95).

known in the 1860s, the era of grand landscape painting expressing the harmony of nature began to wane, never to return.

But the seeds of the modern search for the meaning of the human condition existed in other pantheist and Idealist notions that remained very much alive. Kant's revolutionary claim that objective knowledge does not originate in the world but in a cognitive act of the mind would soon turn the search inward. The concepts of an Absolute Spirit and a unity of nature lingered and were reformulated in secular terms as nineteenth-century science developed. In 1859 the seeds of these ideas were still hidden below ground, but they had been sown in fertile soil and were taking root.

POSITIVISM

In the wake of the French Revolution, early-nineteenth-century social reformers in France and Britain first expressed the concept of positivism: science gives the only valid ("positive") knowledge and science propels progress in history. In France positivism took the form of socialism, and in Britain it was expressed as utilitarianism; these positivist outlooks persisted not only in French and Anglo-American social order but also in the society of science.

The French social philosopher Claude-Henri de Rouvroy, comte de Saint-Simon renounced his title as a sign of his zealous support for the French Revolution. After making a fortune as a financier in Paris, he took up the study of physics in his fifties, befriended scientists, and began the perceptive and imaginative analysis of European history that made him a founding father of French socialism. Saint-Simon sensed that he lived at a critical moment in history, when the privileges and institutions of monarchies had outgrown their usefulness and church doctrine had been rendered obsolete by science. A passionate admirer of Newton, he urged that human affairs be approached in a scientific spirit of inquiry and that new utopian institutions and doctrines be created to suit the emerging society. In *New Christianity* (1825), he envisioned a new brotherhood of workers empowered by a scientific education and no longer in servitude to religious superstition.

Saint-Simon was associated during the last decade of his life with Auguste Comte, a well-educated mathematician and social philosopher who gave positivism an articulate and consistent formulation. Comte declared that human knowledge—by which he meant astronomy, physics, chemistry, and biology—progresses through three irreversible stages, beginning with theology, in which explanations are sought in terms of human emotions (desire and obedience, guilt and punishment) and divine causes are imagined on a human model. Next comes the metaphysical stage, in which abstract, philosophical causes are substituted for personal ones, such as "force" for "desire," and then finally the scientific stage—positivism—in which explanations are found by the inductive method of generalizing from observed facts. Toward the end of his life, Comte despaired of forming a stable society by reason alone, and he attempted a bizarre mix of science and religion. Declaring himself high priest, he used a Catholic model in the naive hope that this would give his demythologized dogma a stronger psychological grip on his followers. In his book *Positivist Catechism* (1852) he described his cult of reason, at the center of which was a new trinity composed of mankind, the earth, and

celestial space; it was complete with holy days such as Newton's birthday, and a calendar of saints with months named after Aristotle, Dante, and Shakespeare.

For the English-speaking audience, the British philosopher John Stuart Mill developed a morality based in science in *System of Logic* (1843), which was the most widely read nineteenth-century text on positivism. At the center of the book is a defense of an extreme form of inductive reasoning in which all knowledge derives from experience and no law of science is above challenge if it does not fit observed facts. A radical libertarian, Mill argued that individuals are free to decide the truth of any proposition based on their own experience and common sense, and to believe nothing solely on the basis of government authority, religious revelation, or because it is a custom. Mill agreed with Saint-Simon and Comte that history was at a turning point and that the undermining of traditional moral beliefs posed a grave threat to the stability of society. Mill's solution was to use inductive reasoning to generalize a moral code based in experience, which led him to the principle that the rightness or wrongness of an act can be judged by whether it has good or bad consequences. Thus a moral verdict is rendered not by consulting a preordained code but by observing the usefulness—utility—of an action in bringing about the greatest good for the greatest number of people. Mill's merger of scientific knowledge, individual freedom, and human happiness was the strongest nineteenth-century expression of humanistic morality.

The predominance of positivism in France and Britain led to the focus on observed fact in nineteenth-century French and British laboratories. As American science developed, it was most closely allied with that of Britain, and researchers in Philadelphia and Boston adopted the same utilitarian outlook and commonsense reliance on only what can be seen with one's own eyes. As the general public in these countries adopted a scientific outlook, late-nineteenth-century French, British, and American artists reflected the seeing-is-believing attitude by creating various styles that were based in observation. Even as their art became increasingly more abstracted from nature, painters in Paris, London, and New York clung to vestiges of depicted details in still lifes, landscapes, and portraits until World War I. In contrast, early-nineteenth-century German science developed in a culture that was less affected by the socialism and utilitarianism that arose in response to the French Revolution and to the democratic reforms sweeping Britain and America. As laboratories opened in Dresden, Munich, and Berlin (as well as Vienna and Moscow), German scientists were less concerned with collecting detailed data from direct observation and more consumed with the broad theoretical questions about nature that they had inherited from German Idealism. Reflecting this distinctive feature of German science, artists in Germany, Austria, and Russia were less grounded in what they saw in the natural world, and as evidence from the laboratories mounted that nature is not what she appears, artists throughout Germanic culture turned their backs on mimesis without regrets and embraced radical abstraction.

I. II. III. IV.
VIII. V. VI.
VII. IX. X. XI.
XII. XIII. XIV.
XV. XVI. XVII.

2

ADOPTING A SCIENTIFIC WORLDVIEW

Man is descended from a hairy, tailed quadruped, probably arboreal in habits.

Charles Darwin, *The Descent of Man*, 1871

WHEN CHARLES DARWIN published his theory of evolution in 1859, two of his ideas became flash points for controversy. Darwin posited that plants and animals were created not by a divine designer but by natural selection and that man had not been made in God's image but had descended from an ape. The biblical view held that God had created the species, with each multiplying "after its kind" (Gen. 1:11, 21), which, taken literally, means that species are forever immutable. How were the followers of Catholicism, Protestantism, or Judaism, for whom God's role as creator was unassailable, to reconcile the enormous implications of Darwin's ideas?

Geological and biological evidence of evolution had been coming to light since the late eighteenth century. Naturalists had accumulated many shells and bones that did not correlate to any existing species, and they began to speculate about why some plants and animals became extinct and why others lived only during certain epochs. In 1812 the French naturalist Georges Cuvier amazed the Paris scientific community by announcing that some bizarre bones found in Bavaria were the remains of an extinct flying reptile, with wings made from a membrane of skin attached to a greatly elongated fourth digit, which he called a pterodactyl ("wing-finger") (plate 16). People flocked to the Philadelphia Museum to see the skeleton of the tusked American mastodon (an extinct ancestor of the elephant) that the naturalist and artist Charles Willson Peale had excavated in upstate New York in about 1801–5. In the 1820s an amateur British fossil hunter, Gideon Mantell, found a tooth that, except for its great size, matched one from a modern iguana (a lizard common today in the American Southwest). Mantell estimated that this herbivore reptile, the iguanodon ("iguana tooth"), had slithered through the bucolic British countryside measuring about one hundred feet long from nose to tail.[1] When Mantell obtained the fossil remains of an entire iguanodon in 1834, he invited the public to see them and noted in his diary: "Among the visitors who have besieged my house today was Mr. John Martin. . . . I wish I could induce him to portray the country of the Iguanodons; no other pencil but his could attempt such a subject."[2] Martin was famous in his day for his imaginative presentation of sublime themes on a grand scale, composed with great Romantic bravura (see plate 273); also an

15. "Astasiaea," in C. G. Ehrenberg, *Die Infusionstierchen als vollkommene Organismen* (Infusion animals as complete organisms) (Leipzig, Germany, 1838), pl. 7.

16. Fossil and reconstruction of a pterodactyl (wing-finger), in Edward Clodd, *The Story of Creation: A Plain Account of Evolution* (London: Longmans, Green, 1888), fig. 16.

17. Max Klinger (German, 1857–1920), *Abduction*, plate 9 of 10 in *A Glove*, 1881. Etching and aquatint on ivory chine collé, 10⅝ x 4¾ in. (26.9 x 12 cm). The Art Institute of Chicago. Gift of Mr. and Mrs. Joseph R. Shapiro in honor of Teri Edelstein, 1992.137.9.

Exotic creatures from the past captured the imagination of artists such as Max Klinger, who cast a pterodactyl in the role of a villain who has stolen a lady's glove in her dreams.

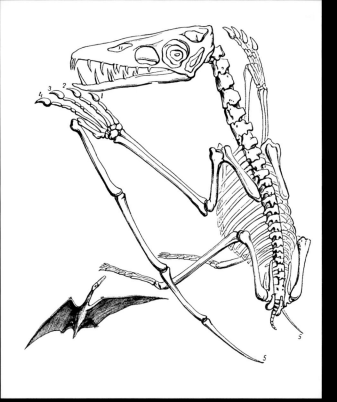

18. "The Country of the Iguanodon," mezzotint, by John Martin (English, 1789–1854), frontispiece in Gideon Mantell, *The Wonders of Geology*, 7th ed. (London: Henry G. Bohn, 1838), vol. 1.

Typical of his dark theatrical vision, Martin imagined a mortal battle being fought between giant iguanodons, in a landscape verdant with tropical vegetation from the age of reptiles—the Mesozoic era. The struggle is witnessed by a fluttering pterodactyl, and the ground is scattered with the coiled shells of ammonites (extinct cephalopods of the Mesozoic).

19. Statues of dinosaurs, in Samuel Phillips, *Guide to the Crystal Palace and Its Park and Gardens* (Sydenham, England: Crystal Palace Library, 1859), 167.

In 1842 the British zoologist Richard Owens named a new order of extinct reptiles the Dinosauria ("terrible [in the sense of awesome] lizards"). When plans were being made to relocate the Crystal Palace to Sydenham near London after the closing of the 1850 world's fair, the board of directors included an outdoor amusement park populated with painted cement models of extinct plants and animals. The dinosaur park opened to great acclaim in 1854 and can be visited today just a short train ride from London.

Implacable November weather. As much mud in the streets as if the waters had but newly retired from the face of the Earth, and it would not be wrongful to meet a Megalosaurus, forty feet long or so, waddling like an elephantine lizard up Holborn Hill.

Charles Dickens, *Bleak House*, 1852

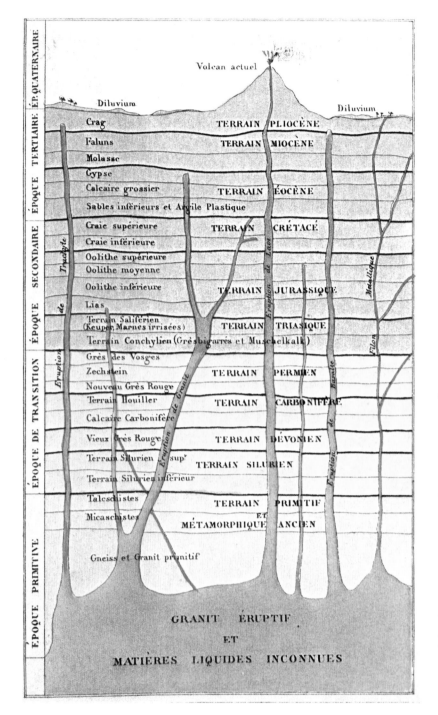

accomplished printmaker, he obliged Mantell by artistically bringing the iguanodon to life (plate 18).

What had happened to these and the other exotic creatures being unearthed? To explain the extinction of some species, Cuvier described in *Inquiry into Fossil Remains* (1812) a series of floods that had extinguished all life, after each of which God created new life-forms. The biblical deluge, according to Cuvier, was the last of the floods to occur. The French naturalist Jean-Baptiste Lamarck disagreed with Cuvier and proclaimed that plants and animals do indeed change form, undergoing "transmutation" in response to their environments. Lamarck gave as an example the giraffe's long neck, which he said was elongated as it stretched to reach leaves higher and higher up. Such acquired characteristics, Lamarck suggested, could be passed on to offspring.

Cuvier explained the layering of the earth's crust in terms of global floods, but the British geologist James Hutton theorized that it had been formed through very slow but observable processes, such as the accumulation of sediment on land and on the floor of the sea (plate 20).[3] It was a contemporary of Cuvier's and Hutton's, the English land surveyor William Smith, who made the crucial observation that each stratum of rock contains only a particular type of fossil. While digging canals, Smith observed a cross section of rock stratum for many miles; as it got thicker and thinner, sometimes disappearing and then reappearing in the next hill, it always contained the same fossils. In 1816 he hypothesized that fossils could be arranged chronologically by stratum and demonstrated that the lower (presumably earlier) strata contained simpler organisms and higher (more recent) levels of rock contained more complex fossils (plate 21). The British geologist Charles Lyell synthesized Hutton's work on the formation of the earth's crust with Smith's relation of the layering of strata to the fossil record and the age of extinct species in *Principles of Geology* (1830–33), laying the foundations for the sciences of geology and evolutionary biology. In the 1830s the Swiss zoologist Louis Agassiz demonstrated that, just as Hutton and Lyell had suggested that rivers carve valleys, so glaciers move slowly, like rivers of ice, and also sculpt the terrain (plate 22). Agassiz further proposed that the earth had gone through periods of extreme cold, which he termed "ice ages," during

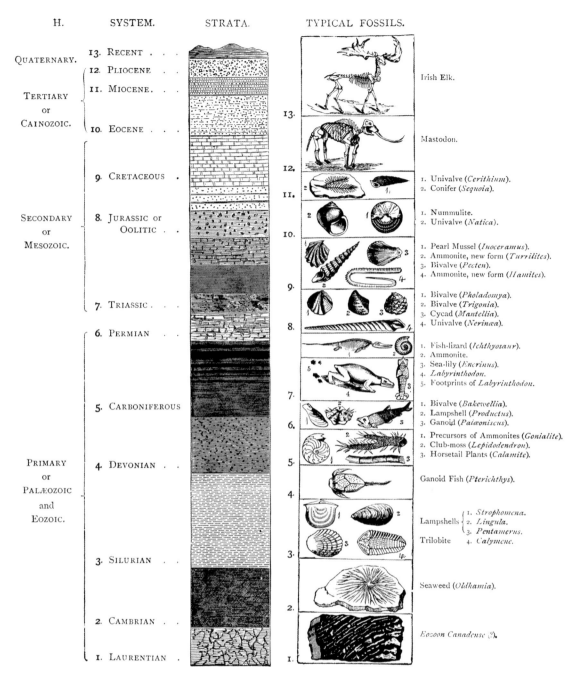

H.	SYSTEM.	STRATA.	TYPICAL FOSSILS.

QUATERNARY. — 13. RECENT . . .

TERTIARY or CAINOZOIC. — 12. PLIOCENE . . / 11. MIOCENE. . / 10. EOCENE . . .

SECONDARY or MESOZOIC. — 9. CRETACEOUS . / 8. JURASSIC or OOLITIC . . / 7. TRIASSIC . . .

PRIMARY or PALÆOZOIC and EOZOIC. — 6. PERMIAN . . / 5. CARBONIFEROUS / 4. DEVONIAN . . / 3. SILURIAN . . / 2. CAMBRIAN . . / 1. LAURENTIAN .

Irish Elk.

Mastodon.

1. Univalve (*Cerithium*).
2. Conifer (*Sequoia*).

1. Nummulite.
2. Univalve (*Natica*).

1. Pearl Mussel (*Inoceramus*).
2. Ammonite, new form (*Turrilites*).
3. Bivalve (*Pecten*).
4. Ammonite, new form (*Hamites*).

1. Bivalve (*Pholadomya*).
2. Bivalve (*Trigonia*).
3. Cycad (*Mantellia*).
4. Univalve (*Nerinæa*).

1. Fish-lizard (*Ichthyosaur*).
2. Ammonite.
3. Sea-lily (*Encrinus*).
4. *Labyrinthodon*.
5. Footprints of *Labyrinthodon*.

1. Bivalve (*Bakewellia*).
2. Lampshell (*Productus*).
3. Ganoid (*Palæoniscus*).

1. Precursors of Ammonites (*Gonialite*).
2. Club-moss (*Lepidodendron*).
3. Horsetail Plants (*Calamite*).

Ganoid Fish (*Pterichthys*).

Lampshells { 1. *Strophomena*. 2. *Lingula*. 3. *Pentamerus*. }
Trilobite 4. *Calymene*.

Seaweed (*Oldhamia*).

Eozoon Canadense (?).

OPPOSITE

20. Cross section of the earth's crust, in Louis Figuier, *La Terre avant le déluge* (The earth before the deluge) (Paris: L. Hachette, 1863), frontispiece.

LEFT

21. Table of stratified rocks and associated fossils, in Edward Clodd, *The Story of Creation: A Plain Account of Evolution* (London: Longmans, Green, 1888), fig. 4.

The periods—such as Devonian and Jurassic—were named in the nineteenth century for the places where fossils from the strata were first excavated—the region of Devonshire in England and the Jura Mountains between France and Switzerland.

which most of Europe and the northern United States was under sheets of ice that chiseled the Alps and gouged out the Great Lakes and the Hudson River as they receded, leaving behind giant boulders.

Geology became a popular pastime in Britain, Europe, and America in the early nineteenth century. The public's interest was aroused by debates in the popular press about the age of the earth, and amateurs collected rock specimens on their nature walks and travels, displaying them in parlor curio cabinets.[4] Alexander von Humboldt, trained as a geologist, had urged a generation of Romantic landscape painters to study the shape of hills and valleys,[5] but it was

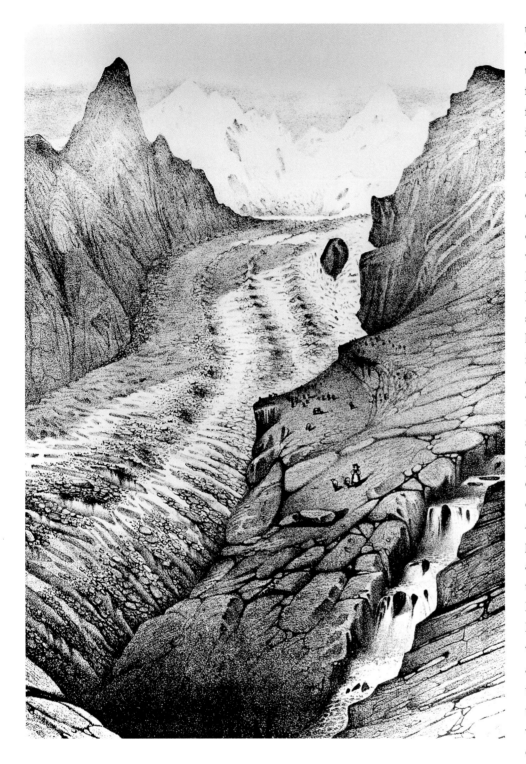

the mid-nineteenth-century art critic John Ruskin who advocated close attention to every crevasse and pebble. Reflecting the British naturalist's penchant for close observation, Ruskin admonished artists to forgo painting sublime vistas in broad brushstrokes and to record specific natural facts in accurate detail: "A rock must be either one rock or another; it cannot be a general rock, or it is no rock" (plate 23). This attitude was adopted by the second-generation Hudson River School painter Asher B. Durand; his early work was in the grand style of Thomas Cole's panoramic vistas, but Durand's mature work presents an intense close-up view that he adopted after reading Ruskin.[6] There is no "general rock" in *Rocky Cliff* (plate 24); Durand has documented layers of sedimentary rock, spotted with lichen. Mosses and grasses have taken root in cracks, the growing tendrils are splitting open the egg-shaped rock on the right. Above, layers of shale are precariously perched, having been loosened by roots and erosion. Durand shared the pantheist outlook of Cole and the New England Transcendentalists, and, like Emerson, for whom God "reappears with all his parts in every moss,"[7] the artist saw the cliff as a microcosm for the divine macrocosm: "The imaginative artist . . . reads the historic record which time has written on all things for our instruction, through all the stages of its silent transition, since the period when this verdant earth was a lifeless, molten chaos, 'void and without form.'"[8]

22. "Glacier at Zermatt," lithograph by J. Bettannier, in Louis Agassiz, *Étude sur les glaciers* (Study of glaciers) (Neuchatel, Switzerland: H. Nicolet, 1840), pl. 4.

The dawn of photography was contemporary with Lyell's and Agassiz's publications in the 1830s and '40s, and the new medium was widely used by those who, like Durand, wanted to record geological subjects accurately.[9] Using large glass negatives on treacherous ascents of cliffs and glaciers and setting up portable darkrooms in freezing temperatures, the Bisson

23. John Ruskin (English, 1819–1900), *A Fragment of the Alps*, c. 1854–56. Watercolor and gouache over graphite, 13½ x 19¾ in. (33.5 x 49.3 cm). Fogg Art Museum, Harvard University Art Museums, Cambridge, Massachusetts. Gift of Samuel Sachs.

BELOW

24. Asher B. Durand (American, 1796–1886), *Rocky Cliff*, c. 1860. Oil on canvas, 16½ x 24 in. (41.9 x 61 cm). Reynolda House, Museum of American Art, Winston-Salem, North Carolina.

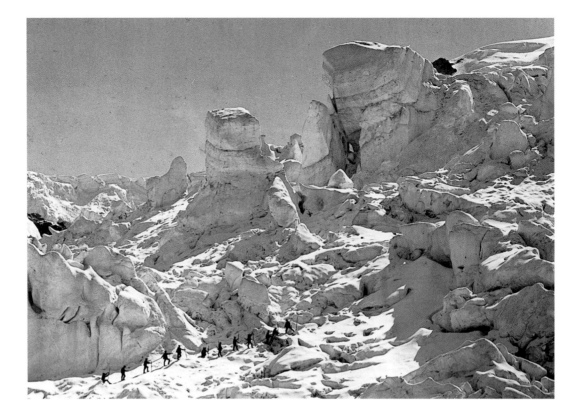

brothers photographed a series of spectacular high-altitude Alpine scenes during the 1859–62 climbing seasons in France (plate 25). Other renowned geological series were made in the United States by photographers whom the government and railroad companies began hiring in the 1860s to accompany expeditions sent to survey the American West.[10] Timothy H. O'Sullivan joined the Geological Survey of the Fortieth Parallel, and his photographs were reproduced in the popular press, arousing public curiosity about where these fantastic rock formations came from.

When Lyell proposed that the earth's rocky crust had developed over many millennia and that plants and animals had changed over time, he was unable to answer the pivotal question of *how* the changes in plants and animals had occurred. If God didn't create all the animals on the fifth day, then where did they come from? In 1831 Charles Darwin, then a twenty-two-year-old gentleman dilettante looking for adventure, set sail as a naturalist on a five-year, round-the-world voyage on HMS *Beagle*. While making careful records of coastal flora and fauna, he began formulating an answer to that question, and by the late 1830s he identified the mechanism for change that Lyell had sought: natural selection.

When the *Beagle* docked in a group of almost barren volcanic islands in the Pacific Ocean about 650 miles west of Ecuador, Darwin's curiosity was aroused by some small black birds. They were similar to a species of finches he had seen on the mainland, but the birds on the Galapagos Islands had fourteen distinctly different beaks—each was either large, medium, or small; wide or narrow; long or short; straight or curved. Darwin observed that each variety ate food only of a certain size and shape that matched its beak. Birds with large beaks ate large seeds, small wide beaks were good for eating cactus, narrow long beaks could retrieve burrowing insects, and so on (plate

26). He postulated that all the finches had descended from the same mainland species and had differentiated to eat the various seeds, cactus, and insects on the island. Darwin formulated his theory with the help of the British economist Thomas Malthus's *Essay on Population* (1798). Progress, Malthus suggested, was always accompanied by an increase in the number of humans, which would then decline as they outran the food supply, leading to famine and war.

Darwin applied Malthus's principle to his finches to explain their differentiated beaks as resulting from competition for food. In general, slight variations in animals of each generation give them the edge to survive longer and reproduce more offspring. Natural selection forms new species over time as favorable traits accumulate (reinforced by an inability to interbreed). Darwin replaced the rigid chain of being with an organic tree of life in which a new species would arise not because plants and animals changed form in response to the environment, as Lamarck had proposed, but because some competitive advantage allowed it to thrive.[11]

After formulating his explanation for evolution, Darwin searched in vain for the rest of his life to find the physical mechanism for natural selection. Meanwhile an Austrian monk, Gregor Mendel, had discovered the mechanism and wrote the laws of genetics in the early 1860s through his careful work crossbreeding plants in his monastery garden. He published his study in an obscure provincial journal in 1865 and sent reprints to prominent biologists and scientific societies, including the Linnaean Society of London. Receiving no positive response, Mendel returned to simple monastic gardening and died in oblivion. In 1900 Mendel's laws of genetics would be rediscovered and made widely available to biologists as they launched the field of genetics in the early twentieth century.

Darwin delayed publication of his theory for two decades because natural selection took away God's role as designer of all the species, an unthinkable heresy. He continued gathering an ever-growing mountain of specimens to make his case ironclad. When a young British naturalist, Alfred Wallace, moved to publish his own similar conclusions in 1858, Darwin was forced to join him in the immediate publication of a joint paper; the following year Darwin published his classic book, *On the Origin of Species by Means of Natural Selection, or The Preservation of Favored Races in the Struggle for Life.*

Darwin, like other scientists and laymen, adjusted his theology to accommodate the new findings rather than turn completely from his faith. In *Origin of Species*, he described a personal God who breathed life into the first living thing, after which natural selection took over: "Thus, from the war of nature, from famine and death, the most exalted object which we are capable of conceiving, namely, the production of the higher animals, directly follows. There is grandeur in this view of life, with its several powers, having been originally breathed

26. Four species of finches native to the Galapagos Islands, in Charles Darwin, *Journal of Researches into the Natural History and Geology of the Countries Visited during the Voyage of H.M.S. "Beagle" round the World* (1840; reprint, New York: D. Appleton and Co., 1882), 379.

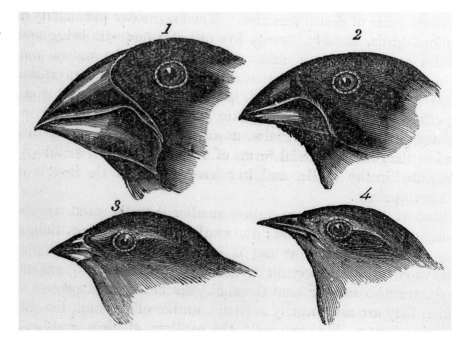

ABOVE, TOP

27. Cartoon in *Punch* 40 (25 May 1861), 213.

The caption declares that "The Lion of the Season" is "Mr. Gorilla."

ABOVE, BOTTOM

28. "Ape," lithograph, in Johann Caspar Lavater, *Physiognomische Fragmente* (Essays on physiognomy) (Leipzig and Winterthur: Weidmannc Erben, Reich, and Heinrich Steiner, 1775), 2:80.

Lavater assured his reader: "Oh man you are not an ape and the ape is not a man. Do not go so low as to compare yourself with an ape —Be happy that you are a man and not what someone else says you are."

by the Creator into a few forms or into one; and that, whilst this planet has gone cycling on according to the fixed law of gravity, from so simple a beginning endless forms most beautiful and most wonderful have been, and are being evolved." Despite Darwin's efforts to stress the "grandeur in this view of life," most people, scientists and laymen alike, were shaken by the radical reduction of the Creator's role and grappled to find common ground between biology and their faith. Some Christians refused to look for nuances in their sacred text and clung to a literal interpretation of the Bible; they took an inflexible stand against evolution, and their intellectual heirs—creationists—remain adamantly opposed to this concept today.[12]

Darwin had sidestepped the issue of man's origin, but the implication of his theory was obvious. As soon as *Origin of Species* was on bookshelves in London, the satirical journal *Punch* was gleefully depicting apes in formal attire moving among elite British society (plate 27).[13] The association of mankind's ancestry with the ape was particularly unacceptable because of old associations of apes with devils. During the Romantic era their sullied reputation had been reinforced when the Swiss clergyman Johann Caspar Lavater gave a low status to apes (plate 28) as part of his rules for evaluating an animal's character and personality on the basis of facial features—physiognomy—which he intended as a moral guide. In his immensely popular *Essays on Physiognomy* (1775–78), Lavater assured his readers that although some men, especially manual workers, might have simian features, *Homo sapiens* are superior. In a Zurich seminary run by Zwinglians (Protestants similar to Lutherans), Lavater met fellow cleric Johann Heinrich Füssli (later known as the artist Henry Fuseli), and the two became lifelong friends. Fuseli, who made the illustrations for the French edition (1781–86) of *Essays on Physiognomy*, adopted Lavater's conviction that "differences in faces express differences in spirits *[Geist]* and hearts."[14] When Fuseli portrayed an evil spirit who has descended on a sleeping woman (plate 29), he employed a simian facial type, a point not lost on the British philosopher and naturalist Erasmus Darwin (Charles's grandfather). In 1783 he described the depraved creature in Fuseli's painting:

> So in his NIGHTMARE *through the evening fog*
> *Flits the squab fiend o'er fen, and lake and bog;*
> *Seeks some love-wildered Maid with sleep oppress'd,*
> *Alights, and grinning sits upon her breast.*
>
> *On her fair bosom sits the Demon-Ape,*
> *Erect, and balances his bloated shape;*
> *Rolls in their marble orbs his Gorgon-eyes*
> *And drinks with leathern ears her tender cries.*[15]

In the visual arts, *aping* also had an older pejorative meaning associated with imitation, as in the classical aphorism "Ars simia naturae" (Art imitates [apes] nature). According to Plato, the painter's mimesis produces an illusion of nature that is inferior to the real thing. As the ape, with an uncouth resemblance to man, mimics human action, so the painter imitates nature. By the Renaissance the simian beast had come to symbolize the arts, such as the ape

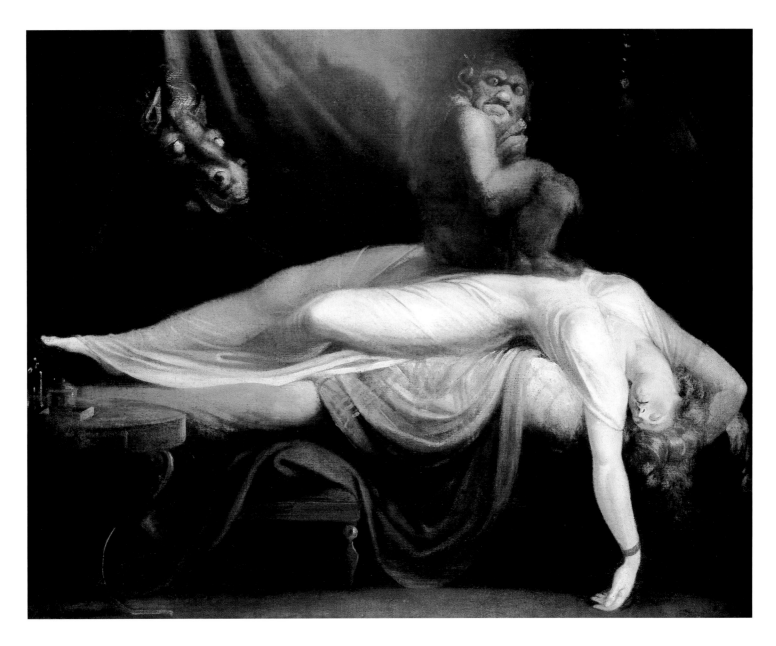

holding a mirror (a source of illusions) who crouches behind the idealized nude figure in Michelangelo's *Dying Slave* (c. 1513, Musée du Louvre, Paris). Western artists had long insisted that they did not merely imitate nature, and after 1859 they became especially outspoken on this topic.

Darwin's reserved temperament didn't equip him for public battle, but he had an effective warrior in the tough and tireless British biologist Thomas Huxley, who defended Darwin's theory in the lecture halls of Britain and published popular expositions of it (plate 30). In 1860 the British Association for the Advancement of Science hosted a public debate billed as "religion versus science" between Samuel Wilberforce, an articulate mathematician and bishop of the Anglican Church, and Huxley. As those present at the debate recalled, Bishop Wilberforce, authoritatively attired in purple vestments, turned to Huxley and begged to know whether it was through his grandfather or his grandmother that he claimed his descent from an

29. Henry Fuseli (Swiss, 1741–1825), *The Nightmare*, 1781. Oil on canvas, 40½ x 49¾ in. (101 x 124.5 cm). The Detroit Institute of Arts. Founders Society Purchase with funds from Mr. and Mrs. Bert L. Smokler and Mr. and Mrs. Lawrence A. Fleischman.

30. Skeletons of (from left to right) a gibbon, orangutan, chimpanzee, gorilla, and man, in Thomas H. Huxley, *Evidence as to Man's Place in Nature* (New York: D. Appleton and Co., 1863), frontispiece.

31. Cartoon by Lindley Sambourne, *Punch* (6 Dec. 1881), 14.

In the lower left, life emerges as a worm from disordered matter— the tumbling rocks that spell "CHAOS"— then quickly passes through a reptile stage (lower right), evolving into a mammal in the ape family (the chimpanzee on top). From that point the ape begins to get a bigger brain, causing some scratching of the head, then stands erect. It is a short step to a caveman and, at the pinnacle of evolution, a British gentleman groomed and attired for the evening with gloves and a top hat. Darwin, sporting a toga, is presented as a cross between a Greek sage and the prehominid ape below him.

MAN · IS · BVT · A · WORM

ape. The crowd erupted with laughter, but Huxley won their minds for science with his famous reply: "If, then . . . the question is put to me, would I rather have a miserable ape for a grandfather, or a man highly endowed by nature and possessing great means and influence, and yet who employs those faculties and that influence for the mere purpose of introducing ridicule into a grave scientific discussion—I unhesitatingly affirm my preference for the ape" (plate 31).[16]

In addition to being an effective spokesman for evolution, Huxley also provided the educated public an alternative to atheism by articulating an approach to religion—agnosticism—that does not deny the existence of God but declares that the deity is unknowable.[17] Whereas atheism was a sign of wickedness, agnosticism, with its modest admission of the vastness of the unknown, became a mark of learned sophistication.

INVISIBLE LIFE

Just as the British controversy over evolution was heating up, the French chemist Louis Pasteur announced in 1862 a germ theory of disease that revolutionized hygiene and medicine. In the ensuing years Pasteur, together with his German colleagues led by the physician Robert Koch, discovered the disease-causing microbes that had cursed mankind for millennia: leprosy (1873), anthrax (1876), typhoid fever (1880), bacterial pneumonia (1881), tuberculosis (1882), diphtheria (1883), cholera (1884), and tetanus (1889). In the 1870s and '80s journalists reported the isolation of each new microbe by Pasteur and Koch as if they were war correspondents at a battlefront (plates 32 and 34).

Whereas Darwin's theory had met with resistance because it threatened core beliefs, the germ theory brought the explanatory power of science into every home. Within decades, in homes from Saint Petersburg to San Francisco, children drank cow's milk that had been heated to destroy bacteria ("pasteurized") and parents disinfected their child's every scratch with iodine. Images in the popular press of microbes in a drop of public drinking water reminded people to boil water, and pictures of germs floating in the air (plate 33) encouraged urban dwellers to get fresh air. Artists focused on subjects related to hygiene and hidden disease—Edgar Degas's bathers and Edvard Munch's sickrooms—and Art Nouveau designers from Victor Horta in Brussels to Frank Lloyd Wright in America created open and airy spaces that were easy to clean and ventilate.

Pasteur made his discoveries with a new tool—the achromatic microscope—that opened a window into the realm of invisible life. When microscopes were invented by seventeenth-century Dutch lens makers, the images they produced were distorted by colored fringes of light (chromatic distortion) at the edges of the magnified object. (This is what Goethe saw when he put a prism to his eye during his experiments on color.) The achromatic lens eliminated the distortion by combining layers of glass with different rates of refraction. Overnight a crystal-clear window opened into the microscopic realm, and for the first time microorganisms were seen in brilliant natural color and immaculate detail. Earlier scientists had barely been able to make out cell walls

32. Cholera microbe, in *Le Grelot* (Paris), 6 July 1884, 1. Yale University Library, New Haven, Connecticut.
Sailors unload from a ship a monstrous cholera microbe in the French port city of Toulon. A broker presents the city with its cholera bill of lading; Toulon has a credit of over three thousand sick or dead but still owes the lives of thousands of its citizens.

33. "This is what we breathe: microscopic animals floating in the air," in Camille Flammarion, *Astronomie populaire* (Popular astronomy) (Paris: C. Marpon and E. Flammarion, 1881), fig. 252.

34. Cartoon by Alfred Le Petit, in *Le Charivari* 51 (27 Apr. 1882): 85. General Research Division, The New York Public Library. Astor, Lenox, and Tilden Foundations.

Science journalists offered the public a new secular saint—the selfless scientist—and Pasteur was one of the first to be canonized. The anthrax bacteria, which threatens sheep, had been isolated in 1876, and Pasteur is shown carrying a lamb as Le Bon Pasteur ("The Good Shepherd").

(plate 35), but in 1838 the German physiologist Theodor Schwann and botanist Matthias Scheiden could see details of intercellular bodies so clearly (plate 36) that they confidently announced a fundamental fact of biology: all living tissue is composed of cells. One of the finest series of images produced during the first decade of the achromatic microscope is a suite of prints, which was engraved and hand-colored after drawings by the German biologist C. G. Ehrenberg, that shows the internal structure of microscopic translucent sea creatures (plates 15 and 37). The subtle coloring and fine detail proclaimed the magnificent and fascinating world that now opened before scientists and artists.

Images of microorganisms made with an achromatic microscope offered the mid-to late-nineteenth-century public what celestial images recorded by the Hubble Space Telescope

Fig: 1.

Fig: 2.

35. Cells in cork, in Robert Hooke, *Micrographia: or Some Physiological Description of Minute Bodies Made by Magnifying Glasses with Observations and Inquiries Thereupon* (London: Royal Society, 1665), pl. 11, facing 114. Rare Books Division, The New York Public Library. Astor, Lenox, and Tilden Foundations.

Looking at a slice of cork through a microscope *(Fig. 1, B)*, British physicist Robert Hooke saw a pattern of regular holes, which he named "cells" because they were lined up like rooms in a monastery. Cork is the protective layer of bark of the evergreen cork oak tree, a branch of which is shown below *(Fig. 2)*. As the tree grows, its outer layers of cells die and the remaining cell walls desiccate and toughen to become cork. So Hooke was actually looking at empty plant cell walls, but even when he looked at the complex fluids that make up living cells, Hooke was unable to see detail because of chromatic distortion.

36. Plant and animal cells, in Theodor Schwann, *Mikroskopische Untersuchungen über die Übereinstimmung in der Struktur und dem Wachstum der Tiere und Pflanzen* (Microscopic researches into the structure and growth of animals and plants) (1847) in *Ostwald's Klassiker* (Leipzig, Germany), no. 176 (1910): pl. 1.

T. LXI.

37. "Phlodinaea," in C. G. Ehrenberg, *Die Infusionstierchen als vollkommene Organismen* (Infusion animals as complete organisms) (Leipzig, Germany, 1838), pl. 61.

38. Ross Bleckner (American, born 1949), *In Sickness and in Health*, 1996. Oil on linen, 84 x 72 in. (213.4 x 182.9 cm). The Broad Art Foundation, Santa Monica, California. Courtesy Mary Boone Gallery, New York.

Just as nineteenth-century artists were threatened by bacteria that caused leprosy, tuberculosis, and cholera, so contemporary artists fear the lethal HIV virus.

offer today: an extraordinary sense of being transported into another scale and to an exotic place tinged with danger. They were exquisitely beautiful, and they were reproduced everywhere. In Berlin the public visited an aquarium dedicated to microscopic sea life (plate 39), where the enlargements of amoebas and protozoa adorning its walls foretold a new artistic vocabulary of organic shapes—biomorphic abstraction. Within decades curved, flat forms—as in a stained, transparent slice of tissue prepared between glass plates for viewing with a microscope—had entered the vocabulary of Art Nouveau and Jugendstil designers. Biomorphic shapes have remained part of the basic vocabulary of abstract art throughout the twentieth century, as in the work of the interwar painters Hans Arp and Joan Miró (see chap. 10), and in the contemporary art by Ross Bleckner (plate 38). Throughout history people had believed that there were living things that were invisible by virtue of being immaterial (ghosts or spirits) but not because they were too small to be seen. When artists such as Odilon Redon approached the microscopic realm in the late nineteenth century (plates 80 and 81), it still retained this old association of mystery. But after the introduction of the achromatic microscope, voyages to microscopic realms were presented to the nineteenth-century public as entertainment (plate 40). Pocket microscopes were marketed to amateur naturalists for walks in the park, and the spread of public education created audiences for popular lectures on science, often illustrated by a projection microscope (plate 41). Lavishly illustrated books for a general audience conveyed to readers the beauty of cells (plates 42–45). After the invention of motion pictures in the 1890s, audiences for short silent films flocked to see adventure tales with invisible villains (*Afraid of Microbes*, 1908).[18]

By the early 1860s Darwin's theory of evolution by natural selection had synthesized data from geology, the fossil record, botany, and zoology into a new world picture. Pasteur's concurrent germ theory of disease revealed a realm that was both fascinating and potentially deadly, and the achromatic microscope provided a clear view of the previously invisible. The germ theory and the microscopic realm soon entered the public mind, but the popular reaction to Darwin's theory of evolution varied from cool rejection (France) to a warm embrace (Germany and Russia). Just how evolution came to be perceived by the public differed depending on the social structure of science within different nations, on the viewpoints of each country's leading scientists, and on the differing types of science journalism that emerged.

At the start of the nineteenth century the social organization of science changed to accommodate a multitude of new researchers who set about filling in the details of the clockwork universe and the great chain of being. They were also instrumental in bringing science to the public. Whereas members of learned societies like Britain's Royal Society and the French Académie des Sciences had been upper-class gentlemen for whom science was ultimately a speculative, philosophical activity, early-nineteenth-century researchers often came from the middle class and performed the more mundane tasks of observing, recording, and synthesizing data in laboratory settings where rapid communication and supportive camaraderie were essential.

These laboratory workers and researchers, who were first called "scientists" in the mid-nineteenth century, founded their own organizations—national associations for the advancement of science. Most association meetings were open to the public and widely attended; to interest the public in science, which was vital to ensure support for research, members regularly gave lectures and demonstrations for general

OPPOSITE
39. Aquarium for Microscopic Marine Life, in anon., "Das mikroskopische Aquarium in Berlin" (The microscopic aquarium in Berlin), *Illustrirte Zeitung* 68, no. 1754 (10 Feb. 1877): 111 (illus.), 113 (text).

LEFT
40. *The Invisible Ones*, 1883. Color lithograph, 21¾ x 14⅝ in. (55.3 x 37.2 cm). National Gallery of Canada, Ottawa. Purchased in 1977.

BELOW
41. Public science lecture, in anon., "L'Exposition des insectes" (Exhibition of insects), *L'Illustration* 76, no. 1958 (4 Sept. 1880): 153 (illus.), 151 (text).

audiences. Researchers in the German states (which weren't unified into a nation until 1871) especially felt the need to communicate with their colleagues and formed the first association in 1822, the German Scientific Association. The British Association for the Advancement of Science was established in 1831 and its American counterpart in 1842. In defiance of older elite societies that conducted all activities in German, Moscow scientists formed the Society of Admirers of Natural Science in 1864 and attracted a broad base of new researchers as well as a popular audience by conducting all its meetings and public programs in Russian. The failure of the French to see the need to establish a broad base of midlevel scientists (the French Association for the Advancement of Science was not founded until 1872) is widely cited as one reason why all areas of French science were in decline by 1900. Members of the British Association, on the other hand, kept English science strong, and by the end of the nineteenth century Germany was the unrivaled leader.

New forms of science education and entertainment rapidly expanded in the nineteenth century, providing the crucial link between the scientist's laboratory, the public's living room, and the artist's studio. The public was presented with science in newspapers, which by midcentury

42. Microscopic animal life, in Amédée Guillemin, *Le Monde physique* (The physical world) (Paris: L. Hachette, 1882), 2: pl. 17.

The magnified animal life includes *(1)* red blood cells, *(2)* blood vessels in the brain, *(3)* fossils of marine protozoa, *(4)* tissue underlying a crawfish shell, *(5)* fragment of bone, *(6)* single-celled organisms, and *(7)* tissue from the retina of a bird.

43. Microscopic plant life, in Amédée Guillemin, *Le Monde physique* (The physical world) (Paris: L. Hachette, 1882), 2: pl. 16.

The magnified plant life includes *(1)* cross section of ebony, *(2)* stems, *(3)* sticker of a nettle, *(4)* red algae, *(5)* liver tissue, *(6)* the herb liverwort, *(7)* grains of pollen, *(8)* tissue slice of wallflower, *(9)* cedar, and *(10)* boxwood.

44. Microscopic minerals, in Amédée Guillemin, *Le Monde physique* (The physical world) (Paris: L. Hachette, 1882), 2: pl. 15.

The magnified minerals include *(1)* crystallized blood, *(2)* a crystal extracted from the egg of a lobster, *(3)* crystals seen in polarized light, *(4)* nugget of gold, *(5)* ammonia crystals, *(6)* sea salt, *(7)* crystallized titanium, *(8)* potassium, and *(9)* natural fibers of copper.

had columns devoted to science, and enterprising publishers found an expanding audience for popular science periodicals.[19] Social reformers encouraged all classes, from manual workers to the educated elite, to study natural science as a healthy recreation that would develop their powers of reasoning. Science fiction became a literary genre, and a visit to a hall of science became a form of entertainment: crowds flocked to natural history museums, planetariums, and botanical gardens, as well as to science and technology displays at international expositions.

Science journalists disdained technical jargon and appreciated the power of images to embody an abstract concept and communicate it to the public. Distinctive national styles of science journalism developed, reflecting attitudes in the laboratory. In England and France science magazines and books were written in an encyclopedic style that featured assemblages of interesting facts. In Britain and France the public, like the scientists, were taught to rely only on direct observation and were discouraged from any speculation based on unobservable phenomena. In Germany, as well as in neighboring Russia, as science grew it retained its Romantic roots. Popular science journalism there presented a grand vision of nature that encouraged speculation beyond the observable—from the microcosm to the macrocosm, from an observation of nature to intuition of the Absolute.

As scientific authority eroded in France during the second half of the nineteenth century, Darwin's natural selection was rejected as unobservable. French artists retained the static outlook of Cuvier and an approach to nature based on direct observation—realism and Impressionism—or observation through a microscope that inspired images of nature at a smaller scale, as in Art Nouveau. As Germany ascended in science, Darwin was embraced there and the new dynamic view of life merged with German Romantic pantheism, producing a powerful vision of spiritual evolution—consciousness evolving within a unified cosmos—from the tiniest monad to Absolute Spirit. Fin de siècle German scientists led the exploration of the full implications of the new scientific worldview, and the German mystical, pantheist reformulation of Darwin's core idea—that nature is a web of dynamic forces without a predetermined purpose or meaning—provided the basis for abstract art. Parting company with their Art Nouveau colleagues, Jugendstil designers began creating decorative patterns to express these blind forces and their evolving spirits, and soon German and Russian artists associated with the Blaue Reiter and Suprematism were painting completely nonobjective canvases.

45. Lava in normal and polarized light, in Hans Kraemer, *Weltall und Menschheit* (Cosmos and humanity) (Berlin: Deutsches Verlaghaus Bong & Co., 1902–4), 1: opp. 376.

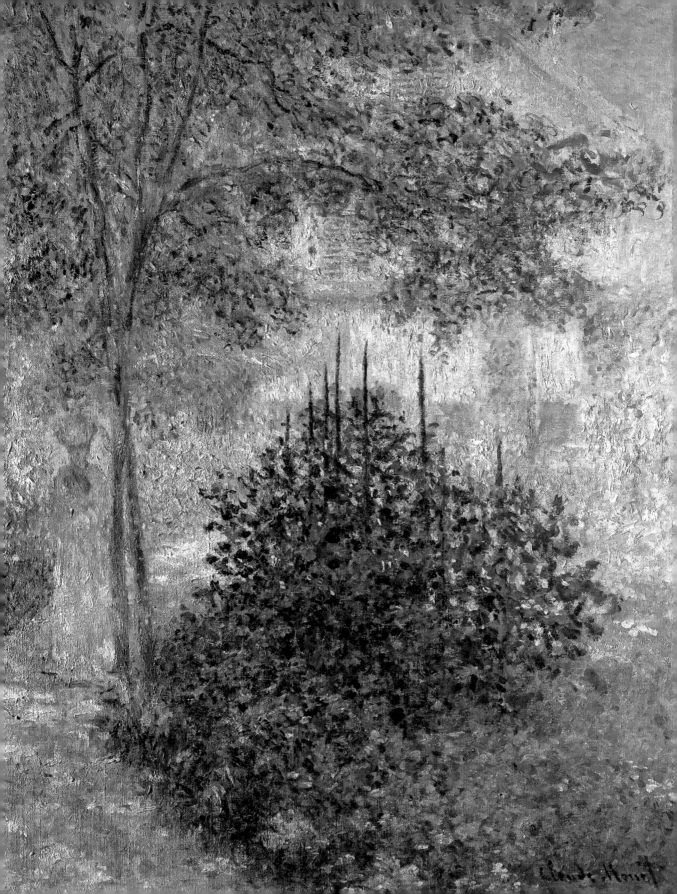

3

THE FRENCH ART OF OBSERVATION: A COOL REJECTION OF DARWIN

The nature of the sensation depends primarily on the peculiar characteristics of the (receptor) nervous mechanism; the characteristics of the perceived object being only a secondary consideration. . . . The quality of the sensation is thus in no way identical with the quality of the object that arouses it. Physically, it is merely an effect *of the external quality on a particular nervous apparatus. The quality of the sensation is, so to speak, merely a* symbol *for our imagination.*

Hermann von Helmholtz, *Handbook of Physiological Optics,* 1856–67

In 1874 Claude Monet exhibited a canvas at the Durand-Ruel gallery with the title Impression. *. . . The critics were puzzled . . . "Claude Monet only renders his impressions— he and his followers are impressionists and nothing else." The name stuck, and by chance it is exactly right. Unlike the other schools in which the artist adds many imprecise variables from past experience to what he actually sees, the Impressionist reproduces the pure visual phenomenon, the subjective experience of things. It is a school of abstraction.*

Paul Adams, "Impressionist Painters," *La Revue contemporaine,* 1886

REFLECTING ATTITUDES that prevailed in the Académie des Sciences, realist artists in the second half of the nineteenth century portrayed their sitters using pre-Darwinian views of the human psyche, and painters remained committed to an art based in the observation of nature. But then "observation" was radically redefined in the Paris art world by the release in 1867 of the French translation of the German scientist Hermann von Helmholtz's new theory of vision, which proclaimed that color and form are not in the world but in the mind. Helmholtz's laboratory evidence that seeing color results from light striking the retina prompted a flurry of responses in the Paris art world and accelerated the quest already under way by the Impressionists to capture their fleeting experience of light.

In France the most important debate about the origin of species occurred at an 1830 meeting of the Académie des Sciences, where the senior scientist in Paris, Georges Cuvier, denounced Lamarck's theory of the mutability of species so dramatically and in such bitter language that consideration of the topic was discouraged for decades. Central to Cuvier's attack was that scientists should never generalize conclusions beyond the observable evidence. He was especially sensitive on this point because natural science was developing out of, and moving away from, philosophy. Like most French scientists, he wanted science to be based in observable data and repeatable experiments, not speculation and generalization. Data were in and theory was out; Lamarck's speculations violated the creed of observation.

46. Claude Monet (French, 1840–1926), *Camille Monet in the Garden at the House in Argenteuil,* 1876. Oil on canvas, 32⅛ x 23⅝ in. (81.7 x 60 cm). The Metropolitan Museum of Art, New York. The Walter and Leonore Annenberg Collection, partial gift of Walter H. and Leonore Annenberg, 2000 (2000.93.1).

47. Cover of a children's book by A. Robida, *Voyages très extraordinaires de Saturnin Farandoul* (Very extraordinary voyages of Saturnin Farandoul) (Paris: Librarie Illustrée, 1879).

48. Underground worlds at the Exposition Universelle in Paris, 1900. Bibliothèque Forney, Paris.

The public was presented with many buried treasures in 1900, including gold mined from the Transvaal lode in South Africa and dinosaur fossils that by the turn of the century were reconstructed walking on their hind legs. Archeology had captured the public's imagination since the pair of painted limestone statues of the Egyptian Prince Rahotep and Queen Nofret (shown behind the dinosaur on the right) had been discovered in 1871. Also in 1900 Sir Arthur Evans excavated the labyrinth of Minos on the island of Crete, and Sigmund Freud declared in *The Interpretation of Dreams* that the psychological past can by reconstructed from buried memories.

When the first French translation of *Origin of Species* appeared in 1862, natural selection became one of several alternative explanations of species discussed in France throughout the second half of the nineteenth century.[1] By midcentury, evolution, or "transformism," as it was called in France, was being discussed, but the French focused on spontaneous generation and early man. In 1860 Pasteur performed the definitive experiment disproving the existence of a "vital force" in matter that caused some forms of life to arise spontaneously from nonlife, and nationalist pride soared in 1868 when French paleontologists found fossils of Cro-Magnon man in a cave on French soil. The skull of the hominid that the Germans had found in their Neander River Valley in 1856 had a backward-sloping brow and a receding chin, but France's caveman was a highbrow.

The translator of Darwin's *Origin of Species*, Clémence Roger, was outspokenly anti-clerical, and her introduction to the book positioned it as opposed to religion, thus linking it

to debates about atheism. Pasteur, who was largely silent on the disputes over transformism, preferred, like all French scientists, to focus on laboratory data: "There are many great problems that arouse interest today: the unity or multiplicity of human races; the creation of man many thousands of years or centuries ago; the immutability of species or the slow and progressive transformism of one species to another; matter reputed to be eternal rather than created; the idea of God being useless, etc.: these are some of the learned questions that men dispute today. I do not discuss these grave topics. . . . I dare speak only on a subject that is accessible to direct observation."[2]

The 1850s and '60s in France, the era of Napoleon III and the Second Empire, was a time of expanding bourgeois wealth and education, and there was a massive increase in popular science publications. The loss of the Franco-Prussian War in 1871 increased the emphasis on science education of all French citizens as a way to strengthen the nation, and the popular science press remained strong until World War I. Between 1850 and 1914 the French public supported over sixty weekly or monthly science magazines, such as *La Science pour tous* (Science for all), a weekly that ran from 1856 to 1901; over twenty annual science magazines, such as *L'Année électrique* (Electricity annual) from 1885 to 1892; and over a dozen book series, such as the *Bibliothèque des merveilles* (Library of wonders), which released 126 volumes between

LOUIS FIGUIER

LES MYSTÈRES
DE
LA SCIENCE

LIBRAIRIE ILLUSTRÉE

1864 and 1895.[3] There were similar publications for children and special releases for visitors to international fairs (plates 47 and 48).

Writing popular science ("la vulgarisation scientifique") was established as a profession in France in the 1850s; the many fine writers, including Louis Figuier, Camille Flammarion, and Amédée Guillemin, generally had considerable science education and saw their mission as translating difficult, obscure information into a popular language. Figuier, the best known, had both a doctorate in chemistry and training in literature that made him a skilled science storyteller (plate 49). Unlike English and American popularizers, French writers like Figuier addressed readers as a passive audience (never as potential contributors to science) and presented science as a highly specialized activity. To engage the idle reader, the French popularizers told tales of the savants as heroes and stressed the drama of discovery. Since there were, as yet, no national associations in France to present public forums on science, amateur organizations did not develop either. However, in addition to the huge market for popular science publications, the world's fairs of the second half of the century included large sections on science and technology in response to public interest, museums of natural history opened across the land, and Jules Verne invented a new popular literature—science fiction—to enchant curious minds.

In the 1860s the most popular book of the new science journalism was Figuier's *Earth before the Deluge* (1863), which presented readers with an overview of their world from the formation of the earth from a rotating cloud of dust, through the geological ages, each with its typical species, to the age of mankind (plate 50). As Darwinian as these illustrations look today in hindsight, in his preface Figuier explicitly denied his support of Darwin's *Origin of Species,* the French translation of which had just appeared. Instead, he essentially upheld Cuvier's view that God directed the creation of new species and the demise of others. Figuier did, however, part with Cuvier over the periodic destruction of all life on earth, assuring parents that the book was fit for children because this old view of apocalyptic ruin was no longer held by geologists: "The sovereign Master who created the plants and animals has willed that the duration of species on the face of the Earth should be limited, as is the life of an individual."[4] Figuier further assured his reader that there was no atheism in his pages; any past conflicts (which he leaves unspecified) between transformism and religion have been resolved: "Geology is, then, far from opposing itself to Christian religion, and the antagonisms that formerly existed have been replaced by happy agreement" (xv). And man's privileged position is undisturbed: "God made man—His latest work—issuing from His creative hand adorned with the supreme attribute of intelligence, by which he is authorized to rule all nature and subdue it to his laws" (xvi).

French popularizers shunned theory and filled their encyclopedic books with fascinating facts encompassing biology, physics, and astronomy as well as technology and applied science. Their religious views ranged from Figuier's belief in a personal Creator to an extremely secular approach. Microscopic images and Pasteur's triumphs filled many pages, and writers also focused on dramatic celestial data, proud that a Frenchman was credited with making the most sensational discovery in nineteenth-century astronomy—the planet Neptune.

OPPOSITE

49. Cover of Louis Figuier, *Les Mystères de la science* (The mysteries of science) (Paris: Librarie Illustrée, 1892).

PAGES 62–63

50. Formation of the earth and the development of life, in Louis Figuier, *La terre avant le déluge* (The earth before the deluge), 4th ed. (Paris: L. Hachette, 1865).

Top row, left to right: *(a)* the earth forming from a rotating cloud of gas, *(b)* condensation, and rainfall on the early globe, *(c)* Silurian period, *(d)* Devonian period; second row: *(e)* marine life in the Carboniferous period, *(f)* Permian period, *(g)* Triassic period with the dinosaurs ichthyosaurus and plesiosaurus, *(h)* Triassic period; third row: *(i)* Lower Jurassic period, *(j)* Middle Jurassic period, *(k)* Lower Cretaceous period with dinosaurs iguanodon and megalosaurus, *(l)* Eocene epoch; bottom row: *(m)* Miocene epoch, *(n)* Pliocene epoch, *(o)* European landscape in the Quaternary period, *(p)* appearance of man.

a

b

e

f

i

j

m

n

c

d

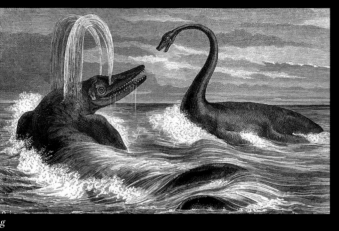

g

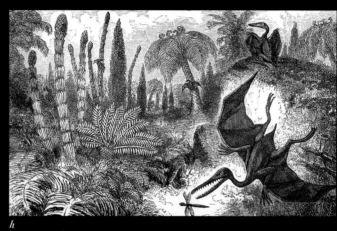

h

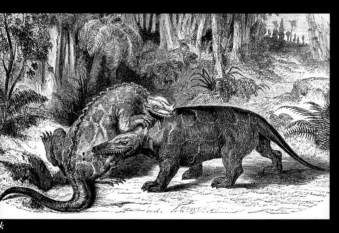

k

l

p

Among artists and intellectuals in France, Hippolyte Taine was the leading spokesman for the fact-gathering bias of the science popularizers. In his *Philosophy of Art* (1865), he argued that an artist, like any living creature, is the product of his environment and that cultural history and art criticism should be based in the scientific method of observation. In 1864 Taine was made professor of art history at the École des Beaux-Arts, and over the next twenty years his influential lectures to young artists and writers stressed the importance of understanding art in terms of its epoch, geography, and the culture in which it was produced.

Taine's wide-ranging views on aesthetics and socialism dominated French intellectual life in the second half of the nineteenth century. One writer who took up Taine's banner was Émile Zola, who in his fifties reflected on his career: "I have submitted to three influences, that of Musset, that of Flaubert, and that of Taine. I was around twenty-five-years-old when I read the latter, and in reading him I developed as a theoretician and a positivist."[5] By "positivist," Zola meant the view that science gives definite (positive) knowledge, and he is a good example of a French realist who was knowledgeable about transformism (but not specifically Darwinism). In his novel *Thérèse Raquin* (1867), Zola's main characters, the adulterous Thérèse and Laurent, copulate out of pure animal drive uncomplicated by love, then as a consequence of the act commit a murder. In response to complaints about his depravity, Zola wrote a preface to the second edition that defends the tale as a realization of "a scientific goal": "I chose individuals wholly dominated by their nerves and their blood, without free will, drawn into each act of their lives by the predeterminations fatally imprinted in their flesh. Thérèse and Laurent are human animals, and that is all."[6]

In his 1879 essay "Le Roman expérimental" Zola compared his empirical approach to writing to *la médecine expérimentale* of French physiologist Claude Bernard.[7] Praising Bernard's innovative work on the chemistry and electricity of the body, Zola stressed that, just as the doctor studied the body, he as a novelist dissected society. Having endured criticism for the alleged cruelty of his novels, Zola may have especially identified with Bernard because the scientist's experimental method was attacked by the antivivisectionists of their day.

Zola proclaimed that this new scientific method of observation was expressed in the naturalism of the plein air painters, especially Édouard Manet: "He is a child of our times. I see him as an analytic painter. All the problems have once more been called into question: science wanted a firm basis and therefore returned to a precise observation of facts. And this movement has been taking place not only in the realm of science; all the disciplines, all human efforts are directed toward the search for sure and definite principles in nature. Our modern landscapists have gone far beyond our painters of history and genre

A Frenchman, an Englishman, and a German were each assigned to write a study of the camel.

The Frenchman went to the Jardin des Plantes, where he spent half an hour questioning the guard and tossing bread to the camel, whom he poked with the point of his umbrella. Returning home, he wrote an article for his paper full of sharp and witty observations.

The Englishman, taking his tea basket and comfortable camping equipment, pitched his tent in the Orient and, after two or three years, produced a thick volume of disorganized facts which reached no conclusions, but had real documentary value.

As for the German, filled with disdain for the Frenchman's frivolity and the Englishman's lack of general ideas, he shut himself up in his study, and there wrote a several-volume work entitled: The Concept of the Camel Derived from the Idea of the Self.

Le Pèlerin (Paris), 1 September 1929

because they have studied our countryside, content to translate the first spot of forest they come upon. Édouard Manet applies the same method to each of his works."[8]

Zola contrasted the objectivity of the naturalists of the 1860s with earlier realism, such as the novels of Charles Dickens, which included moralizing commentary. The task of Zola's naturalist is to record society, not evaluate it. In *Déjeuner sur l'herbe* (1863; Musée d'Orsay, Paris) Manet made no more of a moral judgment about the nude woman and clothed men in a landscape than a sociologist would have done; both artist and scientist record the scene objectively in the vocabulary of their respective fields. According to Zola, Manet "lets himself be guided by his eyes" and records his observations of "large areas of independent hues," producing "an ensemble of precise and delicate spots, which, from several feet away, gives the painting a striking sense of depth."[9]

As part of a whole generation of French realist novelists concerned with capturing subtleties of character, Zola was particularly interested in mid-nineteenth-century medical theories about how a person's mental state is manifest in his or her facial expression and body type, and realist painters of the figure, such as Edgar Degas, also incorporated these views on anatomy into their work. The French disinterest in Darwinian evolution is evident in the fact that Zola and Degas did not connect theories contrasting human and animal appearance with Darwin's theory of man's simian heritage—the talk of London in the 1860s and '70s; instead, French writers and artists looked to pre-Darwinian medical views of brain anatomy—physiology and phrenology.[10]

Early in the nineteenth century Johann Caspar Lavater's theory of the face as an expression of the personality—physiognomy—had merged with the German physician Franz Joseph Gall's proposition that the shape of the head indicates mental traits—phrenology—to produce widespread interest among midcentury physicians in diagnosis by appearance. Artists also adopted such cranial shorthand to get their expressive points across. When a follower of Gall, the Scottish physician and phrenologist George Combe, toured America in 1839–40, he made a studio visit to Rembrandt Peale and noted approvingly that the artist had done his phrenology homework before painting his portrait of the first president, *Washington before Yorktown* (1824–25; Corcoran Gallery of Art, Washington, D.C.): "Washington's head as here delineated, is obviously large; and the anterior lobe of the brain is large in all directions; the organ of Benevolence is seen to rise, but there the moral organs disappear under his hair."[11]

In France, Degas mused in a notebook he used during the years 1868–72: "Make of the *tête d'expression* (in academic parlance) a study of modern feelings. It is Lavater, but a Lavater more relative, as it were, with accessory symbols at times."[12] A *tête d'expression* was a facial type found in studio manuals; in updating Lavater, Degas reflected the common view in Parisian art circles that a simian-shaped head confirmed the bestiality of the lower class. His later drawings of Émile Abadie and Michael Knobloch, nineteen-year-old Parisians who confessed to brutal murders in 1879, emphasize the criminals' telltale backward-sloping foreheads (plate 51). Their case raised fears about the decline of French youth that were frequently expressed in the decade following the Franco-Prussian War; when the trial began in August 1880, the sensational story dominated the French press. What caused the boys to go bad? Was it the poor neighborhoods in which they grew up? Did they have bad blood? Journalists, as well

as Degas, sought a clue in their faces. That same year an even younger lad, fifteen-year-old Paul Kirail, was convicted of a brutal murder; Degas recorded his appearance in another drawing (*Criminal Physiognomy [Paul Kirail]*, c. 1880–81; location unknown).

Degas displayed his drawings of Abadie, Knobloch, and Kirail in the sixth Impressionist exhibition of 1881, together with the wax model for his statue *Little Fourteen-Year-Old Dancer* (plate 52). The connection was not lost on the critics, who noted the dancer's low forehead and other criminal features; according to Henry Trianon, such bestial, lowbrow characters were not welcome in the art world: "Degas . . . shows . . . physiognomies of several wild beasts, drawn by the artist with a certain energy, and . . . he presents us with the statuette of a dancer, who is a detestable and ugly female; the artist makes of her a horrible image of bestiality. . . . Put her in a museum of zoology, of anthropology or of physiology—but in a museum of art, never!"[13]

A contrary sentiment was expressed by Charles Ephrussi, who prized Degas's keen observation:

> *Degas . . . shows some gripping and incisive studies of the murderers Abadie, Kirail and Knobloch, and, most important, a statuette in wax of a young dancer of fourteen years. . . . She presents herself informally in her work outfit, tired and weary, holding her exhausted limbs, stretching her arms in the back. She is terrifyingly ugly, with a coarsely turned-up nose, a prominent mouth and a forehead hidden by hair that falls almost to her small, half-closed eyes. Under her silk pleated skirt, notice . . . the solid placement of her feet . . . the torso like steel. Here is not a dancer with classical lines, but the rat of the opera with a modern expression, learning her trade, with all her stock of bad instincts and vicious inclinations. . . . An ordinary artist would make this dancer like a doll. Degas gives his work the aura of pungent taste and exact science.*[14]

IMPRESSIONISM

In the immediate wake of Darwin's revolution in biology and Pasteur's transformation of medicine, Hermann von Helmholtz proclaimed a new theory of vision. Enlightenment natural philosophers had defended earlier forms of the view that color is not in the world but in the mind;[15] now Helmholtz proved it in the laboratory. Intuiting the essence of this new understanding of vision, artists created embodiments of colored light—Impressionism.

In a Romantic landscape, the light flooding from the skies is a spiritual metaphor for the presence of divinity. Working after the adoption of a scientific worldview, the Impressionists gave light symbolic associations to knowledge ("enlightenment") and to pleasure ("delight"). Today Romantic landscapes are generally perceived as nostalgic reminders of a bygone era when nature was a sacred place, whereas the natural world recorded by the Impressionists is grounded still in our secular view of science so it retains its immediacy and continues to awaken us to its sensual beauty.

At the opening of the nineteenth century, artists' color theory was based in a century of studio practices; artists organized their paints into primary (red, yellow, blue) and secondary (orange, green, violet) hues arranged in a circle or similar figure—as in Philipp Otto Runge's color sphere, which presents the hues at the equator (plate 55). Artists studied the light and dark values located at opposite poles in Runge's sphere and the interaction of complements (red/green, blue/orange, yellow/violet) placed across from one another on the sphere. In the spirit of German Romanticism, Runge associated the three primary colors with Jakob Böhme's divine Trinity in which God and Nature are united or, in Runge's mystical words, "The divine trinity is the symbol of the highest light, just as the three primary colors represent sunlight. . . . When we understand the thousand refractions of the three primary colors, then we will be able to approach comprehension of the divine trinity that we feel in our souls."[16]

In early-nineteenth-century France, studio practice similarly included basic color theory and the study of afterimages (visual images that persist after the stimulus ceases), but without the mystical overtones. Michel-Eugène Chevreul, a French chemist and director of the French royal tapestry manufactory, began giving lectures on color to art audiences in the mid-1830s; encouraged by their popularity, he undertook to publish a studio manual on color theory. Chevreul's friend the physicist André Ampère, an expert on electrical currents in motion, suggested to Chevreul that he formulate his thesis in the form of a scientific law,[17] hence the book's title, *On the Law of Simultaneous Contrast of Colors* (1839). Chevreul did not "discover" the simultaneous contrast of colors but merely gave precise formulation and visually compelling examples of a phenomenon known by artists throughout the ages: the apparent hue and value of a patch of color changes with its background, seeming warmer against a cool ground, lighter against a dark ground, and so on (plate 58). (Fra Angelico did not need color theory to see that a patch of red stands out vividly against a green ground, any more than Bach needed music theory to hear an octave.) Chevreul's contribution was his reformulation of eighteenth-century studio practices in the language of early-nineteenth-century psychology and physical science, thereby making them more accessible to the artists and scientists of his day.

It is not surprising that French Romantic artists manifested an awareness of these color practices in their paintings, such as the complementary shadows and highlights in Delacroix's *Expulsion of Heliodorus* (1849–61; Saint Sulpice, Paris) and in the color diagram in his North African sketchbook (1832; Musée Condé, Chantilly, France). Chevreul's study of the simultaneous contrast of color was reissued in 1864, and a memorial edition appeared in 1889, the year of the author's death. Chevreul never revised the book, but it became the most widely read color manual in the second half of the nineteenth century.

THE THREE-RECEPTOR THEORY OF VISION

BELOW, LEFT TWO

53. Diagram of the eye *(left)*, and cones concentrated in the fovea, the pit of the retina *(right)*, in Hermann von Helmholtz, "Recent Progress of the Theory of Vision" (1868), in *Popular Lectures on Scientific Subjects*, trans. E. Atkinson (New York: D. Appleton and Co., 1891), 204, 209.

BELOW, RIGHT

54. "Curves showing the action of the different colors of the spectrum on the three sets of nerve fibrils [cones]," in Ogden N. Rood, *Modern Chromatics* (London: C. Kegan Paul and Co., 1879), 114.

OPPOSITE

55. Color study, from Philipp Otto Runge (German, 1777–1810), *Farben-Kugel* (Color sphere) (Hamburg, 1810). Hamburger Kunsthalle, Hamburg.

Runge's color sphere, with red, orange, yellow, green, blue, and violet arranged around the equator, is shown from the white pole (upper left) and the black pole (upper right); the possible mixtures within the sphere are shown by the cross section at the equator (lower left) and through the poles (lower right).

The study of how the eye sees color developed in the mid-nineteenth century as a result of work on light and lenses, together with pioneering research on electricity and the nervous system. After Newton performed experiments on the spectrum, he proposed that humans see color because particles of colored light enter the eye. When Thomas Young determined in 1801 that light is a wave, he wondered how the eye could perceive all the colors in the rainbow, which seemed to him to be composed of an infinite number of wavelengths. He reasoned that the eye cannot have an infinite number of receptors, and so it must have only a few, capable of responding just to certain wavelengths of colored light, which somehow produce the perception of all the others. Recognizing that artists of his day mixed all the colors in their palettes from only three primaries, Young hypothesized that the human eye contains receptors for red, blue, and yellow light.

Young made his bold suggestion at a time when electricity and the animal nervous system were only beginning to be investigated. Static electricity was understood by 1800, when the Italian physicist Giuseppe Volta designed the first electrical storage battery, and by the 1820s the flow of electric current through wires was being studied by Ampère and others. Once moving electricity was understood, it occurred to several investigators that messages could be sent through a long wire by inputting electric impulses in a pattern at one end and decoding them at the receiving end. By the 1840s Western cities were linked by telegraph lines, in 1851 a cable was laid across the English channel, and by 1855 plans were under way to lay a cable across the floor of the Atlantic to link Europe with the United States. Concurrent with work on electricity, anatomists were concluding that the animal body has an electrical system. In 1810 Franz Joseph Gall published a study in which he concluded that the brain and spinal cord respond to electrical stimulation. After the development of the achromatic microscope in the 1830s, Theodor Schwann isolated the living cell, and attention turned to certain cells as possible carriers of electrical impulses. Thus the body began to be seen as an electrical machine with nerves acting as wires, and by the 1860s neurology was emerging as a medical specialty.

In a remarkable example of the experimental method, Helmholtz discovered the three receptors for color in the retina that Young had predicted. Helmholtz deduced that the retina is lined with light-sensitive nerve cells (plate 53) and that there are three different kinds of cells—cones—containing different photosensitive chemicals, each of which reaches its peak of sensitivity at a different wavelength of light (plate 54). Young had predicted that the receptors would

Farbenkugel.

Ansicht des weissen Poles.

Ansicht des schwarzen Poles.

Durchschnitt
durch den Aequator.

Durchschnitt
durch die beyden Pole.

ABOVE, TOP

56. Color hexagon showing the mixture of colored pigment, in Charles Blanc, *Grammaire des arts du dessin* (Grammar of composition) (Paris: Jules Renouard, 1867), frontispiece.

ABOVE, BOTTOM

57. Color circle showing the mixture of colored light, in Auguste Laugel, *L'Optique et les arts* (Optics and the arts) (Paris: Germer Baillière, 1869), 152.

respond to red, yellow, and blue, but Helmholtz established the colors to be red, green, and blue. He was the first to clearly distinguish between colored pigments (chemical compounds; plate 56) and colors of light (wavelengths of energy; plate 57), eliminating an area of confusion in color theory. For Helmholtz and later writers on color, the primaries for pigment remained the age-old red, yellow, and blue, whereas the primaries for light could vary.

When, for example, the "red cone" (the cell containing the chemical that is sensitive to red light) is stimulated, it triggers a chemical change in the cell that causes an electrical impulse to leave the cell on a long nerve fiber (a dendrite) and travel into the brain, resulting in the perception of red. When two different wavelengths, say red and blue, fall on adjoining red and blue cones in the retina, the cones combine their signals into a mixed electrical impulse to the brain that causes the perception of violet. Thus the three cones in the retina, through complex combinations of signals, cause the eye and brain to see the primary and secondary colors—indeed, all the colors in the rainbow. Helmholtz also discovered that there is another type of cell in the retina—a rod—that causes the perception of light and dark by responding not to the wavelength of light but to its intensity.

Between 1856 and 1867 Helmholtz published the three volumes of his *Handbook of Physiological Optics* (French translation, 1867), which is the founding text of the physiology of perception. His three-receptor theory of vision explained the afterimages that had long fascinated artists. For example, if you count to thirty while staring at the red circle in the pale green environment (plate 58) and then stare at the black dot in the square to the right of it, you will see an afterimage of a green circle in a reddish environment. This afterimage is caused in the following way: when you stare at the red circle, red light striking the red cones in your retina produces a chemical (rhodopsin) in these nerve cells, but as your eye keeps staring at the red circle the rhodopsin in the cones is getting used up (you might notice that the red begins to fade). In the absence of rhodopsin another chemical now dominates these nerve cells and causes the nerves to fire "green." So when you look away (remove the stimulus) the "red" cones continue to fire "green" until the chemical balance is restored, during which you briefly see an afterimage.

This theory of vision, together with Darwin's theory of evolution, also explained Chevreul's law of simultaneous contrast of colors. The eyes of lower animals, such as moths, respond indiscriminately to the quantity of light, whereas nerve cells in mammalian retinas have evolved to pick out distinctive features from complex patterns of sunlight in the natural world. On the human retina, an object stands out against an opposite background—light against dark, red against green, warm against cool—and the appearance of the color of an object is slightly distorted by its environment, seeming lighter on a dark ground, warmer on a cool ground, and so on.

Because the process of seeing color depletes chemicals in the cones, the eye is continually shifting, very rapidly and imperceptibly, to allow light to be always falling on fresh cones. (Note that it takes extreme concentration to stare fixedly at the red circle for a full thirty seconds.) The strong optical activity that Chevreul noted at the borders of strong contrasts, such

as the red circle against green, occurs because the shifting eye sees opposite colors at the edges of the circle, red-green-red-green in rapid succession. The cones send the brain signals for red and green, resulting in the perception of a "flicker," or vibration, at the edge of the circle.

Young's hypothesis that the eye is a recorder of colored light had long been known to artists from popular science. But after Helmholtz's *Handbook* confirmed it as fact and detailed how the eye works, many science writers and art critics enthusiastically declared that the mysteries of painting—and even of vision itself—had yielded to the explanatory power of science, and popularizations began explaining Helmholtz's theory of vision to artists and the public. In *Optics and the Arts* (1869), Auguste Laugel addressed an audience of artists, to whom he recommended Helmholtz's *Handbook*: "To completely analyze the phenomenon of vision, one must first study the eye as a simple optical instrument, then as a perceptual machine and a receiver of impressions. . . . Optical phenomena interest not only physicians and philosophers, they are also extremely important for those who, in architecture, sculpture, and painting, try to speak to our spirit: the artist must first learn the grammar of the visual language: forms, sizes, and colors."[18]

For a wider intellectual audience, Taine wrote *Intelligence* (1870), an influential exposition of current research on the physiology and psychology of human knowledge, which was so popular that it went through nine editions by 1900.[19] With frequent references to Helmholtz, Taine described how knowledge "from our most abstract ideas to our crudest sensations" is constructed in a strictly deterministic way from sense experiences—sights, sounds, touches, tastes, and smells—that are experienced at birth as meaningless patches of color, bits of sound, and so on. Through experience and "education of the senses," the child forms a picture of the world and invests the sensations with meaning.

58. Color study, from Michel-Eugène Chevreul (French, 1786–1889), *De la loi du contraste simultané des couleurs* (On the law of simultaneous contrast of colors) (Paris: Pitois-Levrault, 1839).

Taine summarized the case histories of five patients who had been born blind due to cataracts, and whose sight had been restored by removal of all or part of the lens. The risky procedure to remove cataracts was performed successfully for the first time in Paris in 1743, and European medical literature reports about a dozen more cases by the mid-nineteenth century. Helmholtz's research on the retina had aroused great interest in these cases because they offered a rare opportunity to test an adult to determine whether vision was innate or learned. In other words, does a newly sighted adult first see "a flower" or "a patch of red and green," which the person learns through experience is a flower? According to the reports of all the postoperative patients, on first looking at the world "the eye has only the sensation of different colored patches more or less light or dark." Taine pointed out that this evidence supported Helmholtz, who "has shown by a multitude of experiments" that humans construct the world from sensations of "colors and shades." Taine went on to compare newborns and newly sighted persons with artists: "Colorist painters know this state well, for they return there; their talent consists in seeing their model as a patch of which the sole element is color, more or less diversified, dull, lively and mixed."[20] This comparison, with its enchanting implication that the artist is constantly seeing anew, resonates with sentiments that had been expressed by John Ruskin[21] and decades later would be reiterated by Claude Monet.

Helmholtz's work helped interested artists understand the physiological basis of afterimages, the contrast of color, and, in general, the physical basis of vision. But for practical advice on applying color theory to painting (which was not Helmholtz's topic), artists continued to consult Chevreul's manual. Chevreul himself believed (incorrectly) that Helmholtz had contradicted his "law" because the physiologist offered alternative choices for primaries of light. In 1879 Chevreul appealed to artists to defend the "true" primary colors by joining him in his battle against Helmholtz, which the old chemist waged as if the future of French art and science were at stake.[22] But Chevreul undercut his own authority by confusing light with pigment.

Since the invention of photography in 1839, researchers had sought a chemical that would respond to different wavelengths of light to produce a color image. After learning of Helmholtz's early work on the three-receptor theory of vision,[23] the Scottish physicist James Clerk Maxwell reasoned that if the eye could perceive all hues by combining information from three color receptors, then a color photograph could be produced by recording a scene with chemicals sensitive to red, green, and blue light and then superimposing the three monochrome images. In 1861 Maxwell made the long-awaited breakthrough to the mechanical production of a color image when he projected a photograph of a colorful Scottish tartan ribbon, to the delight of his audience, the British Academy of Science. Color photographs began to be displayed soon after this, even though permanently fixing a color print was not solved until Hermann Vogel developed photosensitive dyes in 1873.

Monet and the Physiological Perspective

Once artists began to conceptualize painting in terms of the Young-Helmholtz-Maxwell theory of vision, they created a new "art of observation" by turning their attention away from depicting colored objects in the world and focusing instead on their own subjective experience of

color. In Helmholtz's theory, form, like color, is not in the world but in the mind. Perceiving form is learned from experience and geometry is not innate; indeed, Helmholtz declared that there was nothing irrational about a space that violated Euclid's axioms (the first non-Euclidean geometry had been published in Moscow in 1826). Helmholtz's theory of vision triggered the rapid erosion of Renaissance perspective in Western art, and Impressionism became a prime example of the great insight of the German art historian Erwin Panofsky: perspective is not the imitation of the spatial structure of one's visual experience but a "symbolic form" expressing one's concept of the world.[24] The quattrocento painters had transformed the picture plane into a window through which the viewer looked into another space. Linear perspective made artists more conscious of their viewpoint (in front of the picture plane), but the theory focused on a natural world "out there" (in back of the picture plane), giving rules for how to measure it precisely using Euclidean geometry. After Helmholtz described vision as a product of the eye and the brain, the Impressionists—still passionately pursuing the goal of accurate observation—created a new symbolic form; the picture plane became an opaque surface on which to record their subjective responses to light—a physiological perspective. And when the next generation of Impressionists sought to add structure to the myriad colorful daubs and dashes constituting Monet's canvases, Cézanne imposed an order derived not from geometric volumes in a world "out there" delineated by Renaissance perspectives, but from his own subjective experience of space, from his own lived perspective.

Although Helmholtz's theory of vision was not translated into French until 1867, the revolutionary ideas were widely known in the international science community from the late 1850s and were occasionally presented in a public setting. Visitors to the Paris Salon des Refusés of 1863 could see color photographs based on Maxwell's method by Claude Niépce de Saint-Victor (nephew of Nicéphore Niépce, one of the inventors of photography), which were shown only at half-hour intervals to preserve the color.[25] Diego Martelli, a Florentine writer associated with Italy's avant-garde painters the Macchiaioli, visited Paris in the 1860s and '70s, where he befriended Degas and also acquired a French translation of E. W. von Brücke's *Scientific Principles of Fine Art* (1879). Von Brücke's Helmholtzian outlook is reflected in Martelli's explanation of the Impressionists to his countrymen: "Impressionism is not only a revolution in the field of thought, but is also a physiological revolution of the human eye. It is a new theory that depends on a different mode of perceiving the sensation of light and expressing the impressions."[26]

Degas's paintings from the Impressionist era provide an early example of an artist's organization of space on a modernist picture plane. In compositions such as *Place de la Concorde (Vicomte Lepic and His Daughters)* (1875; State Hermitage Museum, Saint Petersburg), he captured his subjective experience of space. The man and the two little girls are off center, each moving in a different direction and looking beyond the edges of the canvas. The whole composition suggests the scattered, fragmentary, blurred glimpses one gets while moving among people on the street—glimpses that the mind, according to Helmholtz, learns through experience to synthesize into a coherent street scene. Historians have disagreed about the extent to which photography influenced Impressionist compositions such as this one; were Degas's and Monet's new pictorial conventions, such as cropped "snapshot" compositions

By "modernity" I mean the transitory, the fleeting, the contingent, the half of art whose other half is the eternal and the immutable.

Charles Baudelaire,
The Painter of Modern Life, 1860

*I reread the aesthetics of
Hegel, Schelling . . . and
Taine. . . . Then I communed
with myself, and in one night,
from 10 PM to 4 in the morning
—the hours when Jesus was
in the Garden of Olives, Saint
John on Patmos, Plato at the
sanctuary at Sunium, Buddha
under the figure of Gaza—
I wrote in ten pages the meta-
physical principles of a new
aesthetics that is consistent
with the unconscious mind of
von Hartmann, the evolution
of Darwin, and the physiology
of Helmholtz.*

Jules Laforgue to Charles
Ephrussi, on writing
"Impressionism,"
12 December 1883

and blurred images, derived from photography or invented by the painters?[27] The dispute misses the source of both—the Young-Helmholtz-Maxwell theory of vision—which gave Niépce and Maxwell the insights they needed to invent photography and led Degas and Monet to a new art of observation.

In the 1870s, Monet painted plein air scenes such as *Camille Monet in the Garden at the House in Argenteuil* (plate 46) with small, varied brushstrokes in a palette of warm and cool colors, such as the red flowers amid the green leaves. Sunlight is suggested by thick strokes of pale hues on the woman's skirt. This is not an eternal, divine light but sparkles highlighting a lovely woman moving through a garden vibrant with color. The immediacy of Monet's style was noted by contemporaries such as the critic Théodore Duret: "Claude Monet has succeeded in setting down the fleeting impressions which his predecessors had neglected or considered impossible to render with the brush. The thousand nuances that the water of the sea and rivers takes on, the play of light in the clouds, the vibrant coloring of flowers, and the checked reflection of foliage in the rays of a burning sun have been seized by him in all their truth."[28]

The three-receptor theory was widely known and discussed by Monet's contemporaries, as their writings attest. A selection of critical responses to Impressionism reveals how much the obsession with light by Monet, Renoir, and others was understood in terms of the new Young-Helmholtz-Maxwell theory of vision. The critic Edmond Duranty, who owned both Amédée Guillemin's *Light* (1879) and Brücke's *Scientific Principles*, described the painter's method as an intuitive analysis of light: "Proceeding from intuition to intuition, they have little by little succeeded in breaking down sunlight into rays, its elements, and in reconstituting its unity by means of the general harmony of spectrum colors that they spread on their canvases. From the point of view of sensitivity of the eye, of subtle penetration of the art of color, it is a completely extraordinary result."[29]

From the 1880s, Monet worked in series and developed a more complex paint application in an effort to capture an atmosphere of light, or in his words: "I am seeking 'instantaneity,' above all, the envelope, the same light spread over everything."[30] Local color is all but absent from *Grainstack (Sunset)* (plate 59), and the artist suggested the "envelope" of daylight with a complex chromatic and textural web of paint created by building up layers of warm and cool hues applied in a multitude of strokes.[31]

Monet's attempt to capture light was described in an influential statement of 1883, "Impressionism," by the young French poet Jules Laforgue. Having attended Taine's lectures at the École des Beaux-Arts in 1880–81, Laforgue was familiar with the new theory of vision and declared that "essentially the eye recognizes only luminous vibrations . . . the three fibrils [neurons] described by Young. . . . The Impressionist sees light as bathing everything . . . with a thousand vibrant struggling colors of rich prismatic decomposition."[32] The poet stressed the ultimate impossibility of recording "the optical sensibility of the painter" with its "imponderable fusions of tone, opposing perceptions, imperceptible distractions, subordinations and dominations, variations in the force of reaction of the three optical fibrils one upon the other and on the external world, infinite and infinitesimal struggles."[33]

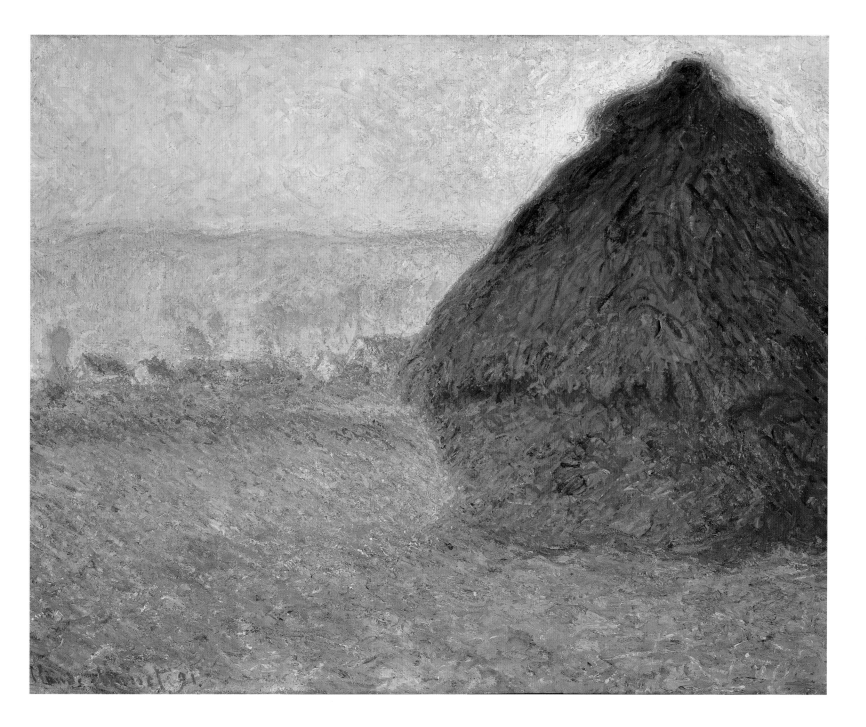

ART NOUVEAU IN FRANCE AND BELGIUM

Pasteur's germ theory of disease had repercussions far beyond the laboratory and hospital. A crusade for hygiene in the second half of the nineteenth century encouraged individuals to clean as never before and to open their homes to light and air. In France and Belgium architects and designers created a new style—an Art Nouveau—that responded to these aims, using a design vocabulary that included microscopic imagery and flowing, biomorphic forms derived from amoebas, protozoa, and cells.

 Enthusiasm for Art Nouveau in Paris reached its peak at the Exposition Universelle of 1900, which presented a retrospective of the glassmaker Émile Gallé and a pavilion with rooms of Art Nouveau furniture built for Siegfried Bing, director of the Paris gallery L'Art Nouveau. René Binet, architect of the main entry portal, modeled it on the form of microscopic radiolarians (creatures with striking crystalline exoskeletons), which Binet knew both from C. G. Erhenberg's book *Infusion Animals* (1838) and from Ernst Haeckel's illustration of them in a field report from about 1880, which reappears in his book *Art Forms in Nature* (plates 60 and 61). Haeckel had set an example for designers by decorating his own study with exotic specimens (plates 62 and 63).[34] In

OPPOSITE

60. "Calocyclas," in Ernst Haeckel, *Kunstformen der Natur* (Art forms in nature) (Leipzig, Germany: Verlag des Bibliographischen Instituts, 1899–1904), pl. 31.

BELOW

61. René Binet (French, 1866–1911), Entrance portal to the Exposition Universelle, Paris, 1900. Photographic Archives, National Gallery of Art, Washington, D.C., SIP 30.

his book *Decorative Sketches* (1902), Binet sought further inspiration in the microscopic realm, combining cellular patterns with large-scale plants and animals; microscopic coral and aquatic animals inspired motifs in a fence (plates 64 and 65).

 In France, Art Nouveau never moved beyond adopting microscopic images as decorative motifs, but in Brussels (then a leading cultural center of Europe) certain artists began considering the whole building as an organism. In 1889 a book on evolutionary aesthetics, summarizing Haeckel's view of the unity of nature, was published in Brussels by the philosopher Eugène van Overloop.[35] In a reiteration of monism, Overloop described man and his creations (including architecture) as composed of simple elements combined according to the laws of nature into a unified whole. A Belgian school of Neo-Impressionism was formed, led by Henry van de Velde, who advocated the expressive use of line to communicate emotion. His interest in the unity of the fine and applied arts led van de Velde from painting to architecture, in which he also developed decorative motifs of abstract sinuous patterns that he wanted to appear not applied to, but growing out of, the building. He was invited by Bing to design his L'Art Nouveau gallery, and he transformed the walls

62. "Deep-Sea Medusae: Pectanthis Asteroides," in Ernst Haeckel's entry, *Report on the Scientific Results of the Voyage of HMS* Challenger *during the Years 1873–76* (Edinburgh, 1880–95), 4: pl. 7. Special Collections, Glenn G. Bartle Library, Binghamton University, State University of New York.

63. Ceiling rosette in Ernst Haeckel's dining room, c. 1900. Ernst Haeckel Haus, Jena, Germany.

LEFT

64. Metal fence, in René Binet, *Esquisses décoratives* (Decorative sketches) (Paris, 1902), 16.

ABOVE

65. Coral and colonies of Bryozoa, in René Binet, *Esquisses décoratives* (Decorative sketches) (Paris, 1902), 7, 9.

Line is a force. . . . it takes its force from the energy of the person who has drawn it.

Henry van de Velde,
Manifesto, 1902

into a jungle of undulating lines, which were complemented with glass by Louis Comfort Tiffany. When the gallery opened in Paris in 1895, it became a standard of Art Nouveau architecture.

In Tassel House of 1893–95, the Belgian architect Victor Horta designed the building and all its furnishings based on natural motifs, from carved flowers on the facade of the entry portal to real plants in the atrium. At the core of the symmetrical townhouse, the central stair-case and entrance foyer, Horta captured the essence of nature as evolving and electric, charged with intense energy and bursting with vitality, by moving away from depicting nature and into abstract patterning. As Horta described it, "I discard the flower and leaf but keep the stalk." His stalk has become swirling lines suggesting the fluid energy of flagella, tendrils (plate 66), neurons, and vines (plate 67).

RIGHT

66. "Desmonema," drawn by Ernst Haeckel for the *Challenger* and reprinted in *Kunstformen der Natur* (Art forms in nature) (Leipzig, Germany: Verlag des Bibliographi-schen Instituts, 1899–1904), pl. 8.

OPPOSITE

67. Victor Horta (Belgian, 1861–1947), Tassel House (main-floor entrance and landing), Brussels, 1893–95.

After Darwin declared that multicellular plants and animals had evolved in the sea, British biologists turned their attention to the ocean in search of the origins of life. What they found inspired a generation of Art Nouveau designers. Naturalists had always assumed that fish and seaweed live near the surface, down only as deep as sunlight penetrates (less than three hundred feet, even in clear water). Since plants need sunlight to grow and since the food chain depends on plants, it seemed impossible that life could be sustained in the total darkness, extreme cold, and intense pressure of the ocean depths.

The first comprehensive maps of ocean currents had been made in the 1850s by an American naval officer, Matthew Maury, who in 1855 published the text that founded the field of oceanography, *The Physical Geography of the Sea*. Maury had turned his attention to mapping the ocean floor as part of the American effort to lay a telegraph cable across the Atlantic (plate 70). During the project, the workers at sea occasionally pulled up a piece of cable and they were surprised to find that, no matter how deep the cable had been, there were always live plants and animals clinging to it.

Hearing these tales, the Scottish zoologist C. Wyville Thomson sailed off the coast of England in 1868 and pulled up a starfish from half a mile down. He was later astonished when his dredge brought up from a depth of three quarters of a mile and even deeper very primitive animals he had never seen before—"living fossils" (plate 69). Thomson concluded that there was no lower limit on life in the sea; all the remains from the green-plant food chain eventually sink

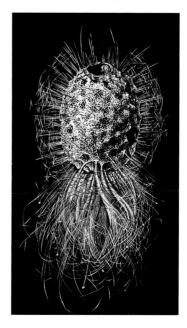

OPPOSITE

68. "Cynthia," drawn by Ernst Haeckel for the *Challenger* and reprinted in *Kunstformen der Natur* (Art forms in nature) (Leipzig, Germany: Verlag des Bibliographischen Instituts, 1899–1904), pl. 85.

ABOVE

69. Sponge, "Rossella velata," dredged from 651 fathoms, in C. Wyville Thomson, *The Depths of the Sea* (London: Macmillan, 1873), 419.

LEFT

70. Vertical section of the North Atlantic, in M. F. Maury, *The Physical Geography of the Sea* (New York: Harper & Brothers, 1855), pl. 12.

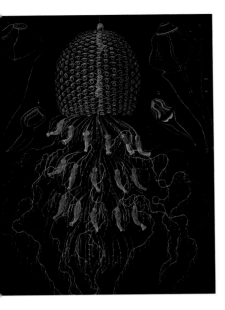

to the ocean floor and provide nourishment all the way down. Thus, less than a decade after Darwin's *Origin of Species*, Thomson's discovery that plants and animals live down to the deepest abysses of the sea expanded the inhabitable area of the earth by 75 percent.

Fired with enthusiasm to explore life in the sea, Thomson talked the British Navy into letting him lead a three-and-a-half-year, round-the-world scientific expedition to study the physics, chemistry, geology, and biology of the seven seas. In December 1872 he set sail with a team of scientists on HMS *Challenger*. In their deepest dredge they brought up living specimens from an unprecedented depth of three and a half miles. The ship was outfitted with a full laboratory, and the scientists catalogued and preserved all the specimens they discovered. From each port crates of specimens were shipped back to Edinburgh, then sent on to about a dozen international experts for fuller study; Haeckel catalogued one of his specialties, radiolarians, which inspired René Binet decades later. The forty-volume official publication documenting the species found on the *Challenger* expedition, with specimens illustrated in hundreds of folios of lithographs, is a monument of late-nineteenth-century natural science (plates 71–73).

ABOVE

71. "Siphonophorae: Forskalia tholoides," in Ernst Haeckel's entry, *Report on the Scientific Results of the Voyage of HMS* Challenger *during the Years 1873–76* (Edinburgh, 1880–95), 28: pl. 8. Special Collections, Glenn G. Bartle Library, Binghamton University, State University of New York.

RIGHT

72. "Crustacea macura," in Charles Spence Bates's entry, *Report on the Scientific Results of the Voyage of HMS* Challenger *during the Years 1873–76* (Edinburgh, 1880–95), 24: pl. 62. Special Collections, Glenn G. Bartle Library, Binghamton University, State University of New York.

OPPOSITE

73. "Siphonophorae: Anthemodes ordinata," in Ernst Haeckel's entry, *Report on the Scientific Results of the Voyage of HMS* Challenger *during the Years 1873–76* (Edinburgh, 1880–95), 28: pl. 24. Special Collections, Glenn G. Bartle Library, Binghamton University, State University of New York.

"Siphonophorae" live at great depths, under enormous pressure and in frigid temperatures; because they pass their whole lives in total darkness, their skin and internal organs are almost totally lacking in pigment to protect them from light.

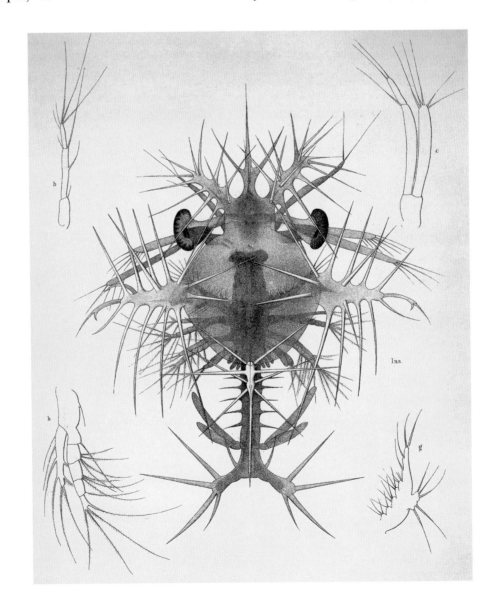

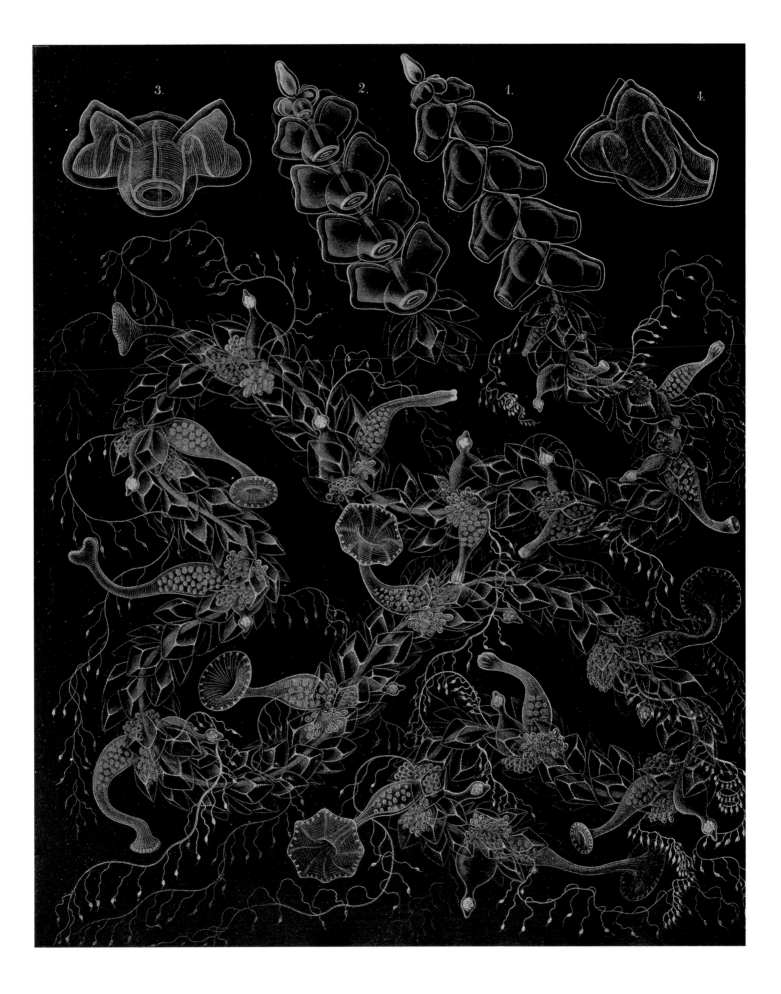

As reports of the mission appeared in the science press, the public became enchanted by the mysterious creatures from the deep. Aquariums were established (plate 74) and Jules Verne took readers on an underwater voyage to meet Captain Nemo (Latin for "nobody") —an early modern antihero, the wanderer without a homeland (plate 75).

Bizarre and beautiful sea life inspired many of the Art Nouveau artists, particularly Émile Gallé. Son of a glassmaker in Nancy, he was educated in philosophy, botany, and geology in Weimar from 1862 to 1866; at his father's retirement in 1874 he took over the glassworks and continued research in botany, editing the journal of the Lorraine Horticulture Society from 1880. These pursuits gave him a thorough knowledge of microorganisms and kept him current regarding discoveries of marine organisms. In his many works inspired by the deep sea, the artist exploited the translucency of glass to suggest mysterious waters where dwell exotic beasts, as in *Hand* (plate 76) and *Sea Dragon* (private collection). In imitation of the sea, these pieces are more translucent at the top and become more opaque as they go down to their bases. The human hand drags seaweed up from the murky depths, and the sea dragon swims in deep relief on the glassy surface. In *Deep Sea* (plate 77) Gallé created an

RIGHT, TOP

74. Aquarium at Le Havre. *Illustrated London News,* 4 July 1868, 21.

The cave design gave visitors the impression that they were deep in the sea when they viewed fish swimming in the tanks. There were also underground pools with a great variety of crustaceans, mollusks, reptiles, and seaweed, and to complete the illusion, the floor was covered with sand.

RIGHT, BOTTOM

75. Members of Captain Nemo's Crew, Wearing Diving Suits, Explore the Sea Floor, lithograph by Edouard Riou, in Jules Verne, *Vingt Mille Lieues sous les mers* (Twenty thousand leagues under the sea) (Paris, 1870).

Above float jellyfish, Portuguese men-of-war, and seaweed; spread out on the ocean floor before the crew are deep-sea medusae, shells, coral, and starfish.

almost opaque vase in deep maroon, blue, and black glass to portray the colorless, transparent fish and sponges that so intrigued him in the cold darkness of the ocean's abyss.

For the occasion of Pasteur's seventieth birthday in 1892, Gallé made a vessel (Musée Pasteur, Paris) inscribed with the bacteria isolated by Pasteur and with the lines: "May this cooled crystal thus preserve the reflection of your flame."[36] Gallé also maintained an interest in philosophy and poetry, especially Baudelaire's, and he would often inscribe a couplet on his ware.

As early-twentieth-century scientists continued to explore microscopic organisms and creatures hidden in the depths of the sea, they redrew the tree of life. In the nineteenth century

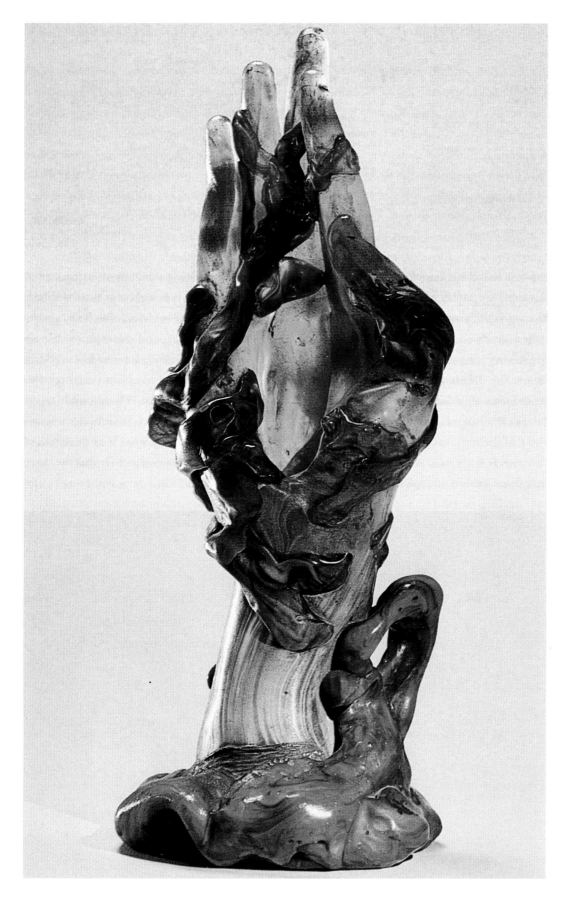

LEFT

76. Emile Gallé, *Hand*, c. 1900. Glass, height 13 in. (32.5 cm). Musée de l'École de Nancy, France.

ABOVE

77. Emile Gallé, *Deep Sea*, c. 1889–1903. Glass with metal foil and applied bits, height 8½ in. (21.4 cm). Musée de l'École de Nancy, France.

Paris Muséum National d'Histoire Naturelle, where he was fascinated by Cuvier's paleontology and anatomy. In this rich atmosphere, Redon created metaphors for moods and reveries using a vocabulary of enchanting cells and deadly microbes, monsters and freaks, plant and animal hybrids, and fearful fossils. His suite of lithographs on the subject, entitled *Origins* (1883), opens with a title page covered with microbes, some with human faces (plate 80). (The bacterium that causes diphtheria was isolated the same year.) The artist never met Pasteur, but in admiration for the renowned chemist he sent him a copy of *Origins*. Redon treasured Pasteur's response: "Only Redon's pencil could give life to these monsters."[41]

The first plate (plate 81*a*) captioned, "When life was awakening in the depths of obscure matter," shows microbes and a primitive vertebrate emerging from slime. Pasteur had disproved the spontaneous generation of life in 1860, showing that one microbe always originated from another, but Darwin's theory of evolution had reopened the question as regards the past. If species had evolved from simpler life forms, then maybe there had been a moment when the first life emerged from nonliving matter. In the second, plate 81*b*, Redon created a plant-animal mixture by giving the light-sensitive surface of the plant an "eye." The next five, plates 81*c*–81*g*, show monsters from classical mythology—a cyclops, a siren, a satyr, a faun, and a pegasus —as mutations—a single eye, a woman who sings like a bird, a man with horns, a human-horse hybrid, and a winged horse. In his review of the 1885 exhibition of *Origins*, the critic Joris-Karl Huysmans proclaimed, "The artist has rejuvenated the myth of man's origins."[42] The last, plate 81*h*, shows an early man, a subject widely discussed in Paris in the 1870s and '80s after the discovery of the Cro-Magnon man fossil.

In addition to merging classical monsters with mutants in *Origins*, in other prints Redon invented his own mutants, such as *Spirit of the Forest* (1880; private collection), with its exaggerated head and small limbs. From his visits to the natural history museum, Redon was familiar with Cuvier's approach to the anatomy of a skeleton as a balance of related parts: "I really took the idea of my monsters from there. . . . Any exaggeration of one part involves the diminution or atrophy of another, in a word, the equilibrium is broken or compensated for in another way. Thus an enormous head, a small body, or vice-versa." Like many other of Redon's complex images, *Spirit of the Forest*—a creature with a distorted but logical anatomy who, like Daphne, also sprouts plant limbs—combines elements from Cuvier, Clavaud, and classical mythology.

a

b

c

d

e

f

g

h

. . .

By 1900 in France a belief in some kind of transformism was held both among biologists and in other disciplines. *Creative Evolution* (1907), by the French philosopher Henri Bergson, for example, posits a vital force *(élan vital)* in the cosmos, borrowing concepts from ongoing discussions about the spontaneous generation of life yet going far beyond the facts of biology. But there was no Darwinian revolution in France—most French biologists professed some version of transformism, but not natural selection. French artists were aware of current thinking about cells, transformism, and brain anatomy, but with the exception of Redon, their exploration of the invisible in the second half of the nineteenth century ultimately amounted to little more than the imitation of nature at a smaller scale. With a keen eye and a desire to create an art of precise observation, the French artist excelled instead in exploring the visible. As an expression of the Young-Helmholtz-Maxwell theory of vision, the Impressionists created a new symbolic form: the physiological picture plane—an opaque surface covered with colors and forms symbolizing subjective experience.

OPPOSITE AND ABOVE

80, 81. Odilon Redon (French, 1840–1916), *The Origins*, 1883. Lithographs, album with frontispiece and eight plates, each c. 12⅜ x 9 in. (30.9 x 22.6 cm). The Art Institute of Chicago. Charles Stickney Collection, 1920-1577–85.

The plates are entitled *(a)* "When life was awakening in the depths of obscure matter," *(b)* "There was perhaps a first vision attempted in the flower," *(c)* "The misshapen polyp floated on the shores, a sort of smiling and hideous cyclops" (detail), *(d)* "The Siren, clothed in barbs, emerged from the waves," *(e)* "The satyr with the cynical smile," *(f)* "There were struggles and vain victories," *(g)* "The impotent wing did not lift the animal into that black space," and *(h)* "And man appeared; questioning the Earth from which he emerged and which attracts him, he made his way toward somber brightness."

4

GERMAN AND RUSSIAN ART OF THE ABSOLUTE: A WARM EMBRACE OF DARWIN

We are at the beginning of a totally new art, an art with forms that mean nothing and remind one of nothing and represent nothing, yet they will be able to move our souls so deeply, so strongly, as before only music has been able to do with tones.

August Endell, "The Beauty of Forms and Decorative Art," 1898

IN THE DAYS OF Caspar David Friedrich, Germany was a disunified conglomeration of industrially backward cities filled with the crumbling Gothic architecture immortalized by German Romantics. The 1848 revolutions that swept Europe were suppressed in German lands, but the Frankfurt parliament determined to modernize and unify Germany. After the battles of the Austro-Prussian War (1866) and the Franco-Prussian War (1870–71), Otto von Bismarck declared a German empire in 1871. By then Dresden, Berlin, Frankfurt, and Munich were among the most industrialized cities in Europe.

In this atmosphere of rapid change, the first German translation of Darwin's *Origin of Species* appeared in 1860, soon followed by translations of Lyell and Huxley. German scientists responded immediately with dozens of books on Darwinian evolution throughout the 1860s and '70s.[1] As industrialists were rejuvenating German cities, scientists were trying to modernize their laboratories and adopt the scientific method that had yielded such extraordinary results in Britain and France. Younger researchers disassociated themselves from the metaphysical speculation of the Naturphilosophen, whom they scorned as grandiose and wooly-minded, and declared themselves proponents of materialism and mechanism. Unlike their British and French colleagues, they were not opposed to theories; they just wanted more rigorous ones.

When they sought philosophical guidance, German scientists looked to thinkers not of the European Enlightenment—Descartes and Locke—but of their own Teutonic tradition: Spinoza and Kant. The leading German scientist of the second half of the nineteenth century, Hermann von Helmholtz, sought to ground Kant's Idealist vision of human knowledge in the physiology laboratory. In the tradition of natural philosophy, Kant had presented arguments for the power of the mind to organize sensory experience; in the new spirit of experimental science, Helmholtz demonstrated, in repeatable experiments, how the eye and the ear respond to light and sound, and how the brain organizes optical and auditory neurological impulses. In so doing, Helmholtz, along with other German and Russian physicists and physiologists, shaped the modern intellectual landscape, in which many researchers believe that the mind constructs a world

82. Coral specimens, in Ernst Haeckel, *Kunstformen der Natur* (Art forms in nature) (Leipzig, Germany: Verlag des Bibliographischen Instituts, 1899–1904).

picture from signs—including nerve impulses—and symbols. This outlook, along with Naturphilosophen's vision of cosmic unity, provided the philosophical underpinnings for abstract art.

With no real competition from German theories, Darwin's natural selection became generally accepted by German scientists in the 1860s as a master narrative that explained the natural sciences. Rather than being predominantly Catholic, as in France, German cities were inhabited by members of diverse religious sects (Lutheran, Evangelical, Catholic, and Jewish), which proved to be a fluid climate in which people could work out compromises between their scientific and religious convictions. Since there was no strong spokesman from a unified German church to oppose Darwin, the new biology caused only minor clerical grumblings.

Popular books on Darwin in Germany were written by practicing scientists, following a tradition in which experts would take it upon themselves to explain important discoveries to the public. In fact, until World War II the masterpieces of nineteenth-and twentieth-century popular science were all written by leaders of German science: Humboldt's *Cosmos* (1845); Helmholtz's *Recent Progress of the Theory of Vision* (1868)—a nontechnical presentation of highlights from his groundbreaking *Handbook of Physiological Optics* (1856–67)—and for artists, his *On the Relation of Optics to Painting* (1871); Freud's *On Dreams* (1902), a popular version of his *Interpretation of Dreams* (1900); and Einstein's *Relativity: The Special and General Theory, a Popular Exposition* (1917), a summary for readers of his 1905 and 1915 publications. The authors of these works were teachers in the best sense; they inspired curiosity, provided lucid exposition, and presented ideas humbly and undogmatically.

In the 1860s, Darwin's theory began to be popularized by several eminent German natural scientists, including the physician and philosopher Ludwig Büchner and the zoologist Karl Vogt. When the first German translation of *Origin of Species* appeared in 1860, the man who would become Darwin's most effective supporter, Ernst Haeckel, was a twenty-six-year-old graduate of medical school who had considered a career as a painter. From his first reading, Haeckel devoted himself to research to support Darwin's theory and to promote the new biology in Germany. In the 1860s he published the most comprehensive early presentations of Darwin's theory in German: *General Morphology* (1866) for the professional and *Natural History of Creation* (1868) for the public (plate 83). Haeckel is best remembered today for his dictum "ontogeny recapitulates phylogeny," by which he asserted that development of an embryo (ontogeny) repeats the evolution of its species (phylogeny). As a researcher, Haeckel has been faulted for inattention to detail and for taking artistic license with his scientific data.[2]

83. Nervous system of animals, in Ernst Haeckel, *Natürliche Schöpfungs-Geschichte* (Natural history of creation) (1868; reprint, Berlin and Leipzig, Germany: Walter de Gruyter and Co., 1920), pl. 19, between 390 and 391.

In one of his many popularizations of Darwin's theory, Haeckel illustrated that multicellular animals share a similar central nervous system. Shown are *(1)* gastraea (Haeckel's name for a primordial ball of cells), *(2)* sponge, *(3)* medusa, *(4–5)* starfish, *(6)* roundworm, *(7–11)* segmented animals, *(12)* flatworm, *(13–15)* other worms, *(16–18)* mollusks, *(19–20)* notochords, and *(21–23)* vertebrae.

But as an illustrator, he has earned a place in art history with his color lithographs illustrating the new biology. In 1899–1904 he published the crowning achievement of his aesthetic pursuits, *Art Forms in Nature* (plates 60, 66, 68, and 82). Executed in a style that reflects his taste for Jugendstil design, his images of life forms proved influential in fin de siècle art circles in Paris, Brussels, Munich, and Saint Petersburg.

Naturphilosophie had a strong following in Russia in the early nineteenth century. In the 1820s the philosophy of Schelling was taught at the universities in Saint Petersburg and Moscow, where most of the professors were from Germany. After the December uprising of 1825 in Saint Petersburg, the tsarist government suspected that the study of philosophy had encouraged political subversion and virtually banned it from Russian universities. But Western philosophy continued to be discussed in small reading groups that often met clandestinely, and from the 1830s to the 1860s they focused almost exclusively on Hegel because of the political implications of his thought.

Russia's defeat by Turkey and its ally Great Britain in the Crimean War (1853–56) led to a national reassessment of the country's position in the modern world. When news of Darwin's theory began arriving from Germany in the 1860s and the first translation of *Origin of Species* appeared in 1864, evolution by natural selection was embraced by scientists and young intellectuals.[3] Steeped in mysticism and withdrawn from society, the Eastern Orthodox Church was ineffectual in stopping the tide of secular reform. As in Germany, popularizers appeared from the ranks of leading scientists, including the anatomist N. N. Strakhov and the plant physiologist K. A. Timiriazev, whose 1865 book *Short Essay on Darwin's Theory* provided generations of Russians with a clear exposition of Darwin's thought.[4] Popular magazines flourished in response to the public's growing interest in all areas of science (plate 84) and fossils were displayed for curious audiences (plate 85). As intellectuals became familiar with evolution, the tide in Russia turned against Naturphilosophie and the study of Idealism in the 1860s, but, as in Germany, it never disappeared.

Within a decade of Darwin's publication, the Russian scientist Alexander O. Kovalevsky formulated a universal theory of embryonic development that gave crucial support to Darwin's theory. He corresponded regularly with Darwin, who took serious note of his Russian colleague's work in *The Descent of Man* (1871).[5] Kovalevsky later recalled: "Darwin's theory was received in Russia with profound sympathy. While in Western Europe it met firmly established old traditions which it had first to overcome, in Russia its appearance coincided with the awakening of our society after the Crimean War and here it immediately received the status of full citizenship and ever since has enjoyed widespread popularity."[6]

When Wassily Kandinsky studied law at the university in Moscow during the late 1880s and early '90s, he was part of an intellectual milieu that had a scientific perspective and remained open to new ideas from the West, especially from Germany. Reflecting on his early years, Kandinsky credited his Russian education for helping him "acquire the capacity for abstract thought. I loved all those sciences, and today still think with gratitude of the enthusiasm and perhaps inspiration they gave me."[7] Artists in Germany and Russia were particularly

fascinated by one momentous implication of Darwin's theory of evolution: the human mind itself is evolving. According to researchers in the new field of experimental psychology, pleasure, especially aesthetic delight, is the driving force that propels consciousness to evolve to higher and higher levels of awareness. At the fin de siècle and in the first decades of the twentieth century, Kandinsky, along with Kazimir Malevich and other avant-garde artists, developed abstract art in Russia and Germany to express this evolving consciousness.

PLEASURE FROM COLOR AND LINE: EXPERIMENTAL PSYCHOLOGY

Working in a scientific atmosphere dominated by a mechanistic outlook, midcentury researchers concerned with the human mind were determined to join the ranks of experimental science, rather than relying on philosophical speculation. They no longer described the unity of spirit and matter as a form of pan*theism* (a universe permeated by a divinity or a World Soul), but more secularly as a kind of pan*psychism*—a cosmos imbued with consciousness. They set about proving panpsychism in the laboratory by demonstrating a link between spirit and matter. Researchers designed experiments to connect a physical cause with a psychological effect; each experiment measured a subject's emotional responses to viewing colors and lines. In so doing they not only founded a new field—experimental psychology—but also established the formal vocabulary for the first generation of abstract artists.

The key to understanding the origins of experimental psychology can be found in the biography of its founder, Gustav Theodor Fechner. Educated when Naturphilosophie was waning, he nevertheless absorbed its outlook, completing a doctorate in medicine in 1822 and doing his early work in physiology and physics. In 1840, while doing experiments on the perception of afterimages, Fechner damaged his retinas (probably by looking at the sun) and found himself unable to read. As his vision deteriorated, he fell into a deep depression. For the next three years

he could not tolerate any light and thus he remained inactive, wearing a blindfold, in a room with the walls painted black. As he slowly began to regain his vision, Fechner was flooded with euphoria and became convinced that he had discovered the fundamental law of the spiritual world and the force propelling the psychic realm: the principle of pleasure *(Lustprinzip)*. Pleasure is to the mind, according to Fechner, what gravity is to the material world—a fundamental force. He went on to formulate a cosmology in which consciousness permeates all matter—from pebbles to planets, from microbes to man—and the universe is governed by the force of gravity and by opposing forces of pleasure and displeasure (expressed electrically as positive and negative, chemically as base and acid, and so on).[8] In the early twentieth century Freud adopted Fechner's pleasure principle as a fundamental psychological force; in "Beyond the Pleasure Principle" (1920) Freud wrote, "An investigator of such penetration as G. T. Fechner held a view on the subject of pleasure and unpleasure which coincides in all essentials with the one that has been forced upon us by psychoanalytic work."[9]

After fully recovering from blindness and depression, Fechner published his cosmology in 1851 in a scientific climate very hostile to Naturphilosophie. Undeterred, he turned his attention to psychology and determined to prove a "psychophysical law" relating the psychological and physical worlds. Ten years and thousands of experiments later (including classic investigations into the visual perception of color, brightness, and distance), he published his results in *Psychophysics* (1860), which is considered the founding text of experimental psychology. Fechner's psychophysical law relates the (physical) intensity of a stimulus to the (psychological) threshold of perception.[10] It had great impact on visual artists because Fechner extended his findings to aesthetics in *Introduction to Aesthetics* (1876). He defined the beauty of an object as those properties that cause immediate pleasure and thus stimulate the mind, which is driven by pleasure.[11] Unlike aestheticians, who deduce what is beautiful from unproven laws of harmony and proportion, Fechner proclaimed that experimental psychology provided an inductive aesthetics, with principles that could be proven by the experimental method. He first isolated the elements of the mind into fundamental units of pleasure, just as the chemists of his day, such as Dmitri Mendeleyev, were isolating the elements of matter. From the complex, ever-changing mosaic of everyday perception, Fechner abstracted colors, shapes, and lines that cause mental pleasure, and he designed tests to measure the quantity of pleasure. For example, ten rectangles of varying dimensions but all the same area and color would be spread out on a table. The subject was asked to rank them in order of aesthetic pleasure and displeasure. Fechner's careful records show that most people preferred the rectangles in the middle, the ones that were not too square and not too elongated. Indeed, his tally determined that the rectangles perceived as most beautiful had sides in the ratio of 34 to 21, which Fechner declared was empirical proof of the pleasing proportions of the golden section.[12]

In Naturphilosophie, man's consciousness expanded spiritually as he transcended toward union with the World Soul. After Darwin, mankind's brain was understood as also evolving physically. Fechner, in turn, claimed to have identified the driving force—pleasure—that made consciousness evolve to higher levels. Therefore beauty—such as the pleasure from looking at a well-proportioned rectangle—helps man expand, evolve, and transform his consciousness. This merger of Romantic mystical pantheism and Darwin's evolutionary worldview into

the concept of evolving consciousness is at the heart of Kandinsky's and Malevich's spiritual art, which aspires to lead the viewer to the Absolute through the contemplation of color and form.

Experimental psychology was promoted in the last decades of the nineteenth century by Fechner's admirer, Haeckel, and by his disciple the physiologist Wilhelm Wundt, who opened the world's first institute for experimental psychology in Leipzig in 1879. Medical students and psychologists flocked there from throughout the West and returned to establish centers in their own cities, including Munich, Vienna, Saint Petersburg, and Moscow, where artists would soon develop Jugendstil, early forms of German Expressionism, and Suprematism.

Evolving Consciousness

At the turn of the century French scientists continued to focus on conducting laboratory experiments and collecting data. They regarded the metaphysical undercurrent in German science—Naturphilosophie and the search for an Absolute—as nonsense. Chevreul, for example, presented his law of simultaneous contrast of color as a summary of facts about visual perception; if he had gone on to ponder the possible spiritual implications of his law, he would have been met by blank stares from other French chemists.

Mainstream German scientists were urged to find a balance between theory and data—as Helmholtz put it, between "a penetrating knowledge of theory" and a "broad, practical experience in experiment." He went on to criticize French scientists for being too narrowly focused on collecting facts, but, on the other hand, he thought that the German scientists who espoused Naturphilosophie, which included Haeckel, erred in the opposite direction by not sufficiently grounding their hypotheses in laboratory data: "To flee into an ideal world is a false resource of transient success. . . . When knowledge only reflects itself, it becomes insubstantial and empty, or resolves into illusions and phrases."[13] Nevertheless, there was a strong resurgence of Naturphilosophie in German science during the last decades of the nineteenth century. The old quest of uniting with the cosmos was revived under the banner of science, and, as Fechner's experiments implied, it was artists who held the keys to the kingdom of the Absolute—abstract color and line.

Scientists sympathetic to Naturphilosophie were heir to a tradition stretching from Pythagoras to Schelling to Fechner to Haeckel, which held that nature is a unity infused with consciousness: man and the universe are related as microcosm to macrocosm, joined by a common spirit. As we have seen, after Darwin's *Origin of Species*, German scientists had fused this tradition of pantheism with the theory of evolution and produced a powerful doctrine of physical and spiritual evolution. Led by Haeckel, these scientists updated the monism of the Naturphilosophen by claiming that natural selection provided the mechanism by which monads combine into ever-greater levels of complexity, first becoming molecules, then cells, and so on to the brain and ultimately the universe. The experimental psychology of Fechner showed artists the way to ascend the cosmic ladder to the Absolute by raising the level of their minds, rung by rung, powered by the force of pleasure from color and form. When considering these doctrines today, it is crucial to keep in mind that for these scientists (Fechner, Haeckel, and their colleagues) the spiritual realm of the Absolute as well as cosmic consciousness and the

psychological were all part of the natural word and within the purview of science—they were *not* supernatural. It is not necessary to look to Eastern religions or the occult to explain most of the spiritual themes in early abstract art;[14] artists found them in fin de siècle European science.

Support for Fechner and Haeckel's view that the mind was evolving toward higher levels of consciousness was provided by a Canadian physician and asylum superintendent named Richard M. Bucke, who published the influential study *Cosmic Consciousness: A Study in the Evolution of the Human Mind* in 1901. Bucke declared that aesthetic intuition occurs at the highest level of the mind—cosmic consciousness—and that the most highly evolved minds are those of artists and poets. Having been Walt Whitman's physician and biographer, Bucke believed that the poet had attained cosmic consciousness in his epic *Leaves of Grass* (1855),[15] and that Whitman was of a higher spiritual order than most. Bucke's term, "cosmic consciousness," was quickly adopted by the American psychologist William James, who gave panpsychism a sympathetic reading in *The Varieties of Religious Experience* (1902). Bucke's view was especially influential because of his association with Whitman, whose celebration of sexuality earned him a devoted following among the Russian avant-garde. Mikhail Larionov opened his manifesto "Rayonist Painting" (1913) with a quote from *Leaves of Grass*, which had been translated into Russian two years before.[16]

In Saint Petersburg the mathematician and mystic Peter Ouspensky also adopted Bucke's cosmic consciousness and merged it with the popular notion that beyond three-dimensional reality is a mysterious fourth dimension. After non-Euclidean geometries were first written by nineteenth-century Russian and German mathematicians, the public became enchanted with the idea that there might be additional spatial or temporal dimensions to reality.[17] In *The Fourth Dimension* (1909), Ouspensky declared that the fourth dimension was neither spatial nor temporal but spiritual—the realm of cosmic consciousness—and he promised his readers that if they developed their spiritual powers, they could ultimately intuit that fourth dimension. After a prologue discussing the importance of intuitive knowledge in Kant's *Critique of Judgment*, and with frequent references to Bucke's *Cosmic Consciousness*, Ouspensky went on to write an extensive treatise on the mind, *Tertium Organum* (Third canon; 1911), describing how to attain cosmic consciousness. Like Bucke, Ouspensky hailed poets and artists as having the highest form of consciousness. With the title *Tertium Organum*, Ouspensky proclaimed that his treatise documented the latest stage in the evolution of the human mind: the first stage had been recorded in the third century B.C. by Aristotle in his *Organum* on deductive logic, and the second stage by Francis Bacon in his *Novum Organum* (1620) on inductive logic. The *Tertium Organum* described how to attain the highest state of consciousness by "intuitive logic—the logic of infinity, the logic of ecstasy" in which everything is both "A and Not-A, or, Everything is All."[18] Ouspensky also proclaimed: "Science must come to mysticism."[19]

There was another, related, worldview—theosophy—that merged traditional pantheist and panpsychic doctrines (a World Soul, Pythagoras's faith in the power of certain numbers, Plato's ideal forms, and so on) with an "occult science" comprising all natural science plus supernatural insight. Pantheism and panpsychism had been linked to theosophical doctrines since the seventeenth century; Böhme, for example, considered himself a theosophist.[20] Helena Petrovna

The prime characteristic of cosmic consciousness is, as its name implies, a consciousness of the cosmos, that is, of the life and order of the universe. . . . Along with consciousness of the cosmos there occurs an intellectual enlightenment or illumination which alone would place the individual on a new plane of existence—would make him almost a member of a new species.

Richard Bucke,
Cosmic Consciousness: A Study in the Evolution of the Human Mind, 1901

Blavatsky founded the Theosophical Society in 1875 in New York. Blavatsky, who was Russian born, preached a harmonious mix of science and religion that, with its element of self-improvement through spiritual perfection, had a strong appeal in Protestant America and also gained followers in Britain, such as Annie Besant and Charles W. Leadbeater. Occurring during the wave of interest in Asian art and culture after trade with Japan was reopened in 1854, theosophical doctrine expanded traditional Western mysticism to include Eastern religion and philosophy.

Rudolf Steiner, the leader of the German chapter of Blavatsky's Theosophical Society from 1902 to 1913, was well educated in Naturphilosphie; he had studied science and philosophy at the University of Vienna between 1890 and 1897, where he edited a collection of Goethe's scientific writings. A great admirer of Haeckel's views, Steiner wrote a pamphlet comparing Haeckel's panpsychism with theosophy; the materialist, according to Steiner, looks at stones, plants, and human beings and studies only inert atoms, but theosophists "can say, in the words Haeckel uses, that we see God in the stone, in the plant, in the brute, and in man."[21]

The difference between occult theosophy (Blavatsky and Steiner) and the scientific concept of evolving consciousness (Fechner and Haeckel) is that for the occultists, the highest rung on the evolutionary ladder—cosmic consciousness—was supernatural and attainable only through theosophical meditation; for the scientists, the highest rung remained in the natural world and could be investigated by the scientific method. Theosophists embraced science because they believed that fin de siècle scientists were "proving" their beliefs. Steiner even changed his mind and decided that he too could use the methods of natural science to study consciousness; to that end he broke with the Theosophical Society, which had become too focused on Eastern philosophy for his taste, and in 1913 he founded his Anthroposophical Society for the empirical study of spiritual matters. Publications by both societies mixed theosophical and anthroposophical dogma with scientific information that was often simply copied, diagrams and all, from well-known science texts; their books and pamphlets contributed to the popularization of science.[22]

Thus, by the turn of the century experimental psychologists, biologists, and psychiatrists had fused the traditions of pantheism and panpsychism with the theory of evolution to produce a compelling doctrine of psychological evolution. The universe was understood as an organic unity, infused with spirit in ever-greater levels of complexity, culminating in consciousness and finally the cosmos. Fechner and his followers had shown artists the way to raise their minds to higher levels of consciousness, propelled by pleasure in color and form. Soon artists began experimenting with patterns of pure color and form. When they were asked, "What is this?" the German artist August Endell replied in 1896, "We all have to learn how to see in terms of pure colors and forms, and not to think about what they might depict. We also have to learn to feel the emotions that arise from seeing the colors and forms, to let these emotions reach our consciousness."[23] In 1908 Endell went on to proclaim, "The depicted object as such has been eliminated. . . . Art comes forth for the first time absolute and unconditioned."[24] And in the 1920s Malevich would compare "the movement of thoughts with the movement of sunlight or comets in the cosmos" and describe Suprematism as an art based in cosmic thought alone that led him on "the ascent to the heights of non-objective art . . . where nothing is real except feeling."[25]

In 1894 Munich became a center for experimental psychology when Theodor Lipps founded the Psychological Institute at the University of Munich, which he modeled after Wilhelm Wundt's institute for experimental psychology in Leipzig. In 1897 Lipps published a study of spatial perception, including discussion of over one hundred optical illusions (plate 86),[26] and he (like Fechner) developed a theory of aesthetics based on the principle of pleasure. Someone looking at a painting or listening to music finds joy in projecting his or her own emotions onto the aesthetic object—feeling empathy for it. Aesthetic experience is pleasurable, according to Lipps, because humans are basically narcissistic; in loving an artwork the viewer (by empathetic projection) is loving himself. In his laboratory experiments Lipps, like Fechner, studied abstract properties of objects; he found that viewers associated yellow with joy, blue with sorrow, and responded to musical discord or harmony with feelings of struggle or triumph.[27] Lipps also taught that there is a fundamental unity between vision and hearing because all sensation is neurological. During his tenure at the university, from 1894 to 1914, Lipps gave public lectures on art in Munich and published his *Aesthetics* in 1903–6.

In 1908 a follower of Lipps, the art historian Wilhelm Worringer, extended the notion of empathy to explain changes in artistic styles. Artists represent the world realistically in eras (such as classical Greece) when they feel at home in—have an empathy for—the everyday world; they abstract from nature, as in Gothic and tribal African art, during eras of alienation from observed reality. Published as *Abstraction and Empathy*, Worringer's thesis provided a fruitful starting point for the twentieth-century German art historians Heinrich Wölfflin and Erwin Panofsky.

In fin de siècle Germany, designers and architects, like their Art Nouveau colleagues in France, turned to nature in search of a new style. It is telling about the French and German attitudes toward nature that Art Nouveau designers remained based in the observation of nature, whereas those who developed the German style—Jugendstil—soon moved away from nature into a totally nonrepresentational style.[28] The central figure in Munich, Hermann Obrist, studied biology and medicine at the University of Heidelberg, but after seeing Arts and Crafts objects during an 1897 trip to London, he was encouraged to pursue a career in art. Inspired by Haeckel's writings and illustrations, he designed fountains with a vocabulary of organic forms, especially spirals.[29] He also designed large embroideries such as *Whiplash (Cyclamen)* (plate 87), which has become a prime exemplar of Jugendstil art because it presents the characteristic flower, leaves, and roots connected to a stem that, like Horta's stalk, thrashes with energy. The critic Georg Fuchs gave the piece the name by which it is now known: "This racing movement seems to us like the abrupt, powerful convolution of the lash at the crack of a whip. Now it appears like the image of sudden, powerful elements: a lightning bolt."[30] Reflecting the experimental psychologist's association of abstract lines and colors with feelings, Fuchs described the appeal of Obrist's embroideries: "They fulfill our yearning for a more spiritual, purer, creative art. . . . These embroideries do not intend to 'mean' anything, to say anything . . . they are companions that involve themselves in our feelings."[31]

1a

1b

2a

2b

86. Optical illusions, from Theodor Lipps, *Raumaesthetik, und geometrisch-optische Täuschungen* (Aesthetics of space, and geometrical optical illusions) (Leipzig, Germany: Johann Ambrosius Barth, 1897), 237, 222.

In the "arrow" illusion *(1)*, a line of the same length appears shorter *(1a)* or longer *(1b)*, depending on the position of the V shapes, which give the viewer the feeling that the line is contracting or expanding. In illusion 2, the same size circle appears smaller *(2a)* or larger *(2b)*, depending on the size of circles that surround it.

An apprentice to Obrist, August Endell had come to Munich in 1892 not to study design but as a philosophy major at the University of Munich, and when Lipps opened the Psychological Institute in 1894, Endell became his avid student. When he won a commission to design the Elvira Photography Studio, Endell created a facade and staircase covered with swirling shapes (plates 88 and 89). In a treatise on the psychology of perception in the Jugendstil magazine *Dekorative Kunst* (1898), he described the power of forms to evoke feelings: "We must learn to look at a tree root, a stem, or a leaf and to see its form—in and of itself—and then to feel any changes in that form. If we can learn how to look at nature this way, a totally new, unknown universe emerges. . . . This is the power of forms. They awaken our inner feelings directly and it is not necessary to posit any other psychological process between forms and feelings."[32] Thus to become empathetic (to use Lipps's terminology), the artist and viewer must both develop the habit of looking at the world abstractly and become attuned to the feelings evoked by the forms, allowing them to reach consciousness. Endell declared that this approach to form led to an artistic vocabulary that was completely abstract and had the power to communicate emotion.[33] Thus he designed the Elvira Studio to awaken feelings in the empathetic viewer, who would approach the swirling form on the facade and then enter the foyer and become engulfed in a jungle of curving, undulating lines. The forms are completely non-representational, as Endell described them: "No ornament was created on the basis of nature studies . . . never was the imitation of nature a goal."[34]

In Vienna the critic Arthur Rössler advocated an abstract, decorative style based on the power of line: "Just as emotions can be expressed in certain bodily gestures, so too can artistic feelings as inner movement be made visible through line . . . significant as symbolic veils, sensuously perceptible expressions of movement of the spirit."[35] Rössler pointed to the Munich artist Adolf Hölzel's decorative patterns as examples (plate 90). Hölzel painted genre scenes for public display, but he confided to Rössler in 1905 that for many years he had also drawn completely nonpictorial patterns of lines that "express the inner process of feeling."[36] Rössler recognized the originality of this abstract approach to design, declaring: "The process is at first unconscious and intuitive, and then becomes a conscious expression of the soul and mind. . . . The forms, rhythms, colors and tones are in harmony with the soul."[37]

By 1900 experimental psychology in Germany, Austria, and Russia had split into two branches, based on a division made by Fechner in *Psychophysics*. He had defined "outer

ABOVE, TOP
87. Hermann Obrist (Swiss, 1863–1927), *Whiplash (Cyclamen)*, c. 1895. Silk on wool embroidery, 47 x 73 in. (119 x 183 cm). Münchner Stadtmuseum, Munich.

ABOVE, BOTTOM
88. August Endell (German, 1871–1925), Elvira Studio (facade), Munich, 1896–97.

OPPOSITE
89. August Endell, Elvira Studio (staircase), Munich, 1896–97.

psychophysics" as research into the relation between physical stimulus (such as seeing food) and an objective, observable response (such as salivating or reaching for food). Russia became a center of research on outer psychophysics—"behaviorism" and "conditioning" (learned reflexes)—after the physiologist Ivan Pavlov performed experiments on the canine digestive system in the 1890s. Fechner's "inner psychophysics"—the relation between physical stimulus (seeing food) and a subjective ("spiritual" or "psychological") response (such as feeling a desire to eat)—dominated German research, producing Lipps's aesthetics of empathy.

In Russia, physiologists who remained sympathetic to inner psychophysics, such as the Saint Petersburg neurophysiologist Nikolai Kulbin, railed against the omission of the spiritual (psychological) dimension in experiments on "Pavlov's dog." Kulbin, who specialized in the mechanism of subliminal sensations,[38] was also interested in Jugendstil design. Around 1905 he learned to paint and created works suggesting organic tissue seen through a microscope and Jugendstil-type landscapes (plate 91). Kulbin would eventually promote an art based on intuition more than stylistic convention, and he became a close friend of many avant-garde artists, including Kandinsky. Showing himself to be keenly aware of the opposed approaches to psychology within German and Russian science, Kandinsky began his 1911 essay "Whither the 'New Painting'" by decrying the materialist approach of a practitioner of "outer psychophysics," the German pathologist Rudolf Virchow, who once said: "I have opened up thousands of corpses, but I never managed to see a soul."[39] Declaring that "a great interest in abstraction is being reborn,"[40] Kandinsky predicted that the future of art and science belonged not to those who looked only at the visible realm but to neurologists like his friend Kulbin as well as to physicists who used intuition and indirect detection to explore the invisible.

In 1907 Kulbin organized Triangle: Art and Psychology, a group of Saint Petersburg artists and poets who explored the relation of art to psychology. He chose the name Triangle because he had concluded from his research that artists impose not only their feelings but also geometric figures onto nature: "Painting is the spontaneous projection of conditional signs from the artist's brain onto the picture."[41] Kulbin also compared the perception of color and music, and he published essays in art periodicals lending his scientific backing to the analogy: "From my own researches I am convinced that it is possible to determine concords and discords in the spectrum, in the scales of colors, just as in musical scales."[42] First given as a lecture in Saint Petersburg in 1908, this text was published by Kandinsky and Franz Marc in the journal *Der Blaue Reiter* (The blue rider) in Munich in 1912.

When Kandinsky went to Munich from his native Russia in 1896, he encountered Haeckel's panpsychism and Lipps's experimental psychology, and the young artist adopted Obrist and Endell's theory of a new spiritual (psychological) art based in abstract decoration.[43] He maintained close contact with Kulbin's Triangle group, and by 1910 he was moving toward abstraction while still retaining remnants of imagery, as in *Little Pleasures* (plate 92), which depicts a couple on the left, along with a rider on a blue horse, set in a landscape with hilltop villages. He painted the pattern of colors and lines on glass, a material traditionally associated with the transmission of spiritual light, and he added a decorative border, as Obrist and Endell often did. (Once he moved into total abstraction in his Blaue Reiter years, Kandinsky turned his back on decoration because he felt it threatened to trivialize abstract art.) Kandinsky wrote an essay for the catalogue

92. Wassily Kandinsky (Russian, 1866–1944), *Little Pleasures*, 1911. Painting on glass with frame, 12 1/16 x 15 7/8 in. (32.5 x 40.3 cm). Städtische Galerie im Lenbachhaus, Munich.

to a 1910 exhibition in Odessa that included Mikhail Larionov, Vladimir Tatlin, Kulbin, Gabriele Münter, Alexey von Jawlensky, and himself. Entitled "Form and Content," it explores the theme of art as spiritual communication and presents ideas from contemporary studies of perception: resonance (the sympathetic vibration of musical tones), and the ability of abstract colors and lines (form) to cause a mental response (content) in the mind. Kulbin read this text on Kandinsky's behalf at the All Russian Convention of Artists in Saint Petersburg in 1911:

> *The work of art comprises two elements:*
> *the inner and*
> *the outer.*
> *The inner element, taken in isolation, is the emotion in the soul of the artist that causes a corresponding vibration (in material terms, like the note of one musical instrument that causes the corresponding note on another instrument to vibrate in sympathy) in the soul of another person, the receiver.*

As long as the soul remains joined to the body, it can as a rule only receive vibrations via the medium of the senses, which form a bridge from the immaterial to the material (in the case of the spectator).

Emotion—feeling—work of art—feeling—emotion.

The vibration in the soul of the artist must therefore find a material form, a means of expression, which is capable of being picked up by the receiver. This material form is thus the second element, i.e., the external element of the work of art.

The work of art is the inseparable, indispensable, unavoidable combination of the internal and external elements, i.e., of content and form.[44]

BECOMING A NEW SPECIES: SUPREMATISM

In Russia abstract art emerged in an atmosphere that included evolutionary biology, experimental psychology, and mystical inclinations long associated with panpsychism.[45] Artists in Saint Petersburg and Moscow imagined that a new species of human beings—artists and poets—was evolving. They vowed to create an art to express the altered perceptions and expanded consciousness of these higher beings (themselves). In addition to Kulbin's advocating form and color to communicate spiritual meaning, spokesmen for the emerging nonobjective styles, the poets Velemir Khlebnikov and Alexei Kruchenykh, strove to invent new languages to express their minds, which they understood to be evolving along the lines explained by Ouspensky in *Tertium Organum.* Khlebnikov, who was educated in mathematics and well aware of ideas that were then current in German symbolic logic, tried to invent a universal rhetoric by isolating sounds and signs common to all languages. For his part Kruchenykh invented the language of *zaum* (Russian for "beyond reason"), which he based in part on recordings of indecipherable automatic speech by religious persons, so-called speaking in tongues, which he knew from a report published in Russian in 1908.[46] Kruchenykh intended *zaum* not to be irrational but to express the higher order of reason that was evolving.

In a 1913 letter about *zaum* to the painter and musician Mikhail Matiushin, Kazimir Malevich acknowledged that a higher reason was developing: "We have come as far as the rejection of reason, but we rejected reason because another kind of reason has grown in us, which in comparison with what we have rejected can be called beyond reason, which also has law, construction and sense, and only by learning this shall we have work based on the law of the truly new 'beyond reason.'"[47] To name the visual vocabulary he was creating, which was comparable to the poets' new verbal language, Malevich coined the term Suprematism, a name suggesting its superiority to Cubism, Futurism, and other avant-garde styles. Malevich painted subjects from science, such as electromagnetism in *Suprematist Composition Expressing Magnetic Attraction* (1911; location unknown), giving the hidden forces mystical overtones, and he assigned magical powers to numbers. He composed *Arithmetic: The Science of Numbers* (an illustration in Alexei Kruchenykh, *Vozropshchem* [Lets's grrumple] [Saint Petersburg, 1913]) in a Cubist and Futurist vocabulary of tilting planes, punctuated by numerals and mathematical symbols.[48]

Also in 1913, Kruchenykh, Matiushin, and Malevich collaborated on the libretto, music, and stage sets for the Suprematist opera *Victory over the Sun,* in which they hoped to communicate

For the depiction of the new and the future completely new words and a new combination of them are necessary.

Alexei Kruchenykh,
New Ways of Words, 1913

93. Pavel Filonov (Russian, 1883–1941), *Formula of Spring*, 1915. Oil on canvas, 100 x 114 in. (250 x 285 cm). State Russian Museum, Saint Petersburg.

their evolving consciousness. For the backdrop of the set Malevich drew a completely abstract pattern that preceded and apparently precipitated his famous *Black Square* of about 1915 (Tret'yakov Gallery, Moscow). In his 1915 treatise *From Cubism to Suprematism in Art*, Malevich described his move into abstraction in terms of numbers, with mystic associations as old as Pythagoras: "I have transformed myself into a zero of form, and have gone beyond o to 1."[49]

In 1914 Pavel Filonov joined with Matiushin and Malevich to form a group of painters called World Flowering, dedicated to expressing their belief that not only the human species but the whole cosmos is an evolving organism (plate 93). After disruptions from World War I and the 1917 Revolution, the goal was continued by the artists, who from 1923 were all in Leningrad and associated with the State Institute of Artistic Culture. Malevich, who was made director of the institute in 1924, put Matiushin in charge of the laboratory to study hearing and vision. In a kind of utopian Lamarckism, Matiushin came to believe that the avant-garde artist's eye itself was evolving and, through proper exercise, could come to have a broader field of vision, to which he gave mystical associations, calling it *zorved* (see-know): "*Zorved* signifies a physiological change from former ways of seeing and entails a completely different way of representing what is seen."[50] Matiushin even predicted that in the artist's eye the cones would grow beyond the fovea (a small depression in the retina constituting the area of most distinct vision), giving the artist detailed peripheral vision in his new expanded visual field.[51]

When World War I broke out, Kandinsky returned to Russia, and after the Revolution he proposed to the State Institute of Artistic Culture that he, like Matiushin, be allowed to establish

a laboratory for the study of psychophysics. But in 1920, Soviet leaders wanted practical uses for art in the new socialist society, and Kandinsky's plan was deemed too focused on subjective aspects of perception. He reworked it and resubmitted it to the Russian Academy of Sciences, but before they could respond Kandinsky had left Russia; he later assumed a position at the Bauhaus, where he taught students to communicate spiritual feelings through an abstract vocabulary.

After adopting a completely nonrepresentational vocabulary around 1913, Malevich too spoke in the language of *zaum*; his work was a radical reduction to abstract lines and rectangles floating on a flat plane, as in *Suprematist Elements: Squares* (plate 94). In 1917 he described removing himself from his painting as he attained total abstraction: "I saw myself in space hidden among the points and colored strips, there, in the middle of them, I depart in the abyss."[52] In the panpsychic tradition, Malevich described man's mind, the microcosm, as linked to the macrocosm by thought alone: "The human skull represents the infinity of movements for con-cepts; commensurate to the infinite cosmos; and like the cosmos possesses no ceiling, no ground, only offering space for projections which allow the appearance of gleaming points, stars in space. In the human skull everything originates and per-ishes exactly as in the universe: comets, epochs, everything originates and perishes in man's conceptions."[53] In the early 1920s Malevich described his evolving consciousness as moving upward toward pure spiritual, incorporeal feel-ing: "The ascent to the heights of non-objective art is arduous and painful. . . . No more 'likeness of reality,' no idealistic images—nothing but a desert! . . . But a blissful sense of liberating non-objectivity drew me forth into the 'desert,' where nothing is real except feeling . . . and so feeling became the substance of my life."[54] Thus, in the first decades of the twentieth century artists in Russia, as well as in Germany, were hastening along the same path as the Romantics had trod—the road to the Absolute.

94. Kazimir Malevich, *Suprematist Elements: Squares*, 1915. Pencil on paper, 19¾ x 14¼ in. (50.2 x 35.8 cm). The Museum of Modern Art, New York. Acquisition confirmed in 1999 by agreement with the Estate of Kazimir Malevich and made possible with funds from Mrs. John Hay Whitney Bequest (by exchange).

LOVING AND LOATHING SCIENCE
AT THE FIN DE SIÈCLE

Gaiety of value is the light dominant; of hue, the warm dominant; of line, lines above the horizontal.
Georges Seurat, 1890

The Earth was dead. The other planets had died one after the other. The Sun was cold.
Camille Flammarion, *The End of the World*, 1894

ARTISTS IN THE CLOSING decades of the nineteenth century could not ignore the irresistible rise of science and technology, and responded from the heart and the mind. The most extreme reactions—of great enthusiasm and bitter apprehension—came from two groups, respectively, Neo-Impressionists and Symbolists. Perched at the borderland of art and science, the Neo-Impressionist Georges Seurat employed an experimental painting method that relied on the latest optical theory. Ever since his brief career in the 1880s, he has been associated with those who deliberately brought science to their art. Artists in Symbolist circles took an opposite approach, finding only bad news in science—decadence, degeneracy, entropy. Symbolist artists and poets rejected the objective mind-set of the realist and scientist, preferring subjectivity and fantasy. Nostalgic about decorative styles from prescientific eras and resigned to their bitter fate of being trapped in a world where they did not feel at home, some Symbolists expressed dismay, even scorn, at what the scientific age promised.

ART FROM THE LABORATORY: SEURAT

In the 1880s Seurat and his associates determined to improve upon Impressionism by incorporating into their techniques scientific findings about light, vision, and experimental psychology.[1] Their goal was to increase the luminosity of their canvases by "painting with light" and to intensify the emotional impact of their art by composing with lines and angles borrowed from experimental psychology.

The older generation of Impressionists had recorded nature's fleeting appearances with pigments, but the new Impressionists—Neo-Impressionists—sought a different approach. In a studio manual well known to Seurat and his friends, the American physicist Ogden N. Rood pointed out that viewers see both natural scenes and painted canvases as a result of light reflected off surfaces that strikes the retinas. In other words, light is the key to capturing nature: "Nature and the painter actually employ, in the end, exactly the same means in acting on the eye of the beholder. The point, seemingly so trite, is touched upon, as an idea seems to

95. Frederic Leighton (English, 1830–1896), *Return of Persephone*, c. 1891. Oil on canvas, 80 x 60 in. (203 x 152 cm). Leeds Museums and Galleries (City Art Gallery), England.

prevail in the minds of many persons that Nature paints always with light, while the artist is limited to pigments: in point of fact, *both* paint with light."[2]

What does it mean to paint with light? Rood described "the custom of placing a quantity of small dots of two colors very near each other, and allowing them to be blended by the eye placed at the proper distance."[3] In his 1886 essay "The Impressionists," on the occasion of the eighth Impressionist exhibition, in which Seurat unveiled *La Grande Jatte* (plate 98), the critic Félix Fénéon declared that the earlier Impressionists had used unmixed colors in a haphazard way, but the new Impressionists would be scientific:

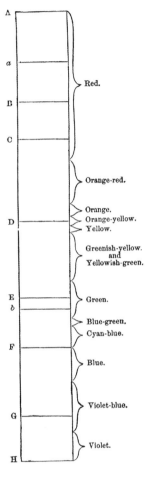

> *They [the Impressionists of Monet's generation] proceeded by the decomposition of colors; but this decomposition was carried out in an arbitrary manner: such and such a streak of impasto happened to throw the sensation of red across a landscape; such and such brilliant reds were hatched with greens. Messieurs Georges Seurat, Camille and Lucien Pissarro, Dubois-Pillet, and Paul Signac divide the tone in a conscious and scientific manner. . . . If you consider a few square centimeters of uniform tone in Monsieur Seurat's* Grande Jatte, *you will find on each centimeter of its surface, in a whirling host of tiny spots, all the elements which make up the tone. . . . Those colors, isolated on the canvas, recombine on the retina: we have, therefore, not a mixture of material colors (pigments), but a mixture of differently colored rays of light.*[4]

Seurat and Pissarro, like the Impressionists, were schooled in color mixture based on Chevreul's color wheel, on which red, blue, and yellow are primaries and the complementary colors are red/green, blue/orange, and yellow/violet. Seurat proclaimed a new method of color mixture that depended on differences between colored pigment and colored light. In Seurat's method, light reflects off a canvas covered with paint dots of the right size and colors, enters the viewer's eye, and strikes the retina, where the colors mix. To learn how to mix colored light, artists turned to studio manuals that taught Helmholtz's and Maxwell's optics with

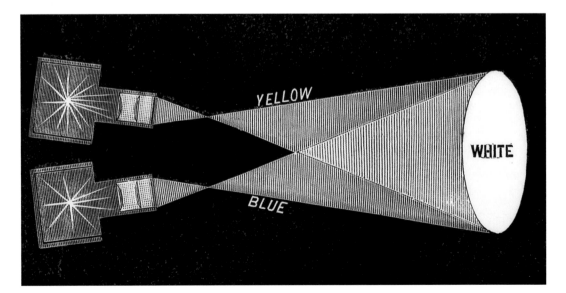

simple experiments they could easily replicate in their studios. In a darkened room, when a narrow beam of white light (sunlight) passes through a prism, it spreads out into a spectrum, from red to violet light. The range of light on the spectrum varies in wavelength, which can be precisely measured (plate 96). When two beams of light mix, they produce a new wavelength (a new color); Helmholtz defined opposite (complementary) colors of light as those that mix to produce white light. Experimenting with pure (spectral) hues, he determined that blue and yellow lights are complementary (plate 97); other complements include violet and yellow-green, indigo blue and yellow, cyan blue and orange, and so on (plate 99). Following Helmholtz, Maxwell organized the same data into a triangular diagram (plate 100), placing red, blue, and green at the apexes and defining them as "primaries" because these are the wavelengths that stimulate the three retinal cones (see chap. 3). Complementary colored lights mix to form white (indicated by "W"), and others blend to form various combinations shown on Helmholtz's chart and Maxwell's diagram.

The mixtures of colored lights generally differ from mixtures of colored pigment. For example, on a painter's palette blue and yellow mix to green, but on Maxwell's triangle, the midpoint between blue and yellow is in the neighborhood of pale blue and pale red—in other words, it is an off-white or a gray. Helmholtz's and Maxwell's rules for mixing colored light

OPPOSITE, TOP

96.　Diagram of a spectrum of light, in Ogden N. Rood, *Modern Chromatics* (London: C. Kegan Paul and Co., 1879), 25.

OPPOSITE, BOTTOM

97.　"Two magic lanterns casting yellow and blue light on the same screen, where it forms white," in Ogden N. Rood, *Modern Chromatics* (London: C. Kegan Paul and Co., 1879), 125.

ABOVE

98.　Georges Seurat (French, 1859–1891), *A Sunday on La Grande Jatte—1884*, 1884–86. Oil on canvas, 6 ft. 9 in. x 10 ft. ³⁄₈ in. (2.1 x 3.1 m). The Art Institute of Chicago. Helen Birch Bartlett Memorial Collection, 1926.224.

	Violet.	Bleu indigo.	Bleu cyanique.	Vert bleu.	Vert.	Jaune vert.	Jaune.
Rouge.	Pourpre.	Rose foncé.	Rose blanchâtre.	Blanc.	Jaune blanchâtre.	Jaune d'or.	Orangé.
Orangé.	Rose foncé.	Rose blanchâtre.	Blanc.	Jaune blanchâtre.	Jaune.	Jaune.	
Jaune.	Rose blanchâtre.	Blanc.	Vert blanchâtre.	Vert blanchâtre.	Jaune vert.		
Jaune vert.	Blanc.	Vert blanchâtre.	Vert blanchâtre.	Vert.			
Vert.	Bleu blanchâtre.	Bleu d'eau.	Vert bleu.				
Vert bleu.	Bleu d'eau.	Bleu d'eau.					
Bleu cyanique.	Bleu indigo.						

ABOVE

99. Helmholtz's chart of mixtures of colored light, in Auguste Laugel, *L'Optique et les arts* (Paris: Germer Baillière, 1869), 150.

BELOW

100. Color triangle showing the mixture of colored light by James Clerk Maxwell, in Ogden N. Rood, *Modern Chromatics* (London: C. Kegan Paul and Co., 1879), 221.

applied both to spectral light (such as that emitted from colored "flashlights") and to reflected light (such as daylight bouncing off the surface of a painting).

Both Fénéon and Camille Pissarro attested to Seurat's interest in Maxwell's disk experiments,[5] which demonstrated how two different wavelengths of light fuse in the eye to produce the perception of a third color under certain conditions. Using an apparatus (plate 101) that rotated circular pieces of painted paper, cut so they could interlock (plate 102), Maxwell optically mixed and adjusted the resulting color. When, for example, disks of blue and yellow are spun, light waves reflected from the paper fall on the observer's retina in rapid succession, and the viewer sees gray. By adjusting the relative amount of blue or yellow paper, Maxwell could produce a yellowish gray or a bluish gray. Red and blue-green similarly mix optically to gray, its warmth or coolness again dictated by the proportions (plate 103).

Another familiar example of optical mixture is color printing, in which the colors of the original image are separated into patterns of dots on four screens, one for each of the primary hues of printer's ink (cyan [blue-green], magenta, and yellow) and black. In a color reproduction, the printed dots are large and saturated enough to reflect a brilliant point of colored light, but

small enough to remain below the threshold of individual discrimination. Early forms of mechanical color printing were introduced in France in the 1880s, and color separations began to be used the following decade.[6]

In general, optical mixture works best if the individual dots or brushstrokes are of a size appropriate to a normal viewing distance. An area of optically fused colored brushstrokes is especially effective in producing rich midtones with unsaturated colors, like flesh tones and grays. In *Grammar of Composition* (1867), a general text on technique written by the editor of the *Gazette des beaux-arts*, Charles Blanc described how Eugène Delacroix had achieved a colorful effect that was beloved by Seurat, the luminous flesh of a nude figure: "How was this miracle wrought? By the boldness with which Delacroix had slashed the naked back of this figure with a definite green, which partly neutralized by its complement rose, forms with the rose in which it is absorbed a mixed and fresh tone apparent only at a distance, in a word a *resultant* color that is called optical mixture."[7] The experience that Blanc described is typical of viewing flesh painted by a fine colorist like Peter Paul Rubens or Delacroix; from a distance the flesh appears to the viewer as a vibrant unity, but when the viewer steps up close to the canvas, a multicolored surface suddenly comes into focus. Blanc also described seeing the rich gray of a cashmere shawl that results from the optical fusion of multicolored threads. Rood stressed that optical fusion works best if the dots are close in value (all light or all dark) and saturation (all pastel or all deep shades), as in grays and beiges: "Colors which are nearly related, or separated only by a small interval, blend harmoniously into each other and produce a good effect."[8] Using pastel dots separated "only by a small interval," Seurat produced a rich, warm beige section of sky near the horizon in *Evening, Honfleur* (plate 104) and another area of greenish gray in the water below the horizon. The brushstrokes are small enough that these sections mix in the observer's eye at a viewing distance of about four to five feet. In a similar example of a close interval of dots, Seurat's fellow Neo-Impressionist Louis Hayet described his method of obtaining a "sort of brick-red or muted scarlet . . . by the optical mixture of diverse oranges, reds, and violets."[9]

Rood warned against optically mixing dots located across the pigment color wheel, that is, against trying to optically mix complementary colored pigments (red/green, blue/orange, yellow/violet) because they tend to mix optically to mud: "If colors are quite distant from each other in the chromatic circle, a rapid transition from one to the other, by blending, produces always a strange and disagreeable effect."[10] High-saturation mixed pigments like green, orange, and violet are more efficiently mixed on the palette to produce more predictable results. Indeed, green pigment must be mixed because, as Rood warned: "cobalt-blue and chrome-yellow give a white or yellowish-white, but no trace of green."[11] On his palette, Seurat mixed many shades of green paint to create the lawn in *La Grande Jatte*; nowhere did he juxtapose small dots of blue and yellow. The color violet can be fused optically from red and blue, as indicated on Helmholtz's chart, but care must be taken to avoid producing a gray. Seurat mixed violet on his palette for the background color of the skirt of the woman at right, and he painted some shadows in her skirt in dots that can optically mix to a purplish gray. Throughout the painting, Seurat used both paint that he mixed on the palette and areas of dots (mainly shadows) that can mix optically.

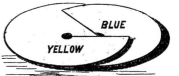

a

b

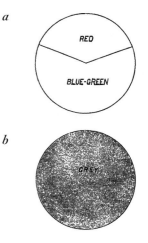

ABOVE, TOP

101.　Apparatus for rotating James Clerk Maxwell's disks, in Amédée Guillemin, *Le Monde physique* (The physical world) (Paris: L. Hachette, 1882), 2:162.

ABOVE, SECOND DOWN

102.　"Maxwell's disks," in Ogden N. Rood, *Modern Chromatics* (London: C. Kegan Paul and Co., 1879), 109.

ABOVE, BOTTOM TWO

103.　"Disk painted with vermilion and blue-green" *(a)* and "Appearance by red and blue-green disk when in rapid rotation" *(b),* in Ogden N. Rood, *Modern Chromatics* (London: C. Kegan Paul and Co., 1879), 131.

Seurat painted his dots and brushstrokes in different sizes, so they cannot all be used in optical mixture; there is no ideal viewing distance from which they all fuse. The role of some dots is to enliven a background color by simultaneous contrast, like the orange dots on the green grass in plate 105. Blanc's remarks on optical mixture indicate how aware he was that the size of the colored element determines whether the artist achieves simultaneous contrast or optical mixture. Blanc noted that large rectangles of red and green produce simultaneous contrast at their border (plate 106*a*), but narrow stripes of red and green optically fuse to gray (plate 106*b*).[12] He added that, on a cool surface, vibrancy (*éclat*, a term from Chevreul) would be achieved if it were "sown with orange spots" (plate 107), as Seurat has done on this patch of green grass (plate 105).[13] Critics have faulted Seurat for such passages, mistakenly assuming that his goal was the

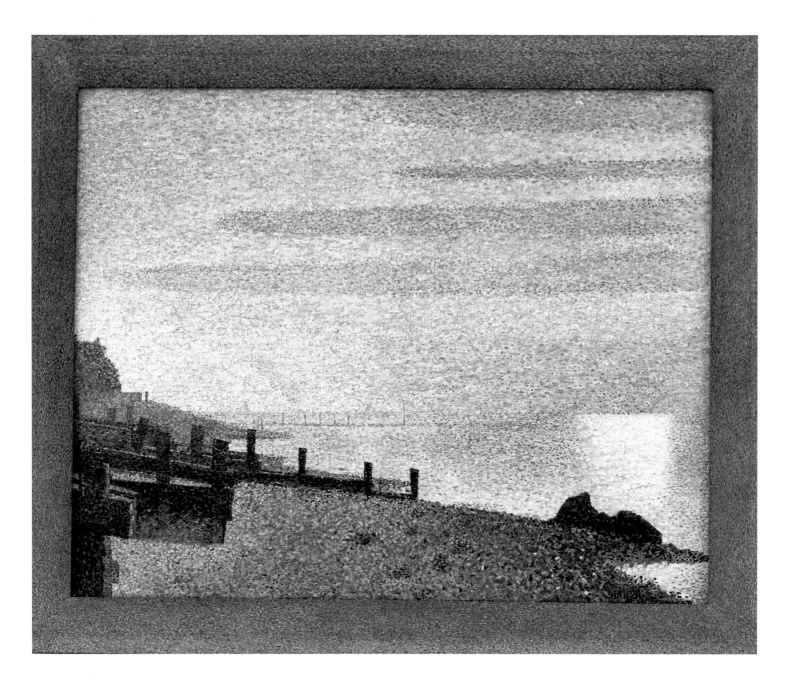

CHAPTER 5

optical fusion of every last dot. Hayet, for example, criticized Seurat for painting adjoining brushstrokes of complementary colors and thereby allegedly dulling the colors.[14] Rather than abide by any single rule of color, Seurat moved back and forth from his new method of painting with light to Chevreul's simultaneous contrast of color.

"It is known," proclaimed Fénéon in his essay "The Impressionists," that "the luminosity of optical mixture is always much greater than that of pigmentary mixture, as established by Rood in the numerous equations for luminosity."[15] Fénéon (who asked Seurat and Pissarro to review his essay before publication) refers here to an experiment for which Rood designed a set of Maxwell disks that would compare colors mixed on a palette with those mixed optically. Rood painted the center of the disk with a mixture of fifty drops of two colors, say vermilion and ultramarine blue (plate 108). Then, on the outer disk, he painted half the area with vermilion, and the other half ultramarine. When he spun the disk, he compared his perception of the mixed pigments (inner disk) with the optical mixture (outer disk). He perceived the inner disk as gray and the outer disk as red-purple. Rood then added a section of black to the outer disk, increasing it until, when spun, the outer and inner colors appeared the same. He repeated the experiment for nine pairs of colors, in each case adding and subtracting areas of color until the inner and outer disks appeared the same.

In keeping with Helmholtz's and Maxwell's studies of the differences between mixed pigment and mixed light, Rood summarized his results: "These experiments serve, then, to show that the results furnished by the palette cannot be relied on to guide us in the interpretation or study of the effects in nature depending on the mixture of colored light."[16] Earlier Rood had remarked on the large amount of black that was added to some of the outer disks, indicating that the optical mixtures were brighter. It is this that Fénéon seized on, declaring that Rood had proven the superior luminosity of optical mixture. But Rood's experiment does not establish that all optical mixtures are more luminous; it simply shows, as Rood states, that the mixtures of pigment and light differ. In general, optical mixes of colors can be more or less luminous than the corresponding pigments, depending on the mix. Rood's sample of nine pairs of colors is very small, and more than half include violet; had Rood chosen other examples, such as ultramarine blue and yellow, he would have gotten a less luminous (dull gray) optical mixture and a brighter (emerald green) mix on the palette.

One can "paint with light," then, in the following limited way. Pure primary hues can be mixed optically, but care must be taken because mixtures of light differ from mixtures of pigment. Specifically, it is possible to optically mix certain violets from red and blue, but since there is no guaranteed gain in luminosity, it is easier to mix violet on a palette, as Seurat generally did. Optical mixture is most effective in producing flesh tones, as Delacroix did, and

a

b

RAPPORTEUR ESTHÉTIQUE
DE M. CHARLES HENRY
N° 111

109. Charles Henry (French, 1859–1926), Aesthetic protractor. Printed on linen, width of base 13½ in. (34.3 cm). This protractor was inserted into a pocket in the binding of *Rapporteur esthétique* (Aesthetic protractor) (Paris: Séguin, 1888).

110. Georges Seurat, *Le Chahut*, 1889–90. Oil on canvas, 68⅝ x 56¼ in. (171.5 x 140.5 cm). Kröller-Müller Museum, Otterlo, The Netherlands.

grays for hazy atmospheres and shadows, as favored by Seurat. The mixing of these subtle tones is accomplished using not pure primary colors but a pastel (for flesh) or a dark value (for shades) of hues with reduced saturation. The resulting optical mixtures produce richer, not brighter, flesh and shadows than those painted with a uniformly mixed beige or gray, because the optical mixture has more varied components.

In addition to his researches in color, Seurat also studied experimental psychology and "Fechner's law," which were both well known in Parisian art circles of the 1880s.[17] Seurat's main source was Charles Henry, a scientific dilettante who worked as a librarian at the Sorbonne. In his book *Introduction to a Scientific Aesthetic* (1885), Henry restated Fechner's thesis: art's function is to expand and raise the viewer's consciousness through the pleasure caused by beautiful colors, lines, and forms.[18] Trained in mathematics and inclined toward mysticism, Henry adopted Fechner's association of pleasure with warm hues and upturned lines. He transformed this simple principle into his "aesthetic protractor," an arcane device that measured the angle of a line in a painting (plate 109). Henry constructed aesthetic protractors (of transparent linen, measuring about thirteen inches across) that he sold to artists along with charts associating angles with hues and moods.

Rather than determining linear angles by eye, Seurat used Henry's aesthetic protractor to design *Le Chahut* (plate 110). The main lines of the composition, such as the dancer's legs and the conductor's baton as well as his mustache, are drawn at uplifting 45-to 60-degree angles above the horizon line. The artist attributed the painting's happy mood to its warm colors and the upward tilt of its lines.[19] Henry's color wheel and aesthetic protractor were designed for his publications by his friend the painter Paul Signac, who put the tools to good use in his didactically titled *Against the Enamel of a Background Rhythmic with Beats and Angles, Tones and Tints, Portrait of Félix Fénéon* (1890; private collection). Signac posed the critic before a backdrop that fills the spiral design from a Japanese print (which were fashionable in fin de siècle Paris) with cheerful upturned forms in warm reds, oranges, and yellows, enlivened by complementary colors.[20] Fénéon celebrates the centerpiece of Henry's "scientific aesthetics"—his

color circle—by gesturing with a cyclamen (a flower whose name derives from the Greek for "circle").

Seurat's and Signac's use of experimental psychology is revealing of the mind-set of French artists. Using data supplied by Henry, the artists extracted the experimental findings (the association of lines and colors with moods) from German experimental psychology without the philosophical overview. Seurat stated that his goal in *La Chahut* was to communicate gaiety and warmth; unlike his German and Russian colleagues, he did not go on to describe happiness as a step on a road to the Absolute, or as the means to any other end. In Paris, pleasure was an end in itself.

In discussions of modern art and science, Seurat's dot paintings have often been cited as an example of either the success or the failure of the liaison. What is extraordinary is the degree to which their intent and technique have been misread. The myth about the greater luminosity of optical mixture has persisted unquestioned; indeed, many twentieth-century historians, following Fénéon, have described all Impressionist and Neo-Impressionist art in terms of it. In a popular mid-twentieth-century textbook, *The Story of Modern Art* by Sheldon Cheney, students were taught: "The impressionists discovered that they gained vividness if, instead of mixing blue and yellow on the palette, for instance, to form a green, they placed side by side on the canvas little streaks of blue and yellow, leaving it to the observer's eye to merge the two primary hues into the one derived hue, a phenomenon occurring as soon as the observer stepped back the proper distance."[21]

This myth discourages students from trusting their own eyes, and the prestige of art's association with science backfires because any student who took high school physics knows that blue and yellow light mix to produce not green but gray. The myth continues in the most recent (1996) edition of the classic textbook *Gardner's Art through the Ages*: "The juxtaposition of colors on a canvas for the eye to fuse at a distance produces a more intense hue than mixing the same colors on the palette. Although it is not strictly true that the Impressionists used only primary hues, juxtaposing them to create secondary hues (blue and yellow, for example, to create green), they did achieve remarkably brilliant effects with their characteristic short,

111. Georges Seurat, *Seated Woman with a Parasol*, 1884. Conté crayon on ivory laid paper, 18⅞ x 12⅛ in. (47.7 x 31.5 cm). The Art Institute of Chicago. Bequest of Abby Aldrich Rockefeller, 1999.7.

Seurat drew this as a study for the woman who is seated in the grass holding a parasol just to the right of center in *A Sunday on La Grande Jatte—1884* (plate 98).

choppy brushstrokes, which so accurately caught the vibrating quality of light."[22] And in the 1998 edition of H. H. Arnason and Marla F. Prather's *History of Modern Art*, the undergraduate reads: "Their techniques involved the placement of pure, unblended colors in close conjunction on the canvas and their fusion on the retina of the eye as glowing, vibrating patterns of mixed color. . . . Seurat, building on Impressionism and scientific studies of optical phenomena, constructed his canvases with an overall pattern of small, dotlike brushstrokes of generally complementary colors—red and green, violet and yellow, blue and orange."[23]

Today, as a teacher, I present Seurat's dot paintings as works in progress by an artist who understood the experimental method and was caught up in the excitement of discovery in the early days of optics. Seurat drew and painted intensely for a decade before his early death at age thirty-one, moving between pigment (à la Chevreul) and light (using optical mixture)—as well as old-fashioned chiaroscuro that has prompted comparison to Piero della Francesca.[24] Perhaps Seurat's vision of afternoon light in a Parisian park is best preserved not in his unresolved, ongoing color tests and trials but in his fully realized, masterful drawings (plate 111).[25]

BAD NEWS FROM SCIENCE: SYMBOLISM

The complex aesthetic movement of Symbolism, at its peak in France in the last decades of the nineteenth century, decried the materialistic preoccupations of the era and the implications of empirical science, such as social Darwinism. Unmoved by scientific facts, Symbolists sought access to more spiritual and psychological realms, including a bitter pessimism and morbid decadence. In 1876 Gustave Moreau painted Salomé dancing lewdly before Herod (plate 132), and within a decade the aesthetics of decadence had spread throughout the West, to England (Aubrey Beardsley), to Belgium (Fernand Khnopff), and to Scandinavia (Edvard Munch). Why not to Germany? In addition to myriad social and political factors, it is perhaps relevant that science in France was in decline in the 1870s and German science was on the rise. Scientific research and discovery are vital threads in the intellectual fabric of a nation, and if they are thin and frayed, as in late-nineteenth-century France, this diminishes the vibrancy of the creative milieu and can contribute to the kind of malaise manifest in fin de siècle Symbolism.

Psychiatric theories that associated creativity with a degenerative psychosis were also adopted in the second half of the nineteenth century, especially by the French.[26] Inspired by Pasteur's discovery of the physical cause of infectious disease, psychiatrists tried to determine the cause of mental illness by locating a physical deterioration in the brain. Seeking an explanation of mental retardation, the mid-nineteenth-century Austrian psychiatrist Benedict Morel had already suggested that a psychological characteristic, such as being melancholic, could cause a physical change in the brain (an acquired characteristic) that would be passed on to offspring, becoming more pronounced in each generation. Morel's idea that melancholy is inherited was extended to all forms of mental illness by the French psychiatrist Valentin Magnan. The Morel-Magnan theory of hereditary insanity was then used by the German psychiatrist Richard von Krafft-Ebing to give an overview of hereditary sexual pathology in his book *Sexual Psychopathology* (1886).

Meanwhile, an Italian psychiatrist, Cesare Lombroso, had begun considering heredity as a factor in criminal behavior. While working in a hospital for the criminally insane in Turin, he also restated in evolutionary terms the age-old association between artistic creativity and mental illness in his *Man of Genius* (1864), declaring that all creative thinkers suffer from a type of degenerative brain disorder. Translated into German and French, his book became well known in Paris, where Lombroso frequently visited his close friend Pierre Janet.

Janet and his teacher, Jean-Martin Charcot, developed theories about mild mental disorders—neuroses—which did not have the same stigma as insanity. In fact, being neurotic was seen as a symptom of artistic genius, and it became fashionable in Symbolist circles. After a visit to Degas's studio in 1874, Edmond de Goncourt noted in his journal: "An original fellow this Degas, sickly, neurotic, with inflammation of the eye to the extent that he is afraid he will lose his sight, but these same characteristics make him an exceptionally sensitive person who feels the subtle character of things."[27]

An artist who was afflicted with a serious mental illness of unknown origin, Vincent van Gogh, was described by the critic Albert Aurier in January 1890, six months before the artist's suicide, as creative in part because of his disorder: "[Van Gogh] is a hyperaesthete with clear symptoms who, with abnormal, perhaps even painful intensity, perceives the imperceptible and secret characteristics of lines and form, and still more those colors, lights, and nuances that are invisible to healthy eyes, the magic iridescence of shadows. . . . This robust and true artist is a thoroughbred with the brutal hands of a giant, the neuroses of an hysterical woman, and the soul of a mystic."[28]

Edvard Munch also suffered physical illness—a severe childhood bronchitis and tuberculosis.[29] The bacterial cause of tuberculosis was isolated in 1882, and there was a hygiene campaign in Oslo to clean up working-class neighborhoods where the disease thrived, but it was too late to save Munch's mother and sister. Drawn to themes of death and dying throughout his life, Munch documented the women's fatal illness in his early painting *The Sick Child* (1885–86; Nasjonalgalleriet, Oslo). During his years in Paris, 1889–92, his style crystallized under the influence of the French Symbolists, and after his return to Norway he painted *The Scream* (plate 112). Munch described his moment of inspiration for this work: "I walked one evening on a road—on one side was the town and the fjord below me. I was tired and ill— I stood looking out across the fjord—the sun was setting—the clouds were colored red like blood. I felt as though a scream went through nature—I thought I heard a scream. I painted this picture—painted the clouds as real blood. The clouds were screaming."[30] For Romantic landscape artists such as Caspar David Friedrich, clouds symbolized a divine presence and they were filled with heavenly light. For Munch, whose family had suffered so much from deadly microorganisms, nature was an unholy place filled with terror, and he associated a colorful sunset not with paradise but with a gushing wound. In the anonymous, androgynous figure on the bridge, Munch created an anguished everyman who covers his or her ears to silence the scream of nature but cannot suppress the scream from within.[31] In 1933, near the end of his long life, Munch reflected: "I was born dying. Sickness and insanity and death were the black angels that hovered over my cradle and have since followed me throughout my life."[32]

112. Edvard Munch (Norwegian, 1863–1944), *The Scream*, 1893. Tempera and pastel on cardboard, 36⅜ x 29⅜ in. (91 x 73.5 cm). Nasjonalgalleriet, Oslo.

Up to the time of Matisse, the
revolutionaries were for the
most part sincere enough. . . .
They committed suicide or
died in madhouses. . . .
With the Cubists and the
Futurists it is no longer a
matter of sincere fanaticism.
These men have seized upon
the modern engine of publicity
and are making insanity pay.

Review of the Armory Show,
New York Times,
16 March 1913

Lombroso's best-known student, the German psychiatrist Max Nordau, attacked Symbolist artists for their "moral insanity, imbecility, and dementia" in his book *Degeneration* (1892).[33] Critics of early modern art adopted diagnostic terms like "maniac" from asylum doctors to describe what they perceived as the deranged minds of abstract artists; if a painting did not depict the "real world," critics claimed that its maker was disassociated from reality, which is a symptom of psychosis.[34] In the 1930s Nordau's book provided the Nazis with the rationale for their condemnation of art other than social realism as sick, which culminated in the infamous exhibition of early modern art *Degenerate Art* that opened to savage reviews in Munich in 1937.

Another theme, entropy, also inspired dark visions in Symbolist art of the late nineteenth century.[35] German physicists had made discoveries about thermodynamics that began to come to public attention because of their ominous consequences: an evolving solar system has not only a beginning but an end.

In 1847 Helmholtz had concluded that the total amount of energy in the universe (or any closed system) is constant and can be neither created nor destroyed—the law of conservation of energy (the first law of thermodynamics; Lavoisier had established the complementary law for the conservation of mass in 1789). In 1850 another German physicist, Rudolf Clausius, pointed out that all energy is not equally useful and that in any conversion of energy some will be lost. Clausius declared that the amount of *useful* energy in the universe is slowly decreasing and that one day none will be left—the second law of thermodynamics.

Darwin's theory of evolution was optimistic—species continually improving themselves—and Lyell's approach to geology had a neutral outlook of cyclical change—mountains and valleys keep forming forever. But Lyell had assumed an eternal source of energy; Clausius proved otherwise, and he declared that one day the entropy of the universe would reach a maximum, with everything attaining the same frigid temperature:

> One hears it often said that in this world everything is a circuit. Where in one place and at one time changes take place in one particular direction, in another place and at another time changes go on in the opposite direction; so that the same conditions constantly recur, and in the long run the state of the world remains unchanged. Consequently, it is said, the world may go on in the same way forever.
>
> The second fundamental theorem of the mechanical theory of heat contradicts this view most distinctly. . . . in all the phenomena of nature the total entropy must be ever on the increase. . . . The entropy of the universe tends towards a maximum.
>
> The more the universe approaches this limiting condition in which the entropy is a maximum, the more do the occasions of further changes diminish; and supposing this condition to be at last completely attained, no further change could evermore take place, and the universe would be in a state of unchanging death.[36]

The British philosopher Herbert Spencer, who is best known for extending Darwin's views on evolution to culture (social Darwinism), brought the implications of entropy to the attention of the educated public. In *First Principles* (1862), he asked, "If evolution of every

kind is an increase in complexity of structure and function that is incidental to the universal process of equilibrium, and if equilibrium must end in complete rest, what is the fate towards which all things must tend?"[37] Even Darwin, who usually maintained his good cheer, despaired at the unavoidable answer: "[Just consider] the view now held by most physicists, namely that the Sun with all the planets will in time grow too cold for life, unless indeed some great body dashes into the Sun and thus gives it fresh life—there is a clash between 'life' and 'believing.' Believing as I do that man in the distant future will be a far more perfect creature than he now is, it is an intolerable thought that he and all other sentient beings are doomed to complete annihilation after such long-continued slow progress."[38]

The science journalist Camille Flammarion described entropy for the public in his 1881 book, *Popular Astronomy*; in a dramatic flourish he suggested that there would come a day when "the last family on Earth has been touched by the finger of Death, and soon their bones will be encased in a shroud of eternal ice" (plate 113).[39] In 1894 he went on to publish *The End of the World*, a fictionalized consideration of alternative ways that life on earth might end; after being spared from threats by comets and asteroids, the planet succumbed to entropy. Across the English Channel, the

113. "The Last Family on Earth," in Camille Flammarion, *Astronomie populaire* (Popular astronomy) (Paris: C. Marpon and E. Flammarion, 1881), 101.

unfortunate hero of H. G. Wells's *Time Machine* (1895) traveled to the future and witnessed the earth's fate: "The darkness grew apace; a cold wind began to blow in freshening gusts from the east, and the showering white flakes in the air increased in number. From the edges of the sea came a ripple and a whisper. Beyond these lifeless sounds the world was silent."[40]

Favorite fin de siècle personifications of nature were not embodiments of life like Flora, goddess of flowers, who had graced so many classical landscapes, but more ambiguous deities like Persephone (Proserpine), goddess of fertility and the bride of Hades. The Pre-Raphaelite artist Dante Gabriel Rossetti painted many versions of her (such as *Proserpine*, 1874; Tate, London), and Frederic Leighton, the longtime president of the Royal Academy, painted Persephone on her annual return from the underworld (plate 95). Escorted by Mercury, she rises toward the light, causing plants to sprout with flowers at the opening to the underworld. Greeted by her joyous mother, the earth goddess Demeter, she brings spring growth and a bountiful harvest, but she is fated to return to a dark and lifeless land.

Popular writers on entropy were quick to assure the public that the sun would still radiate for a very long time, but late-nineteenth-century audiences had a foretaste of the end in the descriptions of death by freezing published in connection with attempts to reach the North Pole. After inspiring Romantic painters of the sea such as Caspar David Friedrich (plate 4), the search for a Northwest Passage went from arctic sublime to grisly reality in the 1860s when it was confirmed that the best of the British Navy, 128 sailors under the command of the legendary John Franklin, had perished in the ice fields north of Canada. In the 1880s arctic explorers turned

114. Lucien Lévy-Dhurmer (French, 1865–1953), *Silence*, 1895. Pastel on paper, 21 x 11½ in. (54 x 29 cm). Private collection, Paris.

115. Alfred Kubin (Austrian, 1877–1959), *North Pole*, 1901. Ink on paper, 9⅝ x 13¼ in. (24 x 33.2 cm). Städtische Galerie im Lenbachhaus, Munich.

their sights to a new goal—reaching the North Pole—and the popular press carried daring yet grim expedition reports.

The Symbolist artist Lucien Lévy-Dhurmer was attracted to the land of ice, death, and silence; in shades of blue pastel suggesting a frozen landscape, he depicted a woman covering her mouth in *Silence* (plate 114). An avid reader of tales of exploration by the popular writer Pierre Loti, whom the artist met in 1895, Lévy-Dhurmer drew a naturalist struggling against the elements in *Lost Explorer* (1896; Musée du Louvre, Paris).

In Alfred Kubin's *North Pole* (plate 115), death towers over the land of glaciers and frozen seas. Kubin's bitter outlook on life (he created this piece as a wedding present) was formed during his adolescence in Austria; after his mother's death when he was ten

years old, followed by the death of his mother's sister (his stepmother) two years later, Kubin's bereaved father was morbidly cruel to him. In developing an artistic vocabulary, Kubin found in science powerful metaphors for his melancholic outlook. His view of science is symbolized by the ape striding over a reclining man who has been reduced to nature, to a mere outcropping of the hilly horizon in *Science* (plate 116). An ape has assumed intellectual superiority over mankind; trudging over the man's limp phallus and carrying a book, the beast "apes" the pose of learned reflection, such as that taken by Rodin's famous *Thinker*. In a series entitled *Lecherousness* (1901–20; Oberösterreichisches Landesmuseum, Linz, Austria), Kubin presented a grim picture of man's animal drives that Darwin's theory of evolution had exposed; dark, hairy apes leer at and brutishly devour a white-skinned Fräulein. Instincts are unleashed in *Grotesque Animal World* (plate 117), which Kubin populated with extinct prehistoric creatures, like the pterodactyls flying above, and fanciful monsters from the deep, like the central beast with pointed head and huge hoofs.

Like Munch, who also lost a young mother to disease, Kubin found no inspiration in the battles won against infectious disease but was obsessed with plagues and pestilence, creating *Cholera* (1898–99; Oberösterreichisches Landesmuseum, Linz, Austria), *Epidemic*, 1901–2, and *The Plague*, 1903–4 (both Lenbachhaus, Munich). For Kubin, as for many Symbolists, science held no promise for the future but brought only grim news about the perils of heredity, reminders of pestilence, and threats of an icy death—degeneration, disease, and entropy.

ABOVE
116. Alfred Kubin, *Science*, 1901–2. Ink, pencil, and watercolor on paper, 14 3/8 x 11 7/8 in. (36.7 x 30.1 cm). Leopold Museum—Privatstiftung, Vienna.

LEFT
117. Alfred Kubin, *Grotesque Animal World*, c. 1898. Ink, pencil, and watercolor on paper, 11 x 8 5/8 in. (27.3 x 21.7 cm). Oberösterreichisches Landesmuseum, Linz, Austria.

LOOKING INWARD:
ART AND THE HUMAN MIND

In a painter there are two things: the eye and the brain; each of them should help the other. The eye and the brain together provide the means of expression, and thus it is necessary to work toward their mutual development, in the eye by looking at nature and in the brain by the logical organization of sensations.

Paul Cézanne, 1904

THE DISCOVERY OF THE UNCONSCIOUS mind and its exploration by German Romantic artists stemmed from early-nineteenth-century studies of electricity and animal magnetism. By the 1860s, when Helmholtz was in Heidelberg performing the experiments on the eye that would be crucial to Monet, Fechner was in Leipzig achieving the first results in experimental psychology, which soon influenced Jugendstil designers, abstract painters in Germany and Russia, and Neo-Impressionists in Paris. In the decades after Impressionism a debate about the structure of the human mind—whether it is a passive recorder or an active organizer of sensations—inspired the art of Cézanne and of the Cubists, who proclaimed the power of the mind to construct a coherent picture of the world.

Meanwhile, in Vienna, Sigmund Freud was demonstrating additional organizing powers of the mind—the unconscious mind. By 1900 Freud had declared that the unconscious mind actively organizes conscious experience, and he therefore located one source of the meaning of waking experience within the unconscious mind. Schooled in the German intellectual tradition, Freud incorporated ideas from the Idealism of Kant and Fechner and from Darwin's theory of evolution in his description of man as an animal driven by unconscious forces—passion and aggression, pleasure and pain, reproduction and survival. Freud emphasized unconscious mental processes in the treatment of mental disorders, coining the term *psychoanalysis* to describe the therapy. Freud gave artists a new muse—their unconscious dreams and desires—that has inspired the modern visual arts from silent film to Surrealism to the most recent multimedia art installation.

THE ACTIVE MIND: CÉZANNE

The Impressionists' recording of light led in the late 1870s to a dissolution of form—the "crisis of Impressionism"—which prompted the reinstatement of formal structure by the Post-Impressionists in the 1880s and '90s. Why did this change occur? The usual answer is that the artists became dissatisfied with the looseness of their brushwork or the casualness of their

118. Marquis d'Hervey de St. Denys, *Les Rêves et les moyens de les diriger* (Dreams, and ways to direct them) (Paris: Amyot, 1867), frontispiece.

compositions. But why? The answer can be found in a debate about the nature of the human mind that captured the imagination of the Parisian intelligentsia: is the human mind a deterministic machine that passively collects the sensations recorded by the sense organs (as in Impressionism)? Or does the brain actively structure conscious experience by organizing those sensations (Post-Impressionism)?

In the first wave of enthusiasm for the scientific worldview—the universe as a great machine, a clockwork—in the 1860s and '70s, at a time when electrical machines such as the telegraph seemed a great marvel, physicians and the public alike came to understand the brain as an electrical machine with inputs from the sense organs that sparked sensory and motor output. In this model of the mind, the eye is a passive recorder of light, and mental functions such as sight and hearing have specific "centers" in the brain, which are the switching stations between the inputs and outputs. In 1861 this mechanical model seemed confirmed when the French neurologist Paul Broca found a speech center in the left hemisphere of the brain (still called "Broca's convolution"), damage to which causes aphasia (loss of language).

In the Impressionist era this mechanical model dominated French neurology, whose most prominent figure was Jean-Martin Charcot. Working at the state-of-the-art research center for organic brain disorders that he established in Paris, by 1870 Charcot was world famous for his own studies on aphasia. Throughout the 1870s he maintained that all mental functions have exclusively physical causes and that the eye is a passive recorder of light. This mechanistic model of the brain was so well known in the Paris art world that the critic Joris-Karl Huysmans could refer, without further elaboration, to "Dr. Charcot's experience with alternations in the perception of color" in a review of an exhibition that included Impressionist work.[1]

Monet understood the eye as a passive recorder of light; as Cézanne famously said: "He's only an eye. But what an eye!" Monet's work evolved, but he never changed his understanding of the eye: "When you go out to paint, try to forget what you have before you, a tree, a house, a field or whatever. Merely think, here is a little square of blue, here an oblong of pink, here a streak of yellow, and paint it just as it looks to you, the exact color and shape, until it gives your own naïve impression of the scene before you." He went so far as to tell a young artist that he "wished he had been born blind and had suddenly gained his sight" so that he could paint "without knowing what the objects were that he saw before him."[2]

When the volumes of Helmholtz's *Handbook* appeared between 1856 and 1867, adherents to the deterministic electrical-machine model of the brain, such as Charcot and Taine, hailed the physiologist for explaining the mechanism of the eye. But Helmholtz disagreed profoundly with their static model and proclaimed that the brain is active in structuring vision. Having been educated in German Idealism, Helmholtz believed that the brain's structure had been described by Kant when he identified the spatial and temporal preconditions of experience (the mental frameworks into which the mind organizes its sensation of the world). Helmholtz determined to anchor in the human body Kant's theory of human knowledge. In doing this, Helmholtz subtly transformed the philosopher's system into a new, scientific view of cognition—the physiology of perception. Kant had described sensations as reflecting the real properties of objects in the world, but Helmholtz shifted the emphasis to the body's sense organs and described vision as a lifelong learning process in which the mind continually

constructs the world from visual signs. Kant had assumed that the spatial precondition of experience was described by Euclidean geometry, but Helmholtz declared that geometry is learned from experience and that, yes, Euclid's rules are most convenient for earthlings but there is nothing unthinkable about a non-Euclidean outlook.[3]

Helmholtz and several of his contemporaries also sought to assess the implications of Darwin's theory of evolution for the new models of the human mind. In the 1870s the English neurologist John Hughlings Jackson suggested that the structure of the brain and nervous system reflects the course of evolution, with the lower (hence earlier) spinal cord and brain stem controlling reflexes, the midsection controlling more complex motor functions, and the most recently evolved cerebral cortex being the seat of the intellect. He argued that, far from having simple in-out wiring, the brain is a dynamic, complex, multilayered structure that is active in organizing perception. In the 1870s and '80s the Russian evolutionary biologist Alexander O. Kovalevsky pointed out that as the embryo grows, the eye develops from the brain. The eye appears first as a bulge in the layer of brain cells, and as it slowly separates to form the eye, it pulls with it the neural fibers that become the optic nerve. Haeckel, who based much of his work on that by his Russian colleague, brought this information about the inseparability of the eye and the brain to the public's attention through his popular illustrations, variations of which were well known in France (plate 119).

This new organic, evolutionary view of the eye and brain as together constructing a picture of the world captured the imagination of the most reflective, theoretically inclined Post-Impressionist—Paul Cézanne.[4] Like Helmholtz, Jackson, and Haeckel, the artist realized that painting nature involved a much more complicated mental process than recording light. Ultimately vision arises from the relation between sensations of light and the dynamic action of the brain; as Helmholtz famously said, "Perception is an act of judgment." In a 1904 conversation with Emile Bernard, Cézanne stated that the painter sees nature with his eyes, but that his brain logically organizes the sensations into a perception.[5] When Cézanne set up his easel to paint *Mont Sainte-Victoire* (plate 120), his goal was not only to record the light reflected from the daylit scene but also to reorganize his perception of light in order to mentally structure the scene to "deal with nature as cylinders, spheres, and cones."[6] From the Impressionists, Cézanne

119. Diagram showing the development of the eye from the brain, in (from left to right) human, chicken, turtle, and fish embryo, in Camille Flammarion, *Le Monde avant la création de l'homme* (The world before the creation of man) (Paris: Flammarion, 1886), 24, fig. 10.

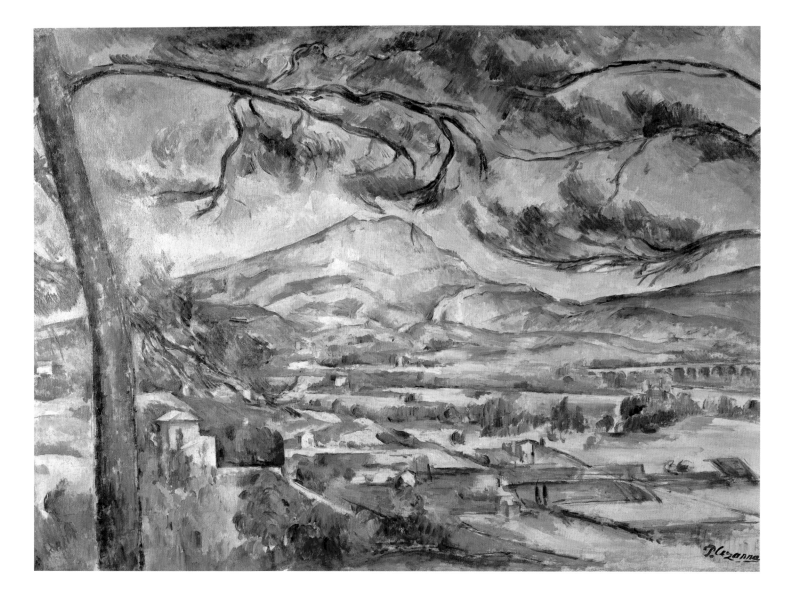

120. Paul Cézanne (French, 1839–1906), *Mont Sainte-Victoire,* c. 1887. Oil on canvas, 26 x 35⅜ in. (66 x 89.3 cm). The Courtauld Institute Gallery, Somerset House, London.

121. Paul Cézanne, *Mont Sainte-Victoire,* 1902–4. Oil on canvas, 27½ x 35¼ in. (69.8 x 89.5 cm). Philadelphia Museum of Art. The George W. Elkins Collection.

inherited the opaque picture plane on which to record his experience of color and form. In clean, planar brushstrokes he painted not cylinders, spheres, and cones frozen in a timeless Euclidean space but volumes in a lived space seen in glimpses, in changing light, from different angles, in and out of focus. Cézanne did for form what Monet had done for color; he rendered his subjective perception of the structure of the natural world in fluctuating, shifting, tilting planes. In *Mont Sainte-Victoire* he arranged the branches of the framing tree to follow the profile of the mountain, thus fusing the foreground and background space into an aesthetic whole. In a self-conscious emulation of the brain's construction of the perception of nature from retinal sensations, Cézanne achieved a "logical organization of sensations" through the cooperation of the painter's eye and brain.

In his late paintings of Mont Sainte-Victoire, Cézanne tipped the scale away from observation and analysis of sensation toward a mental construction—an abstraction—that is only tangentially related to vision. *Mont Sainte-Victoire* (plate 121) is less built up from sensations than created by imagination. Cézanne's many paintings of Mont Sainte-Victoire present a range of

CHAPTER 6

cognition, from analysis of geometric form, as in the earlier example (plate 120), to a free play of the imagination that is less constrained by visual sensations (plate 121). In the conclusion to his essay *On the Relation of Optics to Painting,* Helmholtz described art in words that apply very well to Cézanne: "The specific elements of artistic technique to which investigation in physiological optics has led us are closely related to the highest goals of art. Indeed, we may perhaps entertain the thought that even the ultimate mystery of artistic beauty—that is, the wonderful pleasure we feel in its presence—is really based upon a sense of the smooth, harmonious, and vivid current of our ideas which, in spite of many changes, flows toward a common point and brings to light laws hitherto concealed, allowing us to gaze into the deepest recesses of our own nature."[7]

Although Cézanne preferred to work uninterrupted and in relative isolation in the south of France, he certainly would have been aware of debates about the brain that swirled through Paris from the mid-1880s. Charcot, in a startling reversal for an established scientist

To read nature is to see her as if through a veil that transforms her into patches of color arranged according to a law of harmony. The major hues are thus broken down into modulations. To paint is to record one's sensations of color.

Paul Cézanne, 1904

in midcareer, presented a paper in 1882 to the Académie des Sciences declaring that not only physical but also psychological causes produce mental events, and he proclaimed that they could be investigated using the forbidden technique of hypnotism. Although it had been repudiated by French physicians since the days of mesmerism (see chap. 1), hypnosis was immediately adopted as a viable therapeutic tool once it received Charcot's endorsement. From 1884, when the renowned neurologist married a rich widow, until his death in 1893, he held weekly soirées at their lavish apartment, which were attended by scientists, artists, and writers. Edmond de Goncourt repeatedly lampooned the pomposity of these evenings, but he did not miss them.[8] Charcot also gave dramatic weekly public lectures on the human mind and brain; his demonstrations of hypnosis made him the talk of Paris during 1884–93, and French intellectuals nicknamed him the "Napoleon of Neurosis."

By the time Cézanne died in 1906, the exciting first era of physiology and neurology was over. After Charcot's death certain younger physicians, bitterly opposed to hypnotism, seized control of French psychiatry and moved quickly to purge it of research into unconscious phenomena. After Helmholtz's death in 1894, his fertile mix of physiology, psychology, and philosophy was lost as these fields narrowed their focus and began producing twentieth-century specialists in clinical psychology, psychoanalysis, and symbolic logic. But before the cultural impact of specialization was felt, there was one last manifestation of the grand nineteenth-century quest to understand human cognition—Cubism.

VISION AND MIMESIS: CUBISM

When, for instance, by apprehension of the manifold of a house I make the empirical intuition of it into a perception, the necessary unity of space and of outer sensible intuition in general lies at the basis of my apprehension, and I draw as it were the outline of the house in conformity with this synthetic unity of the manifold in space.

Immanuel Kant,
Critique of Pure Reason, 1781

A posthumous exhibition of fifty-six works honored Cézanne at the Salon d'Automne in 1907. Georges Braque and Pablo Picasso—who as young artists had separately experimented with various modes of Neo-Impressionism, Symbolism, and Fauvism—were so inspired by what they saw that for five years they worked together to extend Cézanne's vision. Their intense collaboration ended with the outbreak of World War I. In 1908 Braque adopted Cézanne's method of recording his concept of the underlying form of the landscape, as in his *Houses at L'Estaque* (plate 122), which prompted the term Cubism. The artists quickly moved to composing freely with successive glimpses of forms and tilted planes, breaking the contours of objects and constructing with fluctuating marks in a shallow space that hovers in front of an opaque picture plane. By 1910, in work such as the portrait of the dealer Daniel-Henry Kahnweiler (Art Institute of Chicago), Picasso barely retained the appearance of the sitter, hovering on the edge of abstraction—as Cézanne had done in his late work.

Braque and Picasso wrote no statements about their work during the Cubist era. However, in 1912 two artists in their circle, Albert Gleizes and Jean Metzinger, described the Cubist approach as trying to capture the artist's subjective experience of space by "moving around an object so as to record successive views of it which, when combined in a single image, reconstitute it in time."[9] Treatises on Cubism written after the war by Kahnweiler and the writer Maurice Raynal also supported a reading of the style in terms of the nineteenth-century theories of cognition inherited from Cézanne. Raynal and Kahnweiler even introduced Kant's

terms "analytic" and "synthetic" to describe Cubist techniques. Kant had defined the terms to describe two types of judgments. An analytic judgment is one in which the predicate is contained within the subject (such as "One and one equals two"); it is verified by simply analyzing the concepts. In a synthetic judgment, which puts together (synthesizes) unrelated ideas (such as "There are two rivers in the town of Königsberg"), the predicate concept is not contained in the subject.

In *Some Intentions of Cubism* (1919), Raynal related the Cubists' method of reducing perceived objects to geometric forms to the mind's ordering of sensations: "Helmholtz . . . had shown us that each sense organ only records particular sensations [patterns of nerve impulses]. As Kant said: 'The senses give us only the material of knowledge, while understanding gives us the form.' This Idealist conception, which has been so fertile for art and poetry, is the traditional basis of great art and most modernists concur with it."[10] Kahnweiler, a well-educated German, wrote similarly in *The Way to Cubism* (1920): "Now Cubism . . . depicts objects in the world as close as possible to their 'primary forms.' . . . The unconscious work that we must do to recognize the structure underlying an object in order to conceive an exact picture of it in our mind is simplified for us by the Cubist painting because it puts the

object before our eyes in its basic form."[11] Then, invoking Kant's distinction between analytic and synthetic judgments, Kahnweiler summarized the Cubist vocabulary and technique: "In order to give a thorough analysis of an object's 'primary' characteristics, [the Cubist can] show it as a stereometric drawing or combine several views of the same object, which the viewer's consciousness then fuses into [the perception of] an object. . . . Instead of only an analytic description, the artists can also create a synthesis of the object, that is, according to Kant, 'to add the different representations of the ones to the others, and seize their multiplicity in a moment of knowledge.'"[12]

122. Georges Braque (French, 1882–1963), *Houses at L'Estaque*, 1908. Oil on canvas, 29¼ x 26⅛ in. (73 x 59 cm). Fondation RUPF, Bern Kunstmuseum, Bern.

Thus Braque and Picasso, who were joined in 1911 by the Spanish artist Juan Gris, continued Cézanne's exploration of cognition in the spirit of Kant. If their work had done only this Cubism would not warrant its position as a pivotal moment in modern art. However, these artists not only adopted Cézanne's mission but, once they reached the brink of nonrepresentation in 1911, they also asked anew the central question of nineteenth-century physiologists,

which had been asked by philosophers since Plato: How does a person know the world? And in their work between 1911 and 1914 they gave a fresh answer.

During the years that Cubism was developing, many in the avant-garde were moving toward abstract art, for the complex reasons we are tracing. Other artists, such as those of Jugendstil, Der Blaue Reiter, and Orphism, were struggling to rid their art of the last vestiges of mimesis in order to attain the goal of a pure, spiritual, absolute art. But Braque, Picasso, and Gris were heirs to an art of observation. They were exploring the mind's symbolic construction of the world—the perception of objects—and thus in 1911 when they reached the brink of total abstraction it was not like attaining the Absolute Spirit but like losing their vision. Monet had fantasized about being born blind and being able to see afresh when his sight was restored. Cubist work from 1911 indicates that something like that happened to these artists; they had a brush with total abstraction (blindness), and it gave them new insight into the visual representation of the world.

How does a person know the world? The mind constructs an image of the world in a way that parallels how an artist creates a picture of it, by means of a multitude of signs and symbols that create illusions of reality. In Gris's *The Table* (plate 124) the newspaper text reads, "le vrai et le faux" (the true and the false), and at the base of the oval, an actual "true" page of a book is shaded by the artist to merge with his depicted "false" book. Gris's *The Table* is a self-conscious absorption with mimesis—a picture about a mental picture of the world. And as vision is prey to optical illusions, so the artist's pictures can deceive; Braque and Gris suggest that the magic of vision and visual art lies in the interplay of illusion and reality. Picasso's *Card Player* (plate 125) is a catalogue of the artist's toolbox—collaged wallpaper, newspaper, playing cards, charcoal drawings, paper silhouettes, pencil sketches—but on closer inspection, it's all an illusion, all puns cleverly created in oil paint. In Braque's *Still Life with Tenora* (plate 123), the newspaper headline declares "l'echo"; the drawn clarinet depicts—is an echo of—the real musical instrument.

In a move aimed at simplifying Kant's several kinds of judgments, Helmholtz had declared that there is only one cognitive process—man's lifelong attempt to construct a

meaningful world picture not only from his sensations but also from his emotions, fantasies, intuitions, deductions, unconscious inferences, and memories. In defining cognition as a symbolic construction of reality, Helmholtz launched the modern search for general theories of signs and symbols to account for human understanding. The Cubist art of Braque, Picasso, and Gris is part of the bedrock of modern art—along with the art of Cézanne—because it is an early artistic expression of the construction of the world from signs and symbols, both by the perceiver and by the artist.[13]

Raynal and Kahnweiler had used the Kantian terms *analytic* and *synthetic* to describe the process of creating a Cubist painting; first the artist analyzed the still life, model, or landscape into primary elements and then reassembled the parts into a new whole. But by the 1930s, with

the advantage of hindsight, Alfred Barr saw that there were two distinct stages of the style and he adopted the terms to name them—Analytic Cubism and Synthetic Cubism; historians have used them ever since.[14] Though somewhat accidental, it still seems fitting that Braque's, Picasso's, and Gris's reflections on a highly philosophical topic—the analogy of cognition and mimesis—should be named with terms first proposed by the founder of German Idealism.

Thus Cubism was understood by those closest to it, from its earliest days in Paris, in terms of topics associated with the late-nineteenth-century physiology of perception. Because Cubism was contemporary with another great revolution in science—Einstein's special theory of relativity (1905)—many historians have speculated that Cubism was influenced by the new physics, or at least that the art and the science express a common world picture. This is incorrect for several reasons: Einstein's theory was unknown to the educated public in prewar Paris because it had not been proven experimentally.[15] When relativity was dramatically confirmed by an observation made during a solar eclipse in 1919 that made headlines around the globe (see chap. 9), Braque and Picasso showed no interest in it because the theory of relativity is irrelevant to the depiction of the earthly objects (landscapes, still lifes, and models) that were the subject matter of Cubist art. Relativity is also irrelevant to the topic of cognition, which was at the core of Cubism. Gris did express an interest in the implications of the theory of relativity—he wrote in a 1922 letter to Raynal that he was studying Einstein's cosmology—but, weakened by prolonged illness, he did not pursue it (Gris died in 1927).[16]

Historians have mistakenly connected Cubism and relativity because there were three scientific revolutions in space and time—one in physiology, one in physics, and one in psychology—and writers have mixed them up. In chapter 3 and in this chapter I have described the first, in which Helmholtz extended Darwin's evolutionary biology to the physiology of perception—from objective space to subjective space—that led artists to abandon Renaissance perspective with its stationary viewpoint and to treat the picture plane as an opaque surface on which to record their subjective experience of color and form as they move through the world. This change to subjective space led to the flickering colors and fluctuating planes suggesting movement that are referred to as "simultaneity" in late-nineteenth- and early-twentieth-century painting.[17] This opaque picture plane of the Impressionists, Cézanne, and the Cubists is the earliest of three modern symbolic forms—"physiological perspective."

Einstein brought about the second revolution in space and time—from earthly space to universal space—which led artists after 1919 to create the second modern symbolic form: "cosmic perspective." Artists in the 1920s addressed Einstein's expansion of the concept of the physical world to include the subatomic realm and outer space by introducing the dimension of time into their paintings and sculpture (kinetic art), by blurring the distinction between matter and energy (architectural glass towers of light), and by considering the relative position of the viewer in the artwork (installation art; for all these topics see chaps. 9–11). With the publication of *The Interpretation of Dreams* in 1900, Freud began the third revolution, from conscious to unconscious space and time. This led artists in the 1920s and '30s to create the third modern symbolic form—"psychological perspective"—by painting their dreams (see chap. 11).

The mistaken association of Cubism with "cosmic perspective" began right after relativity was brought to public attention in 1919. During the development of Cubism (1907–14) writers had associated the style with many scientific developments that were part of the complex matrix out of which Einstein forged his revolution. For example, Gleizes and Metzinger referred to non-Euclidean geometries in their book *About Cubism* (1912), as did Alexandre Mercereau, who was active in bringing the new art to Eastern Europe, in the introduction to a catalogue of a Cubist exhibition in Prague in 1914.[18] Also known in the Cubist circle were speculations by the French mathematician Henri Poincaré about the relativity of space and time, which were precursors to Einstein's theory of relativity.[19] But these were all nineteenth-century ideas awaiting a new synthesis, and there is no evidence whatsoever that any of the Cubists were aware that an obscure young German physicist had accomplished this in 1905. Nonetheless, as soon as the theory was confirmed in 1919, writers linked Cubism to relativity. The earliest example that I know is the Czech art historian Vincenc Kramár, who was familiar with Mercereau's writing on Cubism and formed an excellent collection of Cubist paintings during his trips to Paris in the prewar years, where he was a regular client at Kahnweiler's gallery. After the 1919 eclipse, Kramár, who may have been proud that Einstein had been a lecturer at Prague's German university for three semesters in 1911–12, made the link between Cubism and Einstein's new concept of the cosmos in his book *Cubism* (1921). He referred to the essential relationship of the new art to "the transformation of our idea of the world, as reflected in Einstein's theory and in the studies of the fourth dimension."[20]

In his famous 1925–26 essay on "symbolic form," Panofsky did not mention Cubism but noted (correctly) that artists in the 1920s were beginning to respond to Einstein's space-time; Panofsky referred specifically to El Lissitzky's recent publication describing his kinetic paintings as expressions of space-time ("A. and Pangeometry" [1925]; see chap. 10).[21] Other art historians referred to a connection between Cubism and relativity in the decades that followed, the best known being Sigfried Giedion in his book *Space, Time, and Architecture* (1941), in which he wrote, "Cubism breaks with Renaissance perspective. It views the object relatively: that is, from several points of view, no one of which has exclusive authority."[22] In 1946 Einstein himself stated, in response to the draft of an essay with a similar thesis sent to him by the art historian Paul M. Laporte, that such connections of Cubism and relativity were based on a misunderstanding of the implications of his theory. "For the description of a state of affairs [*Sachverhaltes*] one uses almost always a *single* coordinate system. . . . This is quite different in the case of Picasso's painting. . . . This new artistic 'language' has nothing in common with the Theory of Relativity."[23] But Laporte was undeterred and published his essay in 1948; then in 1953 Panofsky wrote similarly in reference to a diagram of quattrocento linear perspective, "This construction . . . formalizes a conception of space which, in spite of all changes, underlies all postmedieval art up to, say, the *Demoiselles d'Avignon* by Picasso (1907), just as it underlies all postmedieval physics up to Einstein's theory of relativity (1905). . . . It was only with Picasso, and with his more or less avowed followers, that an attempt was made to open up the fourth dimension of time so that objects ceased to be determinable by three coordinates alone and can present themselves in any number of aspects and in all states of either 'becoming' or disintegrating."[24] With Panofsky's immense authority behind the connection of Cubism to

relativity, it became engraved into the master narrative of modern art. By 1975 the art historian Samuel J. Edgerton could write, "The [spatial] paradigm of the Renaissance, in turn, ended with Einstein's special theory of relativity. . . . And today? It is widely agreed that Cubism and its derivative forms in modern art are in the same way the proper pictorial means for representing the 'truth' of the post-Einsteinian paradigm."[25] But an authority of stature equal to Panofsky's, Meyer Schapiro, presented overwhelming evidence against any connection between Cubism and relativity in an essay written in the late 1970s (published posthumously in 2000).[26]

It is remarkable that, although there is not one scrap of historical evidence for a connection between Cubism during 1907–14 and Einstein's theory, historians continue to affirm the connection to this day. We read in the historian William R. Everdell's book *The First Moderns* (1997), "In the *Demoiselles d'Avignon* . . . Picasso had done for art in 1907 almost exactly what Einstein had done for physics"; and in the science historian Arthur I. Miller's *Einstein, Picasso* (2001), "The treatment of time in *Les Demoiselles d'Avignon* is quite complex. . . . Einstein's temporal simultaneity shares with Picasso's the notion that there is no single preferred view of events."[27] Such speculation weakens the interdisciplinary bond between art and science that these historians seek to forge because the historical evidence points to the connection of Cubism not to Einstein's physics but to the first revolution in space and time—the shift from objective to subjective space that was brought about by Helmholtz's physiology of perception.

Dynamic Psychology: Charcot and Freud

For many, the expression of emotions—grief, anxiety, devotion, joy, and love—remained a dividing line between humans and lower animals. In *The Expression of the Emotion in Man and Animals* (1872) Darwin set about to erase the line by conducting a series of experiments in which he correlated human emotions, such as terror and pleasure, with the movement of facial muscles and the emission of sounds. As evidence that particular emotions were expressed by the contraction of specific muscles, Darwin illustrated his book with drawings and photographs comparing humans in various emotional states (plate 126). Darwin then argued that lower mammals use the same facial muscles and sounds to express terror as well as more pleasant emotions (plate 127). In late-nineteenth-century Germany, Austria, and Russia, neurologists and psychologists soon extended Darwin's view of emotions to all human behavior, and by 1900 Freud was describing man as an animal driven by instinctual passions to reproduce and by aggressions to survive.

Meanwhile asylum doctors throughout the West were developing another key component of modern views of the psyche—the nervous disorder with a nonmaterial, psychological cause—which came to be called a "dynamic" illness in the 1880s, to distinguish it from an organic disorder. In France, Charcot maintained that, ultimately, every mental event has a physical cause, although he readily admitted that neurology had not progressed to the point where researchers could always discover it. But he was confident that point would someday be reached, and he established a laboratory of physiological psychology at the Salpêtrière, a hospital in Paris. At his death Charcot left the facility in the hands of his trusted disciple, Pierre

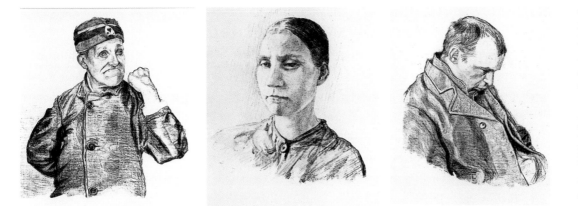

Janet, an expert in pathological forms of psychological automatism (behavior, such as babbling, that is done without deliberation). The opposite position—that there are purely psychological causes of nervous disorders, with no organic manifestation—was argued by Charcot's rival, Hippolyte Bernheim.

In 1873 two physicians, William Gull in England and E. C. Lasègue in France, had first described a syndrome in which healthy young women would limit themselves to dangerously low levels of sustenance in order to achieve a kind of spiritual purity—anorexia nervosa. In Vienna in 1880 Josef Breuer treated a patient, Anna O., who had bizarre symptoms (she could speak English, but not her native language; although she was overcome with thirst, she could not put a glass of water to her lips). The patient found that under hypnosis she could articulate the cause of her distress, thus dissipating her symptoms; Anna O. called it "the talking

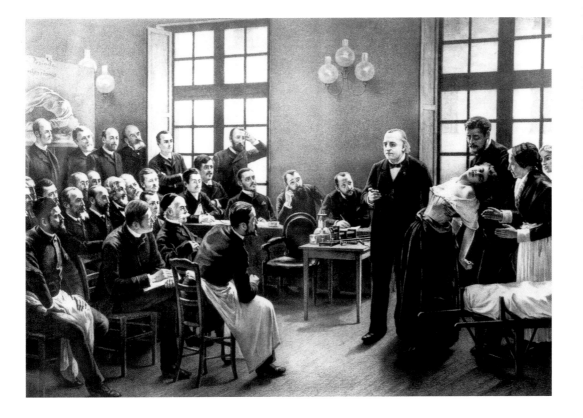

OPPOSITE, TOP TWO

126. Terrified men, in Charles Darwin, *The Expression of the Emotion in Man and Animals* (1872; American edition, New York: D. Appleton and Co., 1873), opp. 300.

In the text accompanying this photograph of a terrified man *(above)*, Darwin explained that the man's platysma muscle (extending from the collarbones to the lower cheeks) is contracted in terror, drawing the corners of the mouth and the lower part of the cheeks downward and backward. Darwin was interested in the research of the French neurologist Duchenne de Boulogne, who produced the same expression by electrically stimulating the neck muscle, as well as the brow *(below)*. Thus Darwin borrowed for his book the photograph of the second (artificially) terrified man from Duchenne de Boulogne's classic *Mechanism of Human Facial Expression* (1862).

OPPOSITE, BOTTOM TWO

127. Placid and pleased ape, in Charles Darwin, *The Expression of the Emotion in Man and Animals* (1872; American edition, New York: D. Appleton and Co., 1873), 136.

ABOVE

128. "Mania," "Melancholia," and "Dementia," lithographs after photographs, in Allan MacLane Hamilton, *Types of Insanity* (New York, 1883).

LEFT

129. Jean-Martin Charcot giving a clinical lesson at the Salpêtrière (1887), lithograph by André Brouillet. Freud Museum, London.

cure." Breuer was joined in her treatment by his younger colleague, Sigmund Freud, and in 1893–95 they copublished the case history in "Studies on Hysteria."[28]

In the late nineteenth century the impact of dynamic psychology can be seen in some presentations of the psyche in the visual arts. However, unlike Helmholtz's research on visual perception, the hypotheses of Charcot and others about automatism, hysteria, and anorexia were not popularized in books and magazines. The topic of insanity was so stigmatized that publishers did not consider it to be suitable reading for the educated public. Thus there was only general knowledge among Symbolist artists about changing ideas of mental illness;[29] however, from the scattered references to it in the art world, it is clear that artists and critics shared with asylum doctors the belief that madness is manifest in the deranged person's outward appearance.

Throughout the nineteenth century, doctors—from Carus to Charcot—believed that mental states were evident in the face and body, and they used illustrated medical manuals to diagnose the three main categories of illness—mania, melancholia, and dementia—by comparing the appearance and behavior of their patients to standard types (plate 128).[30] The maniac shakes his fist in rage, the melancholic woman slumps passively with downcast eyes, and the demented man appears disassociated from reality. The American artist Thomas Eakins may have modeled his haunting portrayal of an anonymous woman, *Retrospection* (plate 130), on a drawing of a melancholic patient (plate 131) at Pennsylvania Hospital in Philadelphia. The drawing was in a sketchbook commissioned in the 1820s by the physician J. K. Mitchell; his son, S. Weir Mitchell, America's leading expert on hysteria and also Eakins's physician, had lent it to the artist.[31] Eakins's figure has the telltale slouch and lowered eyes of a withdrawn melancholic, and he emphasizes her dark mood by painting her face in shadow.

After the new illness hysteria was defined, Charcot continued the practice of making diagnoses based on the patient's appearance, and he was known for presenting the hysteric's symptoms in a theatrical teaching style (plate 129). To record hysterical behavior, especially the convulsive (grand mal) seizure, he established a laboratory for time-lapse photography at the Salpêtrière in 1883,[32] and published the pictures in his renowned *Iconographic Journal of the Salpêtrière*. In the 1880s the art critic Joris-Karl Huysmans was familiar enough with the concept of hysteria to diagnose the figure of Salomé in Gustave Moreau's *The Apparition* (plate 132), describing her as "the goddess of immortal Hysteria, accursed Beauty exalted above all other beauties by the catalepsy that hardens her flesh and steels her muscles."[33] The alluring, deadly woman—the femme fatale—was a popular Symbolist theme, and Moreau painted several episodes from the biblical story of Herod and Saint John the Baptist, whose decapitated head is the grisly apparition that has, according to Huysmans, brought on the dancer's catalepsy. (Catalepsy is a muscular rigidity caused by a shock to the nerves; the afflicted person suddenly stops in his or her tracks.) The critic's suggestion that a beautiful, evil woman embodies hysteria is in keeping with attitudes commonly expressed in fin de siècle medical literature.[34] Hysterical women were not sick but spoiled; according to S. Weir Mitchell, they were "the pests of many households, who constitute the despair of physicians."[35] The attitude is expressed in the portrait of Charcot (plate 129); looking more seductive than sick, the hysteric's dress slips off her shoulders during her convulsion, exposing her young breast—the femme fatale of the Salpêtrière meets the Napoleon of Neurosis.

In addition to Moreau's Salomé, young women with bizarre symptoms—the stereotype of a hysteric—made frequent appearances in Symbolist art, such as Fernand Khnopff's woman as tigress in *Art/The Caress/The Sphinx* (1896; Musée d'Art Moderne, Brussels). This mutant cat-woman has her tail raised for sex with the man she paws, yet she's also on her haunches ready to pounce on him. In *Madonna* (1894–95; Nasjonalgalleriet, Oslo), Edvard Munch desecrated the Virgin by depicting her as a seductress; surrounding her are both sperm cells and the skeletal remains of a fetus, suggesting she is both the giver and taker of life.

Charcot and the Symbolists were some of the last to believe that the condition of a person's psyche was visible in his or her appearance. By 1900 two conceptual shifts were occurring in dynamic psychology that would lead twentieth-century artists to stop depicting the facades of their subjects and to look inward instead, inventing new symbols for the subjective experience of the self. First, as confidence was fading that the brain (understood as an electrical machine) could be known down to its last wire, there was a growing awareness among scientists that the mind (understood as a dynamic organism) was continually changing and could be known only incompletely. Just as Helmholtz and Monet had stressed that the perception of objects in the world was due to an ever-changing flutter of nerve impulses and sensations, so neurologists pointed out that the same could be said of the perception of the self when one looks inward. Fechner had already described conscious feelings of pleasure and pain in terms of nerve impulses, and other scientists did the same for unconscious experiences such as dreams. For example, the marquis d'Hervey de St. Denys hypothesized that the pictures one sees in nocturnal dreams (plate 118, top), result from abstract patterns caused by afterimages and from specks in the fluid in the eyeball, especially noticeable right after one closes the eyes (plate 118, bottom).[36]

Freud, who spent the first twenty years of his career in a neurology laboratory, noted d'Hervey's idea with approval in the introduction to his own 1900 study of dreams. Trained in the Helmholtz school of physiology and neurology, of which his teacher Ernst Brücke was a prominent member, Freud wanted to do for the unconscious mind what Helmholtz had done for vision and hearing, that is, to ground dynamic psychology in a neurological framework. Toward that end in 1895 he described his vision for the merger of psychology and natural science in his "Project for a Scientific Psychology," but by 1900 he had abandoned it because there was so little known about the central nervous system.

After abandoning neurology, Freud tried to describe the elusive, ever-changing workings of the mind from a psychological point of view. He described the unconscious mind as operating below conscious awareness, reorganizing sensory inputs and memories into new symbolic associations that emerge into consciousness as fresh ideas. In this same spirit of trying to unlock the mysteries of the psyche (the mirror of the soul), Max Klinger posed a nude man before a mirror (plate 133), but his brightly lit reflection on the left looks more real. Which is real? The real man meets his illusion where the two images touch. And where is that? They meet in the dream of the woman sleeping below. And what does her dream mean? Such questions posed by Freud and the Symbolists came to dominate the modern search for the psyche.

A second change in fin de siècle dynamic psychology that directed visual artists away from depicting an individual's facade was Freud's shift away from Charcot's method of diagnosing patients by looking at them to his therapy by listening—the talking cure. There are galleries

132. Gustave Moreau (French, 1826–1898), *The Apparition*, 1876. Oil on canvas, 56¾ x 41¼ in. (142 x 103 cm). Musée Gustave Moreau, Paris.

of pictures of Charcot's hysterics, but Breuer and Freud's case history of Anna O. is not illustrated. At first Breuer and Freud used hypnosis to aid their patients in retrieving memories, but Freud found that his patients could recall their past by the free association of words and ideas. Soon patient and therapist did not even look at each other during therapy; the patient free-associated while relaxing on a couch, and the therapist took notes sitting behind the patient, out of sight. Illustrated diagnostic manuals became a thing of the past and diagnosis by case history—a written record of thoughts, fantasies, and desires—the norm. The Symbolists Moreau and Khnopff made imaginative pictures of the femme fatale, but after Freud twentieth-century Surrealists would symbolize her invisible, unconscious interior.

By 1900 brain science had split into two very different approaches to diagnosis and treatment—physical (chemical and neurological, with hospital care for the severely deranged) and psychological (outpatient therapy for the mildly neurotic); the rejoining of these divergent paths did not begin until after World War II (see chap. 13). Charcot's investigations of the unconscious mind had been an unusually speculative and theoretical tendency in French medicine. Charcot's successor tolerated dynamic approaches, but after his death in 1910 the organic psychiatrists closed Janet's laboratory, and for several generations French mental hospitals diagnosed and treated only organic (chemical and neurological) disorders—psychoses. Outpatient care of dynamic disorders with a psychological cause—neuroses—was undertaken by the new field of psychoanalysis, which grew rapidly in Austria, Germany, Britain, and America after Freud published the founding text of modern psychology, *The Interpretation of Dreams* (1900). In France, interest in Charcot's and Janet's work was revived after World War I, and in the 1920s the Viennese doctor of the soul became the talk of Parisian cafés, setting the stage for Surrealism.

133. Max Klinger (German, 1857–1920), *The Philosopher*, 1885–1900. Etching and aquatint, 19¾ x 13¼ in. (49.4 x 33.1 cm). Museum der Bildenden Künste, Leipzig, Germany.

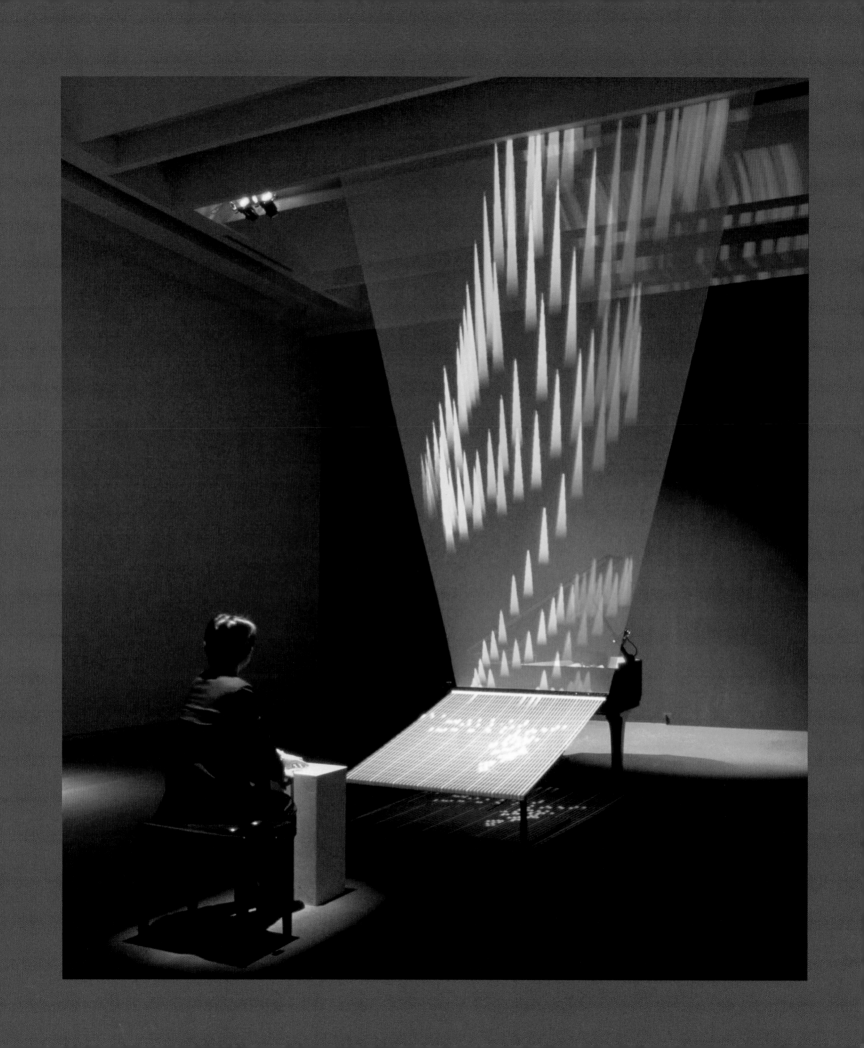

WORDLESS MUSIC AND ABSTRACT ART

We may regard all these colors, that is, all those based on numerical ratios, as analogous to the sounds that enter into music, and suppose that those involving simple numerical ratios, like the consonances in music, may be those generally regarded as the most agreeable.

Aristotle, *On Sense and Sensible Objects*, fourth century B.C.

EVER SINCE PYTHAGORAS expressed the conviction that the universe is governed by numerical relations, Western culture has held the deep belief that the essence of nature is revealed in mathematical equations. From the Pythagorean theorem to Einstein's $E=mc^2$, the laws of nature have carried an aura of certainty and timelessness, as well as aesthetic associations with harmony and symmetry, that have led artists and scientists to ascribe spiritual power to numbers. Pythagoras also discovered a mathematical basis to music: the main musical consonances—an octave, a fifth, and a fourth—are expressible in ratios of the smallest whole numbers—1:2, 2:3, and 3:4, respectively. For example, when one string is twice the length of another, plucking them both produces an octave, which creates an agreeable feeling of finality for the listener—a consonance. A combination of tones not in a ratio of whole numbers—a dissonance—is experienced by the listener as unresolved. In the fourth century B.C. Aristotle transferred this idea of ratios from hearing music to seeing color, in order to explain why some colors feel agreeable and others do not. Aristotle first hypothesized that there are only two fundamental colors, black and white.[1] He proposed the explanation that when looking at a pattern of tiny quantities of black and white—specks too small to be discerned as distinct units—the eye perceives a color. An agreeable color like crimson is produced by only certain ratios of black to white specks, just as harmonious sound is produced by only certain ratios of shorter to longer strings.

THE HARMONY OF THE SPHERES:
MATHEMATICS, ASTRONOMY, AND MUSIC

Pythagoras proposed that the movement of the planets in the heavens generates a harmonic combination of sounds. The velocity of each planet determines its musical tone, and together the planets produce a chord, a harmony—the harmony of the spheres. No documents written by Pythagoras or his cult survive but the Greek astronomer Ptolemy recorded his views on astronomy. Ptolemy also wrote a summary of Greek views of music, *Harmonics*, which ends

134. Toshio Iwai (Japanese, born 1962), *Piano—As Image Media*, 1995. Installation with altered piano. Courtesy of the artist.

Our souls evidently experience the same effects as the melody, as if they recognize the kindred relationship of the ratios of each state and are modeled by some movements appropriate to the individual musical forms. . . . The heavenly hypotheses are perfected in accord with the harmonic ratios. . . . The periods of the celestial bodies are circular and ordered, and similar are the states of the harmonic systems.

Ptolemy, *Harmonics*,
second century A.D.

135. Harmonic motions of the planets, in Johannes Kepler, *Harmonices mundi* (Harmony of the world) (Lincii, Austriæ: sumptibus Godofredi Tampachii excudebat Ioannes Plancvs, 1619), 207. Science, Industry, and Business Library, The New York Public Library. Astor, Lenox and Tilden Foundations.

Kepler scored a part for each of the planets known to him—Saturn, Jupiter, Mars, Earth, Venus, and Mercury—by calculating the high and low notes corresponding to their elliptical orbits. He also included the moon in his chorus: "Hicloeum habet etiam" (Here the moon too has a part). Earth's orbit is almost circular—only very slightly elliptical—so Kepler declared that its perihelion and aphelion are only one note apart, *mi* and *fa* in the medieval scale. Kepler thought this was a sad sound, like a moan, and a reminder of the corruption and imperfection of Earth, because of the symbolic association of the notes with misery and famine.

with praise for Pythagoras's view that music is the link between the microcosm and the macrocosm, between man's soul and the universe.

The seventeenth-century astronomer Johannes Kepler was taken with the idea that the motion of the planets produces musical tones. When he discovered that there is a constant ratio between the average radius of a planet's orbit and the time it takes to orbit the sun (radius cubed is proportionate to time squared), he named it his "harmonic law," because he believed that he had also discovered the score to celestial music. Pythagoras, believing that each planet moves in a circle at a constant speed, had thought that each planet intones one note. After Kepler determined that each planet moves in an ellipse, and that the planet speeds up and slows down as it approaches and then moves away from the sun, he declared that each planet has a range of notes, humming along at a pitch that gradually goes up the scale and then down again. Kepler believed that together the planets could produce a six-part harmony (plate 135).[2]

The Enlightenment inherited the attitude that music has an elevated status because of its inherently mathematical nature and because it is manifest in the celestial realm. Music, like mathematics, exists in immaterial forms that give mankind an intimation of timeless perfection: circles are formed in man's imagination, and harmonic consonants resonate in his immortal soul.

During the Enlightenment, music was still studied within mathematics, and the French philosopher René Descartes, looking for the geometric structure of harmony, organized the musical scale into a circle joined at the octave (*Compendium Musicae*, 1650). After Newton discovered the spectrum, he updated the ancient analogy of music and color by dividing the spectrum into seven parts, corresponding to the seven notes in the scale. He then arranged his seven colors on the scale of Descartes's musical circle to create the first color wheel (plate 136).

In the eighteenth century, musicians separated from mathematics, and composition began to be treated as a fine art, like painting or literature; harmony was written about in terms of aesthetics, not as a topic in mathematics and astronomy. Early in the Enlightenment polyphonic music (such as a Bach fugue) had been understood as a reflection of a divine, immutable,

cosmic order, and music had a primarily liturgical function. With the adoption of a more secular outlook in the mid-eighteenth century, music came to be seen as a reflection of irregular patterns of natural sound, as in program music, and hence less mathematical. With the rise of individualism at the time of the French Revolution, and as harmony-based melodic music developed (such as a Beethoven sonata), music was seen increasingly as an expression of the composer's spirit.

When Kant declared that knowledge is a product of the organizing activity of the mind applied to the givens of experience, it became clear that any melody or musical composition is a synthesis—carried out in the listener's mind—of scattered sounds into a musical whole. As we saw in terms of the art of Jugendstil and Kandinsky (chap. 4), Kant's view of cognition was one of the key catalysts in the development of abstract art. Under its influence, musicians took the first steps into total abstraction and autonomy much earlier than painters. By 1800 musicians had developed and given primacy to "absolute music"—wordless instrumental music without reference to a divine order or to sounds in nature—and by midcentury Eduard Hanslick had written the fundamental text of musical formalism, *The Beautiful in Music* (1854), declaring music to be a self-sufficient realm.

The final step toward music's new expressive role was taken by the Naturphilosophen. In his *Critique of Judgment*, Kant had described aesthetic judgment as knowledge that is incapable of being put into words: "an aesthetic idea cannot become a cognition because it is an intuition (of the imagination) for which an adequate concept cannot be found"; therefore, an aesthetic judgment is inexpressible in language.[3] While the Romantics' suspicion grew that reason could not articulate many areas of reality—emotions, irrational impulses, intuitions—the Naturphilosophen proclaimed that music could say the "unsayable." Words are the language of reason, but music is the language of the heart. In *Aesthetics* (1835) Hegel maintained that

136. Isaac Newton, color circle, *Opticks; or, A treatise of the reflexions, refractions, inflextions and colours of light* (London: S. Smith and B. Walford, 1704), bk. I, pt. II, pl. III, fig. 11, following p. 144. Science, Industry, and Business Library, The New York Public Library. Astor, Lenox and Tilden Foundations.

The work of the painter or poet is a continual copying or reproducing (drawn from reality or the imagination), but it is impossible to copy music from Nature. Nature knows of no Sonata, no Overture, no Rondo. . . . Music consists of successions and forms of sound, and these alone constitute the subject.

Eduard Hanslick, *The Beautiful in Music*, 1854

wordless instrumental music is the highest form of art precisely because it does not represent anything in the external world but expresses only the "subjective life"; melodies are "the immediate expression of the inner life . . . which, while being obedient to the necessity of harmonic laws, yet at the same time lift the soul to the apprehension of a higher sphere."[4] And, in an echo of the Pythagorean view of music as the link between the microcosm and the macrocosm, Schelling declared that music is an embodiment of spirit, uniting the individual with the cosmos (*Philosophy of Art*, 1802–3).

Thus by the opening of the nineteenth century it had been firmly established in German culture that absolute music was the language of the spirit. The Romantic painter Philipp Otto Runge designed *The Nightingale's Music Lesson* (1804–5; Kunsthalle, Hamburg) like a fugue, allowing the painting's musical subject matter to appear in different variations. He planned a cycle of four paintings based on the times of day—but completed only two versions of *Morning* (for example *Morning*, 1808; Kunsthalle, Hamburg)—with the idea that the cycle would be displayed together with a performance of music appropriate to the hour, in order to convey his vision of a harmonic universe. Runge also described colors in musical terms. In his spherical model of pigments with the primary and secondary hues arranged around the equator and white and black at the poles (plate 55), the colors located opposite each other, such as red and green, were "harmonious"; primaries such as red and blue, "dissonant"; and adjacent colors, "monotones."[5]

Sound and Light, Hearing and Vision

The analogy between music and color was reinforced in the public mind in the early nineteenth century by Thomas Young's demonstration that light, like sound, travels in waves. When physiologists also confirmed that hearing sound and seeing color are, from the brain's point of view, the same thing—electrical nerve impulses—sound and light came to seem interchangeable. As neurology expanded in the second half of the nineteenth century, many expressed the desire to hear colors and see sounds—which seemed possible because, as Paul Gauguin put it, "All our senses reach the brain *directly*."[6] The public was also made aware of the patterns made by sound waves, which were widely printed in the popular press after the invention of the telephone (1876; see plates 137 and 138). Since all waves make similar patterns, the public could see for themselves the striking similarity in the appearance of sound waves and light waves, and the analogy was also encouraged by science journalists who published optical figures that were produced by sound vibrations, in other words, literal visualizations of sound (plate 139).

In 1862 Helmholtz laid bare the physical basis of the analogy of music to color in his general theory of hearing, in which he described the ear, like the eye, as a sensory organ that transforms waves into nerve impulses. He first described the physical basis of harmony. It had been known for centuries that the cochlea, the bony spiral in the shape of a snail shell, is the site of hearing, but no one knew how sound was perceived. Helmholtz showed that curled inside the cochlea is a ribbon-thin piece of tissue—the basilar membrane—that vibrates in

ABOVE

137. Patterns made by sound waves, in Amédée Guillemin, *Le Monde physique* (The physical world) (Paris: L. Hachette, 1882), 656.

LEFT

138. Telephone, in Louis Figuier, *Les Nouvelles Conquêtes des sciences* (The new conquests of science) (Paris, 1883), 1:352.

BELOW

139. Patterns produced by vibrations of two tuning forks, set at 1:2 (octave), 2:3 (fifth), and 3:4 (fourth), in Camille Flammarion, *Astronomie populaire* (Popular astronomy) (Paris: C. Marpon and E. Flammarion, 1881), 287.

ABOVE

140. *(a)* The outer ear and cross section of the cochlea. *(b)* The basilar membrane of the cochlea is shown uncoiled; the membrane at rest (straight line) and the membrane vibrating in resonance with a sound wave (wavy line).

BELOW

141. Rows of nerve cells lining a section of the basilar membrane, in Hermann von Helmholtz, "The Physiological Causes of Harmony in Music" (1857), in *Popular Lectures on Scientific Subjects*, trans. E. Atkinson (New York: D. Appleton and Co., 1891), 84.

Why do I understand the musician better, why do I see the raison d'être of his abstractions better?

Vincent van Gogh
to Theo van Gogh,
probably September 1888

response to the frequency of the amplified sound entering the inner ear (plate 140). The membrane is lined with three rows of nerve cells, which have a hairlike fiber that senses the vibration and transmits it to the auditory nerve, which carries the impulse to the brain (plate 141). Helmholtz proposed that there is one hair cell for each pitch that can be discriminated. (It is known today that it is rather groups of some twenty-four thousand nerve cells lining the basilar membrane that are associated with the fifteen hundred pitches that the ear can discriminate.) Helmholtz also proved that a listener's subjective experience of harmony is based ultimately in the structure of the ear itself. He demonstrated that when a hair cell on the basilar membrane is stimulated, it triggers a sympathetic vibration—an overtone—in the hair cells that corresponds to the pitches of the octave, the fourth, and fifth, a pattern of resonance that occurs in music. In other words, hearing an octave, a fifth, and a fourth as a consonance and the perception of overtones are innate features of the human ear.

Helmholtz described hearing and vision as analogous because nerve impulses play a significant role in both, but he also stressed that the analogy is limited by the dissimilarity of the physical structure of the ear and the eye. When a complex sound wave, such as that produced by a three-note musical chord (plate 142), strikes the ear, the nerve cells lining the basilar membrane perform an analysis of the sound wave and send the brain separate, simultaneous nerve impulses for each of the three tones—the ear hears a three-note chord. The nerve cells lining the retina are unable to perform such an analysis on complex colors; when a mixed color such as a bluish green strikes the retina, the eye sends only one impulse to the brain—the eye does not distinguish the component wavelengths and the viewer sees one mixed color, bluish green. As Helmholtz stated: "The eye is unable to decompose compound systems of luminous

waves, that is, to distinguish compound colors from one another. It experiences them as a single, unanalyzable, simple sensation, that of a mixed color. It is indifferent to the eye whether this mixed color results from a union of fundamental colors or with non-simple ratios of periodic times. The eye has no sense of harmony in the same meaning as the ear. There is no music to the eye."[7]

Thus from a physiological point of view, even though music and color are analogous in the sense that perception of them is the result of nerve impulses, the comparison ends there because of the dissimilar sense organs. This may help to explain why abstract art—despite a century of educating the public about the ability of color and line to evoke their feelings—attracts smaller audiences than wordless instrumental music (symphonies, jazz improvisations, violin concertos, and so on).

Visual Music

In England, the adoption of a scientific perspective in the 1860s was stalled in part by the association of science with technology, whose blighting effects could be seen in the belching smokestacks, urban crowding, and health hazards of the industrial revolution. With the pessimism of soldiers who fight a losing battle, artists and writers of the Aesthetic movement resisted the encroachment of science into all areas of life by defending the territory of art and asserting their dominion over the cult of beauty. The belief in the autonomous value of aesthetic qualities such as color and form prompted the leading artist of the movement, James McNeill Whistler, to adopt the analogy of music and color in his work. At the 1863 Salon des Refusés, he exhibited the first of his four Symphonies in White, *Symphony in White, No. 1: The White Girl* (1861; National Gallery of Art, Washington, D.C.), and thereafter he gave his paintings musical titles, such as his *Arrangement in Grey and Black, No. 1: Portrait of the Artist's Mother* (1873; Musée d'Orsay, Paris).

Given the art-for-art's-sake ideology of the Aesthetic movement,[8] it is not surprising that Whistler would make the analogy between music and color, but why did he keep the girl in white and his mother in his art rather than making the leap to abstraction? I would argue that for artists to fully adopt the analogy of painting to music—pure color to pure sound—they first had to embrace the abstract, invisible realms that science was revealing—the microscopic realm, evolutionary biology, and experimental psychology. Because they resisted the impact of technology, and by association science, Whistler and his Aesthetic colleagues turned their backs on the imperceptible and hence on abstract art. Clinging to an old-fashioned view of nature, Whistler continued to describe its outward appearance. Nostalgia for preindustrial

142. Pure and mixed sound waves, in Amédée Guillemin, *Le Monde physique* (The physical world) (Paris: L. Hachette, 1882), 1:635.

Above are "pure" sounds produced by tuning forks: one with long waves (a low tone) and two with shorter waves (higher pitches). At the bottom, the three pure sound waves are combined into a complex wave pattern.

An artist who sees that the imitation of natural appearances,
however artistic, is not for him, the kind of creative artist
who wants to express his own inner world, sees with envy
how naturally and easily such goals can be attained in
music, the least material of the arts.

Wassily Kandinsky, *On the Spiritual in Art*, 1912

society manifested itself in Aesthetic architecture and interiors, which Whistler also designed, and in the handcrafted, floral patterns of Aesthetic furniture, ceramics, metalwork, and textiles designed by William Morris, leader of the British Arts and Crafts movement.

Unlike members of the British Aesthetic movement, Art Nouveau and Jugendstil artists embraced science, especially biology, and their interest in experimental psychology also brought them in contact with research on the similar spiritual (psychological) impact of music and color. Theodor Lipps wrote on the psychology of harmony in music, and August Endell used the music/color analogy frequently in his writings.[9] When, in 1911, Kandinsky first heard a performance of atonal music by the Austrian composer Arnold Schoenberg, he felt an immediate sympathy with the composer's rejection of traditional rules for consonance and dissonance in order to achieve a new form of musical expression of the soul: "Schoenberg combines in his thinking the greatest freedom with the greatest belief in the ordered development of the spirit!"[10] Within a year Kandinsky was associating specific hues with musical sounds; in the same way that someone who reads music can "hear" a score, so, in theory, a viewer who knows the artist's color language can "hear" the painting. Once he started painting totally abstract works, he gave them musical titles (plate 143). The analogy of music to color became commonplace among abstract artists; in reference to the legendary Greek poet and musician Orpheus, Apollinaire gave the name "Orphists" to artists in the Cubist circle such as František Kupka, who moved into abstraction with that analogy in mind (*Amorpha: Fugue in Two Colors*, 1912; Národní Galerie, Prague). The American painters Stanton Macdonald-Wright and Morgan Russell collaborated on the development of a style of painting with color harmonies, which they called Synchromism (plate 144).

The Lithuanian artist Mikalojus K. Čiurlionis studied musical composition and art in Warsaw before creating a series of paintings entitled *The Zodiac*, which shows a band of the sky that includes the paths of the principle planets, the sun, and the moon. He was very interested in astronomy and read *Popular Astronomy* (1881) by the French popularizer Camille Flammarion,[11] which had stunning celestial images, as did the German popular science press (plate 146). Evoking the theme of the harmony of the spheres, Čiurlionis gave each painting a musical title, such as *Sonata No. 6 (Sonata of the Stars) Allegro* (plate 147); planets, stars, and light beams fill the composition, which surges upward. He moved to Saint Petersburg in 1909 and was associated there with the experiments combining music and light that were being done by the Russian composer Alexander Skryabin.[12] In the score for *Prometheus: The Poem of Fire* (1911), Skryabin included a part for a color organ, an instrument that makes no sound but projects colored lights that are coordinated to the musical scale. Such instruments

OPPOSITE
143. Wassily Kandinsky (Russian, 1866–1944), *Fugue*, 1914. Oil on canvas, 51⅞ x 51⅞ in. (129.5 x 129.5 cm). Fondation Beyeler, Riehen/Basel.

BELOW
144. Stanton Macdonald-Wright (American, 1890–1973), *Conception Synchromy*, 1914. Oil on canvas, 36 x 30⅛ in. (91.4 x 76.5 cm). Hirshhorn Museum and Sculpture Garden, Smithsonian Institution, Washington, D.C. Gift of Joseph H. Hirshhorn, 1966.

145. "Solar Flares," in Amédée Guillemin, *Le Monde physique* (The physical world) (Paris: L. Hachette, 1882), 2: opp. x.

146. Sun showing sunspots and corona, in Hans Kraemer, *Weltall und Menschheit* (Cosmos and humanity) (Berlin: Deutsches Verlaghaus Bong & Co., 1902–4), 2: opp. 236.

147. Mikalojus K. Čiurlionis (Lithuanian, 1875–1911), *Sonata No. 6 (Sonata of the Stars) Allegro*, 1908. Tempera on paper, 28⅞ x 24½ in. (72.2 x 61.4 cm). M. K. Čiurlionis National Museum of Art, Kaunas, Lithuania.

had been in use since the seventeenth century and were a popular form of entertainment in the first decade of the twentieth (plate 148).

After being disappointed with the dim flashes of color they attained with a color organ they designed, the Italian Futurists Arnaldo Ginna and Bruno Corra invested in a few hundred feet of film and began applying color by hand, frame by frame, in processes already well known to early animators. Happy with the brilliant colors they produced by projecting with an arc lamp into a darkened room, they produced five abstract films between 1910 and 1912, which Corra described in his manifesto "Abstract Cinema—Chromatic Music" (1912).[13] Of *The Rainbow* Corra wrote:

> The colors of the rainbow constitute the dominant theme, which appears occasion-
> ally in different forms with ever increasing intensity until it finally explodes with
> dazzling violence. The screen is initially grey, then in this grey background there
> gradually appears a very slight agitation of radiant tremors which seem to rise out

of the grey depths, like bubbles from a spring, and when they reach the surface they explode and disappear. The entire symphony is based on this effect of contrast between cloudy grey of the background and the rainbow, and the struggle between them. The struggle increases; the spectrum, suffocated beneath the ever blacker vortices which roll from the background to foreground manages to free itself, flashes, then disappears again to reappear more intensely close to the frame. Finally, in an unexpected dusty disintegration, the grey crumbles and the spectrum triumphs in a whirling of catherine-wheels which disappear in their turn, buried under an avalanche of colors.[14]

In the 1920s the Swedish-born filmmaker Viking Eggeling created *Diagonal Symphony*; throughout the eight-minute silent film, white abstract shapes and lines move slowly against a black background. The first public showing of the film was in Berlin in 1926, together with an abstract film by Hans Richter of the Bauhaus.[15] Richter described his vision of color music on film: "The complete works will be realized on film. The process itself: creative evolutions and revolutions in the realm of the purely artistic (abstract forms); roughly analogous to the sounds of music in our ears. As in music the action (in a totally theoretical sense) is presented by pure material."[16] Oskar Fischinger, whose abstract projections were incorporated into Alexander László's *Colored Light Music* performance of around 1926, emigrated to America during World War II. While working as an animator in Hollywood, he encouraged underground filmmakers to create abstract colors in motion (plate 149).

At the Bauhaus, Gertrud Grunow taught a class in "harmonization," using a grand piano and a chromatic wheel that assigned a body part and a musical note to each color. The Bauhaus catalogue description of Grunow's class reads, "During the entire duration of study, practical harmonization classes on the common basis of sound, color, and form will be taught with the aim of creating a balance between the physical and mental properties of the individual."[17] Another Bauhaus artist, Paul Klee, had a lifelong close association with music; the son of a music teacher in Bern, he learned to play the violin and considered a concert career before

turning to art. For his students at the Bauhaus, Klee demonstrated the linear translation of a musical composition by diagramming a three-part passage from a Bach sonata (1921–22; Paul Klee Foundation, Kunstmuseum, Bern), and he developed linear counterpoint in his *Drawing in Two Voices* (plate 150).

The link between music and color has persisted in the visual arts, especially in works that entail an element of performance. An enchanting recent example was created by Japanese video artist Toshio Iwai. The viewer enters a dark, silent room; in the center of the room is a grand piano with its lid lifted to reveal dimly lit strings. A trackball sits on a stand about ten feet in front of the keyboard. By moving the ball, the viewer triggers a pattern of lights on a scrim stretching to the piano, movement of the keys, and bursts of sounds and lights from the keyboard (plate 134). As the room returns to still darkness, the viewer is left with an echo and an afterimage.

As visual artists continue to be inspired by the analogy of music and color, so musicians and astronomers pursue the harmony of the spheres. The German composer Paul Hindemith wrote an opera based on the life of Kepler in which melodic lines, associated with planets and the moon, repeat at regular intervals to suggest the rhythmic orbiting of the spheres around the tonal center, which the composer identified with the sun (*Die Harmony der Welt* [Harmony of the world], 1957). According to the American Minimalist composer George Crumb, his 1974 piece for two amplified pianos and percussion, *Makrokosmos III*, "might be interpreted as a kind of 'cosmic drama.'"[18] Intrigued as much by the silence of the spheres as by their sound, Crumb has noted that the third movement of this composition, "The Advent," "is associated with a passage from French Enlightenment mathematician Blaise Pascal: 'The eternal silence of infinite space terrifies me.'"[19] For their part, astronomers are today attempting to detect ripples in the fabric of outer space—gravity waves—that are caused by the motion of massive bodies. Conventional astronomy records radiation (such as visible light) at high frequencies; the range of gravity waves would be much lower. This has suggested to some that if gravity waves, which were predicted by Einstein, can be detected, then scientists will be able to convert them into audible sound.[20] Most intriguingly, one might be able to hear an echo of the Big Bang; in Australia and America there are observatories in operation today that are dedicated to detecting gravitational waves, and a satellite observatory is scheduled for launch by NASA in 2009.

OPPOSITE, TOP
148. "Chromatic scale in music and color," in A. W. Rimington, *Colour Music: The Art of Mobile Colour* (London: Hutchison and Co., 1912), opp. 21.

OPPOSITE, LEFT
149. Oskar Fischinger (American, 1900–1967), *Radio Dynamics*, 1945. Color film. Iota Center, Los Angeles.

BELOW
150. Paul Klee (Swiss, 1879–1940), *Drawing in Two Voices*, 1921–22. Paul-Klee-Stiftung, Kunstmuseum, Bern.

8

THE CULMINATION OF NEWTON'S CLOCKWORK UNIVERSE

The art to come will give form to our scientific convictions. This art is our religion,
our center of gravity, our truth. It will be profound enough and substantial enough
to generate the greatest form, the greatest transformation the world has ever seen.

Franz Marc, *Aphorisms*, 1914–15

IN THE CLOSING DECADES of the nineteenth century, physicists began to explain the physical foundations of the universe, just as biologists had explained the origin of species and the workings of the human mind. The basic building blocks of matter—atoms—were being organized into a tidy chart, and the forces that hold the atoms together were being identified as electromagnetism. When Charles Henry and Georges Seurat had studied light in the 1880s, they considered only visible rays; by 1900 a whole spectrum of invisible light was being discovered, and Henry had written a study of mysterious new "X rays." When August Endell was inspired by patterns of electricity, he had in mind an electric force flowing in a current from point to point, much as water does. After scientists developed the theory of electromagnetism, the public came to realize that electricity always travels with a companion, magnetism, and that the paired forces travel in a spherical field of forces—like an exploding ball of energy—at the speed of light to infinity. Physicists were studying atoms and energy not only on Earth but also in the heavens—they had become astrophysicists. A scientific explanation of Newton's whole clockwork universe seemed within grasp.

THE PERIODIC TABLE

Aristotle identified the four basic elements as earth, air, fire, and water; the heavens hung in a fifth (the quintessence)—ether. Eighteenth-century experiments on gases made it clear, however, that there were many more besides air and thus, at the beginning of the nineteenth century, the British chemist John Dalton revived a rival ancient theory. In the Pythagorean spirit, Democritus had declared in the fifth century B.C. that there is only one basic substance—atoms (Greek for "indivisible"). Dalton proposed that atoms differ in weight and combine in small groups to form molecules, and by the 1850s it became clear that each atom can combine with only a fixed number of other atoms; for example, the combination of two hydrogen atoms with one of oxygen always yields a water molecule. This ability to combine, which is called the atom's valence (from Latin for "power"), was found to change according to the weight of the atom.

151. Robert Delaunay (French, 1885-1941), *Simultaneous Contrasts: Sun and Moon*, 1913 (dated on painting 1912). Oil on canvas, diameter 53 in. (134.5 cm). The Museum of Modern Art, New York. Mrs. Simon Guggenheim Fund.

152. Periodic table of elements, modern version.

In 1869 Mendeleyev published the first periodic table of elements arranged by ascending atomic weight. Elements with similar chemical properties form vertical columns. In the late nineteenth century, one more column was added on the far right for the inert ("noble") gases, such as helium and neon, producing the basic format of the modern version of the periodic table. In the twentieth century, after it was determined that the basic building blocks of atoms are protons (particles with a positive charge), the number of protons in each atom (its atomic number) became its distinguishing feature, and the table was simplified by removing the fourteen elements following lanthanum (atomic numbers 58–71; the lanthanides) and actinium (atomic numbers 90–103; the actinides). New elements above uranium (number 92) have been created in the laboratory (see chap. 12) with the goal of completing the seventh period at element number 118. At this writing, number 113 is not yet known, but 114 has been reached with certainty.

153. Periodic table of elements in a helix format, in Dmitri Mendeleyev, *Grundlagen der Chemie* (Foundations of chemistry) (Saint Petersburg, Russia, 1891), after 684.

Mendeleyev and others experimented with alternative models for the periodicity of the elements, such as a helix, with the lightest element at the top center, and the elements arranged by weight on the steps moving down, with turns in the helix corresponding to periods.

1 H																	2 He
3 Li	4 Be											5 B	6 C	7 N	8 O	9 F	10 Ne
11 Na	12 Mg											13 Al	14 Si	15 P	16 S	17 Cl	18 Ar
19 K	20 Ca	21 Sc	22 Ti	23 V	24 Cr	25 Mn	26 Fe	27 Co	28 Ni	29 Cu	30 Zn	31 Ga	32 Ge	33 As	34 Se	35 Br	36 Kr
37 Rb	38 Sr	39 Y	40 Zr	41 Nb	42 Mo	43 Tc	44 Ru	45 Rh	46 Pd	47 Ag	48 Cd	49 In	50 Sn	51 Sb	52 Te	53 I	54 Xe
55 Cs	56 Ba	57 La	72 Hf	73 Ta	74 W	75 Re	76 Os	77 Ir	78 Pt	79 Au	80 Hg	81 Tl	82 Pb	83 Bi	84 Po	85 At	86 Rn
87 Fr	88 Ra	89 Ac	104 Rf	105 Db	106 Sg	107 Bh	108 Hs	109 Mt	110 Uun	111 Uuu	112 Uub	113	114 Uuq	115	116	117	118

58 Ce	59 Pr	60 Nd	61 Pm	62 Sm	63 Eu	64 Gd	65 Tb	66 Dy	67 Ho	68 Er	69 Tm	70 Yb	71 Lu
90 Th	91 Pa	92 U	93 Np	94 Pu	95 Am	96 Cm	97 Bk	98 Cf	99 Es	100 Fm	101 Md	102 No	103 Lr

By the 1860s over sixty elements had been discovered, each with a different weight, valence, and related properties, and chemists began to look for a way to organize them. The solution was found by the Russian chemist Dmitri Mendeleyev, who first put the elements in order by atomic weight and then, guided by their valences, determined that he could arrange the horizontal rows of elements by their repeating characteristics—their periods—so that elements with like characteristics formed vertical columns. In 1869 Mendeleyev published his periodic table of elements (plates 152 and 153). In a daring gesture, in three cases where there was no known element with the atomic weight and chemical characteristics predicted by his table, he left a space for the missing element, confident that it would be discovered. The chemist lived to see his prediction come true: a French, a Swedish, and a German chemist discovered the three missing elements—gallium in 1875 (named for Gaul, the Latin name for France), scandium in 1879, and germanium in 1886.

THE ELECTROMAGNETIC SPECTRUM

When early-nineteenth-century scientists investigated electricity, they began to suspect that it was somehow related to magnetism; both have opposites that attract (positive and negative electrical

charges, north and south poles of a magnet), and both lose their force rapidly with distance. The Danish physicist Hans Christian Ørsted demonstrated in 1820 that there is a link between electricity and magnetism by passing a current through a wire next to which he had placed a compass; the needle pointed perpendicular to the flow of electricity (plate 154). Ørsted's experiment caused a flurry of research on electricity and magnetism, which culminated in 1831 with two inventions: the electric generator, which provided a cheap and abundant source of power, and the electric motor, which put the power to use. Together they sparked the age of electricity.

Then, in 1865, James Clerk Maxwell described the mathematical relation between electricity and magnetism, proving that there is only one force—electromagnetism (plate 155). Having determined that any oscillating charge creates an electromagnetic field that travels at the speed of light (just over 186,000 miles per second), Maxwell concluded that, in fact, light *is* an electromagnetic wave.

In the early nineteenth century the German-British astronomer William Herschel had discovered invisible radiation. In measuring the temperature of different colored lights, he found that the thermometer rose as he moved it through a spectrum from blue to green to yellow to red. Then he happened to hold the thermometer in the darkness beyond red, and to his astonishment the temperature went up—he had discovered infrared radiation. It was a simple step to discover invisible ultraviolet radiation at the other end of the spectrum. In the 1880s Maxwell declared that infrared, visible, and ultraviolet are all forms of the same thing—electromagnetic radiation—that differ from each other only in wavelength. He went on to predict that a whole spectrum of electromagnetic radiation existed of which these were but a small part.

Within decades Maxwell was proven right as radiation at other wavelengths was discovered. In 1888 the German physicist Heinrich Hertz was working with a slowly oscillating current that he suspected would produce electromagnetic rays with very long wavelengths (from a few feet to over a mile). Soon he succeeded in measuring these radio waves. In 1895 the German physicist Wilhelm Röntgen discovered that there are invisible rays at the other end of the spectrum— X rays—that are so small they can penetrate fabric and soft tissue and form a picture of the dense

ABOVE, LEFT

154. "Action of an electric current on a magnetized needle," in Amédée Guillemin, *The Forces of Nature*, trans. Mrs. Norman Lockyer (New York: Scribner, Welford & Armstrong, 1872), 605.

ABOVE, RIGHT

155. Electromagnetic fields of forces emanating from two positive electrodes of unequal size, in James Clerk Maxwell, *Treatise on Electricity and Magnetism* (Oxford: Clarendon Press, 1873), fig. 1.

156. "Polychrome interference patterns," Amédée Guillemin, *Le Monde physique* (The physical world) (Paris: L. Hachette, 1882), 2: opp. 294.

In 1808 a method had been devised to produce polarized light (a beam of light composed of waves that vibrate in only one plane), and when the whole electromagnetic spectrum was discovered, it gave scientists many new sizes (wavelengths) of polarized light to use as probes with which to investigate the structure of matter. In these examples the public was shown beams of polarized light passing through six crystals, producing interference patterns that reveal their internal, microscopic architecture.

157. X ray of the bones *(left)* and bones together with the arteries *(right)* of a hand, in L. Gastine, "Nouvelles études au moyens des rayons x" (New studies using x rays), *L'Illustration* 108, no. 2802 (7 Nov. 1896): 363.

bones inside of a living body (plate 157). By 1900 gamma rays, which had even smaller wavelengths and hence could even penetrate bone, had been discovered. We know today that the longest radio waves can have wavelengths taller than Mount Everest and the shortest-wavelength gamma rays are the size of the diameter of an atomic nucleus; only a very small percentage of the electromagnetic spectrum is visible to humans. The public was fascinated by the discovery of each new form of invisible radiation, especially X rays, because—in an era when swimsuits covered the body neck to knee—they could penetrate clothing and flesh.[1] Early-nineteenth-century inventors had devised a method to conduct electrical impulses (Morse code) along a wire, and in 1866 the Atlantic had been spanned by a telegraph cable connecting America and Europe. By the 1890s the current carrying the code was known to be electromagnetic impulses, and the Italian physicist Guglielmo Marconi announced that Morse code could be sent through the atmosphere without a wire at all because air is the conducting medium for the radio waves discovered by Hertz. In 1901 the first wireless message in Morse code was beamed from Cornwall, England, to Newfoundland, Canada. Soon radio antennas bristled from ship masts and urban towers; in Paris, a wireless telegraph station was installed atop the Eiffel Tower, making this symbol of modernity also a beacon of electromagnetism at the opening of the twentieth century. Early silent films gave invisible electromagnetic forces a leading role in mystery tales, such as the double feature released by Vitagraph in 1908, *Galvanic Fluid* and *Liquid Electricity*. For adult audiences in Paris, Gaumont produced the scandalous *X-Ray Glasses* in 1909.[2]

His doubts of the sanity of the entire business flashed and vanished again as he looked across to where Griffins sat at the breakfast-table,— a headless, handless dressing-gown, wiping unseen lips on the miraculously held serviette.

"It's simple enough—and credible enough," said Griffin, putting the serviette aside and leaning the invisible head on the invisible hand.

"No doubt to you, but—" Kemp laughed. . . .

"You know I dropped medicine and took up physics? No!—well, I did. Light— fascinated me."

"Ah!"

"Optical density! The whole subject is a network of riddles—a network with solutions glimmering elusively through. And being but two and twenty and full of enthusiasm, I said, 'I will devote my life to this. This is worth while.' You know what fools we are at two and twenty?"

H. G. Wells, *The Invisible Man*, 1897

158. Magnetic fields on earth, in Hans Kraemer, *Weltall und Menschheit* (Cosmos and humanity) (Berlin: Deutsches Verlaghaus Bong & Co., 1902–4), 1: 401.

159. Pattern of electrical discharge between clouds, mountain, and shore during a lightning storm, in Hans Kraemer, *Weltall und Menschheit* (Cosmos and humanity) (Berlin: Deutsches Verlaghaus Bong & Co., 1902–4), 1: pl. 4 overlay.

Marconi's invention of wireless telegraphy led scientists to turn their attention to the electrical and magnetic properties of Earth's atmosphere (plates 158 and 159). Hertz had shown that a focused beam of radio waves travels in a straight line; how could Marconi's dots and dashes of Morse code have traveled the curved path over Earth's surface from Cornwall to Newfoundland? They soon discovered that the atmosphere contains layers of atoms that carry an electric charge (ions) and that radio waves are reflected from the ionosphere as light is reflected in a mirror (plate 219). Suddenly the whole sky seemed alive with energy.

ASTRONOMY, SPECTROGRAPHY, AND THE BIRTH OF ASTROPHYSICS

The major scientific breakthroughs in the nineteenth century had been in the life sciences—evolutionary biology, medicine, the physiology of perception, and psychology. Discoveries in astronomy and physics had been less dramatic, but they did provide several important ideas to artists who moved into abstraction in the early twentieth century. As bigger telescopes were built and photography captured celestial images, the late-nineteenth-century public developed a fascination with outer space and a growing sense of Earth's modest position in the solar system —a small sphere moving through a vast void. In the 1850s a mural-size photograph of the moon was the hit of the Crystal Palace Exhibition in London, and the German public came in droves to gaze at a giant lunar reconstruction exhibited in Bonn (plate 160).

ABOVE

160. Visible hemisphere of the moon on exhibit in Bonn, in "Das Relief der lichtbaren Halbkugel des Mondes" (A relief of the illuminated half of the moon), *Illustrirte Zeitung* 13, no. 589 (14 Oct. 1854): 254 (illus.), 251 (text).

LEFT

161. Train of rockets to the moon, illustration by Henri de Montaut, in Jules Verne, *De la terre à la lune* (From the earth to the moon) (Paris, 1865).

Early science fiction writers and filmmakers fired the public imagination with fantasies of traveling to the moon (plates 161 and 174). However, the most telling indication that earthlings were gaining a sense of their small, relative, and shifting position in the universe was the great popularity in the late nineteenth century of pictures of Earth seen from the moon and the other planets (plate 162).

Historians and astronomers have identified many specific celestial bodies in van Gogh's night skies, such as the constellation Aries in *The Starry Night* (plate 165); the swirling cloudlike forms in this work have even suggested to some viewers a spiral nebula.[3] Known today to be galaxies, spiral nebulas appear as wisps of a cloud (a "nebula") to the unaided eye; some were first seen to be spiral-shaped in 1844 with the new British seventy-two-inch telescope (plate 166). Drawn in 1844 and first photographed in 1888, spiral nebulas were depicted in late-nineteenth-century newspapers and science popularizations. In a letter to Emile Bernard, van Gogh expressed his confidence that questions previously addressed by religion would someday be answered by science, concluding that "Science, scientific reasoning, seems to me an instrument with a great future."[4]

Two of the biggest conceptual jolts in modern astronomy occurred when Uranus and Neptune were discovered, expanding the solar system beyond the six planets that can be seen with the naked eye—Mercury, Venus, Earth, Mars, Jupiter, and Saturn. After the invention of the telescope everyone evidently assumed that the six planets known since antiquity constituted the whole solar system because no one searched for another planet. Then, one night in 1781, a point of light caught Herschel's attention; it did not have a fuzzy edge like a star but instead was a disk with a clear outline—he was astonished to have stumbled upon a seventh planet. His discovery of Uranus opened the minds of scientists and the public alike to the possibility of an expanded solar system—what else could be out there?

OPPOSITE

162. Earth from the moon, in Amédée Guillemin, *Le Monde physique* (The physical world) (Paris: L. Hachette, 1882), 2:22.

BELOW

163. Earth from the moon, 1968. NASA/NSSDC.

The nineteenth-century dream of seeing the earth from the moon came true on 24 December 1968, when the American probe Apollo 8, the first manned mission to the moon, circumnavigated the moon ten times. One of the three astronauts on board, Frank Borman, took this photograph, which became an icon of man's exploration of space. Apollo 8 set the stage for the first lunar landing, and on 20 July 1969 Neil Armstrong first set foot on the moon.

For decades the new planet was closely observed, and it became clear that there was a deviation in Uranus's orbit. What was pulling on it? By the early nineteenth century it was widely suspected that there could be yet another planet, but what were an astronomer's chances of finding a body estimated (correctly) to be another billion miles beyond Uranus? If it were visible at all, it would be just a pinpoint of light among myriad stars, perhaps too small to resolve into a disk. The tale of the discovery of the eighth planet, which reached mythic status as it was retold throughout the nineteenth century, showed the educated public the importance of mathematics in a science that had traditionally been based in observation, pointing, once again, to the observational bias of British and French science, and the Germanic love of theory.

The mathematicians John Couch Adams of Cambridge and Urbain Leverrier of Paris independently calculated the position of the possible planet so that an astronomer could point a telescope to an exact location in the night sky. But the British Royal Astronomer was so opposed to letting mathematics guide observation that he tossed Adams's coordinates aside into a drawer at the Royal Observatory at Greenwich. Meanwhile, Leverrier calculated that on 11 August 1846 the eighth planet would be in opposition, that is, in a straight line with the sun and Earth and therefore at maximum visibility (planets go through phases like the moon). Having failed to persuade astronomers at the Paris Observatory to open the dome of their telescope and getting frantic as the planet began to wane, Leverrier mailed his calculations to an associate at the Berlin Observatory. Untroubled by a theoretical approach to science, after receiving his French colleague's urgent letter on 23 September 1846, the German astronomer Johann Gottfried Galle turned his telescope to Leverrier's coordinates and in less than an hour he had Neptune in his sights (plate 164).

In the second half of the nineteenth century, astronomy moved even further from direct observation when the biggest discovery was made not in an observatory but in a chemistry laboratory. In 1835 the French positivist Auguste Comte had cited the chemistry of the stars as something forever unknowable: "We see how we may determine their forms, their distance, their bulk, and their motions, but we can never know anything of their chemical or mineralogical structure."[5] But within a few decades Comte had been proven wrong by the German physicist Gustav Kirchhoff. In the early nineteenth century the English physicist Thomas Young had performed experiments that supported the wave theory of light, which led to extensive study of light spectra and interference patterns of light waves (plate 156). In 1814 a physicist had noticed that when a ray of sunlight shines through a prism, the resulting spectrum is not continuous but mysteriously missing certain wavelengths, which appear as dark lines, or "spectral lines." Kirchhoff studied the phenomenon by heating different elements to incandescence in his laboratory and analyzing the spectra of light given off. He found that each glowing element gave off light only of certain wavelengths (plate 167). In 1859 he announced that every element produces characteristic spectral lines, a spectral "fingerprint" by which it

164. The planets of the solar system, including Neptune, in Louis Figuier, *La Terre avant le déluge* (The world before the flood), 4th ed. (Paris: L. Hachette, 1865), 32.

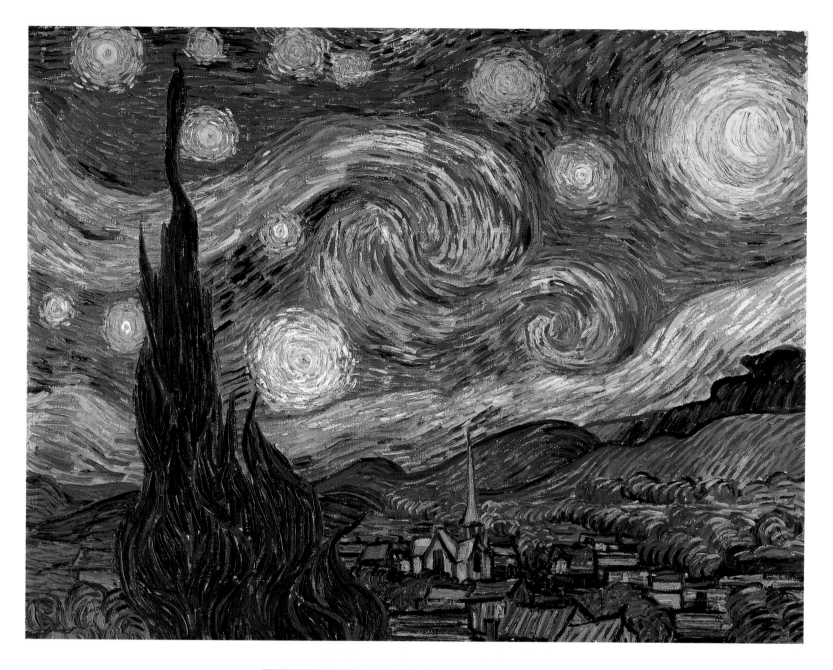

165. Vincent van Gogh, *The Starry Night*, 1889. Oil on canvas, 29 x 36¼ in. (73.7 x 92.1 cm). The Museum of Modern Art, New York. Acquired through the Lillie P. Bliss Bequest.

LEFT

166. Spiral nebula drawing by William Parsons, earl of Rosse, made from visual observations using his telescope with a seventy-two-inch-diameter lens in 1844, in Camille Flammarion, *Astronomie populaire* (Popular astronomy) (Paris: C. Marpon and E. Flammarion, 1881), 814.

RIGHT

167. Spectrographs of the sun, a star (Sirius), and several elements, in S. T. Stein, *Das Licht* (Light) (Leipzig, Germany: Spamer, 1877), pl. 6.

BELOW

168. "Multicolored Stars," in Camille Flammarion, *Les Merveilles célestes* (Wonders of the sky) (Paris: L. Hachette, 1869), opp. 156.

The different colors of the stars result from the variety of visible light emitted (and absorbed) by the different elements they are burning.

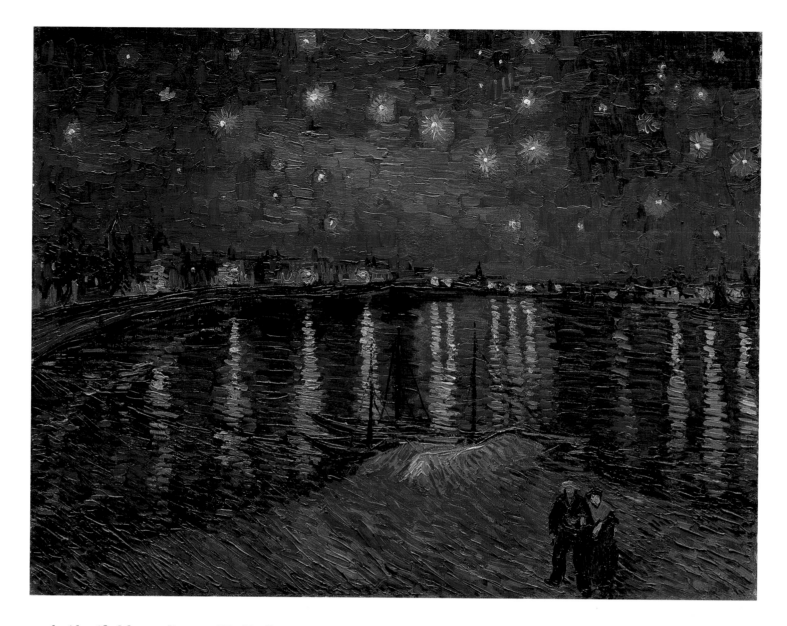

can be identified from a distance. Kirchhoff went on to identify the elements burning in the sun and other stars and to suggest that the different colors of stars result from their burning different elements.

Illustrations explaining the colors of stars were common in science journalism (plate 168), and van Gogh may have been aware of them. A letter to his brother confirms that he painted *Starry Night over the Rhône* (plate 169) from direct observation: "[I painted] a study of the Rhône—of the town lighted with gas reflected in the blue river. Over it the starry sky with the Great Bear [Big Dipper]—a sparkling of pink and green on the cobalt blue field of the night sky, whereas the lights of the town and its ruthless reflections are red gold and bronze green."[6] Van Gogh confided to his brother that he still occasionally felt "a terrible need of— shall I say the word?—religion. Then I go out at night and paint the stars."[7]

By the 1890s physicists were discovering different wavelengths of electromagnetic radiation, learning to decode its messages, and describing it less with pictorial visualizations, such

169. Vincent van Gogh, *Starry Night over the Rhône*, 1888. Oil on canvas, 29 x 36 in. (73.7 x 91.4 cm). Private collection.

RIGHT

170.	Thomas Eakins (American, 1844–1916), *Professor Henry A. Rowland*, 1897. Oil on canvas, 82½ x 53¾ in. (209.6 x 136.5 cm). Addison Gallery of American Art, Phillips Academy, Andover, Massachusetts.

Newton used a single triangular glass prism to produce a spectrum. After Kirchhoff invented spectrography, physicists found they could produce a more detailed spectrum if they used many parallel lines lying in a row separated by small distances. The easiest way to produce such a series was to cut on glass. Rowland conceived of a ruling machine with a diamond point, shown on the table, that was capable of etching an extraordinary forty-three thousand parallel lines within one inch. The maker of the instrument, Theodore Schneider, is shown in the background. In the frame above are two spectrographs that show the presence of sodium.

OPPOSITE, LEFT

171.	František Kupka (Czech, 1871–1957), *Woman in the Triangles*, 1909–10. Ink on paper, 9½ x 8¾ in. (24.1 x 22.2 cm). Musée National d'Art Moderne, Centre Georges Pompidou, Paris.

OPPOSITE, RIGHT

172.	X ray of a hand in motion, in R. Villers, "Cinematography and X Rays," *La Nature*, 39 (June–Nov. 1911): 101. Film stills by Pathé Frères.

as Maxwell's force fields, and more with charts, diagrams, and numerals. Thomas Eakins captured the era in his portrait of Henry A. Rowland (plate 170), an American physicist who did graduate study in Germany under Helmholtz and returned to Baltimore to do research in electromagnetism and spectrography. Eakins presented the everyday visible world—Rowland sitting in his laboratory—surrounded by the invisible and conceptual—the physicist's concepts recorded in the diagrams and numerals that Eakins incised into the gilded chestnut frame. Rowland holds the invention for which he is best known, a diffraction grating used in spectrography.[8]

Kupka, Delaunay, and Duchamp

Working amid great popular interest in X rays and electromagnetism, some artists in prewar Paris adopted Braque's and Picasso's distinctive Cubist vocabulary of geometric planes and forms to depict the human figure not as solid but dissolved into a pattern of overlapping, transparent planes that revealed the body's interior. Artists represented the space around the figure not as empty but filled with invisible energy that was suggested by patterns of force lines.

The Czech painter František Kupka's interests ranged from mysticism to virtually all the sciences. In 1892 he left Prague for Vienna, where he moved in Jugendstil circles and became life-long friends with the critic Arthur Rössler, who was a strong advocate for abstract styles of art based on the power of line (see chap. 4). After settling in Paris in 1896, Kupka painted *The Beginning of Life: The Waterlilies* (1900–1903; Musée National d'Art Moderne, Paris) with the evolutionary theme of animal life emerging from plants. On a pond of waterlilies one flower glows; over it hovers an orb containing a sprouting bud or egg, from which develops an ovum containing a human fetus. In 1905 Kupka began attending lectures at the Sorbonne on biology, physics, and physiology, and his interest in light is evident in *Study for Disks of Newton* (1911–12; Musée National d'Art Moderne, Paris).

Newton had discovered "disks" of color (rainbow-colored fringes causing chromatic distortion) that result from light passing through lenses (see chap. 2). In *Woman in the Triangles* (plate 171), Kupka constructed the figure with overlapping transparent planes that suggest an X ray. For example, in the bands that pass over her arm on the right, her arm appears in various stages of "exposure" as if viewed with waves of different degrees of penetration.

Also using a Cubist vocabulary of transparent planes, in 1912 the French artist Marcel Duchamp dissolved the form of a human body—as in an X-ray or a time-lapse photograph—in *Nude Descending a Staircase (No. 2)* (1912; Philadelphia Museum of Art). Historians have frequently cited X-ray imagery and time-lapse motion studies as sources for Kupka and Duchamp.[9] The artists may also have been intrigued by pictures in the Paris popular science press of time-lapse X-ray studies (reproduced as film stills) of bodies in motion (plate 172). In Kupka's drawing, Duchamp's painting, and the time-lapse X-ray study, the invisible interior of the human body is revealed, but only for a fleeting moment.

173. Robert Delaunay, *Windows*, 1912. Oil on canvas, 18 x 15¾ in. (45.7 x 40 cm). Hamburger Kunsthalle, Hamburg.

174. Georges Méliès (French, 1861–1938), *A Trip to the Moon*, 1903. Black-and-white film.

Robert Delaunay created a series of "simultaneous windows" by arranging faceted planes of color in a shallow space to achieve Chevreul's simultaneous contrast. In *Windows* (plate 173), Delaunay juxtaposed planes of red and green, orange and blue to enliven the surface with apparent movement—optical flickering—at the edges of the planes. In the same year he wrote a manifesto entitled "Light" that began:

Impressionism is the birth of Light in painting.

Light reaches us through our perception.

Without visual perception, there is no light, no movement.

Light in Nature creates color-movement.

Movement is provided by relationships of uneven measures,
of color contrasts among themselves that make up Reality.

This reality is endowed with depth (we see as far as the stars)
and thus becomes rhythmic simultaneity.

Simultaneity in light is the harmony, the color rhythms which
give birth to Man's sight.

Human sight is endowed with the greatest Reality since it
comes to us directly from the contemplation of the Universe.

The Eye is our highest sense, the one which communicates most
closely with our brain and consciousness, the idea of the living
movement of the world, and its movement is simultaneity.[10]

In this passage Delaunay demonstrates his familiarity with a century of research on light: Young's colors as different wavelengths ("uneven measures"), Chevreul's interaction of color ("color contrasts"), and Helmholtz's physiology ("visual perception"). But unlike his nineteenth-century forebears, Delaunay was also aware of invisible radiation; in many works from this era Delaunay included a picture of the Eiffel Tower crowned with its radio transmitter. In "Tower," a 1913 poem written in homage to Delaunay, Blaise Cendrars recalled it as "a beacon shining with all the splendor of the aurora borealis of your wireless telegraph."

In "Light," Delaunay also acknowledged the growing evidence, from Kirchhoff's spectrography to Maxwell's electromagnetism, that light is the language of the cosmos ("contemplation of the Universe"). Like other artists who had traveled in their imaginations to outer space with Jules Verne or the filmmaker Georges Méliès (plate 174), he had a sense of man's position in the solar system. The year after commencing his light-filled *Simultaneous Windows* series, Delaunay began a celestial series, including *Simultaneous Contrasts: Sun and Moon* (plate 151), in which a universal light links the viewer to the heavens; light shines from the sun, crosses the ninety-three million miles to Earth, then enters the viewer's eye and mind. The artist demonstrated that earthly color principles also apply in the celestial realms—the sun is made of warm hues, the moon of cool— thereby generalizing Chevreul's findings into a law of universal simultaneity.

FUTURISM, RAYONISM, AND VORTICISM

In Milan artists rallied around the poet Filippo Tommaso Marinetti after he published his 1909 manifesto urging the destruction of Italy's classical past and the creation of an art for the future. The artists also found inspiration in the scientific revolution of their day, as made clear in their "Futurist Painting: Technical Manifesto" (1910), which was signed

by Umberto Boccioni, Carlo Carrà, Luigi Russolo, Giacomo Balla, and Gino Severini. "Victorious science has nowadays disowned its past [in order the better to serve] the material needs of our time; we would that art, disowning its past, were able to serve at last the intellectual needs which are within us."[11]

The artists chose subjects from new technology, such as Balla's *Street Light* (plate 175). He painted light waves, broken down into their spectral components, linking the object with its surrounding space. "This painting," Balla said, "besides being an original work of art, is also scientific because I tried to represent light by separating it into the colors that compose it. It is of great historical interest because of the technique and the subject. No one at that time [1909] thought that an ordinary electric lamp could be reason for pictorial inspiration. On the contrary, I was inspired by it, and in the study I wanted to represent light and above all to demonstrate that romantic 'moonlight' had been supplanted by the light of the modern electric lamps, to wit, the end of romanticism in art."[12]

The Futurists wanted to visualize rapid motion—Marinetti called it the "aesthetics of speed"—because of the association of high velocity with science and technology: "The gesture which we would reproduce on canvas shall no longer be a fixed *moment* in universal dynamism. It shall simply be the dynamic sensation itself (made eternal)."[13] Balla began to realize this goal in *Dynamism of a Dog on a Leash* (plate 176), in which he suggested motion with an overlapping, shifting pattern of the dachshund's semitransparent legs and leash, a method Balla borrowed from time-lapse chronophotographs of figures in motion (plate 177). The process had been invented in 1888 by the French physician and physiologist Étienne-Jules Marey for his scientific studies of animal bodies, such as *The Animal Machine* (1882). By the first decade of the twentieth century, photographers could produce time-lapse images of objects moving much faster than a walking animal, such as a falling object (plate 178). In his attempt to visualize motion, Balla soon edited out the dog and leash, presenting the essence of the "dynamic sensation itself" in the force lines and the repeated patterns of a time-lapse image, as in *Abstract Speed* (1913; Tate, London).

X-ray images intrigued the Futurists because they seemed to dissolve matter and offer a new kind of vision: "Who can still believe in the opacity of bodies, since our sharpened and multiplied sensitiveness has already penetrated the obscure manifestations of the medium?

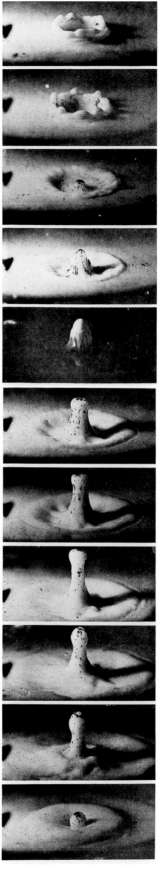

Why should we forget in our creations the double power of our sight capable of giving results analogous to those of X rays?"[14] The experimental psychologist's interest in communicating emotion through abstract form, color, and especially dynamic line also runs throughout Futurist art and writing. Balla knew Cesare Lombroso, the experimental psychologist in Turin who focused on what the artwork of his patients might reveal about their mental deterioration (see chap. 5). Until Lombroso's death in 1909, Balla attended his lectures in Turin, and he

a

b

c

owned a copy of Lombroso's *Man of Genius*. Balla's interest in experimental psychology is suggested by a work he did early in his career, a painting in Neo-Impressionist style of a patient (*The Mad Woman*, 1906; private collection).

Boccioni's series *States of Mind* (plate 179) is a mix of physical and psychological dynamism. Borrowing a term from Maxwell's field theory, the Futurists referred to "force lines,"[15] which in Boccioni's work became a metaphor for hidden emotions. Rather than show the figures in successive positions, as in Balla's *Dynamism of a Dog on a Leash*, Boccioni depicted the energy extending from the figure into space simultaneously in all directions and to infinity, as in field theory (plate 155). He wrote in his "Technical Manifesto of Futurist Sculpture" (1912): "We have to start from the central nucleus of the object that we want to create, in order to discover the new laws, that is, the new forms, that link it invisibly but mathematically to the apparent plastic infinite and to the internal plastic infinite."[16]

Boccioni seems to have been enchanted by the idea that his sculpture was connected to its surrounding space by invisible energy and radiation. He conveyed this by surrounding his figure with floating planes in order to "cut throughout it and section it in an arabesque of directional curves."[17] In 1914 the artist wrote of wanting to achieve a sense of "infinite succession" in *Unique Forms of Continuity in Space* (plate 180): "It seems clear to me that this succession is not to be found in repetition of legs, arms, and faces, as many people have stupidly believed, but is achieved through the intuitive search for *the unique form that gives it continuity in space*. . . . The unique dynamic form that we proclaim is nothing other than the suggestion of a form in motion, which appears for a moment only to be lost in the infinite succession of its variety."[18]

In Russia, Mikhail Larionov and Natalia Goncharova took up the Futurist cause, which they knew from the 1909 Russian edition of Marinetti's manifesto. Both had done early work in the Russian Jugendstil style and were familiar with the expressive use of abstract line and color. Larionov declared that "Rayonism" would depict visible and invisible radiation. In *Glass* (plate 181), he painted rays reflecting and refracting from transparent, interpenetrating surfaces, as well as the patterns formed between the planes by the rays.

179. Umberto Boccioni (Italian, 1882–1916), *States of Mind*, 1911. Charcoal and chalk on paper, three-image series, each 23 x 34 in. (58.4 x 86.3 cm). The Museum of Modern Art, New York. Gift of Vico Baer.

These drawings were first shown in an exhibition of Futurist works that opened in February 1912 at the Galerie Bernheim-Jeune, Paris. The drawings were described in the exhibition catalogue:

(a) Those Who Stay: "In the pictorial description of various states of mind of leave-taking, perpendicular lines, undulating and as it were worn out, clinging here and there to silhouettes of empty bodies, may well express languidness and discouragement."

(b) The Farewells: "Confused and trepidating lines, either straight or curved, mingled with the outlined hurried gestures of people calling one another, will express a sensation of chaotic excitement."

(c) Those Who Go: "Horizontal lines, fleeting, rapid and jerky, brutally cutting into half-lost profiles of faces or crumbling and rebounding fragments of landscape, will give the tumultuous feelings of the persons going away."

180. Umberto Boccioni, *Unique Forms of Continuity in Space*, 1913. Bronze, 43⅞ x 34⅞ x 15¾ in. (111.2 x 88.5 x 40 cm). The Museum of Modern Art, New York. Acquired through the Lillie P. Bliss Bequest.

In Britain in 1914, the painter and poet Wyndham Lewis founded the Vorticism movement and edited its magazine *Blast*. Like Futurism, Vorticism aimed to destroy (blast) the past (the Victorian era) and create art for the new machine age. But unlike their Italian colleagues, the British artists were keenly aware of the dehumanizing aspects of industrialism, as Lewis expressed in the anonymous patterns in *Crowd* (1915; Tate, London). The poet Ezra Pound gave the movement its name, declaring that "the vortex is the point of maximum energy. It represents, in mechanics, the greatest efficiency. We use the words 'greatest efficiency' in the precise sense—as they would be used in a text book of Mechanics."[19] In *The Vorticist* (1912; Southampton City Art Gallery, Southampton, England), Lewis presented the artist as the center of an apparent burst of mechanical energy. Pound described himself as a "wave detector" because to write poetry he had to detect the invisible, and he described art as "a sort of energy, something more or less like electricity or radioactivity, a force transfusing, welding, and unifying."[20]

Rayonism proceeds from the following tenets: Luminosity owes its existence to reflected light (between objects in space this forms a kind of colored dust). The doctrine of luminosity. Radioactive rays. Ultraviolet rays. Reflectivity.

We do not sense the object with our eye, as it is depicted conventionally in pictures and as a result of following this or that device; in fact, we do not sense the object as such. We perceive the sum of the rays proceeding from a source of light; these are reflected from the object and enter our field of vision.

Mikhail Larionov,
"Rayonist Painting," 1913

CRACKS IN THE CLOCKWORK: ENTERING THE SUBATOMIC REALM

Atoms were supposed to be the indivisible building blocks of the clockwork universe—three combined to form a water molecule, a thousand joined together to make an organic molecule, and billions of trillions to form a star. Two forces were thought to hold all the parts together: electromagnetism for atoms and molecules, gravity for stars and planets. Then, between 1895 and 1905 physicists discovered that atoms aren't solid after all and that there are other, unknown forces coming from within the atom itself.

In the 1820s the Scottish botanist Robert Brown had noticed that grains of pollen suspended in water continually move in an erratic jiggling pattern ("Brownian motion"). Such movement was studied throughout the nineteenth century, but it wasn't until the first decade of the twentieth century that scientists were finally able to confirm their hypothesis that atoms and molecules are not just convenient theoretical constructs but physical objects with dimensions. In 1905 Einstein worked out the mathematics of determining molecular size from the amount of particle jiggle, and in 1908 the French physicist Jean-Baptiste Perrin succeeded in making a photographic tracing of the microscopic path of particles in water. This image constituted the first direct observation of the size of molecules and the first recorded image of matter on the atomic level (plate 182).

As Einstein and Perrin were confirming the physical existence of atoms, other physicists were reaching the startling conclusion that an atom is not solid and indivisible but composed of smaller particles. Röntgen's discovery of X rays had prompted a flurry of experiments on radiation at the atomic level. In 1896 the French physicist Antoine Becquerel decided to study fluorescent substances to see if they give off X rays. The substance he chose to test happened to have a little uranium in it, and thus, to his amazement, Becquerel recorded radiation even when the crystal was in total darkness and not fluorescing. The Polish chemist Marie Sklodowska Curie followed up immediately on this lead and tested several uranium compounds, proving in 1897 that the amount of radiation was proportional to the number of atoms of uranium—in other words, radioactivity is an atomic phenomenon. The radiation was found to be of two types, heavier particles that were positively charged, which were named "alpha particles," and smaller, negatively charged "beta particles." By 1900 Becquerel and Curie were suggesting that as the uranium atoms were giving off radiation, they were converting into other kinds of atoms. In 1901 Marie Curie's husband, the French chemist Pierre Curie, first measured the heat produced by radiation from the element radium, determining that one gram gives off 140 calories per hour and would continue emitting energy at that rate

Today it seems that the transmutation of matter, the dream of the alchemists, is not a utopian fantasy. Our modern alchemists have discovered the philosopher's stone in radium.

M. Troller, "Radium and the Transmutation of Matter," 1907

for over one thousand years. He realized that a radioactive substance must have within it a new kind of energy, far greater than any chemical fuel known to mankind. It would takes physicists a mere quarter-century to unleash its power.

Meanwhile, the British physicist J. J. Thomson and others were studying electrical currents. In 1875 the British physicist William Crookes had invented the vacuum tube (a tube of glass from which most of the air has been evacuated, as in a lightbulb). When current is released from an electrode (the bare end of a wire) in a Crookes tube, what comes out? Thomson concluded that the current is a stream of particles and, because of the way the particles deflect in a magnetic field, he knew they carried a negative charge. He called them "electrons" because he believed (correctly) that the particles carry electricity. Thus Thomson had suggested that there are particles smaller than an atom; within a decade and a half the path of a subatomic particle had been photographed and reproduced in the popular French-, German-, and English-language press for all the world to see (plate 183).

Becquerel compared Thomson's electrons with radiation from uranium and determined in 1900 that the negatively charged beta particles shooting out of radioactive atoms *are* electrons. Two years later physicists noticed that if light is shone on a piece of metal, its atoms also give off electrons (the "photoelectric effect"). Why do atoms of uranium, radium, copper, and gold emit electrons? Do atoms have a substructure that includes electrons? Perhaps an atom is a positively charged substance in which electrons are embedded; Thomson volunteered the idea that it might be like the raisins in an English muffin. This model was not greeted with enthusiasm, and the search continued.

Looking for ways to probe the subatomic realm, physicists built a device that would accelerate the heavy, positively charged alpha particles and fire them like "atomic bullets." The New Zealand–born British physicist Ernest Rutherford experimented by firing alpha particles at various thin sheets of material, such as gold leaf, and recording the hits. Most of his bullets went straight through, indicating that most of the gold atoms were empty space. But a small percentage of the particles was deflected at various angles. What were they striking? From the number and angle of deflections, Rutherford deduced that atoms have a hard core—a nucleus— and by calculating the size and spacing of deflections, he further determined the size of the nucleus. In 1911 he proposed his "solar system" model—the nuclear atom—in which most matter is densely concentrated in the positively charged nucleus, around which rotate much smaller, negatively charged electrons, resulting in a stable, electrically neutral atom. In 1914 Rutherford suggested that the hydrogen nucleus is a single particle, a "proton," which is the

183. The path of a subatomic particle, as indicated by one of C. T. R. Wilson's earliest cloud chamber photographs, 1911; reproduced in *La Nature*, 15 Nov. 1913, 409.

184. "The Radium Dance," sheet music cover, Jean Schwartz, composer (New York: Shapiro, Remick, 1904). Bella C. Landauer Collection of Business and Advertising Art ("Radium, uranium, etc. Scrapbook"), negative number 72264. Collection of The New-York Historical Society.

Within a few years of Marie Curie's discovery of radium, particles flying around the subatomic world inspired the movements and tempo of this Broadway tune by Jean Schwartz. Born in 1878 in Budapest where he learned to play the piano as a child, Schwartz came to New York in 1891 and formed a partnership with the lyricist William Jerome. Schwartz composed "The Radium Dance" for their 1904 Broadway hit musical comedy *Piff! Paff!! Pouf!!!*, starring Eddie Foy Jr. and Alice Fisher.

building block of the nuclei of bigger atoms; a two-proton nucleus is helium, three protons make lithium, and so on up the periodic table to uranium, with its ninety-two-proton nucleus surrounded by a swarm of ninety-two electrons. Today we know that this model (plate 193) is basically correct, although the details have been refined. In 1932 a third subatomic particle was discovered: the atomic nucleus also contains particles that have the same size and weight as protons but no electric charge—neutrons.

185. "Forms of electric discharge," in Amédée Guillemin, *The Forces of Nature*, trans. Mrs. Norman Lockyer (New York: Scribner, Welford & Armstrong, 1872), 632.

When Marc met Kandinsky in 1910, they discovered a shared desire to create art with spiritual content, and from 1911 to 1914 they joined with several other kindred souls to produce exhibitions and a publication under the banner *Der Blaue Reiter* (The blue rider). For Kandinsky there were two kinds of scientists: materialists and spiritualists. He despised old-fashioned, "seeing-is-believing" biologists such as Rudolf Virchow because, in his opinion, Virchow was a soulless materialist. In 1911 Kandinsky wrote in despair, "In this era of the deification of matter, only the physical, that which can be seen by the physical 'eye,' is given recognition. The soul has been abolished by a matter of course."[21] But in *On the Spiritual in Art* (1912), Kandinsky expressed great admiration for the other kind of scientist, physicists of his day such as Crookes, who were describing invisible forces that, in Kandinsky's eyes, merged the material with the spiritual.[22]

Thomson had used the vacuum tube invented by Crookes to discover electrons, but Crookes himself missed making the crucial discovery and thought (incorrectly) that he had found something else—a new state of matter, "radiant matter," which "constitutes the physical basis of the universe."[23] When Crookes proposed radiant matter at a public lecture in 1879 in which he demonstrated his vacuum tube, he was criticized by other physicists for his metaphysical leanings. However, by Kandinsky's day, matter was beginning to seem just as bizarre as Crookes had intuited: "In some of its properties, Radiant Matter is as material as this table, whilst in other properties it almost assumes the character of Radiant Energy. We have actually touched the border land where Matter and Force seem to merge into one another, the shadowy realm between Known and Unknown, which for me has always had peculiar temptations. I venture to think that the greatest scientific problems of the future will find their solution in this Border Land, and even beyond; here, it seems to me, lie Ultimate Realities, subtle, far-reaching, wonderful."[24]

After Hertz discovered radio waves, Crookes—who from 1896 to 1899 was president of the British Society for Psychical Research—posited that the wireless telegraph was analogous to mental telepathy: "The transmission of thought and images directly from one mind to another without the agency of the recognized organs of sense." He proposed this thesis at a public lecture in 1898 at the British Association for the Advancement of Science. Within a few years of the discovery of radioactivity, Crookes built a remarkable device—a spinthariscope (from the Greek *spintharis* for "spark")— for actually *seeing* individual scintillations caused by subatomic particles. (A spinthariscope is the size of a spool of thread and consists of a metal tube with a magnifying lens at one end, through which one looks at a phosphorescent surface, over which a speck of radioactive material is suspended on the tip of a tiny needle. After spending a half hour in total darkness to accommodate the eye for night vision, the viewer looks into the spinthariscope through the lens and sees magnified flashes of light caused by alpha particles striking the phosphorescent surface [zinc sulfide].) Spinthariscopes were sold as toys to a public curious about the bizarre subatomic world; scientists such as Rutherford used them to give a quantitative measure of radioactivity.

Kandinsky's many references to theosophy in *On the Spiritual in Art* reveal less of an interest in the occult than in scientific topics presented in a spiritualist vocabulary. The difference between a theosophist like Blavatsky and a physicist like Crookes is that the latter, despite the "peculiar temptations" of the "Border Land," always, in the end, adhered to repeatable experiments and independent confirmation of results—the scientific method. By 1914 Kandinsky had lost interest in theosophy, but he maintained a lifelong interest in science.

All the latest discoveries in physics and astronomy, from X rays to spectrographs, were on view for artists to see at Germany's premiere science museum of the era, the Deutsches Museum in Munich (plate 186). Kandinsky claimed that his move into a totally abstract style was prompted in part by Thomson's discovery of the electron: "A scientific event removed one of the most important obstacles from my path"—a reference to the formulation of "the electron theory—i.e., the theory of moving electricity, which is supposed completely to replace matter."[25] In works such as *Painting #201 (Winter)* (plate 187) from his 1914 series on the four seasons, Kandinsky visualized nature during the season of bitter cold, with stark colors on a chilly white ground. His biomorphic forms have lost their earlier Jugendstil clarity, and they no longer suggest cells seen through a microscope. Now his forms suggest the atomic realm; they have lost their solidity and fuse with the space around them like, in Kandinsky's words, "a stone is dissolved into thin air before my eyes."[26]

Marc, a native of Munich, had begun his education in philosophy and theology before turning to art in 1900, and he maintained an interest in metaphysical topics in his art. He studied landscape painting in Munich and Bavaria, becoming preoccupied with painting animals, which he felt retained a spontaneous spirit lost to civilized man. Marc often spent hours in the Bavarian countryside observing horses and cows at pasture, as well as birds and deer in the wild, studying their particular ways of moving and responding to light and noise. He slowly developed a thoughtful, expressionist style of painting animals in a landscape.

In a remarkable work of 1906, Marc painted a man and a dog bowing their heads before what appears to be a comet (plate 188).[27] The reverential attitude of these figures, who treat the comet as divine, is typical of Marc's interest in nature from both a scientific and a mystical perspective. Marc manifests his deep respect for animals by showing the dog as equal to the human; both are nude and both are praying. There was great interest in comets during the first decade of the twentieth century because Halley's comet was due to return in 1910. It was awaited by the public with great anxiety because astronomers predicted (correctly) that the earth would pass through the comet's tail, with unknown consequences (the phenomenon turned out to be harmless).

Paul Klee went to Munich from his native Bern to study art at the Munich Academy from 1898 to 1901, after which he traveled throughout Europe, eventually settling in Munich in 1906. In 1910 he recorded in his diary that he wanted to "render light simply as unfolding energy" and

The collapse of the atom was equated, in my soul, with the collapse of the whole world. Suddenly the stoutest walls crumbled. Everything became uncertain, precarious and unsubstantial. I would not have been surprised had a stone dissolved into thin air before my eyes and become invisible. Science seemed destroyed; its most important basis was only an illusion.

Wassily Kandinsky, "Reminiscences," 1913

186. Astronomy display *(above)*, and Wilhelm Röntgen's equipment for discovering what came to be called X rays *(below)*, in the guidebook *Deutsches Museum* (Leipzig, Germany: B. G. Teubner, 1907), 50 and 69.

"to accumulate vast quantities of energy lines."[28] Some of his drawings from this time show the artist's interest in representing light with dense patterns of cross-hatched lines (*Young Woman [Light Form]*, 1910; Miyagi Museum of Art, Sendai, Japan). In 1911 Klee met Marc and Kandinsky and began participating in their Blaue Reiter exhibitions and almanac; in April 1912 he met Delaunay just as the latter was commencing his *Simultaneous Windows* series (Delaunay participated regularly in Der Blaue Reiter activities from 1911). Interested in Delaunay's views on light as a universal force, Klee agreed to translate his unpublished manifesto as "Über das Licht" (About light) for the Berlin avant-garde journal *Der Sturm* in 1913.[29]

In the autumn of 1912 Marc met Delaunay and followed his French colleague's example in extending his vision of nature to include the heavens. Marc typically united the earth and sky with rays of light, as in *Blue Horse with Rainbow* (plate 189). He sensed that artists of the near future would create art forms reflecting the new knowledge of the deep structure of nature, from the subatomic microcosm to the farthest star: "They will not be looking for this new form in the past, nor will they want to find it on the outside of nature, in her stylized facade. They will build the new form from within, according to their new knowledge. This knowledge will have changed the old fables of the world into a general principle of form, and transform the old philosophy, which looks at the outside of the world, into another one that looks into it and beyond."[30]

In work such as *Blue Horse with Rainbow*, Marc merged his depiction of the "outside of nature"—animals in a landscape—with the new scientific discovery of the essence of nature "from within"—forces of energy and the dissolution of matter. The horse and rainbow both appear solid and their forms merge, but the spectrum in the sky will vanish in a moment. In keeping with Delaunay's vision of light as a universal force, the air, land, and animal are also permeated by other invisible forces—straight lines and arabesques suggesting radio waves, heat, and sound—giving a formal unity to the composition that can be read as a metaphor for the unity of nature. In his works on the eve of World War I, Marc was beginning to paint the forces of nature abstractly as a pattern of energetic lines, as in *Fighting Forms* (1914; Bayerische Staatsgemäldesammlungen, Munich). Marc was mobilized and kept a sketchbook during the war years; in *Strife* (plate 190) he translated trench warfare into his abstract vocabulary: "There were strange forms all around me, and what I saw, I drew; harsh evil forms of black, steel, blue, and green, colliding head on. It was excruciating."[31] Marc was killed near Verdun in 1916.

After 1859 scientists were able to study the physical properties of stars with spectrography. Using the technology to probe the interior of stars, the Danish astronomer Ejnar Hertzsprung and the American Henry Russell announced in 1913 that the different colors of stars are related to their brightness, which suggested that the chemistry of stars changes over

189. Franz Marc, *Blue Horse with Rainbow*, 1914. Watercolor, gouache, and pencil on paper, 6⅜ x 10⅛ in. (16.2 x 25.7 cm). The Museum of Modern Art, New York. John S. Newberry Collection.

190. Franz Marc, *Strife*, from wartime sketchbook, 1915. Pencil, 4 x 6¼ in. (9.8 x 16 cm). Staatliche Graphische Sammlung, Munich.

time. Having devised a way to determine the absolute magnitude of a star (its brightness as seen, in the imagination, by an observer from a uniform distance of three light years away), they produced spectrographs for a group of stars and found that their spectra change with their brightness in a regular way. When they arranged the stars on the chart from dim to bright, the stars' colors made a pattern through the spectrum from red to blue (plate 191). When the Hertzsprung-Russell diagram was published in 1914, it pointed the way to understanding the chemical and physical evolution of stars.

The same year Klee created a metaphor for the creation of stars that put the discovery, which he could have known from a display about it at the Deutsches Museum, into a cultural perspective. Klee never attempted a literal transcription of a concept from science but rather, in works such as *Genesis of the Stars* (plate 192), he made visible the interconnected efforts being made in his day to understand the structure and meaning of the natural world. Using dashes of ink and bursts of watercolor, Klee achieved his goal of creating "light simply as unfolding energy," and across the bottom of the piece the artist wrote after the date "1 Moses 1:14," which in the German Bible of Martin Luther reads: "And God said, Let there be lights in the firmament of the heavens to divide the day from the night; and let them be for signs, and for seasons, and for days, and years."

FIG. 1.

LEFT, TOP

191. Hertzsprung-Russell diagram linking the color of stars with their temperature, in Henry Norris Russell, "Relations between the Spectra and Other Characteristics of the Stars," *Nature* (1914): 252.

Hertzsprung and Russell plotted stars by their luminosity (their absolute magnitude), shown on the vertical axis going from dimmest at the bottom to brightest at the top; they plotted the stars' surface temperature on the horizontal axis, moving from cool stars that emit red light (on the right), through the spectrum to the hottest that emit blue light (on the left). As stars go through their life cycle, they grow brighter (ascending the vertical axis), and they go from emitting red light to blue (moving from right to left on the horizontal axis). Astronomers after Ejnar Hertzsprung and Henry Russell determined that stars over a certain mass reach a gravitational imbalance at midlife that causes them to expand (moving off the main sequence and becoming red giants, shown in the upper right) and then collapse (into white dwarfs, shown below the main sequence on the left). This is the fate predicted for our sun in several billion years; it is currently in the main sequence at absolute magnitude +5.

LEFT, BOTTOM

192. Paul Klee (Swiss, 1879–1940), *Genesis of the Stars (1 Moses 1:14)*, 1914. Pen and watercolor on paper, mounted on cardboard, 6⅜ x 9½ in. (16.2 x 24.2 cm). Private collection, Munich.

STRUCTURE OF THE RADIUM ATOM

EINSTEIN'S SPACE-TIME UNIVERSE

Man seeks to form, in whatever manner is suitable, a simplified and lucid image of the world,
a world picture, and so to overcome the world of experience, by striving to replace it to some
extent by that image. That is what painters do and poets and philosophers and natural
scientists, all in their own way. And into this image and its information each individual places
his or her center of gravity of the emotional life, in order to attain the peace and serenity which
cannot be found within the confines of swirling personal experience.

Albert Einstein, "Principles of Research," 1918

IN AN AMAZING BURST of scientific creativity, Albert Einstein postulated three new theories in one year—1905: the special theory of relativity, the quantum theory of radiation, and his law of the conservation of mass-energy. Each was important, but the theory of relativity (further refined in the general theory of relativity in 1916) was revolutionary. Einstein shattered the notion of absolute space—the great, still ether in which the Newtonian universe resided—and replaced it with a radically altered vision of cosmic unity that links space and time.

THE THEORY OF RELATIVITY

For hundreds of years everyone had known that Earth, the planets, and all the stars in the clockwork universe are in continual motion. Newton had suggested that the universe itself, however, is at absolute rest. He conceived of it as a vast, motionless volume, like a cube in Euclidean geometry, filled with an invisible stationary ether—named after Aristotle's fifth element. Newton understood time as wholly separate from space and counted out by points on an endless line. Any two events are either simultaneous or one comes before the other on the line. Newton's absolute space and time seemed so obvious that they were rarely discussed in the nineteenth century.

When the wave theory of light was adopted in the early nineteenth century it appeared to require the ether to transmit light vibrations through the universe; light seemed to need something to "wave." Assuming that light traveled through the ether at a constant speed, the physicists Albert Michelson and Edward Morley in the United States set about to measure Earth's motion relative to the ether. They reasoned that a beam of light traveling in the direction of Earth's motion and reflected back by a mirror would have a different distance to travel than a beam sent out from the same point at a right angle and reflected back. To test this hypothesis they invented an ingenious laboratory device, an interferometer, to split a beam of light and send half of it going off straight and half at a right angle. After the light was reflected back from mirrors,

193. Ernest Rutherford's and Niels Bohr's solar-system model of hydrogen, helium, lithium, argon, krypton, neon, sodium, copper, xenon, and radium, in H. A. Kramers and Helge Holst, *The Atom and the Bohr Theory of Its Structure* (New York: Alfred A. Knopf, 1923), foldout following 210.

positioned at precisely the same distance from the beam splitter, the interferometer rejoined the beams so that the displacement of the two light waves could be observed. But after many attempts, Michelson and Morley concluded in 1887 that the light always returned in phase, indicating that it had traveled the same distance. What does this mean?

In 1902 the French mathematician Henri Poincaré declared that the failure of the experiment was evidence for his view that the axioms of geometry are not generalizations from experience, but are mere conventions.[1] In other words, Euclidean geometry is not necessarily true but rather it contains useful axioms, and for most purposes Euclidean geometry is convenient because it corresponds to sense experience. But the negative results of the Michelson-Morley experiment indicated that science needed a new convention.

In 1905 Einstein supplied a new overall theory of the universe that accounted for Michelson's and Morley's negative results and extended Poincaré's insight about the conventionality of frames of reference. He did a thought experiment; Einstein imagined that he was riding on a beam of light that was streaking through the heavens, and he asked what the universe would look like to him from that viewpoint. His basic assumption was that the speed of light in a vacuum is always the same, regardless of the motion of the light source relative to the viewer. From this premise Einstein deduced the basic features of a universe: the speed of light is an upper speed limit; if an object approaches the speed of light, time is dilated, the length of the object is contracted, and its mass increases.

The Newtonian laws of physics still apply when observing anything on human scale (from the size of a molecule to the solar system) and when moving at speeds well under the speed of light. However, when one observes an event occurring in a framework that is moving at great speed (approaching the speed of light) relative to the observer's framework—such as when a person observes events occurring in subatomic or intergalactic realms—Newton's laws no longer hold and Einstein's do. Einstein called this a principle of *relativity* because speed is defined relative to an observer. The Michelson-Morley experiment had failed because there is no absolute space—no ether at rest—against which to define velocity.

A consequence of Einstein's theory is that mass must be viewed as a very dense form of energy, as he summarized in his famous formula $E=mc^2$, in which E is energy, m is mass, and c is the speed of light. The speed of light squared is such a vast number that when multiplied by even a small amount of mass, such as a grain of sand, it becomes equivalent to an immense amount of energy. In any process that gives off energy, such as burning oil, a little mass is lost; and any gain of energy entails the gain of a little mass. On a human scale, any gain or loss of mass is so minute that it goes unnoticed, which is why Lavoisier and Helmholtz could consider matter and energy as separate phenomena when they wrote the laws of conservation (see chap. 5). But once researchers began studying radioactivity, the relation between loss of mass to the production of energy could no longer be overlooked because, in the subatomic realm, a vast amount of energy was produced in proportion to the units of the lost mass, as Pierre Curie had noticed. Once Einstein expanded his theory to include the newly discovered relationship of energy to mass in the subatomic realm, the old separate conservation laws were subsumed under a new, more general law of conservation of mass-energy.

In 1907 the Russian-born German physicist Hermann Minkowski demonstrated that Einstein's theory of relativity meant that time must always be taken into account when giving location; space and time do not exist independently and should be joined into one concept, space-time. Minkowski also suggested describing events by using a four-dimensional geometry, the traditional three dimensions plus time. By this point Einstein was trying to generalize his 1905 theory, called "special" because it considered only objects moving at a constant speed, to apply also to objects accelerating under the force of gravity. So Einstein welcomed the idea of incorporating time into measurements, and he adopted the notion of space-time.

When Einstein expanded his special theory of relativity to account for the force of gravity, his generalized theory stated that a gravitational field would bend light waves. He suggested that this phenomenon could be verified if stars beyond the sun, and just off its edge, could be observed during a total eclipse of the sun, by comparing the stars' positions at the moment of the eclipse with where they were against the stellar background when the sun did not intervene. Any shift in their position resulting from the bending of light would be detectable. Although Einstein published this general theory in 1916, a test of it had to await the end of World War I. In 1919 the British Royal Astronomical Society organized an expedition to view a total solar eclipse from an island off West Africa. The stellar shift was observed exactly as Einstein had predicted, thus confirming the bending of light as it passed through the sun's gravitational field (plate 194). These results were announced at a meeting of the British Royal Society on 6 November 1919; the British mathematician Alfred North Whitehead was in the audience and described the moment:

> *The pilgrim fathers of the scientific imagination as it exists today are the great*
> *tragedians of ancient Athens: Aeschylus, Sophocles, Euripides. Their vision of fate*
> *remorseless and indifferent, urging a tragic incident to its inevitable issue, is the*
> *vision possessed by science. Fate in Greek tragedy becomes the order of nature in*
> *modern thought. The absorbing interest in the particular heroic incidents, as an*
> *example and verification of the working of fate, reappears in our epoch as*
> *concentration of interest on the crucial experiments. It was my good fortune to be*
> *present at the meeting of the Royal Society in London when the Astronomer Royal*
> *for England announced that the photographic plates of the famous eclipse, as*
> *measured by his colleagues in Greenwich Observatory, had verified the prediction*
> *of Einstein that rays of light are bent as they pass in the neighborhood of the sun.*
> *The whole atmosphere of tense interest was exactly that of the Greek drama: we*
> *were the chorus commenting on the decree of destiny as disclosed in the*
> *development of a supreme incident. There was a dramatic quality in the very*
> *staging: the traditional ceremonial, and in the background the picture of Newton*
> *to remind us that the greatest of scientific generalizations was now, after more*
> *than two centuries, to receive its first modification. Nor was the personal interest*
> *wanting; a great adventure in thought had at length come safe to shore.*

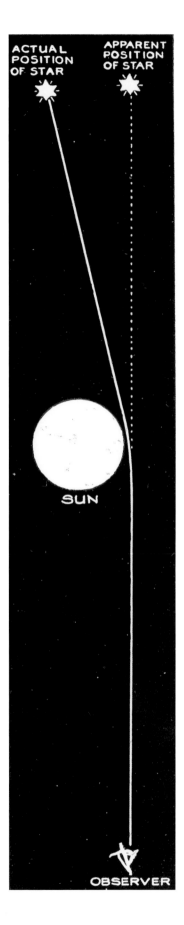

The presentation of Einstein's theory to the public differed by country, which ultimately led to corresponding variations in artistic response. In Germany the new view of the universe was explained by leading scientists, including Einstein, as comprehensible by nonspecialists.[3] The German public knew about Einstein's theory well before the dramatic November 1919 announcement. In April, Berlin's *Vossische Zeitung* published an informative report of a public lecture that Einstein had given, "Basic Ideas of the Relativity Theory," which described the main points of the theory in a clear, understandable way and also announced the forthcoming eclipse.[4] On the day of the eclipse (29 May 1919), the newspaper's readers were reminded by a headline of the significance of the event—"The Sun Brings It to Light"—and thus German readers were prepared to applaud the confirmation of Einstein's prediction and to understand its significance. In November 1919 Einstein had already published *Relativity: The Special and General Theory, a Popular Exposition* (1917), which remains his best-known popular work,[5] and he gave many interviews to the media and public lectures after his theory was confirmed. Other German scientists also assumed the role of teacher, notably Max Born, a renowned professor of physics at the University of Berlin, who in 1919–20 wrote lucid newspaper articles, lectured to large public audiences, and published the popular book *Relativity Theory* (1920).

In general, German scientists and science journalists presented the theory of relativity as intelligible and of great interest to all educated Germans. They spoke in a restrained, tutorial tone, and writers did not hesitate to include some mathematics. Artists who had a link to German culture in 1919 were soon incorporating ideas about space-time and the new cosmos into their painting, photography, film, design, and architecture.

British and American scientists did not step forward to inform their publics but instead fostered a myth of the incomprehensibility of the universe, putting generations of artists and other educated persons at grave risk of intellectual poverty.[6] In Britain the public was not prepared for the announcement, and writers for the *Times*, in the aftermath of the war, sensationalized it as a battle in which Newton, the English father of modern science, was under attack by a "Swiss Jew."[7] One headline of 7 November, 1919, read "Newtonian Ideas Overthrown." (Einstein mused that the British journalist had applied the theory of relativity to politics because the journalist's political framework had influenced his observations: the Englishman described Einstein as a Swiss Jew, but German journalists were hailing him as a "German scientist.")[8] The president of the Royal Society, J. J. Thomson, was quoted in the article as questioning whether physicists really had to revise the foundations of physics or had only learned a new fact. In the following weeks many British scientists defended Newton in the media, and the *Times* published numerous letters to the editor from readers casting a vote for Newton because during the eclipse the amount that the light had bent was "so minute."[9]

In general, the theory of relativity was presented to the British public as an antagonistic battle between Newton and Einstein, with reporters stressing controversies about the validity of relativity, without clearly explaining in the *Times* or other popular publications what was at issue. In 1920 the renowned British physicist and member of the eclipse expedition,

Most of the fundamental ideas of science are essentially simple, and may, as a rule, be expressed in a language comprehensible to everyone.

Albert Einstein,
The Evolution of Physics, 1938

In a popular sense, the difference between the theories of Newton and those of Einstein are infinitesimal, and as they are purely mathematical and can only be expressed in strictly scientific terms it is useless to endeavor to detail them for the man in the street.

J. J. Thomson, 1919

Arthur S. Eddington, published the most widely read English-language popularization of Einstein's theory, *Space, Time, and Gravitation: An Outline of the General Theory of Relativity.* Eddington presented the new physics as irrelevant to the physical world of everyday experience: "In regard to the nature of things, this knowledge is only an empty shell—a form of symbols. It is knowledge of structural form, and not knowledge of content."[10]

In America, Einstein's theory was dramatized as a battle between esoteric scientists who live in an ivory tower and everyday people who use common sense. Rather than help non-scientists understand Einstein's theory so that the man on the street could feel part of the revolution in cosmology, in the months following the announcement American scientists assumed the attitude of their British colleagues and reveled in the image of inscrutability. In the first days after the announcement, an unnamed astronomer stated in an interview with a reporter for the *New York Times,* "Enough has been said to show the importance of Einstein's theory, even if it cannot be put into words," and the American astronomer W. J. S. Lockyer was quoted as saying that Einstein's discovery "though very important does not affect anything on earth and does not personally concern ordinary people."[11] As this myth of incomprehensibility and irrelevance was forming in November 1919, the editors of the *New York Times* expressed the frustration felt by educated Americans at the British and American scientists who hid behind a veil of inscrutability, but in the end they succumbed to the same anti-intellectualism that afflicted the scientists.

> *As all common folk are suavely informed by the President of the Royal Society that Dr. Einstein's deductions from the behavior of light as observed during an eclipse cannot be put in language comprehensible to them, they are under no obligation to worry their heads, already tired by contemplation of so many hard problems, about this addition to the number. . . .*
>
> *It would take the Presidents of at least two royal societies to give plausibility, or even thinkability, to the declaration that as light has weight, space has limits. It just doesn't, by definition, and that's the end of that—for common folk—however it may be for higher mathematicians.*[12]

In the early 1920s leaders of American science became alarmed that the ordinary citizen's "ivory tower" view of physicists was eroding public support for science. The American Association for the Advancement of Science hired its first press officer in the mid-1920s, and many popular articles published in the 1920s stated that pure science is the source of technology and therefore good for business. Science journalists pointed out that $E=mc^2$ means that the atom is the source of enormous energy—"a source of power inconceivably greater than any possible requirement of the human race"—and once scientists learned to release atomic energy, "the world's people will be freed from the need of constant toil."[13] But the American public continued to view Einstein's physics as incomprehensible, irrelevant, and weird. It is not surprising that British and American artists and writers made little use of the theory in the decades following the confirmation of relativity. Their occasional references to it betray an appalling lack of science education.

195. Diagram of Albert Einstein's thought experiments, in Charles Nordmann, "Une Révolution dans notre connaissance du monde" (A revolution in our understanding of the world), *L'Illustration* 157, no. 4082 (28 May 1921): 507 (illus.), 504–7 (text).

In this illustration of the relativity of motion, the hat and umbrella are falling from the point of view of observers in the stationary elevator above, but to descending observers the hat and umbrella are at rest.

Einstein's theory joined up subject and object, in very much the same way as it joined up space and time.

Lawrence Durrell, *A Key to Modern British Poetry,* 1952

From the earliest days of the popularization of the new cosmology, in places where lucid exposition was lacking there developed a widespread misunderstanding that physical relativity implies moral relativity or cultural relativity—"everything is relative"—which persists to this day (plate 196). While this is not the place to address this topic, it is a reminder of the extent to which the educated public in the twentieth century looked to scientists for moral guidance.

"To you it was fast."

196. Cartoon by Eric Lewis, in the *New Yorker*, 13 Nov. 2000.

The theory of relativity applies in full to the universe of fiction . . . [where] there is no more place for a privileged observer in a real novel than in the world of Einstein.

Jean-Paul Sartre, 1939

In France, Poincaré's work on the conventionality of axioms of geometry had set the stage for the theory of relativity, as Einstein often acknowledged, and so relativity was welcomed in Paris in 1919 as confirmation of the French mathematician's theory. French journalists presented Einstein in the same breath with Poincaré and gave the public the impression that, yes, the theory of relativity was revolutionary (plate 195), but that they already knew a lot about its background because of Poincaré. French intellectuals invited Einstein to Paris to lecture at the Collège de France and confer with them in 1922, and he was interviewed for the popular press during his visit.[14]

When relativity came to international attention in 1919, most French artists were becoming engrossed in the unconscious mind, so the new physics claimed only mild attention in Surrealist circles. References to the space-time universe were typically given a psychoanalytic spin (plate 197), and Poincaré was ubiquitous (plate 198). Nonetheless, Einstein was revered by French artists as one of the savants.

ABOVE

197. Salvador Dalí (Spanish, 1904–1989), *The Persistence of Memory*, 1931. Oil on canvas, 9½ x 13 in. (24.1 x 33 cm). The Museum of Modern Art, New York. Given anonymously.

Dalí proclaimed in 1935 that the soft watches in this painting are a metaphor for "Einsteinian space-time . . . nothing else than the tender, extravagant and solitary paranoiac-critical Camembert of time and space."

RIGHT

198. Man Ray (American, 1890–1976), *Surface with a Constant Negative Curvature, Derived from the Pseudosphere*, 1932–34. Photograph. 9⅝ x 7¼ in. (24 x 18 cm).

Underlining the French role in the new cosmology, Man Ray made this photograph of a plaster model of a non-Euclidean volume at the Institut Henri Poincaré, for display at a 1936 Surrealist exhibition in Paris.

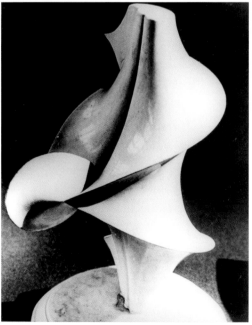

Because his scientific authority was unrivaled, after 1919 Einstein became a spokesman for science and responded to many queries about spiritual matters in letters and published statements. His "cosmic religion"—basically a pantheist reverence for nature—was widely held by the educated public in the interwar era. His outlook was abandoned only when the detonation of the first nuclear bomb in 1945 ushered in an era of public cynicism and dread.

Einstein was born to German Jewish parents and raised in a secular home in Munich; his family did not attend synagogue, observe holy days, or abide by dietary restrictions. In his education, which was broadly humanistic with a concentration in theoretical physics, he was drawn to prophets and scholars throughout the ages who espoused a pantheistic outlook. In accordance with this tradition Einstein believed that there is an order to the universe, which he experienced as a feeling of awe before nature. He held this sensation to be sacred, in the sense of being of utmost importance. Einstein identified God with these cosmic laws, which he believed were completely deterministic; "God does not play dice with the universe."[15] He distinguished sharply between faith in a personal, supernatural God, which he dismissed as prescientific, and conviction that there is a cosmic order, which he felt was essential to the scientific outlook. Without intensely felt belief—a faith, if you will—that there is a structure in nature, science becomes bookkeeping: "Science without religion is lame; religion without science is blind."[16] Einstein objected to the association of science with atheism because a lack of religious feeling was deadening to the imagination. He was equally opposed to the organized church's resistance to science because it led to intellectual poverty.

Among German intellectuals of the late 1920s there was a strong move led by logical positivists to rid science of metaphysical associations, and the pantheistic spiritual yearnings of the nineteenth-century Naturphilosophen were especially shunned. In 1927 Freud, always on guard against psychoanalysis being viewed as a religion, published *The Future of an Illusion* (the illusion being religion). In it he described religious feeling about any God, personal or pantheistic, as infantile; a personal God is a father figure, according to Freud, and pantheistic feelings for uniting with Mother Nature are a desire to return to the womb.[17] Einstein disagreed with Freud's diagnosis of all religious impulses as pathological, believing instead that even prescientific religious impulses are the sign of a healthy (if uneducated) mind: "We followers of Spinoza see our God in the wonderful order and lawfulness of all that exists and in its soul as it reveals itself in man and animal. It is a different question whether belief in a personal God should be contested. Freud endorsed this view in his latest publication. I myself would never engage in such a task. For such a belief seems to me preferable to the lack of any transcendental outlook of life, and I wonder whether one can ever successfully render to the majority of mankind a more sublime means in order to satisfy its metaphysical needs."[18] For Spinoza—an uncompromising rationalist who proclaimed that the universe embodies an order that the human mind can discover—nature was sacred but not shrouded in supernatural secrets; God/Nature is completely predictable and knowable. In his major work *Ethics Demonstrated in a Geometric Manner* (1677), Spinoza put forth his pantheist doctrine in the format of Euclid's *Elements of Geometry*, as a proof drawn from premises, axioms, and definitions.

Devout believers are safeguarded in a high degree against the risk of certain neurotic illnesses; their acceptance of the universal neurosis spares them the task of constructing a personal one.

Sigmund Freud,
The Future of an Illusion, 1927

Einstein's best-known statement on the spiritual came in a long essay, "Religion and Science," written for the *New York Times Magazine* in 1930. Religious experience, he said, develops in three stages: primitive man has a "religion of fear"; after he becomes socialized, man develops a "social or moral conception of God," who rewards and punishes. Einstein described the third as "the cosmic religious feeling":

> *The individual feels the futility of human desires and aims and the sublimity and marvelous order that reveal themselves both in nature and in the world of thought. Individual existence impresses him as a sort of prison, and he wants to experience the universe as a single significant whole. The beginnings of cosmic religious feeling already appear at an early stage of development, for example, in many of the Psalms of David and in some of the Prophets. Buddhism, as we have learned especially from the wonderful writings of Schopenhauer, contains a much stronger element of this. The religious geniuses of all ages have been distinguished by this kind of religious feeling, which knows no dogma and no God conceived in man's image; so that there can be no church whose central teachings are based on it. Hence, it is precisely among the heretics of every age that we find men who were filled with this highest kind of religious feeling and were in many cases regarded by their contemporaries as atheists, sometimes also as saints. Looked at in this light, men like Democritus, Francis of Assisi, and Spinoza are closely akin to one another.*[19]

Einstein's pantheistic views were widely discussed in the 1920s and '30s in the context of science, theology, and the general culture, and they remain extremely influential to this day. As Thomas Huxley's agnosticism was a required attitude among late-nineteenth-century scientists, so Einstein's sense of wonder at the cosmos was shared by many scientists and artists in the interwar era, a time of major breakthroughs in cosmology and subatomic physics. And as artists in the 1920s began to search for ways to express Einstein's space-time universe, a new understanding of the atom emerged that led some scientists to declare that ultimate reality cannot be pictured at all.

QUANTUM MECHANICS

When Max Planck was a student in Berlin in the closing decades of the nineteenth century, his teachers advised him against a career in physics. They reasoned that physicists were so close to completely describing every last cog of the clockwork universe that there wouldn't be anything left for him to do. He earned his degree in physics nonetheless, and when in 1900 he defined a "quantum," he pulled the pendulum out of the great clock. To account for observations of how hot objects appeared to radiate heat, Planck hypothesized that radiant energy is emitted not in a continuous stream but in small packets of energy, each of which is a discrete quantity—a quantum. In 1905 Einstein showed that light consists of quanta (with the energy in each of its packets proportional to the frequency of its wavelength); thus in some respects, a light wave can be treated as a group of particles ("photons"). In 1913 Niels Bohr went on to use quanta to explain

2p m = 0

4f m = 3

2s m = 0

4d m = 1

5f m = 0

3s m = 0

the absorption and emission of electromagnetic energy by atoms. He began with the simplest case, a hydrogen atom, which Ernest Rutherford had described as composed of a nucleus with a charge of +1, orbited by a single electron with a charge of −1. Bohr proposed that the electron actually has several possible orbits. Which orbit the electron takes depends on whether it has more or less energy, and the electron's momentum can take on only certain quanticized values. The electron does not expand its orbit smoothly; it jumps (takes a "quantum leap") to the next orbit. As the atom loses energy, the electron drops to a lower energy level and orbits closer to the nucleus. As it drops, the electron gives off a quantum of radiation, such as a light wave, with an energy equal to the energy difference of the orbits.

Bohr's "quantum model" of the hydrogen atom was a confirmation of the hypothesis that light is emitted in discrete quanta at the atomic level—atoms can absorb and emit energy only in precise wavelengths. Bohr had also explained the origin of hydrogen's "spectral fingerprint"—the unique pattern of light it emits—which is the basis of spectrography (see chap. 8). Bohr and others tried to extend his quantum model to multielectron atoms, but by 1925 they had had only limited success. Then, almost simultaneously, three physicists—Werner Heisenberg in Germany, Louis de Broglie in France, and Erwin Schrödinger in Switzerland—proposed laws governing quantum energy within the atom. By 1927 those laws had been synthesized into a general theory known as quantum mechanics, which describes the organization of all ninety-two elements on Dmitri Mendeleyev's table and explains all Gustav Kirchhoff's spectrographs as caused by the emission and absorption of energy. A centerpiece of the theory is that, just as light (energy) is a particle, so electrons (particles) are wavelike. By the late 1920s the quantum had become so essential to physics that all physics from Newton to Planck began to be called "classical physics" and after Planck, "quantum physics."

The Visible and the Absolute: Abstract and Nonrepresentational Art

In describing the first wave of abstract art that emerged in response to the revolution in biology in the late nineteenth and early twentieth centuries, I distinguished different approaches to abstracting from nature, including the representation of nature at a smaller scale (Art Nouveau) and the recording of an artist's cognition of nature (the physiological perspective of Monet, Cézanne, and the Cubists). These styles were based ultimately in vision (what things look like), and Art Nouveau, Impressionist, and Cubist paintings are pictures in the sense that they are depictions of the natural world, although nature had changed (it got magnified, and it went inside the nervous system). Only art about the Absolute (by Endell, Kandinsky, and Malevich) was truly nonrepresentational (not a picture); it did not use perspective (it was not a symbolic form of the artist's concept of space and time) but borrowed signs and ideas from music and mathematics to embody a concept of a supremely evolved consciousness—an Absolute Idea.

The second wave of abstract art precipitated by the revolution in physics raised issues again about the extent to which an artist can visualize the invisible realms revealed by science. After popular interest shifted from evolutionary biology to physics in the early twentieth century, and after Newton's absolute space and time had been deposed, some wondered whether

there was still an Absolute. History has shown that no matter how unimaginably bizarre nature came to seem, both artists and scientists wanted pictures of it, and the notion of an Absolute continued to be meaningful in both the studio and the laboratory.

The space-time universe described by the general theory of relativity was the product of two very visual minds. Einstein realized that space and time are relative to an observer's framework by imagining what the universe would look like if he were riding through it on a light wave; Minkowski conceived of space-time by visualizing the laws of nature using geometry.[20] In place of the lost Newtonian absolutes, Minkowski proposed not only a new space-time geometry but also a new metaphysical outlook in which the universe is an unchanging, four-dimensional realm—he called it the "Absolute World"—that one cannot experience physically but only imagine in the mind's eye.[21]

Artists developed several styles of abstract art that attempted to picture the new understanding of nature. Incorporating abstract motifs from diagrams related to the structure of matter and energy, the Futurists used force lines to represent electromagnetic energy. After the confirmation of the theory of relativity in 1919, other artists developed a cosmic perspective to picture the new symbolic form of space-time: they abandoned Euclidean geometry and imagined the non-Euclidean space-time universe and the quantum realm; architects designed skyscrapers to connect with the cosmos. Physicists themselves argued about the extent to which the most elementary building blocks of the natural world—the matter and energy in atoms—can be pictured at all. When Niels Bohr presented his quantum mechanical model of the atom in 1913, he tried to provide a visualization of spectral lines (which represent the energy given off or absorbed by an electron as it passes from one state to another) by borrowing Rutherford's miniature solar system, which remains to this day the most popular image of the atom in the popular imagination (plate 193).

Erwin Schrödinger suggested that Bohr's model made more sense if it treated the electrons as waves; he envisioned the vibrating wave-matter (the electron) as a cloud of energy (plate 199). For his part, Heisenberg considered all such pictures misleading and advocated representing the structure of an atom using only the numerical values of its spectral lines. But most physicists found that it was easier to think about subatomic events if they had a visual model in mind, and thus in the 1920s and '30s pictures by Schrödinger and others prevailed in both the laboratory and the studio.[22] It was only in 1945, in response to the unleashing of the nuclear force—the awesome, terrifying, almighty new Absolute—that artists in Italy and America developed a completely nonrepresentational style (lacking depiction and any spatial or temporal perspective) in response to the new physics.

A remarkable and captivating result of Bohr's atomic theory is the demonstration that the atom is a small planetary system.... The thought that the macrocosmos is reflected in the microcosm exercises a great magic on mankind's mind; indeed its form is rooted in the superstition (which is as old as the history of thought) that the destiny of men could be read from the stars. The astrological mysticism has disappeared from science, but what remains is the goal of comprehending the universal law of the world.

Max Born, "Quantum Theory and Errors in the Sums," 1923

199. Erwin Schrödinger's electron clouds, in H. E. White, "Pictorial Representations of the Electron Cloud for Hydrogen-like Atoms," *Physical Review* 37 (1 June 1931): 1416.

In these models of the hydrogen atom, which is composed of one proton and one electron, Schrödinger envisioned the electron as a diffuse cloud of energy hovering around the proton. The various shapes diagram different patterns of probable locations of the electron.

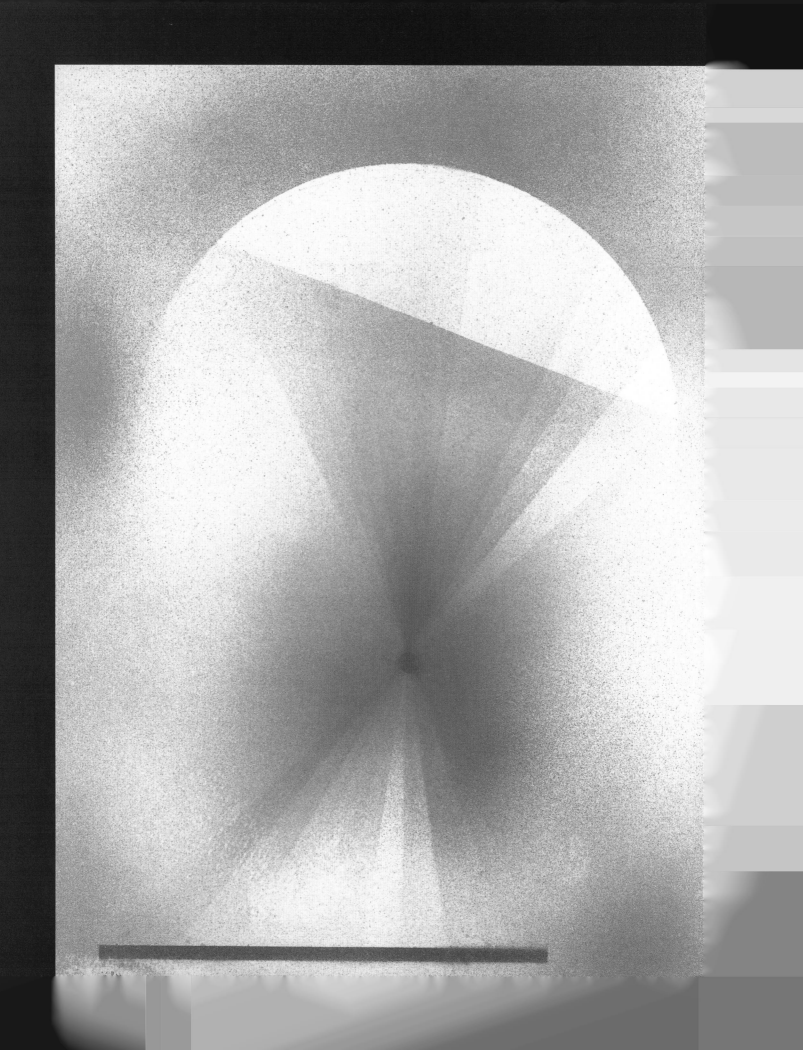

Abstract Art with a Cosmic Perspective

While the expressive possibilities of Neoplasticism are limited to two dimensions (the plane),
Elementarism realizes the possibility of plasticism in four dimensions, in the field of space-time.
Theo van Doesburg, "Elementarism," 1926–27

IN THE LATE NINETEENTH century the dualisms that had defined the clockwork universe—matter and energy, mind and matter—began to dissolve, and the ancient quest to conceptualize nature as a unified whole, as a synthesis of the microcosm and macrocosm, showed signs of renewal. Scientists had developed spectrography and theories of electromagnetism that related both to the atom and to the cosmos, and there was a resurgence of panpsychism in Munich Jugendstil. The confirmation of Einstein's theory of relativity—in which matter and energy, space and time, are inextricably bound together—strengthened artists' desire to express cosmic unity. Artists who had derived a vocabulary of biomorphic shapes from the microscopic realm soon extended their imagery to express themes of the macrocosm.

Other artists and architects, who had been composing with the squares, rectangles, and cubes of Euclidean geometry, now learned that Einstein's space-time universe was four-dimensional. Suddenly Newton's Euclidean model of the universe as a vast three-dimensional volume was obsolete. In Euclid's geometry the shortest distance between two points is a straight line; in Einstein's universe, the line is curved. Many artists asked: What does the new geometry mean for us?

Biomorphic Abstraction

The unified explanation of nature, coupled with the influence of panpsychism (the view that all matter has consciousness) encouraged artists to make graphic expressions of the merger of microcosm and macrocosm. The Jugendstil artist Hans Schmithals studied in Munich with Hermann Obrist, and he adopted his teacher's spiral motif in a series of paintings. Nineteenth-century astronomers had generally agreed that Earth and the solar system were formed from a rotating cloud of gas (the "nebular hypothesis"). Schmithals created a stunning visualization of a primordial cloud, but the cloud is not composed of inert matter; this is a cloud of bacilli—sentient, living organisms (plate 201).

František Kupka's interest in electromagnetism (see chap. 8) also had a panpsychic, cosmic dimension: "If an artist is sensitive and open to all impressions, his being resonates with

200. Paul Klee (Swiss, 1879–1940), *Horizon, Zenith, and Atmosphere*, 1925. Watercolor on paper, mounted on board, 15 x 10⅝ in. (37.9 x 26.9 cm). Solomon R. Guggenheim Museum, New York. 48.1172.X533.

events and movements throughout the whole universe. His inspiration comes not only from his intellect, but the 'visit of the muse' is also a concrete, physiological phenomenon. . . . The artist's central nervous system becomes a conductor of telepathic communication, picking up the wave vibrations of an idea that is, as one says, 'in the air.' The artist, without being conscious of it, becomes the vehicle of an independent idea."[1] Before World War I, Kupka began a series of paintings with cosmic themes, including *Cosmic Spring* (plate 202), in which forms suggesting microorganisms, crystals, minerals, and gases merge in bands over what is apparently a celestial globe. In 1912–13 the artist described his cosmic vision as the interconnectedness of forms in nature: "Reproductive cells connect to other cells and these connect to others. Thus every organism launches into its environment as it expands and grows, and the ways in which it adapts to its particular milieu is manifest in its appearance. The same is true of clouds, which are accumulations of vapor that are shaped by movements in the atmosphere. . . . Stalactites suspended in salt caves . . . icicles from waterfalls . . . both result from the same process of condensation that creates patterns of frost on a window pane."[2]

Curving, cellular forms from the microscopic realm that had inspired late-nineteenth-century Art Nouveau and Jugendstil artists were kept in the public eye in connection with two exciting fields of medical research—genetics and antibiotics. After Gregor Mendel's laws of genetics were rediscovered in 1900, biologists began mapping the location of genes on the

203. Film of a drop of blood that is infested with spirochetes, in "Cinematography of the Invisible," *La Nature* 37 (June–Nov. 1909): 365.

This drop of blood, magnified ten thousand times, reveals infection with spirochetes, spiral-shaped bacteria that are visible in the film as wavy white lines.

204. Hans Arp (French, 1886–1966), *Automatic Drawing*, 1917–18; dated on work 1916. Ink on paper, 16¾ x 21⅜ in. (42.6 x 54 cm). The Museum of Modern Art, New York. Given anonymously.

chromosome. The first complete chromosome map of the drosophilia (fruit fly) was completed in 1934, and the first chemicals with strong antibacterial properties—antibiotics—were developed in 1935 (sulfa drugs), followed by the isolation of the germ-killing agent in penicillin on the eve of World War II. Microscopic images in the popular press were enhanced in the first decades of the twentieth century by improved staining and lighting techniques, which gave tissue slices and crystals clearer definition (plate 205), and by filmmaking through a microscope, which brought the public fascinating glimpses of cells in motion (plate 203).

Artists who worked in styles related to cosmic unity before World War I had created styles of biomorphic abstraction using cellular forms derived from Art Nouveau. During the war artists also invented automatic methods such as pouring ink, for making abstract shapes. Hans Arp's early career included collaboration with Der Blaue Reiter, with whom he shared the desire to communicate spiritual themes through abstract color and form. When World War I broke out, Arp sought refuge in Zurich, and in 1915 he wrote the preface to a catalogue for an exhibition that included collages, tapestries, and embroideries by himself, Sophie Taeuber, and others. In the short text he expressed the central theme of his work—a search for an absolute reality in the Platonic and mystical tradition of seeing (finding insight) in the darkness. "Art should lead to the spiritual, and the real. This reality is neither objective reality, not the subjective reality of thought, but a mystical reality that is related to vision in the following Neoplatonic sense: 'When in daylight one cannot truly see; one can see truth only in darkness, in the abyss.'"[3]

After the poet Tristan Tzara launched Zurich Dada with his manifesto of 1916, Arp began using automatic techniques, such as tearing and dropping scraps of paper as well as pouring ink (plate 204), to generate biomorphic shapes. But unlike many of the Dadaists, Arp was drawn to automatic behavior not because of its link with the irrational regions of the unconscious mind and mental illness but because of its associations with automatic processes, such as breathing and memory, that occur below conscious awareness in a healthy individual. Arp was familiar with this meaning of automatism from his colleague in Zurich Dada, the poet and student of neuropsychiatry Richard Huelsenbeck, who described automatic physical and mental processes as follows: "The automatic forces of nature are the forces that support the self, as we feel these and their regulatory influence in our bodies and in our daily lives."[4]

In abandoning himself to chance processes, Arp, like Endell and Kandinsky before him, was connecting with natural forces, not his Freudian unconscious. In so doing he developed a vocabulary of ovoid shapes: "I simplified my forms and united their essence in moving ovals, symbols of metamorphosis and the development of bodies. *Terrestrial Forms*, a wood relief that Picabia reproduced in his review *391*, dates to this time [1917–18], and it was the first of a long series."[5] Arp had a lifelong interest in pre-Socratic philosophers and other proponents of cosmic unity, and thus it is not surprising that for a reading he gave on stage at the Cabaret Voltaire on 12 May 1917, Arp chose a text by the great German mystic Jakob Böhme. Indeed, Arp's 1915 proclamation that "one can see truth only in darkness, in the abyss" was in sympathy with Böhme's 1634 description of his journey toward union with the World Soul as moving from blindness to sight: "I am as blind a man as ever was, and am able to do nothing. But in the spirit of God, my rejuvenated spirit seeth all."[6]

205. Crystals of caffeine, in Jacques Baschet, "La microphotographie et l'art décoratif" (Microphotography and decorative art), *L'Illustration* 178, no. 4594 (21 Mar. 1931): 349 (illus.), 349–51 (text).

After World War I, Arp settled in Paris, where Einstein's new view of the universe was publicized to the art world in the periodical *L'Esprit nouveau.* By the late 1920s Arp had developed a style of biomorphic abstraction that expressed the new view of the cosmos as a dynamic unity; it featured biomorphic, biological forms (the microcosm) floating in vast space (the macrocosm), created by automatic processes (invisible forces in nature). For example, in *Objects Arranged According to the Laws of Chance: Navels* (1930; Museum of Modern Art, New York), Arp arranged ovals (navels, symbolizing the origin of life) in front of a void by an automatic process (a natural force). He made the cosmic link specific by calling the works in this series *Constellations* (plate 206). Reflecting on his *Constellations* in 1950, Arp wrote: "The forms that I created between 1927 and 1948 and that I called cosmic forms were vast forms meant to encompass a multitude of forms such as: the egg, the planetary orbit, the path of the planets, the bud, the human head, the breasts, the sea shell, the waves, the bell. I arranged these forms into patterns like constellations 'according to the laws of chance.'"[7]

The French popular press of the 1920s was filled with celestial imagery as astronomers argued about the size and shape of the new space-time universe. A "yardstick" to measure distance had been provided in 1912 by the American astronomer Henrietta Leavitt. Stars that fluctuate in brightness in a very regular way had been found in the constellation Cepheus, and Leavitt established that the period of brightness of these stars varies directly with their absolute

206. Hans Arp, *Constellation with Five White Forms and Two Black, Variation III*, 1932. Oil on wood, 23⅝ x 29⅝ in. (60 x 75.5 cm). Solomon R. Guggenheim Museum, New York. 55.1437.

magnitude (as opposed to how bright they look from Earth)—the longer the period, the brighter the star. Because she discovered them in the constellation Cepheus, Leavitt named these fluctuating stars "cepheid variable stars," but their great usefulness in measuring distance derives from their presence throughout the sky. Thus, if a celestial array contains a cepheid star, the astronomer knows its absolute magnitude from its period and can calculate how far away it is from its apparent magnitude—if a cepheid with a long period of brightness appears faint in the night sky, then it is very far away.

Using cepheids, astronomers by the mid-1920s had determined that the Milky Way galaxy is in the shape of a lens, with a diameter of about 100,000 light years (a light year is the distance light travels in a year). Popular publications printed diagrams of the galaxy, locating our sun about three-fourths of the way out to the rim. This struck scientists and the public alike as being a very big galaxy, and the imagination of the educated public was suddenly expanded (plate 207); many in the early 1920s wondered whether the Milky Way was the entire space-time universe. Fanciful diagrams in the popular press invited the public to ponder various universes (plate 208); what was the size and shape of the cosmos? In search of an answer, attention focused on nebulas—small wisps of luminous fog that are visible to the naked eye. On a clear, moonless night, in the constellation Andromeda one sees a very distinct elongated oval nebula. Kant had speculated that the Andromeda nebula is an "island universe," and William Parsons had discovered its spiral structure in 1845 using England's new seventy-two-inch reflector telescope. But Parsons saw no stars in the nebula; why did it glow? Using the new one hundred-inch telescope atop Mount Wilson in California, in 1924 Edwin Hubble focused on the Andromeda nebula, and it resolved into a disk-shaped galaxy composed of stars; he had discovered that there is a second galaxy in the universe (plate 209), just like the Milky Way. Moreover it contained cepheid stars, so Hubble could calculate its distance from Earth—over

207. "Model of the Galaxy," in J. S. Plaskett, *The Dimensions and Structure of the Galaxy* (Oxford: Clarendon Press, 1935), pl. II, facing 30.
 This 1935 model, which is essentially the one used today, presents the Milky Way as a vast rotating disk with a diameter of 100,000 light years. The diagram is in parsecs, which is an astronomical unit of length based on the distance from Earth at which stellar parallax equals one second of arc (one par|allax|sec|ond| equals 3.258 light years). Shown edge-on, the disk has massive clusters of stars pulled to its center by the force of gravity. The sun is about three-fourths of the way out, shown here on the left about 10,000 parsecs (30,000 light years) from the galaxy's center.

a

b

208. Theories of the universe, in Charles Nordmann, "L'Univers est-il infini?" (Is the universe infinite?), *L'Illustration* 158, no. 4107 (19 Nov. 1921): 460 (illus.), 458–61 (text).

As late as 1921 astronomers still argued about whether the Milky Way (Voie Lactée) was *(a)* the entire universe, surrounded perhaps by a few nebulas and groups of stars. Or were there *(b)* several other galaxies (Autres Voies Lactées)? Today astronomers estimate that the universe contains 100 billion galaxies.

RIGHT

209. Andromeda Nebula, visible light photograph, 1959. Mount Wilson Observatory, Palomar, California. American Museum of Natural History Library, New York.

a million light years away. Many other galaxies were soon found, even farther away, and by the late 1920s it became clear that the universe contains hundreds, even thousands of galaxies.

In an atmosphere of great popular interest in stars and galaxies during the 1920s and '30s, other artists in Paris followed Arp's path and developed forms of biomorphic abstraction incorporating celestial imagery. Constantin Brancusi studied mathematics, physics, and industrial arts for four years in his native Romania before studying sculpture in Bucharest and then Paris. Thus, he had the training to understand very well the significance of the confirmation of Einstein's new cosmology in 1919. The following year he created a simple symbol of creation (plate 211), an ovoid form suggesting both an egg and a celestial body. Brancusi had used this biomorphic form since 1909 (*Sleeping Muse*, 1910; Centre National d'Art et de Culture Georges Pompidou, Paris, and *Sculpture for the Blind*, 1916; Philadelphia Museum of Art), and he would have been aware, from his friend and fellow Romanian Tristan Tzara, of its use by Zurich Dadists such as Arp. Like Arp, after 1919 Brancusi expanded symbolic associations of the simple form to encompass the cosmos.

The Spanish artist Joan Miró adopted a vocabulary of cellular shapes in the mid-1920s, after experimenting with Fauvism and Cubism in Barcelona and then settling in Paris

210. *Hubble Deep Field*, a true-color image assembled from many exposures taken with the Wide-Field and Planetary Camera 2 in blue, red, and infrared light for ten consecutive days, 18–29 December 1995. Robert Williams and the Hubble Deep Field Team (StScI) and NASA.

The recent dramatic increase in the number of known galaxies in the universe is based, in large part, on this picture. The Hubble Deep Field is a tiny "keyhole" view all the way back to the visible horizon of the universe. The image was made by aiming the Hubble Space Telescope at a dark spot just above the cup in the Big Dipper and recording for ten consecutive days. The area covered by the photograph is the size of a grain of sand seen from six feet away, and it provides a needle-thin core sample of the universe. About 40 million similar "snapshots" would be needed to cover the entire sky. Though small, this sample of the sky is considered representative of the typical distribution of galaxies in space because the universe, statistically, looks the same in all directions. Before this image was taken in 1995, the estimate of galaxies in the universe was about 10 billion. After counting up the 3,000 galaxies in this tiny sample of the sky, astronomers added 50 billion galaxies to the total number in the universe. Today the sum has risen to over 100 billion and astronomers are still counting. Looking out in space is also looking back in time; some of the galaxies in the Hubble Deep Field were formed less than a billion years after the Big Bang.

in 1920. Like Arp, Miró used biomorphs as a universal language—symbolizing an egg, a cell, a seed, a star floating in space, as in *Birth of the World* (1925; Museum of Modern Art, New York). The artist created its dripped and stained background using automatic techniques, on which he floated forms suggestive of birth in the microworld (a sperm, an ovum) and in the macroworld (a planet or star forming from a cloud). Miró went on to create a series of constellations using the same vocabulary (plate 212), often with the playfulness of children's art; against an empty background space, the artist painted spheres and stars that float weightless, without gravity in the void, then connected them with lines to form pictures—constellations.

Artists working in styles of biomorphic abstraction found continued inspiration in astronomy, as many new galaxies were discovered and classified. In addition to using cepheid variable stars to measure distance, interwar astronomers found that they could use the spectra of stars to measure their speed; the spectral pattern in light waves from a moving star shifts in the same way that sound waves from a moving source do. If a whistle is blowing at a constant pitch on a moving train, to a stationary observer standing near the tracks the sound appears to get higher as the train approaches (because the peaks of the sound waves are hitting the observer's eardrums at closer intervals) and to get lower as the train speeds away. But to an observer riding on the train, the sound appears constant. The same relativity of observation is true for light waves in the space-time universe. Just as the pitch of a train whistle rises as it approaches and drops as it recedes, so the pattern of lines in starlight shifts to the blue end of

OPPOSITE

211. Constantin Brancusi (Romanian, 1876–1957), *Beginning of the World*, c. 1920. Marble, metal, and stone, 29⅝ x 11⅜ in. (75.2 x 29 cm). Dallas Museum of Art. Foundation for the Arts Collection, gift of Mr. and Mrs. James H. Clark.

ABOVE

212. Joan Miró (Spanish, 1893–1983), *Morning Star*, from the *Constellation* series, 1940. Tempera, gouache, egg, oil, and pastel on paper, 15 x 18⅛ in. (38 x 46 cm). Fundació Joan Miró, Barcelona.

213. "The Velocity-Distance
Relations for Extra-Galactic
Nebulae," in Edwin Hubble,
The Realm of the Nebulae (New
Haven, Conn., and London: Yale
University Press, 1936), 69.

On the right are five nebulas (known today to be galaxies) that Hubble picked to demonstrate his law because they contain cepheid variable stars, and thus he could measure the distance of each nebula from Earth. He then did a spectral analysis of the light coming from the five nebulas; the absorption lines (recorded for burning calcium) are shown on left. Each spectra looks the same because Hubble published this illustration of the patterns of absorption lines in black and white; but in color, as he saw them, the lines in the top spectra (for NGC 221) moved from the blue end of the spectrum on the left to red on the right; in the next (NGC 4473) the color of the pattern of lines is shifted slightly to the red end of the spectrum (indicated by the small arrow pointing right). Just as hearing a train whistle descend the scale as it speeds away, seeing light from a nebula shift to the red end of the spectrum indicates that it is receding. NGC 221, located 900,000 light years away, is receding at 125 miles per second; NGC 4473, located much further from Earth at seven million light years away, recedes much more rapidly at 1,400 miles per second. And so on with Hubble's other three nebulas, whose increasing redshifts he indicated with the longer arrows.

the spectrum if the star is approaching Earth and moves to the red end if the star is receding. As new galaxies were discovered, their spectra were measured; some, such as Andromeda, were moving toward Earth, but most were moving away. In 1929 Hubble suggested that all the accumulated measurements showed a pattern in the movement of galaxies: as galaxies get farther away, their velocity increases proportionally, that is, if one galaxy is twice as far away from Earth as another, then it recedes at twice the speed—Hubble's law (plate 213). Newspapers, popular science magazines, and a host of books for the general public, such as Arthur S. Eddington's classic *The Expanding Universe* announced to a startled world that the universe is expanding very, very rapidly.

After the Bauhaus closed in 1933, Kandinsky traveled to Paris and joined Arp, his old friend from the days of Der Blaue Reiter. Building on his background in Jugendstil biomorphism and the pursuit of cosmic unity, Kandinsky adopted the style of biomorphic abstraction from Arp and others and began painting cellular shapes, such as *Environment* (plate 214). At the Bauhaus, Kandinsky had already done drawings after microscopic images (plate 215); never one to use automatic techniques, he abstracted those forms directly from biological sources.[8] In

sympathy with Arp's pantheist approach to nature, Kandinsky declared "the 'hidden soul' in all things, seen either by the unaided eye or through microscopes or binoculars, is what I call the 'internal eye.'"[9]

In 1930 the heavens were again brought to public attention by the discovery of a new planet. The detection of Neptune in 1846 had left a tiny fraction of Saturn's and Uranus's perturbations unaccounted for, and early-twentieth-century astronomers, with bigger telescopes and better photography, continued the search for yet more planets. The long, tedious search had not been described in the popular press, and in 1930 the public was astonished to learn that there was another planet, Pluto, named for the ruler of the netherworld (plate 216). That same year Alexander Calder made his first mobile sculpture, whose detached elements, suspended in space, may have been inspired by the discovery.

After being educated at the Art Students League in New York, Calder began visiting Paris in 1926. There he was drawn to the more whimsical aspect of Miró's style of biomorphic abstraction (as in *Harlequin's Carnival*, 1924–25; Albright-Knox Art Gallery, Buffalo), and he began making wire sculptures of animals. Inspired to move into abstraction by a visit to Piet Mondrian's studio in 1930, Calder did so not in a geometric but in a biomorphic style. At this time of great interest in astronomy, Calder created his first kinetic sculptures composed of organic forms and began suspending mobiles (plate 218). In addition to deriving biomorphic forms from automatic processes such as dripping paint, he also let the forms be arranged by air currents. The artist later described the cosmic associations of his work:

a

b

Périhélie
1989 4.400 millions de Km

Orbite Uranus Saturne

de Neptune

Orbite de Pluton 1930

Aphélie
7.400 millions de Km.

I think that at that time [1930] and practically ever since, the underlying sense of form in my work has been the structure of the universe, or part thereof. For that is a rather large model to work from. What I mean is that the idea of detached bodies floating in space, of different sizes and densities, perhaps of different colors and temperatures, and surrounded and interlarded with wisps of gaseous condition, and some at rest, while others move in peculiar manners, seems to me the ideal source of form.

I would have them deployed, some nearer together and some at immense distances. And a great disparity among all the qualities of these bodies, and their motions as well.[10]

There was extensive study of Earth's atmosphere in the interwar decades, but astronomers became increasingly frustrated because they were looking out into the cosmos through veils—thin layers of gas surrounding the globe. Some electromagnetic radiation (such as visible light) passes through the veils, but air absorbs and deflects other signals from the stars (such as ultraviolet radiation) (plate 219). Astronomers began to dream of getting above the veils and having a clear, unobstructed look at the sky; in half a century their dream would come true with the launch of transatmospheric telescopes such as today's Hubble Space Telescope.

Paul Klee may have been inspired in the 1920s by popular reports about radiation in the atmosphere to create his haunting *Horizon, Zenith, and Atmosphere* (plate 200). By the

OPPOSITE, TOP

216. "Pluto, the New Planet in the Solar System," in *La Nature* 59 (15 June 1931): 531.

OPPOSITE, BOTTOM

217. Saturn as seen from one of its innermost moons, in Lucien Rudaux, "Les spectacles du monde de Saturne" (Views of the planet Saturn), *L'Illustration* 189, no. 4776 (15 Sept. 1934): 80 (illus.), 77–80 (text).

The discovery of Pluto prompted great public interest in the planets, leading this science journalist to describe what Saturn looks like up close, from its innermost moon. Shown here in three-quarter phase, the planet is tipped relative to the imagined viewer on its moon, which orbits in the same plane as its rings.

ABOVE

218. Alexander Calder (American, 1898–1976), *Untitled (The Constellation Mobile)*, 1941. Painted wire and wood, 34 x 42 in. (86.4 x 106.7 cm). National Gallery of Art, Washington, D.C. Gift of Mr. and Mrs. Klaus G. Perls.

early 1940s, the Austrian artist Herbert Bayer was engrossed in studies of the atmosphere and of astronomy. Bayer had studied at the Bauhaus in 1921–23 and returned to teach there in 1925–28. He followed discoveries during the 1930s while working as a designer in Berlin, and after emigrating to New York in 1938 his painting focused almost exclusively on developments in science, as the artist has stated: "Around 1940, the paintings explode with diagrammatic arrows, flying receptors and activities in space. They reflect a vision of cosmic intervals and exchange inspired by the sciences probing into the universe."[11]

In the early 1940s astronomers began not only looking at the universe but also listening to it. Radios were common in the interwar years but were plagued by a crackling interference pattern of sound—static. Bell Telephone Company set one of its engineers, Karl Jansky, to solve the problem, and in 1932 he astounded his colleagues by announcing that the static was coming not from the radio, or the building, or a passing aircraft but from far beyond the solar system—the constellation Sagittarius. By the early 1940s engineers had crafted telescopes to detect radio waves from outer space, and they were making radio images of the crab nebula (plate 220), a supernova that exploded in A.D. 1054 (plate 221). Bayer created several fanciful images that drew on the new technology, such as his *Interstellar Exchange* (plate 222).[12] Flying black arrows (right-hand side), wavy lines, and long, thin forms (center) suggest moving waves carrying the "messages" through red, white, and gray nebulas to distant stars, with the dots above forming a dome of heaven. Bayer included a reference to the ultimate, atomic source of the electromagnetic radiation, the ball-and-stick models of molecules (center), and instruments used to record currents in the atmosphere (the weather station tower topped by twin balls).

219. Cross section of earth's crust and the atmosphere, in Harlan True Stetson, *Earth, Radio, and the Stars* (New York, 1934), frontispiece.

220. Radio contour map of the crab nebula made with a radio telescope. Courtesy Simon Mitton. Cambridge University, England.

221. Red light photograph of the crab nebula, 1959. Mount Wilson Observatory, Palomar, California. American Museum of Natural History Library, New York.

222. Herbert Bayer (Austrian, 1900–1985), *Interstellar Exchange*, 1941–42. Oil on canvas, 66 x 37 in. (167.6 x 94 cm). Herbert Bayer Collection and Archive, Denver Art Museum.

After Hubble determined that the universe is expanding, it was natural to run the clock backward and ask how the expansion had begun. Russian-born physicist George Gamow, who had emigrated to America in 1934, synthesized the thinking of several physicists on the topic in 1948 and proclaimed that the universe began as an explosion—the Big Bang. Gamow predicted that evidence for the primal conflagration should still linger in the universe today. He reasoned that the initial explosion would have produced a surge of energy that, as the universe expanded and cooled, would have maintained a wavelength suitable to the size and temperature of the universe in any given epoch. According to Gamow's calculations, that meant that in the twentieth century there should be throughout the universe a faint pattern of microwaves—a radiation echo, if you will, of the Big Bang. This telltale radiation was recorded first from Earth in the mid-1960s and then from a transatmospheric satellite in the 1990s, in a dramatic confirmation of the Big Bang theory of the origin of the universe.

GEOMETRIC ART AND ARCHITECTURE IN A NON-EUCLIDEAN UNIVERSE

Mathematicians began formulating non-Euclidean geometries in the nineteenth century as part of a general effort to place all of mathematics on a firm foundation of logic that would insure valid reasoning. Nikolai Lobachevsky and Georg Riemann each developed a new geometry by denying Euclid's axiom that parallel lines never cross. In the same spirit, logicians abandoned Aristotle's ancient method of analyzing arguments by syllogism, and by the mid-nineteenth century they had adopted modern algebraic notation and devised symbolic logic. The British mathematician George Boole's fundamental treatise *The Mathematical Analysis of Logic* (1847) introduced two-value Boolean algebra, on which all subsequent processing of electrical information is based. This search for a universally valid logical language culminated in the magnum opus by the British mathematicians Bertrand Russell and Alfred North Whitehead, *Principia Mathematica* of 1910–13. As its title suggests, the authors hoped to provide the basic laws for mathematics, as Newton had done for physics and astronomy.

During World War I, artists and designers had searched for their own universal language of geometry;[13] they aimed to express cosmic unity, and they were also mindful that a common language could help unite war-torn nations. The Cubists Braque, Picasso, and Gris had constructed their paintings, in part, by organizing their fleeting sensations into geometric planes and volumes. The artists of Purism, De Stijl, Suprematism, and Constructivism vowed to move beyond the faceted planes of Cubism and arrive at a purer geometry; their art would be based in the reasoning power of the mind alone. They wanted to sweep away what they perceived as the cluttered, decorative corruptions of Cubism being produced by its countless imitators. Amédée Ozenfant, Piet Mondrian, El Lissitzky, and Naum Gabo cited the authority of past masters of geometry, especially Plato and Spinoza, and soon they were composing with a vocabulary of straight lines, circles, and cubes from Euclid's *Elements*.

Then the world learned in 1919 that the universe is not Euclidean after all and that an arcane geometry in which parallel lines cross describes the real world. Lobachevsky and Riemann thought their geometries described wholly imaginary spheres, but Einstein found that

the space described by Riemann's non-Euclidean geometry—a space with a continuous positive curvature—is the real universe. Because space is warped by the gravitational fields generated by massive stars and galaxies, in cosmic space the shortest distance between two points is not a straight line. Within the complex intellectual matrix of German culture in the 1920s, the confirmation of Einstein's theory of relativity had a profound effect on fields based in German Idealism because a fundamental tenet of Kant's theory of knowledge is that Euclidean geometry is part of the framework of human reason. The change affected all areas of thought that use geometry, including painting, design, architecture, and the psychology of spatial perception (Gestalt psychology).[14]

From a practical point of view architects, like all earthlings, could have continued using only Euclidean geometry. One needs to think in terms of curved space and the relativity of space-time only when measuring events occurring in the subatomic and celestial realms at great speeds relative to the observer. The interest in concepts of relativity and mathematics expressed by interwar architects and designers underscores the extent to which they approached their tasks from not only practical but also imaginative viewpoints. When the French painter Amédée Ozenfant and the Swiss designer and architect Charles-Édouard Jeanneret (known as Le Corbusier) published their manifesto of Purism in 1918, they declared that art "should induce a sensation of mathematical order" that would address "only the most elevated faculties of the mind" and express the "universal properties of sensations and reason."[15] Rejecting the Cubist styles of Albert Gleizes, Jean Metzinger, and Roger de la Fresnaye as overly complex, Le Corbusier and Ozenfant envisioned a post-Cubist style of geometric order and symmetry. Purist paintings, such as Ozenfant's *Still Life* (plate 223), are composed of interlocked elementary shapes that appear machine-made.

In 1920 Ozenfant and Le Corbusier founded and edited the journal *L'Esprit nouveau*, which became a source for artists of information about the latest in science. In its first years the journal published dozens of articles about Einstein's theory of relativity and Freud's psychoanalysis. The publication was funded by wealthy Swiss industrialists, and its audience included young professionals and avant-garde artists. The editors commissioned or wrote their own clear expositions of Purism, art, and science directed at a wide audience. For example, Paul Le Beq provided a lucid overview of the theory of relativity in a 1921 article in which he commented, "Einstein's system places mathematics at the pivot of science."[16]

223. Amédée Ozenfant (French, 1886–1966), *Still Life*, 1920–21. Oil on canvas, 32 x 39⅝ in. (81.3 x 100.6 cm). San Francisco Museum of Modern Art. Gift of Lucien Labaudt.

Le Corbusier at this time developed his pure "white box" architectural style using slabs and columns. The collaboration with Ozenfant culminated in 1925 in his cellular slab design for the Pavillon de l'Esprit Nouveau at the Exposition des Arts Décoratifs et Industriels Modernes in Paris, with paintings by Ozenfant (plate 224). That same year Ozenfant and Le Corbusier ceased publication of their journal and went their separate ways, never having considered the implications of the new geometry for their Euclidean style. Within a few years Ozenfant abandoned the Purist machine metaphor and began introducing organic elements into his Purist paintings. In his book *Foundations of Modern Art* (1928) he reflected: "In the past, a confused pluralism ruled over the sciences. Mechanics, physics, chemistry, biology, etc., were almost independent of each other. Nowadays they tend to merge into electromagnetics, a monism with innumerable attributes. The ideal of science is to discover the formulas whose function is to reconcile all possible phenomena. The equations of Einstein, in which time ranges with the three classical Euclidean coordinates, attempt a complete synthesis of the universe and claim to be able to account for every possibility."[17] Ozenfant spent the next decade painting a vast overview of life forms, *Biological Life* (1931–38; Musée Nationale d'Art Moderne, Paris), composed of intertwined organisms teeming with life.

224. Le Corbusier (Swiss, 1887–1965), "Pavillon de l'Esprit Nouveau," 1925. In Jean Badovici, "Entretiens sur l'architecture vivante," *L'Architecture vivante* (Autumn/Winter, 1925), pl. 50.

For he . . . whose mind is fixed upon true being, has surely no time to look down upon the affairs of earth. . . . His eye is ever directed towards things fixed and immutable, which he sees neither injuring nor injured by one another, but all in order moving according to reason; these he imitates, and to these he will, as far as he can, conform himself.

Plato, *The Republic*, fourth century B.C.

In 1917 a group of artists and architects in the Netherlands joined together to articulate a universal language of pure color and geometric form; they believed it was so fundamental that they called it simply "the style"—De Stijl. Organized by the painter and architect Theo van Doesburg, the group included Piet Mondrian, the sculptor Georges Vantongerloo, and the architect J. J. P. Oud. The painters achieved universality by covering white canvases with rectangles of color in paintings that were virtually indistinguishable from each other; compare van Doesburg's *Composition II* (1918; Solomon R. Guggenheim Museum, New York) with Mondrian's *Composition with Color Planes* (1917; Museum Boijmans Van Beuningen, Rotterdam). Whether designing a sculpture to place on a pedestal or a whole building, Vantongerloo and Oud composed with white cubes and spheres, as in Vantongerloo's *Construction in the Sphere* (1917; Collection Nelly van Doesburg, Paris-Meudon) and Oud's factory at Purmerend, Netherlands (1919). In 1918 the De Stijl group proclaimed their united vision in a manifesto: "There is an old and new consciousness of the age. The old is connected with the individual. The new is connected with the universal. . . . In the new plastic art, by removing the restriction of natural forms, they [the founders of De Stijl] have eliminated what stands in the way of the expression of pure art."[18]

Van Doesburg also founded and edited the journal *De Stijl*, and its first issues focused on painting, featuring Mondrian's multipart text "Neoplasticism in Painting." Mondrian had been raised in a strict Calvinist family, and he showed an interest in spiritual topics from an early age. The Dutch chapter of the Theosophical Society had been founded in 1890 and attracted Symbolist artists such as Jan Toorop. Mondrian joined in 1909, and for the rest of his life he kept a book of Rudolf Steiner's lectures given in Holland in 1908. Mondrian's *Evolution* (1911; Haags Gemeentemuseum, The Hague) embodies the attainment of higher levels of consciousness through concentrated thought, or in theosophical terms, through meditation. The painting progresses from sensory perception (woman with red flowers on the right) to imagination (woman with six-pointed stars, the symbol of theosophy, on the left), culminating in intuition (central woman, eyes now wide open, head surrounded by white light). Over the next two decades Mondrian read widely in classical Greek philosophy and Eastern religion. The artist also read the most famous of all Dutch philosophers, Spinoza, whom Einstein also admired because he achieved universality through a geometric method (see chap. 9).

Mondrian slowly developed a mature style that no longer expressed theosophical enlightenment but a Pythagorean and Neoplatonic worldview, in which there is cosmic unity based in mathematical form. To symbolize the universe, he used only the most basic elements of painting, primary colors and geometric shapes, or as he put it in 1917, "The new plastic cannot be cloaked by what is characteristic of the particular, natural form and color, but must be expressed by the abstraction of form and color—by means of the straight line and determinate primary colors."[19] After World War I, Mondrian moved ineluctably toward his signature style of horizontal and vertical lines with only the primaries plus white, gray, and black. In *Composition with Red, Yellow, and Blue* (plate 225) the artist presented a view of reality that, as proclaimed in the 1918 manifesto, was "connected with the universal."

For van Doesburg, the universe had changed since 1918. After the confirmation of Einstein's theory of relativity, he vowed to create an art in keeping with the new cosmic space-time.[20] To van Doesburg, the perpendicular lines and plane geometry in Mondrian's compositions suddenly seemed too static. In a style he called Elementarism, van Doesburg added a third spatial dimension, by allowing lines to float in front of the background plane, and a fourth dimension of time, by introducing diagonal lines to suggest motion (plate 226). To protest these violations of classical Platonic, Euclidean space, Mondrian withdrew from De Stijl in 1924.

In the early 1920s van Doesburg also began exploring ways to incorporate the new cosmology into building design. He relocated to Weimar and, although

The truly modern artist consciously perceives the abstractness of the emotion of beauty: he consciously recognizes aesthetic emotion as cosmic, universal. This conscious recognition results in an abstract creation, directs him towards the purely universal.

Piet Mondrian,
"Neoplasticism in Painting," 1917

225. Piet Mondrian (Dutch, 1872–1944), *Composition with Red, Yellow, and Blue*, 1920–26. Oil on canvas, 39⅜ x 39⅞ in. (99.7 x 100.3 cm). Tate, London.

226. Theo van Doesburg (Dutch, 1883–1931), *Contra-composition of Dissonances XVI*, 1925. Oil on canvas, 40 x 72 in. (100 x 180 cm). Gemeentemuseum, The Hague.

RIGHT

227. Theo van Doesburg, *Color Construction in the Fourth Dimension of Space-Time*, 1924. Ink and gouache, 22¼ x 22 in. (56.3 x 56 cm). Stedelijk Museum, Amsterdam.

he was not on the Bauhaus staff, he worked closely with his colleagues there to develop his concepts. His basic idea was that, after Einstein's revolution in cosmology, reflective men and women thought differently about their relation to the universe. Space and time on Earth had not changed—one still measured them with yardsticks and watches—but one's understanding of terrestrial space and time relative to celestial space-time had changed profoundly. Van Doesburg wanted to capture the viewer's new consciousness of the cosmos in order to make people feel at home in their universe, by building homes to echo the heavens—a microcosm of the macrocosm.

In his 1924 drawing for a house, *Color Construction in the Fourth Dimension of Space-Time* (plate 227), van Doesburg designed the structure by estimating the movements of the inhabitant through the rooms—that is, by considering motion (time) as integral to floor plan (space). Unlike Le Corbusier and Oud's closed (Euclidean) white cubes, van Doesburg's space opens in all directions to its environment (the universe). He wanted to give inhabitants the sensation of floating—like citizens of the universe released from gravity. In 1924 van Doesburg summarized his views in "Towards a Plastic Architecture":

> *The new architecture takes account not only of space, but also of time as an accent of architecture. The unity of time and space gives the appearance of architecture a new and completely plastic aspect (four-dimensional temporal and spatial plastic aspects).*
>
> *The new architecture is anti-cubic, i.e., it does not strive to contain the different functional space cells in a single closed cube, but it throws the functional space (as well as canopy planes, balcony volumes, etc.) out from the center of the cube, so that height, width, and depth plus time become a completely new plastic expression in open spaces.*
>
> *In this way architecture (in so far as this is constructionally possible—a task for the engineers!) acquires a more or less floating aspect which, so to speak, runs counter to the natural force of gravity.*[21]

The Hungarian designer and theorist László Moholy-Nagy, who joined the international community of artists at the Bauhaus in 1923, also focused his art on man's interaction with space, time, and light. Like van Doesburg, he approached the new physics with cautious enthusiasm; in his gravity-defying graphic style (plate 228), he let sans serif type float and run vertically up the page. Moholy-Nagy remained with the Bauhaus in Weimar and Dessau until 1928 and later joined the faculty of the New Bauhaus in Chicago, in 1937. In the 1940s he commented on the impact of Einstein's revolution on the conceptual framework of generations of designers: "Einstein's terminology of 'space-time'

228. László Moholy-Nagy (Hungarian, 1895–1994), advertisement for the Bauhaus Books series, 1926. Bauhaus Archiv, Berlin.

Despite the fact that the basis of the mathematical approach to art is in reason, its dynamic content is able to launch us on astral flights which soar into unknown and still uncharted regions of the imagination.

Max Bill,

Mathematical Approach to Contemporary Art, 1949

and 'relativity' has been absorbed into our daily language. Whether we use the terms 'space-time,' 'motion and speed,' or 'vision in motion,' rightly or wrongly, they designate a new dynamic and kinetic existence freed from the static, fixed framework of the past."[22] A student of Moholy-Nagy at the Bauhaus during 1927–29, Max Bill embraced van Doesburg's program of building an art on rational principles related to mathematics. Intrigued by a geometric figure—a plane that loops to form a volume—in 1935 Bill created *Endless Ribbon* (plate 229). He was convinced that artists could use mathematical means without undermining their creativity.

Color theory at the Bauhaus had followed Michel-Eugène Chevreul's early-nineteenth-century laws of simultaneous contrast, which were taught virtually unaltered by the German-born painter Josef Albers, but the study of form there was dominated by Gestalt psychology. The term *Gestalt* means shape or form, and it had been introduced into psychology in the 1890s by the Austrian philosopher Christian von Ehrenfels, a contemporary of the experimental psychologists Theodor Lipps and Wilhelm Wundt. Like them, he was particularly interested in optical illusions because he felt they supported his view that the perception of space is inherently structural; one does not see the world as a mosaic of colored patches, but rather one picks out a pattern or a form—a Gestalt. After the universe was shown to be non-Euclidean in 1919, the Gestalt theory of spatial perception came to prominence because it emphasized that spatial perception is not innate but learned from experience. The movement was centered in Berlin, where researchers in the 1920s and '30s analyzed the perception of reversible figures (plate 230).

Gestalt psychology was of great interest to Albers, who introduced the study of optical illusions into his teaching at the Bauhaus, and further developed his Gestalt studies after relocating to the United States in 1933. Albers's mature style, as seen in his *Homage to the Square* series (plate 231), in which nested squares of opaque color create an illusion of translucency,

combines Chevreul's color theory with lessons in spatial perception from Gestalt psychology. The Gestalt psychologist Rudolf Arnheim was also part of the East Coast art world in the 1950s. Born in Germany and educated in Gestalt psychology at the University of Berlin in the 1920s, he relocated during World War II to America, where he proclaimed the interpretive power of the mind to organize fields of visual data. He and fellow Gestalt psychologist Anton Ehrenzweig studied the psychology of creativity and argued that there are parallels between artistic and scientific ways of thinking. The impact of Arnheim's book on Gestalt aesthetics, *Art and Visual Perception* (1954), Albers's renowned treatise *Interaction of Color* (1963), and Ehrenzweig's Gestalt look at art history, *The Hidden Order of Art* (1967) was manifest in a generation of American Op and Minimalist artists.

Albers's best-known student, the American painter and printmaker Richard Anuszkiewicz, became a master craftsman in the production of intricate color studies. In the serigraph in plate 232, Anuszkiewicz shows squares of the same red, orange, and yellow hue against bluish and greenish backgrounds and lets viewers discover the subtle changes that the background shift causes in their perception of the foreground hues. Seeking to avoid his art being confused with an experiment at an optometry clinic, which was a problem that plagued Op artists, Anuszkiewicz emphasized that his work is about more than optics by titling his suite of serigraphs *The Inward Eye* and by enclosing a poem to accompany each print in the portfolio. Gestalt theories of spatial perception provided an explanation for the viewer's cognition of the simple geometric sculpture of Minimalist art; even though a viewer from any one angle gets only partial, distorted views of, for example, Robert Morris's Plexiglas-on-plywood cube, *Untitled* (1965; Tate, London), he or she nevertheless perceives a Gestalt (a cube).

In the mid-1930s, M. C. Escher began making prints related to the new geometry,

In the simpler regular polyhedrons such as cubes and pyramids one need not move around the object for the sense of the whole, the gestalt, to occur. One sees and immediately "believes" that the pattern within one's mind corresponds to the existential fact of the object. . . . The sensuous object, resplendent with compressed internal relations, has had to be rejected.

Robert Morris, "Notes on Sculpure," 1966

232. Richard Anuszkiewicz (American, born 1930), *The Inward Eye*, 1970. Serigraph, 26 x 19½ in. (66 x 49.5 cm), from a portfolio of ten serigraphs published by Aquarius Press, New York. Private collection.

continuing until his death in 1972. A Dutchman who worked somewhat in isolation, Escher was an avid reader of popular books on astronomy throughout his career. From the 1940s, he studied optical illusions and was a fan of the Gestalt psychologist Ernst Gombrich, who in turn published a popular article on Escher's work, "How to Read a Painting (Adventures of the Mind)" in 1961.[23] In *Other World* (plate 233), Escher symbolized the new space-time "world" in which there are multiple perspectives.

In Russia, Kazimir Malevich and Mikhail Matiushin had developed a universal abstract language to express the insights of those whose brains, according to the artists, were more highly evolved than those of other mortals. When Einstein's theory focused the world's attention on cosmology, Malevich and other Russian artists and designers produced many cosmic fantasies along the lines of popular science fiction, including what Malevich called his "Suprematist Machine": "The earth and the moon. Between them, a new Suprematist satellite can be constructed, equipped with every component, which will move along an orbit shaping its new track."[24]

In the Suprematist circle there were also a few brave souls who tried to assimilate Einstein's space-time cosmology—as fact, not fiction—in a Suprematist style. El Lissitzky met Malevich in 1919 and became a lifelong convert to Suprematism. Trained in architecture, engineering, design, and graphics, and widely traveled in Europe, Lissitzky had enough technical background to be keenly aware of the significance of Einstein's revolution. In 1920–21 he proclaimed: "The absolute of all measures and standards has been destroyed. When Einstein constructed his theory of particular and general relativity, he proved that the speed with which we measure a particular distance influences the size of the unit of measure."[25]

Lissitzky developed a style that he hoped would express Einstein's universe. Using a Suprematist vocabulary of simple lines and geometric shapes floating in front of a blank background, he produced his three-dimensional *Proun* (an acronym for "project for the new art"). To suggest the dematerialization of matter in a universe in which energy and mass are equivalent, the artist used transparent effects, such as the grid at the bottom of *Proun 99* (plate 234). Hovering, floating forms suggested motion and a temporal dimension; sometimes the painting literally moved, as in *Proun: Eight Positions* (plate 235), which rotates on the wall. By including optical illusions (such as the central vertical stripe in *Proun 99*, which "flips" from flat to cylindrical), the artist hoped to make the viewer feel at home in a new universe that defied common sense.

Proud that the first non-Euclidean geometry had been created by a Russian, Lobachevsky,

Lissitzky titled his artistic manifesto "A. and *Pangeometry*" (1925), symbolizing "Art" with "A," in a nod to mathematical formulation, and acknowledging Lobachevsky's 1829 book *Pangeometry*. In the spirit of Lobachevsky's creation of a spherical universe in his imagination, Lissitzky conceived of the space in his *Prouns* as unrelated to the commonsense world of terrestrial landscapes. In his manifesto, the artist paid tribute to his intellectual ancestors: "Lobachevsky and Gauss [the French mathematician] were the first to prove that Euclidean space is only *one* instance in the unending succession of spaces. Our minds are incapable of visualizing this, but that is precisely the characteristic of mathematics—that it is independent of our powers of visualization."[26]

 Lissitzky met van Doesburg in 1922 in Berlin, where some artists were experimenting with film as the medium with which to capture the imaginary space of Einstein's quantum

233. M. C. Escher (Dutch, 1898–1972), *Other World*, 1947. Wood engraving, 12⅝ x 10⅜ in. (31.5 x 26 cm).

universe. They met the pioneers of abstract animation, Viking Eggeling and Hans Richter (see chap. 7), and all joined forces in promoting abstract film as the new universal language because it incorporated the element of time and produced a dematerialized, abstract realm from light alone.[27] Richter in 1921 pronounced that, to be a universal language, the cinema must present not moving pictures but moving geometric shapes: "There can be no doubt that the cinema, as the new sphere of operation for creative artists, will quickly be in demand for the production of works of art. . . . It is absolutely essential for this new art to be composed of clear, unambiguous elements. Without them it might develop as a game—even a highly seductive game—but never as a language."[28]

Moholy-Nagy noted that, as in collage, the filmmaker's cutting techniques express the shifts in time and place characteristic of the fragmented modern psyche and the physicist's

234. El Lissitzky (Russian, 1890–1941), *Proun 99*, c. 1923–25. Water soluble and metallic paint on wood, 50¾ x 39 in. (129 x 99.1 cm). Yale University Art Gallery, New Haven, Connecticut. Gift of Collection Société Anonyme.

warped universe.[29] Montage, he reflected, "tend[s] toward 'more dimensional' solutions which must be developed further to conquer psychological and physical space-time."[30] The Russian filmmaker Sergei Eisenstein had seized on this idea in 1929 and declared in "The Filmic Fourth Dimension":

> *The fourth dimension?! Einstein? Or mysticism? Or a joke? It's time to stop being frightened of this new knowledge of a fourth dimension. Einstein himself assures us: "The non-mathematician is seized by a mysterious shuddering when he hears of 'four-dimensional' things, by a feeling not unlike that awakened by thoughts of the occult. And yet there is no more commonplace statement than that the world in which we live is a four-dimensional space-time continuum."*
>
> *Possessing such an excellent instrument of perception as the cinema—even on its primitive level—for the sensation of movement, we should soon learn a concrete orientation in this four-dimensional space-time continuum.*[31]

235. El Lissitzky, *Proun: Eight Positions*, c. 1923. Metal foil, oil, and gouache on canvas, 54¾ x 54¾ in. (139.3 x 139.3 cm). National Gallery of Canada, Ottawa. Purchased 1973.

Meanwhile, another Russian artist had been searching for a universal abstract language and had developed a geometric vocabulary by a somewhat different route. Naum Gabo had a deep knowledge of science and engineering, as well as training in German philosophy. He went to Munich from his native Belarus in 1910 to study medicine and natural science at the University of Munich, where the faculty included the discoverer of X rays, Wilhelm Röntgen.[32] In 1912 Gabo shifted his studies to the department of philosophy, which was still dominated by Lipps's aesthetics of empathy. He continued his scientific pursuits at the Technische Hochschule, studying mathematics and engineering on the side. When the war broke out he took refuge in Norway and after the Revolution returned to Russia, where he found great interest in the study of X rays. The Russian physicist Abram Ioffee, an assistant to Röntgen in Munich, had also returned to Russia and established the State X-Ray and Radiological Institute in Saint Petersburg in 1918.

In 1920 Gabo, with his brother the artist Antoine Pevsner, wrote a statement acknowledging the significance of Einstein's recently confirmed theory of relativity for "the growth of human knowledge with its powerful penetration into the mysterious laws of the world which started at the dawn of this [the twentieth] century."[33] The brothers declared: "Space and time are reborn to us today. Space and time are the only forms on which life is built and hence art must be constructed."[34]

Gabo formed his mature style at this time with a new vision of space and time. He scoffed at the Futurists' attempt to capture motion with static paintings based on time-lapse photography: "It is obvious now to everyone of us that by the simple graphic registration of a row of momentarily arrested movements, one cannot re-create movement itself."[35] And he declared that his inspiration was the whole universe of light: "Look at a ray of sun[light] . . . the stillest of the still forces, it speeds more than 300 kilometers in a second . . . behold our starry firmament . . . who hears it . . . and yet what are our depots to those depots of the Universe? What are our earthly trains to those hurrying trains of the galaxies?"[36]

From his studies in Munich, Gabo was aware that matter is mainly empty space, and he had already begun using transparent planes in his prewar work. Now Einstein had proven that matter *is* energy, Gabo dematerialized his sculpture even more; from the 1920s onward he created work with celluloid. Also in keeping with the new physics, he devised a way to link time and space by creating his first kinetic sculpture in 1919. A motor in the base of *Kinetic Construction: Standing Wave* (plate 236) causes a bar of metal to oscillate, producing a pattern of waves (what is known in physics as a "standing wave"); the motion of the bar in real time creates a volume in space. Throughout his long career Gabo introduced ever-greater translucence as new materials were devised, including Plexiglas in 1936 and nylon monofilament during World War II. He often returned to the theme of spheres in works such as *Translucent Variation on a Spheric Theme* (plate 237), creating metaphors for Einstein's non-Euclidean, spherical universe.

In the late nineteenth century, Art Nouveau architects had begun using the analogy of the building as an organism—designed to perform functions and adapted to its site—that is fundamental to all modern architecture. After Einstein's revolution shifted the attention of designers and architects to the heavens, architects in the 1920s created a powerful new metaphor for urban man's spiritual renewal in the new space-time universe: glass skyscrapers.

During World War I, the Berlin architect Bruno Taut had written two short books, both published in 1919, proposing that humanity could be brought into harmony with the cosmos by contemplating light streaming from the heavens through the new architectural glass. Making an analogy between the medieval cathedral and the new multistoried structures made possible by the development of steel and the elevator, Taut proclaimed that the deep spirituality and communal spirit of the Middle Ages could be revived if such tall steel structures were veiled in glass. By building new secular cathedrals—glass skyscrapers—the architect would harmonize society, make man feel at home in the cosmos, and fill his spirit with joy. Every city and town needed to have built at its center a glass tower—a "city crown" (*Stadtkrone*)—where citizens weary from materialism could refresh their souls and contemplate the universe.[37]

When the war ended, there was no money in the German economy to build such dreams, but after the 1919 confirmation of Einstein's theory linking the smallest subatomic particle to the farthest star, Taut's imagination was fired to produce one last vision of architecture linking the microcosm and macrocosm, the artist's book *Alpine Architecture* (1919). In a short text and series of sketches, Taut tells the tale of a destroyed Gothic cathedral whose shattered fragments "become atoms and are dispersed through the universe" until they coalesce under the force of gravity into a "cathedral star" (plate 238). After colliding with a meteor, some of the atomic debris from the cathedral star falls to Earth, where it becomes part of the material from which the new architecture will be built (plate 239).

During the economic slump of the postwar years, the architect Ludwig Mies van der Rohe was also in Berlin fantasizing about what could be built in the new materials. In his *Studies for Glass Skyscrapers* of 1919–21, he imagined an extraordinary series of crystalline structures made by hanging a skin of tilting panes of glass around floors cantilevered out from a steel spine (plate 240).

In Moscow in 1919, a time of postrevolution zeal for socialism and fascination with cosmology, the Constructivist sculptor Vladimir Tatlin, director of

BELOW

238. "Cathedral Star," lithograph by Bruno Taut (German, 1880–1938), in *Alpine Architectur* (Alpine architecture) (Hagen, Germany: Folkwang Verlag, 1919), pl. 26. Page size 15¼ x 12½ in. (38.7 x 31.7 cm). The Museum of Modern Art Library, New York.

OPPOSITE

239. "Globes! Circles! Wheels!," lithograph by Bruno Taut, in *Alpine Architectur* (Alpine architecture) (Hagen, Germany: Folkwang Verlag, 1919), pl. 28. Page size 15¼ x 12½ in. (38.7 x 31.7 cm). The Museum of Modern Art Library, New York.

‚DIE KUGELN! DIE KREISE! DIE RÄDER!'

240. Ludwig Mies van der Rohe (German, 1886–1969), model for a glass skyscraper, 1921–22. Bauhaus-Archiv, Berlin.

The new architecture reflects a complete spiritual revolution in the individual.

Walter Gropius, 1923

Lenin's "Plan for Monumental Propaganda," drew up architectural plans for his Monument to the Third International (a Communist organization) (plate 241), which epitomizes cosmic unity. Lenin intended the building complex—which was planned (but never built) to stand almost as tall as the Eiffel Tower—to function as the center of world government after the global Communist revolution. Tatlin designed the external steel framework in the form of a double spiral that leaned at an angle so that its apex pointed to Polaris, the North Star. Just as the earth rotated on its axis once every twenty-four hours, making the constellations in the northern hemisphere appear, as a result, to turn around Polaris, so Tatlin's Monument and Polaris would remain motionless relative to each other—literally at a still point, with great symbolic meaning. Tatlin designed three steel-and-glass office buildings within the spiral framework to house the decision-making bodies of the global administration. Each building would move in harmony with the earth's daily rotation and annual revolution around the sun. At the bottom would be the largest building, in the shape of a cylinder (housing conferences and congress meetings), moving imperceptibly to complete its annual rotation; in the middle a conical office structure (for executive activities) would rotate monthly; and on top there was a cubic glass tower (housing an information center constantly broadcasting by telegraph, telephone, radio, and loud-speaker) that would rotate daily. On top there was also to be an open-air screen, lit up at night, on which inspirational and news bulletins would be projected; during the frequent overcast weather in Moscow, the text would be projected onto the clouds.

When the Bauhaus opened in Weimar in 1919, its director, Walter Gropius, vowed to incorporate into building design the latest scientific and technological advances in order to renew man's spirit through secular architecture. Gropius underlined the spiritual mission of architecture by choosing a woodcut of a Gothic cathedral by Lyonel Feininger to adorn the title page of the founding manifesto of the Bauhaus. When the school came under right-wing political pressure, Gropius sought the professional support of Germany's cultural leaders, and Albert Einstein responded by joining the Bauhaus board of directors in 1924.[38] After the school relocated to Dessau the following year, Gropius designed its new building with workshops encased

in a vast curtain of glass (plate 242). While his extensive use of glass might have evolved from the function of providing daylight for the student in the workshops, his floor-to-ceiling glass, which makes the walls appear to dissolve, has no other purpose than to make spirits soar.

In 1932 Henry-Russell Hitchcock and Philip Johnson curated an exhibition for the Museum of Modern Art in New York of architecture built since 1922, which included photographs of buildings by Mies and Gropius. By the early 1930s the sun never set on steel, glass, and concrete architecture, so the curators gave the style its current name—"the International Style." Inspired by the 1919 confirmation of Einstein's theory of relativity, the dream to build an architecture for citizens of the universe was eventually realized in structures such as Mies's soaring Seagram Building in New York (with Philip Johnson, 1954–58), and—with a nod to Taut's dream of the cathedral star—Johnson's cathedral made of glass, Crystal Cathedral (1980, Garden Grove, California).

ABOVE, LEFT
241. Vladimir Tatlin (Ukrainian, 1885-1953), Drawing for the Monument to the Third International, 1919.

ABOVE, RIGHT
242. Walter Gropius (German, 1883-1969), Workshop of the Bauhaus, Dessau, Germany, 1926. Bauhaus-Archive, Berlin.

plantation boophile d'outremer hyperboréenne / max ernst

plantation farcineuse hydropique parasite / 1921

max ernst

SURREALIST SCIENCE

The unconscious is the true psychic reality; in its innermost nature it is as much unknown to
us as the reality of the external world, and it is as incompletely presented by the data of
consciousness as is the external world by the communications of our sense organs.

Sigmund Freud, *The Interpretation of Dreams*, 1900

HISTORIANS COMMONLY POINT to the sources of Surrealism in theories of the unconscious mind, especially those put forth by the neurologists Jean-Martin Charcot and Pierre Janet, and the psychoanalysts Sigmund Freud, Carl Jung, and Jacques Lacan. While these medical men are certainly Surrealism's most direct scientific sources, Surrealism also originated during Einstein's revolution in cosmology, and some of the artists made an analogy between the "surreal" space-time universe and the bizarre world of their dreams and fantasies.

IMAGINING THE UNCONSCIOUS:
THE PSYCHOLOGICAL PERSPECTIVE

Surrealism was an international intellectual movement centered in Paris that began in the 1920s. The Surrealist poets and artists were united by a desire to plumb the depths of the unconscious mind, and their initial inspiration came from the French dynamic psychology of Charcot's heir, Janet. The leader of Surrealism, the French poet André Breton, was trained in medicine (he was a medical school dropout), and he knew Janet's writings because he cared for psychiatric patients during World War I. In 1919 Breton joined with the French writer Philippe Soupault in their first experiment with automatic writing, in which they emulated Janet's patients who were afflicted with pathological forms of psychological automatism; as Soupault stated, "The term automatic writing was suggested to us by Pierre Janet."[1] The poets suspended conscious control and let the words flow forth, composing an early example of stream-of-consciousness poetry, *Les Champs magnétiques* (1919). Adopting the theory that the suspension of conscious control would produce an expression of the unconscious mind, artists who gathered around Breton, such as Max Ernst, developed other automatic techniques. To begin works of art (for example, *Natural History*, a suite of thirty-four drawings, which were exhibited and published as a booklet in 1926), Ernst would take rubbings from uneven surfaces in a technique he called "frottage"—a psychiatric term for the abnormal desire to rub one's clothed body against the body of a stranger. In the first Surrealist manifesto of 1924, Breton

OPPOSITE, TOP

243. Max Ernst (German, 1891–1976), *Boophilic Plantation of Hyperborean Ultramarine*, c. 1921. Watercolor and ink on printed reproductions, 3¾ x 4¹⁵⁄₁₆ in. (9.5 x 12.5 cm). Private collection, Berlin.

Compare the pictures that Ernst picked for this collage with the marine microorganisms in C. G. Ehrenberg's 1838 publication (plate 37).

OPPOSITE, BOTTOM

244. Max Ernst, *Farcical Hydropic Parasitic Plantation*, 1921. Watercolor and ink on printed reproductions, 3¾ x 4¹⁵⁄₁₆ in. (9.5 x 12.5 cm). Private collection, Berlin.

In the spirit of a farce, Ernst entitled his rearrangement of science images with absurdly complex technical terms.

declared the central position of automatism by defining Surrealism as "psychic automatism in a pure state."

Given his clinical background (limited though it was), Breton considered himself an expert on psychiatry and borrowed concepts from it throughout his career. He and the French writer Louis Aragon published a commemoration of Charcot's discovery of hysteria in the periodical *La Révolution surréaliste* (1928), defining their artistic goal as beauty that was "convulsive" (as in a hysterical grand mal seizure). To lend credence to their periodical, the editors designed it to look like the popular science magazine *La Nature*.[2] The same year Breton published a novel in the form of a psychiatric case history of a deranged women in a mental hospital who wants to kill a doctor (*Nadja*, 1928). Publically denounced by Janet and other Paris psychologists for inciting patient violence, Breton responded with a defense of the uncensored expression of unconscious desires.[3]

Freud differed from Janet both in his concept of the unconscious mind and his therapeutic methods. Darwin had been unwelcome in Paris and thus he had little effect on French psychologists, but he was crucial for Freud; the animal drives—passion and aggression—provided the biological life-force essential to his view of the psyche as a battleground between the expression of animal desires and their repression in the unconscious mind.[4] For Freud, the unconscious mind of each individual (whether healthy or ill) was continually, dynamically reorganizing psychic material—making new symbolic connections—below conscious awareness. Thoughts unacceptable to the conscious mind were repressed, but the irrepressible desire would reappear in disguise as a character in a dream or as a bizarre symptom without a physical cause. Freud's method for going from the observed data (the remembered dream or the symptom) to the psychic cause (the repressed wish) was the free association of words and images that the patient and therapist followed, through chains of associations, until they reached the repressed forbidden thought. The goal of psychoanalysis was to bring buried thoughts to consciousness, examine them in the light of day, and thereby dispel their dark powers.

Although Freud's founding text of psychoanalysis, *The Interpretation of Dreams* (1900), was not translated into French until the late 1920s, there were about twenty reviews and articles on psychoanalysis published in prewar Paris,[5] and Breton knew about Freud during the war from these secondary sources. Breton's close collaborator the artist Max Ernst read Freud in German in his native Cologne before settling in Paris in 1922. A key difference in the public attitude toward psychoanalysis, as opposed to Janet's treatment of hysteria, aphasia, and other ailments, is that Freud presented his theory as a treatment for neurosis, the everyday ailment of ordinary people (neurosis was not stigmatized as a form of insanity, as psychosis was). In the German tradition of making science accessible, Freud himself wrote several popularizations of his theory, beginning with *On Dreams* (1901). By the early 1920s psychoanalysis was becoming known in Paris, and by 1930 therapy was fashionable.

Surrealist artists symbolized the Freudian unconscious not by depicting the facade of a hysteric, as the Symbolists had (see chap. 6), but by creating a new psychological perspective to visualize the inside of the neurotic mind. Freud taught that space and time are distorted in dreams because the unconscious mind reorganizes psychic material. Events are transposed in time: the adult dreamer is in her childhood crib; and the flow of time is uneven: the terrified

dreamer runs but moves only at a snail's pace. Locations are displaced: the dreamer steps through his bedroom doorway into the ocean; and one object metamorphoses into another: a pistol comes alive as a bird. Some Surrealists proclaimed that the film screen was best suited to be the new psychological picture plane: film can produce distortions in time (slow motion, running the film backwards, splicing to shift the viewer forward and back in time) and displacements in space (double exposures, dissolving one image into another). Also, like a dream, film is viewed in darkness in a hypnotic state, and it occurs over time: "A true hallucination is required, which tends to reinforce the other conditions of the cinema, just as, in a dream, the moving images succeed each other without depth, on a single plane artificially delimited by a rectangle, like a geometric hole into a metaphysical kingdom."[6] Luis Buñuel and Salvador Dalí's *Un Chien Andalou* (1928), for example, used montage (the cinematic version of collage) to present a dreamlike series of seemingly unrelated events that lack a narrative temporal sequence of past, present, future. In its most famous clip, location is displaced as a cloud moving across the full moon metamorphoses into a scalpel slitting a woman's eyeball. According to Buñuel, the film does not depict a particular dream but rather mixes "the aesthetics of surrealism with Freudian discoveries."[7]

For Ernst, collage was an effective way to present a psychological perspective because the technique—the assembling of an artwork from fragments of printed pictures and text— echoed the unconscious mind's creation of a dream from scattered images and words. He developed a vocabulary of images borrowed from popular science magazines and books, making an analogy between the invisible and the unconscious, as in his 1921 series of watercolors and ink drawings made on top of biology images of microscopic sea life (plates 243 and 244).[8] Science imagery provided Ernst ways to transport the viewer from the commonsense world of waking into a minute wonderland filled with alien creatures—as in a dream. He also created metaphors for the therapeutic technique of free association by making collages of disassociated words and pictures. In *The Inside View* (1931; private collection), he took an astronomy diagram that shows the size of the sun as seen from different planets and made it into a psychological "inside" view by pasting on various images—a map, a breast, a skull, a flame—that related neither to each other nor to the nearby text. Late in his life, after Russian scientists began the space age by putting the first satellite (Sputnik) into orbit in 1957, Ernst returned to the analogy of psychological and celestial spaces in a series called *Configuration* (plate 245), in which orbs and constellations float in the black void of inner and outer space.

The Belgian painter René Magritte also symbolized free association, by pairing images with words that do not literally describe them. In *Key of Dreams* (plate 246), he painted a clock and wrote the words *the wind*. What do a clock and wind have to do with each other? The answer is behind a closed door in the unconscious mind of the dreamer, and the "key" to unlock it is the free-association process that the painting illustrates.

The Surrealists also made an analogy between the operation of the unconscious mind— making new symbolic associations—and the work of the artist: creating new visual signs. As the psychoanalyst examined how a dream was constructed, so the artist self-consciously reflected on the art-making process, becoming preoccupied with the distinction between reality and illusion in the psyche and in art. This analogy is the subject of Ernst's *Day and Night* (plate

the door the wind

the bird the valise

247). The setting is a barren, rocky landscape filled with canvases, and one moves from the dark landscape (reality, the night) into the light pictures of it (illusions, the day). Such puzzles and games, all set within the illusory world of art, were repeatedly played as Surrealist artists self-consciously examined their craft.

Freud famously claimed not to understand Surrealism; more precisely, he found the uninterpreted dream meaningless—just an arrangement of unrelated words and images. In a letter to Breton, Freud wrote: "The telling of the dream, what I call the 'manifest' dream, is of no interest to me. I have been dealing with a way to find the latent [buried, hidden] meaning of the dream, which could be obtained from the manifest dream by analytic interpretation. A collection of dreams without the connected associations, without knowledge of the circumstances under which it has been dreamt, does not have any meaning to me, and I can barely imagine what it would mean to others."[9] This points to a basic difference between the scientific and artistic use of dreams in this era. Freud, as a therapist, aimed to demystify the dream by explaining the origin

OPPOSITE

245. Max Ernst, *Configuration*, 1974. Oil on panel, 16 ½ x 12⅝ in. (40.6 x 31.1 cm). Courtesy Cavaliero Fine Arts, New York.

ABOVE

246. René Magritte (Belgian, 1898–1967), *Key of Dreams*, 1935. Oil on canvas, 16¼ x 10¾ in. (41.3 x 27.3 cm). Collection of Jasper Johns, New York.

of its seemingly unrelated components in the patient's past experience. The Surrealists, as artists, wanted to express the irrationality of the unconscious mind by retaining the mystery of the dream. Hence the Surrealists spawned decades of art that, like a dream that is simply reported without the dreamer's associations, is uninterpretable. Ernst's collages (plates 243 and 244) are particularly striking examples of such Surrealist dream images because they make unintelligible the ultimate examples of visual clarity—science diagrams and illustrations.

In the early 1930s the young French psychiatrist Jacques Lacan entered the Surrealist circle in Paris, where he became a rare example of a scientist whose thinking was directly influenced by an artist. Lacan was trying to extend Freud's psychoanalysis beyond the treatment of mildly ill neurotics to severely deranged psychotics. He focused on paranoia because it entails a misconception of reality that is an extreme version of everyday neurotic fantasies. He visited Dalí's studio and learned from the artist his "paranoid-critical method" of combining unrelated images to form a new symbolic whole, as in *Metamorphosis of Narcissus* (plate 248), in which the crouching youth is combined metaphorically with a pile of rocks. Dalí called his method "paranoid" because he recognized that, just as the psychotic had delusions, so the artist created a fantasy by forging a double image.[10] Lacan published his psychiatric doctoral thesis in 1932, in which he incorporated Dalí's analysis of the paranoid's perception of the world as a symbolic reordering of reality.[11]

Throughout the 1920s and '30s neurologists and other researchers who worked with physical features of the brain had repeatedly charged that psychoanalysis is not a science because its data are unobservable and its method (free association) does not yield repeatable results (every psyche is unique). Freud answered these critiques by declaring that his methods

OPPOSITE

247. Max Ernst, *Day and Night*, 1941–42. Oil on canvas, 44¼ x 57½ in. (112.4 x 146 cm). The Menil Collection, Houston. Purchased with funds provided by Adelaide de Menil Carpenter.

ABOVE

248. Salvador Dalí, *Metamorphosis of Narcissus*, 1934. Oil on canvas, 20 x 31 in. (50.8 x 77.5 cm). Tate, London.

were as scientifically rigorous as was possible for the investigation of inherently elusive, invisible psychic subject matter. He died in 1939 on the eve of World War II, having devoted his career to psychology after abandoning any hope of a physical, neurological approach. Then, in the 1950s, three critical discoveries were made about chemical, neurological, and genetic features of the brain that gave scientists the tools they had lacked. Soon the psyche entered the laboratory, and Freud's dream of a unified physical and psychological theory of the human mind— neuroscience—began to come true and to inspire a new generation of artists (see chap. 13).

Carl Jung's theory of a collective unconscious was also contemporary with Surrealism, but its influence was felt less in Europe than in the United States. Jung, the son of a Swiss Protestant clergyman, was an early follower of Freud, but the alliance ended before World War I because Jung disagreed with Freud's views on sexuality. Freud believed that humans have a life-force (sexual drive) from birth, but Jung held that children are not sexual until puberty. During the war Jung, secluded in his residence near Zurich, performed a kind of self-analysis in which he daily wrote down his dreams and fantasies; by 1919 he was confident that he had discovered within himself a series of primordial images—or archetypes; these included his anima (a

female alter ego that determined how he perceived women). Through studying the myths of other cultures, Jung generalized this finding in *The Psychological Types* (1921), in which he declared that all human beings are born with a collective unconscious, the repository of archetypes. Jung also proposed a psychological variant of Ernst Haeckel's late-nineteenth-century biological view that ontogeny recapitulates phylogeny; as each individual matures psychologically (becomes an adult), he or she repeats the historical development of culture, retaining traces of earlier (savage, intuitive) stages. The problem with modern man, according to Jung, is that he has an overly developed rational, scientific outlook. In several very popular books, such as *Modern Man in Search of a Soul* (1933), Jung declared that to achieve mental health, modern individuals must restore the balance in their minds between reason and intuition. A rejuvenation of intuition (the "soul" in Jung's title) was to be accomplished by bringing to consciousness the archetypes that are buried (forgotten) in the savage, intuitive part of the brain. The role of the artist was to express these archetypes: "The creative process, so far as we are able to follow it at all, consists in the unconscious activation of an archetypal image, and in elaborating and shaping this image into the final work."[12]

Jung's outlook never took root in Surrealist circles—it was too prudish and had too many religious overtones—but it suited American culture in the interwar decades. Jungian psychology gained followers in New York, where Jung, speaking fluent English, was a regular lecturer; and in 1936 a society in support of Jung (today's Jung Institute) was formed to train analysts and publish doctrine. Jung's outlook, which promised spiritual rebirth through myth and cross-cultural unity of mankind, had a strong appeal to American artists in the late 1930s and early 1940s. Adolph Gottlieb and Mark Rothko regularly used ancient mythology, such as Gottlieb's pictographs on the myth of Odysseus from the 1940s and Rothko's *Omen of the Eagle* (1942; National Gallery of Art, Washington, D.C.). In a 1943 interview, Rothko declared: "If our titles recall known myths of antiquity we have used them again because they are the eternal symbols upon which we must fall back to express basic psychological truths. . . . And modern psychology finds them persisting still in our dreams, our vernacular, and our art."[13]

The American painter Jackson Pollock not only read about psychology and mythology but was also periodically a patient in various mental health facilities, due to an alcohol addiction that began in adolescence. His first hospitalization was for four months in 1938 (at age twenty-six), and in 1939–41 he underwent a Jungian analysis.[14] His painting *Male and Female* (plate 249) is informed by a Jungian search for archetypes. Just as males are born with an anima, so females have an innate concept of masculinity—an animus—that is the basis of a woman's view of the opposite sex. Pollock's paired archetypal figures are depicted as if carved in a Native American totem pole (recalling Pollock's youth out West).

In the early 1940s, during the formative years of Abstract Expressionism, American artists continued to use Jungian archetypes in search of the savage, intuitive parts of their minds. They ceased in 1945 when American soldiers dropped the atomic bomb; archetypes from a collective unconscious and myths from past cultures suddenly seemed irrelevant.

OPPOSITE
249. Jackson Pollock (American, 1912–1956), *Male and Female*, c. 1942. Oil on canvas, 73¼ x 48⅞ in. (186 x 124.3 cm). Philadelphia Museum of Art. Gift of Mr. and Mrs. H. Gates Lloyd, 1974.

In the 1930s, after Einstein and Hubble confirmed that space-time is warped and that the universe is expanding, some artists in Surrealist circles adopted ideas and motifs from astronomy and physics, creating work that in most cases expressed both the unconscious realm and the space-time universe. Indeed, the weirdness of certain interwar discoveries (about subatomic particles, the structure of the universe, and so on) made them alluring to Surrealists and apt metaphors for their wildest dreams. In several works from the early 1930s, such as *Mental Arithmetic* (1931; destroyed) and *The Monumental Shadow* (1932; private collection), Magritte created metaphors for the new cosmos by placing huge spheres and cubes in small-town neighborhoods, like aliens from outer space. In 1932, three years after Hubble's confirmation of the expansion of space-time, Magritte painted *The Universe Unmasked* (plate 250), in which a familiar building disintegrates while cubes float, suggesting they are in outer space away from Earth's gravity. Both the earthly and the celestial are enveloped in nebulas; the universe revealed—unmasked—by science is mysterious indeed.

In *Time Transfixed* (plate 251), Magritte created a metaphor for the relativity of time. Science popularizers in the 1920s and '30s often used the example of a moving vehicle to explain the relativity of time (plate 252). Magritte's painting compares earthly time (the stationary clock on the mantel) with relative space-time (represented by the moving train below). Magritte freezes the two times together in an instant of astonishment. Time is "transfixed."

250. René Magritte, *The Universe Unmasked*, 1932. Oil on canvas, 29 x 36⅞ in. (75 x 91 cm). Collection Crik, Brussels.

251. René Magritte, *Time Transfixed*, 1938. Oil on canvas, 58⅞ x 39½ in. (147 x 98.7 cm). The Art Institute of Chicago. Joseph Winterbotham Collection, 1970.426.

With this painting's original French title, *La Durée poignardée*, Magritte suggested that time—duration (*la durée*)—has been annihilated. *"Poignardée"* has the connotation of being made motionless by awe, but it literally means being impaled. Space has also been shattered; the mirror in this strange new world reflects only one candlestick.

252. Relativity of time in a moving tank, in Charles Nordmann, "Une Révolution dans notre connaissance du monde" (A revolution in our understanding of the world), *L'Illustration* 157, no. 4082 (28 May 1921): 504 (illus.), 504–7 (text).

A shell is shot from either end of a moving tank; the shells leave when the tank is at the exact midpoint between two targets. To observers in the tank, the shell on the left appears to strike the left target first (because daylight reflected from the target has a shorter distance to travel back to strike the eyes of observers in the tank). But to the two stationary timekeepers standing below the targets, the shells strike simultaneously.

The Viennese artist Wolfgang Paalen joined the Surrealist movement in Paris in 1935, and he participated in Surrealist exhibitions and activities there until the outbreak of the war. He fled to Mexico, where he remained for the rest of his career, associating with intellectuals and artists such as Frida Kahlo and Diego Rivera; in the 1940s he exhibited regularly at the Julien Levy Gallery in New York. Early in the decade he decided to break with Surrealism in order to realize his vision of a new art that linked the insights of Einstein's physics with the age-old wisdom of Native art of the Americas.

Paalen was critical of other artists' uses of science: "Science and art both have their roots in the imagination; form and sense cannot be separated since no mental concept can become intelligible without assuming a form. But it is equally false to poeticize science (surrealist error) as to try to make a scientific art (abstract error)."[15] In work such as *The Messenger* (plate 253), Paalen created a figure—a cosmic messenger—using a vocabulary of forms that combined shapes representing how the artist imagined curved webs of space-time with the simple, curving shapes of traditional Mexican pottery. From 1942 to 1944 he published the magazine *Dyn* (from the Greek word for "possible"), which brought his message to an international audience. In 1942 Paalen sent out a questionnaire on Hegel's Idealism to intellectuals throughout the West, including a question that reveals his interest in philosophy and science: "Is the 'dialectic method' a scientific method of investigation?" In *Dyn* he published the responses he received from André Breton, Harold Rosenberg, Meyer Schapiro, Clement Greenberg, Robert Motherwell, Bertrand Russell, and Einstein: the last replied that the dialectic method "is not of any special interest either from the standpoint of contemporary physics or of the history of physics."[16] Paalen's closest collaborator was the British painter Gordon Onslow-Ford, who shared his interest in cosmology (*Without Bounds*, 1939; Museum of Modern Art, San Francisco), and Paalen published work by the young Robert Motherwell, who translated his French texts for the American audience.

Paalen, who knew Breton well from his Paris Surrealist years, remained friendly with the poet even after developing his breakaway Surrealist style. Breton visited him in Mexico and showed an interest in artists in the *Dyn* circle. In 1945 Breton, in a rare mention of physics, acknowledged the influence of the new cosmology on painters associated with Surrealism:

If when they venture into the scientific realm, the precision of their language is somewhat unreliable, it cannot be denied that their common, fundamental aspiration is to move beyond the universe of three dimensions. Although that was one of the leitmotifs of Cubism in its heroic period, it must be admitted that this question poses itself in a much more pointed manner since Einstein's introduction of the notion of space-time *into physics. The necessity of a suggestive representation of the four-dimensional universe asserts itself particularly in Matta (landscapes with several horizons) and in Onslow-Ford. [Oscar] Dominguez, motivated by similar preoccupations, now bases all his researches in the domain of sculpture on obtaining* lithochronic *[Breton's invented term for four-dimensional]* surfaces.[17]

In 1936 Breton had published an article with Christian Zervos, "Mathematics in Abstract Art," in the Parisian art periodical *Cahiers d'art*. It was illustrated by Man Ray's photographs of geometric models, including non-Euclidean examples, from the Institut Henri Poincaré (plate 254; see also plate 198); the photographs were also shown at an exhibition of Surrealist objects in Paris in 1936. These well-known photographs may well have been a source for painters, like Oscar Dominguez and Matta, who sought to visualize cosmic spaces. Dominguez, who was born in Spain, settled in Paris in 1934 after meeting Breton and becoming an active member of the Surrealist group. On the eve of

OPPOSITE

253. Wolfgang Paalen (Austrian, 1905–1959), *The Messenger*, 1941. Oil on canvas, 79½ x 30 in. (200 x 76.5 cm). Tate, London.

ABOVE

254. Man Ray (American, 1890–1976), *Polyhedron*, c. 1934. Photograph, illustration in André Breton and Christian Zervos, "Mathématique et l'art abstrait" (Mathematics and abstract art) *Cahiers d'art* 11 (Paris, 1936): 12 (illus.), 4–10 (text).

LEFT

255. Oscar Dominguez (Spanish, 1906–1957), *Nostalgia of Space*, 1939. Oil on canvas, 28¾ x 36⅛ in. (73 x 91.8 cm). The Museum of Modern Art, New York. Gift of Peggy Guggenheim.

256. Roberto Sebastian Antonio
Matta Echaurren (Chilean, born
1911), *The Vertigo of Eros*, 1944.
Oil on canvas, 6 ft. 5 in. x 8 ft. 3 in.
(2 x 2.5 m). The Museum of Modern
Art, New York. Given anonymously.

World War II he began a series of cosmic landscapes, such as *Nostalgia of Space* (plate 255), in which he sought to express a nonterrestrial, non-Euclidean geometry of outer space. Like an endless dreamscape, the composition fades into the background and into a pit of space below, filled with webs of lines suggesting the models of non-Euclidean volumes.

In the 1930s the Chilean Surrealist Matta read popularizations from several branches of science, including Einstein's theory of relativity and early-twentieth-century publications on cosmic evolution as well as morphology.[18] He was taken with Man Ray's photographs of geometric models in *Cahiers d'art*, feeling they captured an expressive quality of geometry that he found lacking in Machine Age architecture of the 1930s.[19] In paintings such as *Galaxies: Mysticism of Infinity* (1942; formerly André Emmerich Gallery, New York) and *The Vertigo of Eros* (plate 256), Matta gathered together his diverse interests in physics, psychology, and biology to create an imaginary space that merges outer space (the irregular geometry) and the psyche (the dark and somber mood).[20]

The Spanish Surrealist Remedios Varo was the daughter of an engineer and studied the sciences from her youth. In the 1930s she lived in Paris, where she became involved with Surrealist activities and married the French poet Benjamin Péret. During the rise of Fascism she and Péret fled to Mexico, where she developed her style of fantasy based in the history of science. Most of her Surrealist-era images relate to pre-twentieth-century discoveries, but she addressed contemporary science in late work such as *Space-Time Weaving* (1956; private collection). It shows a mechanical man and woman, their bodies composed of wheels and cogs, seen through a warped, gridlike veil, suggesting the fabric of space-time. In *Phenomenon of Weightlessness* (plate 257), Varo created a metaphor for Einstein's space-time universe. One of the orreries is floating free from gravity, indicating that it is in outer space; the scientist (sporting a very Einsteinian halo of hair) steps through from earthly space on the left to another relative viewpoint on the right. The difference between the left and right frames of reference is suggested by their being tipped in relation to each other.

Thus the Surrealists developed new ways of representing space and time to visualize the inside of the neurotic mind—a psychological perspective—using film and collage, as well as the metamorphosis of images and odd juxtapositions of image and word, to suggest the displacements of space and the warping of time in dreams. Some of them also borrowed imagery and ideas about distortions in cosmic space and time, making analogies between the irrational landscapes of the mind and the non-Euclidean, warped space-time universe.

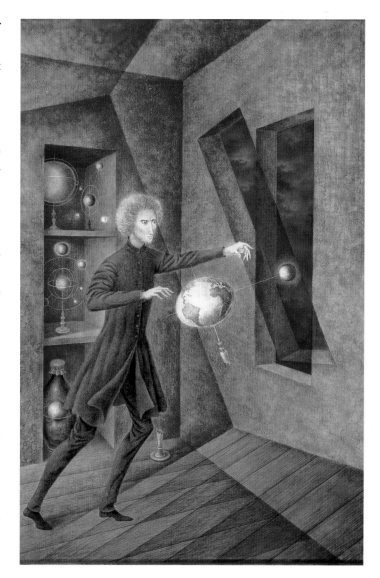

257. Remedios Varo (Spanish, 1908–1966), *Phenomenon of Weightlessness*, 1963. Oil on canvas, 29½ x 19¹¹⁄₁₆ in. (75 x 50 cm). Private collection, Mexico.

THE ATOMIC SUBLIME

Terror can only exist if the forces of tragedy are unknown. We now know the terror to expect. Hiroshima showed it to us. We are no longer, then, in the face of mystery.

Barnett Newman, "The New Sense of Fate," 1948

MUCH HAS BEEN WRITTEN about the origins of Abstract Expressionism in European Surrealism and Jungian psychology.[1] It should not be overlooked that some of these artists, as well as their contemporaries in Italy's Spazialismo movement, also responded to the most important scientific discovery of their day—nuclear energy. That find was made as the West was hurling itself into another world war, and so its first application was the design of a new weapon—the atomic bomb.[2] Never before had temperatures as fiery and forces as powerful as those raging in the sun been unleashed on the face of the earth. Artists who were contemplating Freudian dreams or Jungian archetypes were awakened on 6 August 1945 to a world in which there was suddenly the threat that all life on earth could end in a nuclear inferno.

ITALIAN PHYSICS AND AEROPITTURA

In 1901 Pierre Curie had hypothesized that there was a new energy source in the atom, and in the following decades Ernest Rutherford and others probed the atom by firing protons at different elements. In 1934 the French husband-and-wife team of physicists Frédéric Joliot and Irène Curie (daughter of Pierre and Marie Curie) established that firing protons at a sheet of aluminum had not only transmuted the aluminum (thirteen protons in the nucleus) to phosphorous (fifteen protons) but had also produced artificial radioactivity. In other words, when they stopped firing the protons, the newly created phosphorous was radioactive. With the development of particle accelerators in the 1930s, the existence of a nuclear force was confirmed. The research that led first to splitting the atom and then to setting up a controlled chain reaction of nuclear fission (the essence of an atomic bomb) was begun in Italy in the 1930s and concluded in America in the early 1940s, under the direction of Enrico Fermi.

In the mid-1920s one of Italy's senior physicists, Orso Corbino, who was also politically active as a senator, had the dream of making Rome a center for the new field of subatomic physics. Although he was wary of the new Fascist government, which had come to power in 1922 under Mussolini, Corbino got its support by convincing key politicians that science was

258. Barnett Newman (American, 1905–1970), *Onement I*, 1948. Oil on canvas, 27¼ x 16¼ in. (69.2 x 41.3 cm). The Museum of Modern Art, New York. Gift of Annalee Newman.

essential to the modernization of Italy. Thus he secured the funds and the authority to equip the laboratories of the University of Rome and to hire Italy's brightest young physicists; in 1926 Fermi accepted Corbino's offer of a professorship. Corbino also enlisted Fermi and the other young physicists he gathered, such as Franco Rasetti, to help recruit bright students and instill enthusiasm in the general public for the new science. To this end, in 1928 Fermi published the first textbook on subatomic physics in Italian (rather than German),[3] and he gave many public lectures at the Italian Association for the Advancement of Science—on the theory of relativity, the structure of the atom, and the nature of light—which were published as popularizations.

The public audience for the new Roman center for subatomic physics included second-generation Futurists, who had relocated from Milan to Rome after World War I. Led by Giacomo Balla and Filippo Tommaso Marinetti and joined by many younger artists, including Fedele Azari, Gerardo Dottori, and Enrico Prampolini, the revitalized Futurists updated their vision of capturing rapid motion and expressing dynamism to accord with postwar developments in the theory of relativity and subatomic physics. Like the biomorphic abstract artists in interwar Paris (see chap. 10), the Futurists in Rome developed a style expressing the cosmic unity taught by the new cosmology, but with several distinctly Italian features: an ancient Roman pantheist vision, a vocabulary of force lines, and an aerial viewpoint.

The ancient theme of the unity of the microcosm and macrocosm was discernible in Parisian art of the period, but the artists who created it—Arp, Miró, Calder, and Kandinsky, for example—lacked a common philosophical outlook on the topic because they came from diverse backgrounds (German-French from Alsace, Spanish, American, and Russian). By comparison, every Italian schoolchild was taught the powerful pantheist vision of Cicero's *Dream of Scipio* (51 B.C.) and its Roman Catholic restatement by Dante in his *Divine Comedy* (c. 1310–14). Based in the cosmology of Pythagoras and Plato, Cicero described man's soul as coming from a perfect place beyond the moon, to which his spirit returns after death. In his introduction to *The Banquet* (c. 1304–7), Dante acknowledged that his view of the cosmos was inspired by the *Dream of Scipio*, and its pantheist vision of man's unity with the heavens underlies the poet's three-tiered inferno, purgatory, and paradise in *The Divine Comedy*.

During World War I, Balla had already begun to imbue his force lines with a spiritual dimension, as in *Forms-Spirits* (1918; Galleria Nazionale d'Arte Moderna, Rome). Then, in the 1920s, as the Futurists learned of the forces linking the subatomic realm with the cosmos, they expressed a traditional Italian pantheist vision of cosmic unity, both physical and spiritual, using their vocabulary of force lines. In the 1920s they also transferred their fascination with speed from the automobile to the airplane, as in Balla's *Force of an Airplane* (c. 1920; Casa Balla, Rome).[4] Before the war, Futurist painting had a stationary viewpoint—for example, a moving auto as seen by a motionless viewer. After the confirmation of Einstein's theory of relativity, the Futurists changed their viewpoint to that of a moving observer with a shifting aerial

perspective. As a pilot during the war, Azari had perceptual experiences unique to aerial vision, such as the impression that parallel urban structures are tilting, captured in his *Perspectives of Flight* (plate 259), which Marinetti hailed as "the first work of aerial painting."[5]

The artists, who named their style Aeropittura (Aerial Painting), captured the spectacle unique to the experience of flying in a single-engine propeller plane, which is capable of tight turns and dramatic nosedives, producing views very different from those seen by passengers in a multiseat airliner.[6] These panoramas include the illusion (when in a spin) that the ground is curving like the picture on an open fan, as in Alessandro Bruschetti's *Spin* (plate 261); an X-shaped visual field caused by doing a quick 360-degree aerial somersault (a "loop"), as in Tullio Crali's *Looping* (plate 260); and "ground rush," the illusion that the earth is flying up into one's face (seen in a nosedive if one gets dangerously low), as suggested by Tato's aerial photographs (*Sensation of Flight*, 1932). In 1929 the Futurists declared in their "Manifesto of Aerial Painting":

> —*The changing perspectives of flight constitute an absolutely new reality, which has nothing in common with the traditional reality of a terrestrial perspective;*
> —*The elements of this new reality have no fixed location and are created by the perpetual movement itself;* ...
> —*One soon arrives at a new spirituality and an awareness of an extraterrestrial realm.*[7]

The Futurists also used aerial views as metaphors for the shifting frameworks in the new space-time continuum and for the distortions caused by relative motion. According to Marinetti: "The airplane, which glides, nosedives, or climbs in a spiral, creates an ideal hypersensitive observatory, suspended in infinity and made dynamic by the consciousness of movement that changes the value and rhythm of minutes, of seconds, and of visual sensations. Time and space are pulverized by the sudden observation that the earth flies by under an apparently motionless airplane."[8]

Like Scipio (who has a dream in which he views the earth from the heavens above), the viewer is not just *in* the sky, but *of* the sky; he looks up to his spiritual home, such as the nebulas in Dottori's *Dynamic Forces* (plate 262), and he looks down to his physical home, such as the hills in Dottori's *Reds and Greens* (plate 263). And in the tradition of Cicero and Dante, a link of the microcosm to the macrocosm is made by giving the painting an aerial viewpoint, as in Fillia's *Terrestrial Transcendence* (1931; location unknown) and Prampolini's *Extraterrestrial Spirituality* (1932; location unknown).

When the neutron was discovered in 1932, it gave the physicists in Rome an excellent tool with which to probe the atomic nucleus, and Fermi began bombarding many different elements with neutron bullets. In radioactive decay, big atoms (like uranium) transmute to smaller

The globes of the stars far surpassed the earth in size, and now the earth itself seemed to me so small that I was ashamed of our empire, which reaches hardly more than a point on its surface.

Cicero, *Dream of Scipio*, 51 B.C.

261. Alessandro Bruschetti (Italian, 1910–1980), *Spin*, 1932. Oil on canvas, 23½ x 19⅝ in. (60 x 50 cm). Fonte d'Abisso Arte, Milan.

LEFT
262. Gerardo Dottori, (Italian, 1884–1977), *Dynamic Forces*, 1926–28. Colored pencil on board, 10 x 13⅝ in. (25 x 34 cm). Courtesy Lattuada Studio, Milan.

BELOW
263. Gerardo Dottori, *Reds and Greens*, 1925. Oil on canvas, 14 x 32 in. (35 x 80 cm). Courtesy Lattuada Studio, Milan.

Using the traditional Italian fresco medium, Dottori also painted *Apotheosis of Flight* (1929) for the Ostia Airport near Rome, out of which the painter often flew.

atoms by spontaneously losing protons. Like Joliot and Curie in Paris, Fermi found that he could do the opposite and make small atoms get bigger, but he had a greatly improved method. Unlike the proton bullets used in Paris, a neutron bullet has no electric charge and so the particle is not repelled by the positively charged nucleus and easily penetrates the atom. For example, when Fermi shot a neutron into the nucleus of an atom of carbon, which has six protons, a negative charge was given off (an electron flew out); the neutron, effectively, became a proton. In this way Fermi produced a seven-proton nucleus, which is a stable (nonradioactive) atom of

nitrogen. Fermi also discovered a way to control the *speed* of the neutron bullet that gave him hitherto unknown control over the transmutation process.

His success with transmutation made Fermi wonder whether he could possibly create a *new* atom, one unknown in nature, by adding a proton to the (then) last element on the periodic table—uranium, which has the atomic number 92 (that is, it has ninety-two protons)—and in 1934 he aimed his neutron gun at a chunk of uranium. Chemical analysis seemed to indicate that a new element of atomic number 93 was among the bombardment debris, but Fermi could not explain all the characteristics of the other resulting atoms. In June 1934, in a burst of enthusiasm, Corbino (without Fermi's approval) publicly announced that the new "element 93" had been created in Rome. The Italian press declared a victory for Italian science, and newspapers around the world reported the discovery. As Fermi was well aware, the announcement was premature because he had not proven conclusively that he had created the new element. It took him several years to realize that he was actually doing something much more revolutionary than creating a new element, something that even the medieval alchemists had never dreamed of—he was playing with nuclear fission.

BUILDING THE BOMB

Fermi kept bombarding uranium for several years, but before he could solve all the mysteries of his bombardment debris, he was distracted by political pressure from Mussolini's government, which was increasingly allied with the Nazis. In 1938 Fermi (himself Catholic but with a Jewish wife) became distressed when laws against Jews were passed in Italy. When he traveled to Stockholm that year to receive the Nobel Prize in physics, Fermi took the opportunity to flee with his family to America.

The analysis of the debris from the bombardment of uranium was also being worked on by Fermi's colleagues in Berlin, the Austrian physicist Lise Meitner and the German Otto Hahn, who suspected that the neutron bullets had split the uranium nucleus into two atoms. Then Meitner, who was an Austrian Jew, had to flee Berlin in 1938 after the Nazi occupation of Austria. Safe in Sweden and intuiting the implications of the hypothesis, Meitner entrusted her nephew to hand-carry a copy of the laboratory data to Niels Bohr, who was just leaving Copenhagen for a physics conference in Washington, D.C. She also published a description of the ability of a neutron to "fission" uranium in the January 1939 issue of the British journal *Nature*, effectively letting the nuclear genie out of the bottle. When Bohr announced Meitner's and Hahn's hypothesis to his colleagues in America, physicists rushed back to their laboratories, and within six months many had confirmed experimentally that the uranium atom could be split.

When the uranium nucleus is split into two half-size nuclei, the total weight of the two smaller parts is less than the original. The difference in mass has been converted into an enormous amount of energy; the conversion is summarized in $E=mc^2$. Equally important, the fission releases approximately two neutrons, which in turn split other nuclei, beginning a chain reaction. Splitting one nucleus releases 200 MeV (million electron volts) of energy and two neutrons, which split two more nuclei releasing 400 MeV and four neutrons, which split four

more nuclei releasing 800 MeV and eight neutrons, and so on. In billionths of a second an astonishing amount of energy is produced; fissioning one ounce of uranium is equal to detonating 600 tons of TNT.

By 1939 it was public knowledge that the uranium atom could be split; when World War II broke out, Werner Heisenberg remained in Germany, where he was put in charge of the Nazi effort to build an atomic bomb. By this time Einstein was a refugee in America, living in Princeton, New Jersey.[9] After it came to his attention that the fissioning experiments were being repeated in Berlin, he wrote to President Roosevelt in August 1939 to alert him and to recommend that American research on nuclear fissioning be accelerated. In 1941 Roosevelt approved an American effort to design an atomic weapon (the Manhattan Project); later that year Japan bombed Pearl Harbor, and the United States entered the war.

In 1942 the first nuclear chain reaction was accomplished at the University of Chicago by an international team of physicists under Fermi's direction. At a laboratory in Los Alamos, New Mexico, under the direction of the American physicist J. Robert Oppenheimer, the first atomic bomb was completed in 1945 by a team that included Bohr, who had fled Nazi-occupied Denmark in 1943. By 1945 Hitler had been defeated, but fighting continued in the Pacific. The United States dropped the first nuclear fission bomb on Hiroshima on 6 August 1945, and a second bomb three days later on Nagasaki with a combined force of 35,000 tons of TNT. Japan surrendered and World War II ended.

European refugee physicists working with their American colleagues had opened the door to the atomic age, and although some scientists returned to their homelands after 1945, the international center of science remained in the United States. Einstein lived in Princeton until his death in 1955, trying (unsuccessfully) to formulate a theory that would unify gravity and electromagnetism with the nuclear forces—a grand unified theory of the universe, which remains the elusive goal of some cosmologists, who today call it the "Theory of Everything." With massive government and industry support beginning in the late 1940s, American science was dominated for decades by the arms race and space exploration. The art capital of the West also shifted to American soil, and post-1945 American art was infused with a mixture of mystical awe and fearful dread of the primeval power that physicists had unleashed from the subatomic realm—an atomic sublime, if you will.

ART FOR THE ATOMIC AGE:
ABSTRACT EXPRESSIONISM AND SPAZIALISMO

Barnett Newman, Mark Rothko, and Jackson Pollock heard about the discovery of nuclear fission along with everyone else in August 1945, and within a few years, driven by themes associated with atomic energy, they each moved into total abstraction and achieved their mature styles: Newman's *Zip* paintings (beginning 1948), Rothko's floating rectangles of color (from 1947), and Pollock's poured paintings (from 1947).[10] Newman revived the Romantic term *sublime* to describe the new art, but he also stressed that Abstract Expressionism was a *new* sublime because science had changed artists' understanding of nature.[11] Whereas Friedrich and Turner had painted awesome energy streaming from spectacular cloud-filled skies, Newman,

*The atomic bomb has changed
everything except the nature
of man.*

Albert Einstein,
New York Times Magazine,
23 June 1946

*Like the Greek fate, which
was the projection of a social
image—the only valid symbol
of a people proud of their
sense of civilization—our
fate is likewise the product
of civilization. . . . We are
living, then, through a Greek
drama; and each of us now
stands like Oedipus and can
by his acts or lack of action,
in innocence, kill his father
and desecrate his mother.*

Barnett Newman,
"The New Sense of Fate,"
1948

Rothko, and Pollock knew that the strongest forces in nature were within invisible particles in the core of matter. The Romantics had felt humbled in the presence of their immense and majestic deity, Mother Nature. After 1945 scientists assumed a godlike role by unleashing the mightiest force in nature, and the Abstract Expressionists felt dread and anxiety at the knowledge that such powers were in mortal hands. Expressing a conviction that was common among postwar intellectuals, the artists proclaimed that humankind needed to reexamine its spiritual and moral values.

Newman and Rothko, driven by the postwar spiritual self-examination, expressed in their art the mystery and somber tragedy of life in the atomic age. Newman was suited by education (which included an undergraduate degree in philosophy from the City University of New York in 1926) and by his contemplative temperament to assume the role of spiritual leader. His family and friends have attested to his lifelong attachment to the philosophy of Spinoza,[12] and Newman's writing bears the stamp of pantheism, seeking the mystical union of the self with nature in language that recalls Spinoza's God/Nature—"the One." In the spring of 1945 Newman described his art as focused outward and aimed at a transcendental union with the "world-mystery"—as distinct from Surrealism, which focused inward and aimed at expressing individual feelings: "Surrealism is interested in a dream world that will penetrate the human psyche. To that extent it is a mundane expression. It is still concerned with the human world; it never becomes transcendental. The present painter is not concerned with his own feelings or the mystery of his own personality but with the penetration into the world-mystery. His imagination is therefore attempting to dig into metaphysical secrets. To that extent his art is concerned with the sublime. It is a religious art which through symbols will catch the basic truth of life, which is its sense of tragedy."[13]

Newman's vision bears a striking resemblance to Einstein's cosmic religion (see chap. 9), which Newman may have known from the days he was struggling to become an artist in New York during the late 1920s and early '30s. The 25 April 1929 *New York Times* headline "Einstein Believes in 'Spinoza's God'" may have caught Newman's attention, or he may have noted Einstein's long article, "Religion and Science," detailing cosmic religion in the 9 November 1930 *New York Times Magazine.* Over a decade later—by which time Newman was exhibiting at Betty Parsons Gallery in New York along with Rothko, Pollock, Adolph Gottlieb, and Clyfford Still—the transcendental goals of the emerging Abstract Expressionist artists were belittled by Clement Greenberg: "I myself question the importance this school attributes to the symbolic or 'metaphysical' content of its art; there is something half-baked and revivalist, in a familiar American way, about it."[14] Greenberg invited Newman to respond, and the artist defended the pursuit of a transcendental reality: "If I may make an analogy, it is as if we were to compare an Einsteinian formula to a non-Euclidean geometry. In one the formulas are symbols that evoke in stenographic fashion the imagined idea complex that is Einstein's vision of the cosmos. . . . It is, of course, more difficult to understand Einstein, for we must evoke his world, re-creating his reality from his nonmaterial stenography. . . . And so with the painters. The Americans evoke their world of emotion and fantasy by a kind of personal writing without the props of any known shape. This is a metaphysical act."[15] In other words, in a formula by Einstein (such as $E=mc^2$) the parts refer to a theoretical reality that exists only in

the scientist's mind, just as the referent of an Abstract Expressionist painting exists only in the artist's mind. On the other hand, according to Newman, any geometry (such as non-Euclidean geometry) is an abstraction from the physical earth and larger physical universe, as was European geometric abstract art of the 1930s and '40s.

Rothko similarly had the education and reflective disposition to prepare him for the role of spiritual leader. Although he emigrated to the United States from Russia when he was thirteen years old, speaking only Russian and Yiddish, within a few years he had so excelled in a Washington state high school that he won an academic scholarship to Yale University, where he studied literature, history, and mathematics. Rothko's work of the early 1940s, such as *Birth of Cephalopods* (plate 264), manifests his well-informed interest in natural history.[16]

Like many other American intellectuals during the political unrest before and during World War II, Rothko was drawn to Carl Jung's hypothesis of a human collective unconscious, with its promise of cross-cultural bonds uniting mankind (see chap. 11). In 1943, as war raged in the Pacific, Gottlieb, together with Rothko, declared that ancient myths and primitive art expressed the anxiety of their times: "All primitive expression reveals the constant awareness of powerful forces, the immediate presence of terror and fear, a recognition and acceptance of the brutality of the natural world as well as the eternal insecurity of life. That these feelings are being experienced by many people throughout the world today is an unfortunate fact, and to us an art that glosses over or evades these feelings, is superficial or meaningless."[17]

Since research on the bomb had been top secret, the American public was completely unprepared for the radio announcement on a Monday afternoon in August that American soldiers had destroyed a Japanese city the size of Denver in less than a second, using a new kind

264. Mark Rothko (American, 1903–1970), *Birth of Cephalopods*, 1944. Oil on canvas, 39½ x 53½ in. (100.3 x 135.9 cm). National Gallery of Art, Washington, D.C. Gift of the Mark Rothko Foundation.

For the first three billion years of life on earth, animals were no more than a single cell. The artist shows several such parameciums outlined in black in the lower left and right; their oval shapes contain a cell nucleus and have whiplike flagella for locomotion. Life improved when cells joined together in colonies to form sponges—the large pink forms to the left and right of center—cup-shaped aggregates of undifferentiated cells that take in food and eject waste from a single opening (shown by the artist at the top). The birth of cephalopods 600 million years ago in the Cambrian epoch of prehistory introduced a great improvement in the design of animals; the body is a tube through which nourishment flows only in one direction. Today a cephalopod (Greek for "head-footed") is a sea animal whose limbs are located around its mouth, like the tentacles of an octopus, so that it can grasp food and feed itself. Rothko painted a primitive form of this marine invertebrate with its black tube body in the center, its mouth above (surrounded by dozens of limbs), and its anus below. Far from being a static textbook illustration, Rothko's cephalopod is a majestic creature, its colorful limbs waving triumphantly in the water above the lowly sponges and parameciums, and its birth is a joyful celebration, in pastel hues and swirling forms, of the force of life.

of weapon—an atomic bomb. Conventional bombs that the Allies had dropped on Berlin and Dresden produced energy from a chemical reaction (so all the atoms remained intact). The public learned that the stupendously greater energy of the new secret bomb came from within the atom, from the destruction of mass that occurred when its nucleus was split. Any thing or person at ground zero in Hiroshima was immediately vaporized, and in a single flash of unfathomable energy buildings were transformed into rubble as far as the eye could see. The by-products of nuclear fission also transformed the city into a radioactive wasteland; over the city hung a cloud of radioactive vapor and dust that slowly drifted away, contaminating survivors of the blast. A flood of radio and newspaper reports compared modern man's discovery of nuclear energy to primitive man's discovery of fire, and there was a sense of foreboding about what the discovery meant for the future. After Japan's surrender a few days following the bombings, Edward R. Murrow commented on CBS radio: "Seldom if ever has a war ended leaving the victors with such a sense of uncertainty and fear, with such a realization that the future is obscure and that survival is not assured."[18]

Unlike the presentation in the 1920s of the theory of relativity and atomic physics to the American public as incomprehensible, journalists and government spokesmen made great efforts to demystify the new weapon and explain a nuclear chain reaction to the man on the street. In President Truman's first speech to the nation after the bombings, he (correctly) compared the energy released by the bomb to the nuclear energy that powers the sun.[19] *Life* magazine, which had five million subscribers, devoted its 20 August 1945 issue to the bomb (plate 265) and presented a lucid, illustrated exposition of the splitting of an atom of uranium (plate 266). The editors underlined the importance of the discovery with another article detailing the history of the study of forces in nature: readers were told about Newton's force of gravity holding the stars and planets in place, Maxwell's electromagnetic force holding atoms together, and now a nuclear force holding the atomic nucleus together, which according to *Life*, "provided another proof of the Einstein theory that matter is simply energy in another form."[20] The editors noted the great power displayed by the bombing of Hiroshima: "In the heart of the city were oil stores, electric works, and many bridges . . . centuries-old temples and a public garden

famous for its flowering trees. . . . The atomic bomb had blown three-fifths of Hiroshima off the face of the earth."[21]

In the same issue, *Life* published a commentary on the implications of the bomb for future wars, including a sobering reflection by General Carl Spaatz, commander of the airmen who dropped the bombs, "Wouldn't it be an odd thing if these were the only two atomic bombs ever dropped?"[22] In "The Atomic Bomb and Future War," Hanson W. Baldwin, who was a military analyst for the *New York Times*, wrote that the future held the possibility of "devastating 'push-button' battles."[23] Three months later *Life* published a description of World War III— the "36-Hour War"—not as science fiction fantasy but based on a formal report that had been released that week, written by General Henry A. Arnold, commander in chief of the U.S. Air Force, to the secretary of war (plate 267). Taking off from Arnold's declaration that "with present equipment an enemy air power can, without warning, pass over all formerly visualized barriers and can deliver devastating blows at our population centers,"[24] *Life* illustrators presented "how such a war might be fought if it came" (plate 268).[25]

Despite the simultaneous bombing of thirteen cities and the fact that "more than 10,000,000 people have been killed by the bombs,"[26] *Life* magazine's "36-Hour War" ended on a grisly but upbeat note: "U.S. rockets lay waste the enemy's cities. . . . The U.S. wins the atomic war."[27] In December 1945 *Time* magazine named Harry Truman Man of the Year and summarized the American public's mood in the accompanying editorial: "What the world would best remember of 1945 was the deadly mushroom clouds over Hiroshima and Nagasaki. Here were the force, the threat, the promise of the future. . . . In such a world, who dared be optimistic?"[28]

After the bomb, Newman and Rothko soon ceased painting visible images from nature. In response to the unleashing of the nuclear force—the awesome, terrifying, almighty new Absolute—they developed completely nonrepresentational styles lacking any spatial or temporal perspective. In 1946 Newman painted a metaphor of nature as a "pagan void" (plate 269);

ABOVE, LEFT

267. "The Atom Bombs Descend on U.S.," in "36-Hour War," *Life*, 19 Nov. 1945, 28–29. Illustration by A. Deydenfrost.

According to the *Life* writer, "In the panorama above, looking eastward from 3,000 miles above the Pacific, *Life*'s artist has shown the U.S. as it might appear a very few years from now, with a giant shower of enemy rockets falling on 13 key U.S. centers. Within a few seconds, atomic bombs had exploded over New York, Chicago, San Francisco, Los Angeles, Philadelphia, Boulder Dam, New Orleans, Denver, Washington, Salt Lake City, Seattle, Kansas City, and Knoxville."

ABOVE, RIGHT

268. "By the marble lions of New York's Public Library, U.S. technicians test the rubble of the shattered city for radioactivity," in "36-Hour War," *Life*, 19 Nov. 1945, 35. Illustration by N. Sinkler.

The *Life* caption reads: "San Francisco's Market Street, Chicago's Michigan Boulevard, and New York's Fifth Avenue are merely lanes through the debris."

he later commented that he selected titles for his works to indicate his feeling while he was working on a piece. In the year after scientists unleashed nuclear energy, Newman painted a black hole in the midst of a shape that suggests both a microscopic amoeba and a massive cloud; this is not an abyss reached after a spiritual journey but a nonexistence—a void—produced by pagan science.

The Abstract Expressionists also ceased painting ancient myths after the atomic bomb. Newman explained that the artists no longer shared ancient man's terror before unknown forces of nature because, after the bomb, the artists knew the forces.[29] He declared further that the artists would create an art expressing modern tragedy— the human condition after the bomb—"the new sense of fate" appropriate to the atomic age. Although the genocide of the war is outside the scope of this book, it should be remembered that Newman and Rothko were both Jewish, and the postwar coverage of the Holocaust was another factor in their somber mood. In "The Sublime Is Now" (1948), Newman wrote: "We are asserting man's natural desire for the exalted, for a concern with our relationship to the absolute emotions. We do not need the obsolete props of an outmoded and antiquated legend. . . . We are making it out of ourselves, out of our own feeling. The image we produce is the self-evident one of revelation, real and concrete."[30] In the tradition of pantheism, Jewish mysticism, and Spinoza's God/Nature—"the One"—Newman had

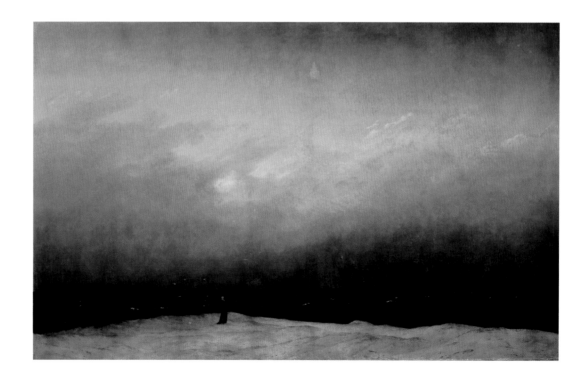

his revelation on 29 January 1948, when he made a line that was not *on* the surface but *of* his canvas (one with it) in a continuous field, his first *Zip* painting (plate 258). Newman has described this work as "A field that brings to life other fields, just as the other fields bring to life this so-called line. That painting called *Onement I*: what it made me realize is that I was confronted for the first time with the thing that I did, whereas up until that moment I was able to remove myself from the act of painting, or from the painting itself."[31]

271. Mark Rothko, *No. 5 (Untitled)*, 1949. Oil on canvas, 85⅛ x 63⅛ in. (215.9 x 160 cm). Chrysler Museum of Art, Norfolk, Virginia. Bequest of Walter P. Chrysler Jr.

272. Jackson Pollock (American, 1912–1956), *Number 1, 1948*, 1948. Oil and enamel on unprimed canvas, 5 ft. 8 in. x 8 ft. 8 in. (1.7 x 2.6 m). The Museum of Modern Art, New York. Purchase.

By the late 1940s Rothko was composing with rectangles of luminous color floating on a uniform field (plate 271), and he felt that the subject of this work was "basic human emotions—tragedy, ecstasy, doom."[32] Like Newman, Rothko acknowledged his Romantic lineage,[33] and his fields of color recall Friedrich's voids, with their metaphysical, spiritual overtones, as in *Monk by the Sea* (plate 270).

In the postwar decade, as the educated public learned about nuclear energy, artists became aware that many quantum physicists believed that nature was fundamentally indeterministic. For example, Hans Arp, looking back on his use of chance in his *Cosmic Forms* of 1927–48, stated in 1950 that he had "unconsciously obeyed a law that has now become a supreme law. I used the name 'According to the Laws of Chance' naively without realizing that this was a law encompassing Planck's law of cause and effect."[34] The Abstract Expressionists' use of chance techniques was rooted in the Surrealists' recognition of the creative role of chance in nature; genetic mutations provided species with new possibilities, and automatic processes, as well as free association, revealed repressed memories. For Newman, Rothko, and Pollock the use of chance came to have an added moral dimension because it was commonly assumed that indeterminism in microphysics implied free will in the macroworld of human affairs. For example, two weeks after the bombing of Hiroshima, the editor of *Life* wrote: "The

thing for us to fear is not the atom but the nature of man, lest he lose either his conscience or his humility before the inherent mystery of things. Atomic science certifies that mystery. Its own laws condemn us to ultimate ignorance; but also to the eternal freedom of choice inherent in an indeterministic universe."[35] For the Abstract Expressionists, chance techniques—the gesture, the stain, the drip—became actions expressing human free will.

Pollock was drawn to the theme of deadly power that was reiterated throughout early reports of nuclear energy. A self-destructive, chronic alcoholic, Pollock intuited the dark heart of the atom, and his poured paintings are icons of matter as energy. Asked by an interviewer in 1951 to comment on the "controversy" caused by his "method of painting," Pollock replied: "It seems to me that the modern painter cannot express this age, the airplane, the atom bomb, the radio, in the old forms of the Renaissance or of any other past culture. Each age finds its own technique."[36] The artist's web of gestural lines captures the energy associated with nuclear force, and like Newman and Rothko, he worked on a large mural scale that engulfs the viewer (plate 272).

Pollock's poured paintings also communicate a human nervous energy. Grounded in the Surrealist expression of the unconscious, Pollock saw his technique as expressing not only his times but also his emotions, as he stated in 1951: "I want to express my feelings rather than illustrate them. Technique is just a means of arriving at a statement."[37] Pollock's technique captured the fearful mood in the Romantic sublime: the tumultuous forces felt by those being hurled to their deaths as the earth erupts in John Martin's painting of the apocalyptic day of judgment (plate 273), or the frenzy of the panic-stricken residents of the burning city in Thomas Cole's *Course of Empire: Destruction* (1836; New-York Historical Society). Eyewitnesses to the detonation of the atomic bomb have described similarly horrific scenes: "My clothes were tattered and covered with blood. I had cuts and scratches all over me, but all of my extremities were there. I

273. John Martin (English, 1789–1854), *The Great Day of His Wrath*, 1851. Oil on canvas, 78½ x 121¼ in. (196.5 x 303.2 cm). Tate, London.

274. Lucio Fontana (Italian, born Argentina, 1899–1968), *Spatial Concept: "Waiting,"* 1960, from the *Tagli* (cuts) series. Tate, London.

looked around me. Even though it was morning, the sky was dark, as dark as twilight. Then I saw streams of human beings shuffling away from the center of the city. Parts of their bodies were missing. Their eyes had been liquefied."[38] Sensitive to the unspeakable suffering caused by the bomb, and well acquainted with his own dark demons, Pollock created poured paintings that resonate with both nuclear energy and human nervous energy.

In Europe in the late 1940s and early '50s, the Italian-Argentinean artist Lucio Fontana also created art expressing matter as energy in response to nuclear fission. Having spent the war in his South American birthplace, Fontana did not bring to his work the distraught overtones of the American artists. In the 1930s he had a studio in Milan and was associated with Abstraction-Création, an international group of abstract artists based in Paris. In 1946 he was a major con-

tributor to a manifesto written in Buenos Aires by several young artists belatedly calling for an art based on Einstein's cosmology. After citing the dynamism of Futurism as their predecessor for capturing modern life, they proclaimed a new art of space and time: "Color, the element of space, sound, the element of time and the movement that takes place in time and space, are the fundamental forms of the new art, which contains the four dimensions of existence. Time and space."[39]

After his return to Italy in 1949 Fontana produced a work of art by stretching a canvas and then puncturing it with holes to create passageways between the terrestrial world (as depicted on the artist's canvas) and the universe (metaphorically the void beyond the canvas). Reflecting on his *Buchi* (holes) series, the artist stated: "I made a hole in the canvas to suggest the expanse of cosmic space that Einstein had discovered. Light and infinity pass through these holes; there is no need to paint."[40] To heighten the association of the holes with celestial space, Fontana punctured a pattern suggesting a stellar constellation (*Spatial Concept*, 1952; Centre National d'Art et de Culture Georges Pompidou). In keeping with the gestural abstraction of Abstract Expressionism and parallel developments in the late 1940s and 1950s in European painting (referred to as Art Informel, Tachisme, or Art Autre), Fontana added slashes to his vocabulary of punctures, beginning his *Tagli* (cuts) series (plate 274).

Fontana's themes related to Einstein's theory of relativity had been pursued by many interwar artists and architects in Italy and the West. What distinguishes Fontana as a post-1945 artist of the *atomic* age is his transformation of matter into energy, and his creation of art with energy (light) alone, in environmental work from the late 1940s until his death in 1968. In his *Spatial Environment with Black Light* (1949), Fontana completely blackened the interior of the Galleria del Naviglio in Milan, and within the light-tight space he hung amorphous forms covered with fluorescent paint, which he lit with ultraviolet light. A few minutes after entering the total darkness, the viewer's eyes were adapted for night vision, and the phantom rays appeared.

The Futurists had painted electromagnetic force lines in the traditional medium of oil paint; Fontana instead created bright, shiny new atomic-age images of force lines that were *literally* energy—light—in his first "drawings" in neon. Soon Fontana was working with architects to create whole environments defined by light (plate 275). These installations fulfilled the vision stated in his "Technical Manifesto" of 1951, in which Fontana acknowledged that as nineteenth-century physical science ("materialism") had led to abstract art, so the recent discovery of new forces in nature would lead to a new dematerialized art of pure energy:

> The discovery of new physical forces, the control of matter and space gradually impose on man conditions that never existed earlier in history. . . . Abstraction was conceived and was gradually arrived at through distortions. However, this new period [modern abstract art] does not meet the needs of man today. . . . It is necessary to go beyond painting, sculpture, and poetry. . . . We conceive a synthesis as the sum of physical elements: color, sound, movement, space, forming an ideal and material unity. Color, the element of space, sound, the element of time and movement that develops in time and space. These are the basic forms of the new art that comprises the four dimensions of existence. . . . A new art form is taking shape, light forms in space.[41]

RIGHT

275. Lucio Fontana, *Structure,*
1951. Neon installation at Milan
Triennale.

BELOW

276. Roberto Crippa (Italian,
1921–1972), *The Creation of the
World,* 1952. Oil on canvas, 52
x 52 in. (130 x 130 cm). Private
collection, Bergamo, Italy.

In five manifestos from 1947 to 1952, Fontana formulated his theories about an environmental art that he called Spazialismo (Spatialism). He soon gained followers such as Gianni Dova, who had been active in the short-lived Arte Nucleare (Nuclear Art) group that formed in 1951 to create a style relevant to the atomic age. Fontana enlisted Roberto Crippa to join Spazialismo after seeing the first exhibition of the young artist's painted webs of gestural lines in 1947 in Milan. A professional stunt pilot who was internationally competitive in aerial acrobatics, Crippa merged the Aeropittura artist's pursuit of the sensation of flight with Fontana's desire to embody atomic energy (plate 276).

Fontana continued creating light environments throughout the 1960s, in works such as *Black Environment* for the 1968 Venice Biennale, composed of shafts of light in a darkened space, and *White Labyrinth* for the Documenta in Kassel of the same year, a completely white maze leading to a slash on a panel of white (plate 277). His dematerialized art-as-energy influenced decades of environmental artists, light sculptors, and conceptual artists. But perhaps Fontana's most direct heir is the Italian artist Mario Merz of the Arte Povera group, who since 1969–70 has been presenting an immaterial concept—the Fibonacci numerical series—in light (plate 278).

Leonardo Fibonacci was a mathematician in Pisa in the thirteenth century, when that port city had strong trading ties with Islamic North

Africa. The child of a merchant who frequented North Africa, Fibonacci was tutored by a Muslim mathematician, and from childhood he sensed the intuitive clarity of arithmetic in Arabic numerals ($32 + 43 = 75$) rather than clumsy Roman numerals ($XXXII + XLIII = LXXV$), which were still used in territories of the old Roman empire. In 1202 Fibonacci dealt the death blow to Roman numerals in Europe by publishing his *Liber abaci* (Book of the abacus), in which he defined an infinite series of numbers in which each is the sum of the two preceding, and pointed out how much easier it is to calculate the series using Arabic numerals (1, 1, 2, 3, 5, 8, 13, 21) as opposed to Roman (I, I, II, III, V, VIII, XIII, XXI).

Merz was intrigued by the rapid expansion of the series: "The Fibonacci numbers expand in an accelerated manner, and thus they inspired my idea that it is possible to assign a new number to everything in the world, including material objects and living organisms."[42] As with any infinite series, a partial list of the numerals can be made visible, but the infinite series of Fibonacci numbers exists only in the artist's imagination.

In the late 1930s, while Fermi was bombarding uranium in Rome, the German physicist Hans Bethe, who had been in America since 1935, was theoretically establishing the sequence of nuclear reactions that causes the sun to shine. In the first plausible explanation of the source of the sun's energy, Bethe hypothesized that during the fusion of the hydrogen nucleus (one proton) to create helium (two protons) and even heavier elements (with more protons), some of the matter is converted to energy (just as in the fission of uranium), and that hydrogen fusion is the energy source for all stars, including the sun. Bethe could not test his idea in the laboratory because hydrogen fusion would require heating the hydrogen protons to a degree found only in the center of stars.

But then in 1939 uranium fission gave scientists a way to produce, for the first time in human history, thermonuclear heat on earth. Experimenters soon fused hydrogen, and they discovered an important difference between fusion and fission; when hydrogen is fused, the amount of energy released for every proton or neutron is four times greater for fusion reactions than in a fission reaction. On 1 November 1952, American physicists detonated the first H-bomb (hydrogen fusion bomb) on an atoll in the Pacific Ocean, releasing five hundred times the energy of the Hiroshima bomb. Noting that the hydrogen fusion released neutrons, it

occurred to some physicists and engineers that they could build bombs in layers of fissionable uranium and fusible hydrogen. The fissioned core of uranium produced the "match" to fuse the hydrogen, releasing neutrons that could in turn fission an outer blanket of uranium. The first combination fission-fusion bomb was detonated by the United States at Bikini Atoll in the Pacific on 1 March 1954, prompting scientists around the world to observe ominously that there was no theoretical limit to the number of layers in such a bomb. The 1954 test caused severe radioactive fallout over seven hundred square miles in the Pacific, a side effect that scientists had not predicted. In the earth's atmosphere, physicists also discovered a radioactive element not found in nature (strontium 90, with a half-life of twenty-eight years).[43] It has since been confirmed that this radioactive by-product of the H-bomb, which is chemically similar to calcium, has been absorbed into the bones of all vertebrates on the face of the earth. Strontium 90 will remain in the earth's atmosphere, and in the bones of all animals, for another 150 years.

By the mid-1950s Pollock was in severe physical and mental decline, and in 1956 he died in a car accident. Newman and Rothko continued as prophets in the doomsday atmosphere of the nuclear arms race. Working in series, the artists produced multicanvas installations with spiritual themes of wholeness and transcendence. Newman's work on the theme of Christ's passion (plate 279) is a series of *Zip* paintings in somber black, white, and raw canvas, in which the artist's goal was to express the pivotal moment in Christ's suffering as described in the New Testament: "And about the ninth hour Jesus cried out with a loud voice, 'Eli, Eli, lema sabachthani?' that is, 'My God, my God, why hast thou forsaken me?'" (Matt. 27:46). The words of Jesus on the cross are a quotation from the Hebrew Bible (Psalm 22:1), and in making this reference Matthew is comparing the suffering of Jesus to the pain expressed by the author of the Psalms, which are ascribed to the young shepherd David, who went on to become the King of Israel. In other words, when Jesus reached his darkest hour, he was linked by words in a sacred Hebrew text to the spiritual and political leader of the Jewish people. Newman wrote: "The cry of *lema*—for what purpose?—this is the Passion and this is what I have tried to evoke in the paintings."[44] Thus in the aftermath of World War II, Newman, a Jew, chose this traditional Christian subject matter to communicate a question universally asked at times of excrutiating physical or mental anguish—Why?

279. Barnett Newman, *Fourteen Stations of the Cross*, 1958–66 (the first six of the fourteen paintings are shown here). Magna and oil on canvas, each 78 x 60 in. (198 x 152 cm). National Gallery of Art, Washington, D.C. Collection of Robert and Jane Meyerhoff.

Rothko was given the opportunity to create an environment with a similarly intense and intimate mood when he was commissioned by John and Dominique de Menil to create a series of paintings for an ecumenical chapel in Houston (plate 280). Aware of how context affects the perception of abstract fields of color, especially how easily they can be trivialized and seen as background decoration, Rothko had always insisted on controlling the installation of his work. Painting a series for this place of meditation gave him an optimal environment in which to work, and he filled the apse and walls with large triptychs and panel paintings in shades of purple and black. A central skylight in the octagonal building illuminates the still, silent space, and Rothko's somber paintings surround the contemplative visitor. The mood in this series, Rothko always insisted, was not his own; the funereal colors and shadowy forms expressed the tragedy of the human condition in the nuclear age.

280. Mark Rothko, Rothko Chapel, 1965–66. Houston.

EK-sistenz

für Felia

THE DISUNITY OF NATURE:
POSTMODERN ART, SCIENCE, AND THE SPIRITUAL

The Theory of Everything is a term for the ultimate theory of the universe—a set of equations capable of describing all phenomena that have been observed, or that will ever be observed. It is the modern incarnation of the reductionist ideal of the ancient Greeks. . . . For better or worse we are now witnessing a transition from the science of the past, so intimately linked to reductionism, to the study of complex adaptive matter, firmly based in experiment, with its hope for providing a jumping-off point for new discoveries, new concepts, and new wisdom.

Robert B. Laughlin and David Pines, "The Theory of Everything," 2000

GERMAN IDEALISM was among the casualties of war in the twentieth century. As a living body of thought that was passionately believed and vigorously argued, it was damaged in the dismantling of European intellectual life during World War I and then annihilated during the cultural devastation of World War II. With it died the worldview of the wholeness of nature; after Einstein failed to formulate a grand unified theory of the universe, scientists in both the physical and biological sciences generally abandoned the search for cosmic unity.[1] Einstein's vision survives today in a few resolute cosmologists' pursuit of a Theory of Everything, but many physicists are wary of the quest, such as Robert B. Laughlin of Stanford University, who shared a Nobel Prize in physics in 1998, and David Pines of the Los Alamos National Laboratory.[2] And after Newman and Rothko, few artists have tried to express an Absolute.

The present postmodern era uses "modern" to conjure the epoch that unfolded when Renaissance thinkers revived the ancient vision of cosmic unity, which in turn drove Enlightenment science and led to German Idealism. The postmodern era attempts to cope with the loss of that vision, and although its dialogue is often confused and conflicted, two fundamental features are clear: there is no unity in nature—no oneness of the universe—and words like *nature* and *truth* do not name objective entities but are meaningful only within systems of human thought.

Standing amid the rubble of the foundations of Western culture, some have cried out in alarm at the loss of secure surroundings, while others have moved forcefully and vocally to create new systems of meaning. From this cacophony it is possible to discern among artists today proponents both of cynicism and of a kind of mysticism—the *via negativa* (Latin for the "negative way"). Both mind-sets were first expressed by critics of the original classical Greek concept of cosmic unity, and they reappeared in the late nineteenth century as scientists began to dismantle the Enlightenment clockwork universe. Now, with the vision of cosmic unity gone, cynicism and mysticism dominate the landscape of art, science, and the spiritual at the opening of the twenty-first century.

281. Anselm Kiefer (German, born 1945), *Essenz/Ek-sistenz* (Essence/ek-sistence), 1975. Watercolor and gouache on paper, 11¾ x 15⅝ in. (29.8 x 39.7 cm). The Metropolitan Museum of Art, New York. Purchase, The Barnett Newman Foundation Gift, 1955 (1955.14.17).

CYNICISM AND CHANCE

The Greek Cynics emerged in the mid-fourth century B.C. as voices opposed to fundamental beliefs in Greek civilization. Mocking man's elevated place in Aristotle's chain of being, they called themselves "dogs" (*cynics* in Greek). They defied social taboos by being cynical—"playing the dog"—minimizing creature comforts (by, for instance, sleeping in the streets) and maximizing freedom of action (by, for instance, sniffing around wherever they pleased). The founder of Cynicism, the philosopher Diogenes, lived as a beggar in Athens after he was exiled from his native Sinope for defacing the city's gold coins. A contemporary of Plato and Aristotle, Diogenes was a witty, sarcastic provocateur who spawned a literary tradition of satire and parody dedicated to defacing the cultural currency.

The outspokenness and unconventionality of cynicism reemerged among late-nineteenth-century artists who seized on the introduction of statistics into physics and chemistry. This, they believed, was evidence that science was absurd. Methods to measure events occurring by chance had been introduced into physics by scientists working in thermodynamics, who speculated that temperature involves random molecular movement. In the 1860s James Clerk Maxwell showed how to determine molecular speed in a gas moving in all directions, at all velocities, and he related temperature to the average speed. He did this by introducing probability measures (statistics); for the first time in Newtonian physics, results—such as the locations of molecules in a gas—were given not as a certainty (as whole numbers) but with a high degree of probability (as fractions).

Maxwell was quick to see that his introduction of a degree of uncertainty into the kinetic theory of gas had implications for debates about free will and determinism:[3] "Recent developments in molecular science seem likely to have a powerful effect on the world of thought. The doctrine that visible bodies apparently at rest are made up of parts, each of which is moving with the velocity of a cannon ball, and yet never departing to a visible extent from its mean place, is sufficiently startling to attract the attention of an unprofessional man. But I think the most important effect of molecular science on our way of thinking will be that it forces on our attention the distinction between two kinds of knowledge, which may for convenience be called the dynamical [deterministic] and statistical."[4]

He was great at pouring scorn on his contemporaries. The school of Euclides he called bilious, and Plato's lectures a waste of time. . . . He would wonder that the grammarians should investigate the ills of Odysseus, while they were ignorant of their own, or that the musicians should tune the strings of the lyre, while leaving the dispositions of their own souls discordant. . . . When he was sunning himself in the Craneum, Alexander [the Great] came and stood over him and said, "Ask of me any boon you like." To which he replied, "Stand out of my light."

A description of Diogenes, who lived in the fourth century B.C., recorded by Diogenes Laertius in the third century A.D.

The topic was taken up by the philosophically astute mathematician Henri Poincaré in his popular essay "Chance" (1908), in which he described the laws of chance followed by gas molecules in motion, as well as other probabilistic natural phenomena. In *The Value of Science* (1904), Poincaré had already hailed the end of the reign of Pierre Laplace's determinism in French science because of the collapse of deterministic principles at the atomic level.[5]

The French artist and writer Alfred Jarry gleefully embraced probabilistic measures because they undermined Enlightenment determinism and, in his opinion, proved that reality is absurd and incoherent. Jarry's play about a grotesque personification of stupidity, *Ubu roi*, pre-

miered at the French Symbolist theater Théâtre de l'Oeuvre in 1896. Mocking science by adopting chance techniques, Jarry playfully created other irrational nonsense as well. In his 1898 satiric memoires of a "Dr. Faustroll, the pataphysicist," Jarry defined *pataphysics* as "the science of imaginary solutions."[6] In a "telepathic letter" from Doctor Faustroll to Lord Kelvin—Sir William Thomson, the senior British physicist working on the theory of gases—Jarry mused that Maxwell had undermined the precise instruments of measurement, "the measuring rod, the watch, and the tuning fork."[7] When first published in Paris in 1911, Jarry's book was hailed by the avant-garde poet Guillaume Apollinaire because it suggested spontaneous methods for creating verse.[8]

A few years later Marcel Duchamp, who shared Jarry's love-hate relation to physics and chemistry, devised his own unit of measure, by dropping three pieces of meter-length string from the height of one meter. After the pieces of string fell into allegedly random shapes, Duchamp affixed them to a support (plate 282). Reflecting on the piece, the artist later mused: "The idea of chance, which many people were thinking about at the time, struck me too. The intention consisted above all in forgetting the hand. . . . Pure chance interested me as a way of going against logical reality."[9] In a similar vein, in 1913 the artist composed his *Musical Erratum* by selecting the notes from a hat and wrote the libretto by copying the definition of the verb *print* from a dictionary.[10]

Duchamp incorporated mathematics, perceptual theory, optics, and chemistry into much of his work. In his *Bride Stripped Bare by Her Bachelors, Even (The Large Glass)* (1915–23; Philadelphia Museum of Art), he presented the theme of sexual union between mechanical partners as the movement of an "illuminating gas," with frequent references to the kinetic theory of gas.[11] The bride's desire stimulates the bachelors, causing gas to flow into their bodies, which are represented as hollow, phallus-shaped molds. The gas then travels to the bride's chamber, not along direct (certain) paths but by circuitous (probabilistic) routes. For both Jarry and Duchamp, chance was a tool with which to parody science and reason; their satirical work has undercurrents of ridicule. In notes written to accompany the viewing of *The Large Glass*,[12] Duchamp declared that he was in pursuit of "a reality which would be possible by slightly distending the laws of physics and chemistry."[13] Although Jarry's "pataphysics" and Duchamp's "playful physics" create alternative realities and amusing satires, it should be noted that they are not art about *science*; when one "slightly" distends the laws of physics and chemistry, they are no longer the laws of physics and chemistry.

282. Marcel Duchamp (French, 1887–1968), *3 Stoppages Étalon* (3 standards of obstruction), 1913–14. Assemblage: three meter-length threads glued to three painted canvas strips, each mounted on a glass panel, and three wood slats, shaped along one edge to match the curve of the threads. The Museum of Modern Art, New York. Katherine S. Dreier Bequest.

In French, *stoppage* refers to an obstruction, such as a break in an electrical current.

In the 1920s chance was introduced into the subatomic realm when it was determined that the subatomic events described by Max Planck and others—quantum mechanics (see chap. 9)—are governed by the uncertainty principle, which states that simultaneous knowledge of both the time and the place of a subatomic event is impossible.

In this controversial part of the 1927 quantum mechanical model, Heisenberg claimed that physics must abandon the assumption, which is implicit in Newton's physics, that a particle has a definite location and velocity. The intrinsic limitation on experimental results at the subatomic level, Heisenberg said, meant that one can determine the outcome of events only with a degree of probability. For example, Heisenberg proposed a "thought experiment" with a microscopic camera. Suppose that one is trying to detect a small particle, say an electron, using light with very, very small wavelengths—gamma rays (plate 283). Heisenberg showed that the gamma ray used to observe the electron introduces enough energy to change the particle's velocity. By the time the image of the electron is reflected back into the microscopic camera, the particle is no longer following the same path because observing it also disturbed it. If light of a lower frequency (a longer wavelength with less energy) is used, in order to disturb the particle less, the longer wavelength will record an image of the electron that is less sharply focused. Heisenberg concluded that you can know with precision either the electron's location or its speed, but not both; if position is known with certainty, then velocity is estimated to a degree of probability.

The uncertainty principle had the effect of weakening the law of cause and effect and introducing an element of chance into the very foundations of physics. The idea that the subatomic realm is indeterministic has had widespread cultural impact, beginning in the 1930s and continuing to this day. The authors of quantum mechanics wanted to communicate their ideas to the educated public, and they gave popular lectures and wrote many explanations in the 1930s and continued after World War II. As Erwin Schrödinger put it: "If you cannot—in the long run—tell everyone what you have been doing, your doing has been worthless."[14]

They also wrote a remarkable number of books and essays about the implications of the uncertainty principle for philosophy, culture, and even for the visual arts, such as Niels Bohr's book *Atomic Theory and the Description of Nature* (1934): "In our century, the study of the atomic constitution of matter has revealed an unsuspected limitation of the scope of classical physical ideas and has thrown new light on the demands on scientific explanation incorporated in traditional philosophy."[15]

Heisenberg's uncertainty principle had widespread implications because he claimed that indeterminacy is not just due to the limitations of a tool of science, such as the gamma-ray microscope, but is inherent in the process of measuring itself. Hitler's assumption of power in 1933, however, interrupted work in subatomic physics in Germany and delayed most cultural responses to it. One immediate reaction came from Salvador Dalí, who painted *Intra-atomic Equilibrium of a Swan's Feather* (plate 284) in the year Heisenberg published the uncertainty principle. Dalí translated movement characteristic of the subatomic realm—intra-atomic equilibrium—into the macroworld of everyday objects, depicting a hand, a

283. "Heisenberg's γ-ray [gamma-ray] microscope," drawn by George Gamow to illustrate his essay, "Quantum Billiards," in *Mr. Tompkins in Paperback* (Cambridge, England: Cambridge University Press, 1967), 76.

Gamow popularized physics in short stories about Mr. Tompkins, a bank clerk who is intrigued by science and falls in love with the daughter of a physics professor. The professor takes it upon himself to instruct his future son-in-law in the ways of the subatomic world, such as Heisenberg's gamma-ray microscope.

swan's feather, and other objects floating in defiance of gravity. On the eve of World War II, Man Ray painted a farewell to the billiard-ball world in *Chance* (as in a game of fortune) (plate 285). A billiard table sits not level on the earth but askew, and chance is the rule of the new game. Physicist George Gamow dubbed the new game "quantum billiards" (plate 286) in his series of popularizations of quantum physics that began appearing in 1938 in Britain's science magazine *Discovery*, which was edited by C. P. Snow.[16]

After 1945 the cultural response to indeterminacy at the subatomic level began to increase throughout the West, forming part of the landscape of postmodernism.[17] It is perhaps relevant to the continued negative and cynical attitude toward chance in physics that the author of the uncertainty principle was also the architect of the Nazis' failed atomic bomb. After 1945 Heisenberg became director of the Max Planck Institute for Physics at Göttingen, in West Germany.[18] Widely reviled within the scientific community, the renowned physicist spent his

284. Salvador Dalí (Spanish, 1904–1989), *Intra-atomic Equilibrium of a Swan's Feather*, 1927. Oil on canvas, 31 x 38⅝ in. (77.5 x 96.5 cm). Private collection.

ABOVE

285. Man Ray (American, 1890–1976), *Chance*, 1938. Oil on canvas, 24 x 29 in. (61 x 73.7 cm). Whitney Museum of American Art, New York. Purchase, with funds from the Simon Foundation, Inc.

RIGHT

286. "The white ball went in all directions," drawn by George Gamow to illustrate his essay, "Quantum Billiards," in *Mr. Tompkins in Paperback* (Cambridge, England: Cambridge University Press, 1967), 66.

The professor's tales of the quantum realm cause our hero, Mr. Tompkins, to have many weird dreams, such as playing billiards in a non-Euclidean space.

remaining decades defending his reputation and pondering cultural topics. The apparent mix in Heisenberg's psyche of intellectual brilliance and moral blindness have made him a focus of ongoing debates about science and society.[19]

One artist who embraced Heisenberg without ethical qualms was Dalí, who had spent the war in New York. Dalí had already been expelled from the Surrealist movement in 1937 for painting his dreams about Adolf Hitler (*The Enigma of Hitler*, 1937; private collection), and he infuriated his critics by reminding them that, according to Freud, the unconscious mind is uncensored. Most artists in the 1950s were cynical about nuclear research, but Dalí—in a gesture of satirical one-upmanship—declared his devotion to Hitler's bomb builder: "In the surrealist period I wanted to create the iconography of the interior world—the world of the marvelous, of my father Freud. I succeeded in doing it. Today the exterior world—that of physics—has transcended the one of psychology. My father today is Dr. Heisenberg."[20] Throughout the 1950s, Dalí symbolized the subatomic realm by transposing unpredictable features of the microworld to human scale, depicting disintegrated objects floating free from gravity. For example, the soft watches and landscape of the original *Persistence of Memory* (plate 197) are broken apart in Dalí's 1952–54 version, *The Chromosome of a Highly Colored Fish's Eye Starting the Harmonious Disintegration of the Persistence of Memory* (plate 287).

Dalí was also one of the rare artists who followed subatomic particle research during the Cold War. Throughout the 1920s physicists studying the radioactive decay of atoms had asked why, when they added up the amount of charge, mass, and energy of the electrons flying out of the nucleus, they came up short in the energy column. They hypothesized that another

287. Salvador Dalí, *The Chromosome of a Highly Colored Fish's Eye Starting the Harmonious Disintegration of the Persistence of Memory*, 1952–54. Oil on canvas, 10 x 13 in. (25.4 x 33 cm). Salvador Dalí Museum, Saint Petersburg, Florida.

Dalí may have begun this disintegration of matter with a chromosome because the double-helix structure of DNA, which had been identified as the nucleic acid in chromosomes in 1929, was announced in 1953, during his work on the painting.

particle was being emitted that accounted for the missing energy, and Fermi named the phantom a "neutrino" (Italian for "little neutral one") because, if it existed, it must be electrically neutral and have little or no mass, since the electrons accounted for all the charge and mass. Then, in 1930, Paul Dirac suggested that every subatomic particle exists in two forms, as matter (its normal state in nature) and antimatter (with an opposite charge). In 1956 two American physicists devised a way to record an antineutrino, from which the existence of a neutrino could be inferred; neutrinos have since been recorded directly. The confirmation of the existence of the neutrino inspired Dalí to compose his "Anti-Matter Manifesto": "If the physicists are producing antimatter, let it be allowed to painters, already specialists in angels, to paint it. . . . It is with pi-mesons and the most gelatinous and indeterminate neutrinos that I want to paint the beauty of angels and of reality. I will soon succeed in doing it."[21]

During the postwar nuclear arms buildup and the U.S.–U.S.S.R. space exploration race, most artists took a gloomier view of subatomic physics and the implications of the uncertainty principle. The satiric outlook expressed by Jarry's *Ubu roi* resonated with the mood of cultural uncertainty, and his persona was revived in the 1950s in the Theater of the Absurd. The lost souls in the Irish playwright Samuel Beckett's *Waiting for Godot* (1953) spend their days waiting, but they are uncertain for whom, or what, they are waiting. Duchamp had left Paris in 1942 during the Nazi occupation, and after the war he remained in New York where he became a role model for younger artists. Adopting Duchampian wit and irony, some artists merrily mocked the Abstract Expressionists' pursuit of Oneness and an atomic sublime. A member of Fluxus, an international group that aimed to break down the distinction between art and life, the Korean artist Nam June Paik produced a down-to-earth *Zip* from mundane static in *Zen for TV* (plate 288). The Pop artist Roy Lichtenstein debased the Action painter's gesture by rendering it in a cartoon version in *Brushstrokes* (plate 289).[22] The transcendental overtones of Fontana's luminous environmental art were not spared scorn; the American artist Bruce Nauman created a neon wall sculpture, in the style of an advertisement in a store window, which contains the jingle: "The true artist helps the world by revealing mystic truths" (*Window or Wall Sign*, 1967; collection of the artist).

In a more profoundly cynical assault, the whole spiritual basis of abstract art came under attack on American soil in the postwar decades. The indeterminism of subatomic physics had undermined Einstein's view of cosmic unity, and the cultural demise of German Idealism during the war eroded it further. This vision of cosmic unity in art and science had provided the theoretical foundation for the emergence of abstract art in Germany, Austria, and Russia at the fin de siècle, and sustained its spread in the 1920s and '30s to Paris and New York. The loss of this vision threatened to empty abstract art of its meaningful content. When Diogenes died in about 320 B.C. the classical Pythagorean outlook still dominated Athens; Duchamp was a luckier cynic and lived to see the demise of the modern vision of cosmic unity. From the shores of the new superpower, the United States, where the culture was steeped in

Neutrinos they are very small.
 They have no charge and have no mass
And do not interact at all.
The earth is just a silly ball
 To them, through which they simply pass
Like dustmaids down a drafty hall
 Or photons through a sheet of glass.
 They snub the most exquisite gas,
Ignore the most substantial wall,
 Cold-shoulder steel and sounding brass,
Insult the stallion in his stall,
 And, scorning barriers of class,
Infiltrate you and me! Like tall
And painless guillotines, they fall
 Down through our heads into the grass.
At night, they enter at Nepal
 And pierce the lover and his lass
From underneath the bed—you call
 It wonderful; I call it crass.

 John Updike, "Cosmic Gall," 1960

Anglo-American utilitarianism and observational science, Duchamp witnessed the death of the Absolute, and he led a generation of American artists in a dance on its grave. Artists in the 1960s, such as Frank Stella, Carl Andre, Sol LeWitt, Robert Morris, and Donald Judd, proclaimed a new abstract art without any content whatsoever—meaningless objects—Minimalist art. What is one of Stella's black paintings, such as *Getty's Tomb* (1959; Los Angeles County Museum of Art), telling us? Where is the painting taking us? How does it transform us? According to the artist, these are the wrong questions: "What you see is what you see."

The Minimalist outlook reflected both Duchampian cynicism and the postwar mind-set of American culture that is rooted in "just-the-facts" science. With its assembly-line production of empty rectangles, the next generation of American abstract artists continued to mock the metaphysical foundations of abstract art. In the 1980s Peter Halley painted floating rectangles in harsh colors with crisp edges and styrofoam-style surfaces (*Two Cells with Conduit and Underground Chamber*, 1983; Sonnabend Gallery, New York). As the artist has described his work: "The paintings are a critique of Idealist modernism. In the 'color' field is placed a jail. The misty space of Rothko is walled up. . . . The 'stucco' texture is reminiscent of motel ceilings.

OPPOSITE
288. Nam June Paik (Korean, born 1932), *Zen for TV*, 1975–94. Video shown on a monitor, 16 x 12½ x 16 in. (40.6 x 31.8 x 40.6 cm). Courtesy of the artist.

BELOW
289. Roy Lichtenstein (American, 1923–1997), *Brushstrokes*, 1965. Oil on canvas, 48 x 48 in. (121.9 x 121.9 cm). Private collection.

290. Eve Andrée Laramée (American, born 1956), *Apparatus for the Distillation of Vague Intuitions,* 1994–98. Installation with hand-blown and etched glass, steel, copper, and tables. Courtesy of the artist.

The artist has stated: "In my work I question the pervasive idea that art and science occupy completely unrelated realms (intuition vs. cognition). I try to draw attention to areas of overlap and interconnection between artistic exploration and scientific investigation, and to the slippery human subjectivity underlying both processes. Through my work I speculate on how human beings contemplate and consider nature through both art and science in a way that embraces poetry, absurdity, contradiction, and metaphor."

The Day-Glo paint is a signifier of 'low budget mysticism.'"[23] But the Minimalists and their successors failed to void their art of content because art audiences, despite being instructed to see only "literal" objects, persisted in making chains of associations to the art, no matter how pristine the artist's forms or how cynical their intentions. This is because, as Helmholtz, Freud, and today's neuroscientists have all taught us, the human mind continually searches its memory for symbolic associations to whatever it perceives—be it a sacred icon or debased trivia—as part of the mind's lifelong construction of a meaningful picture of the world.[24]

Other latter-day Cynics, primarily French philosophers and American academics, have also raised the possibility that, since in the postmodern mind-set knowledge is always subjective and incomplete, the scientific method is based on the false premise that there is objective truth to discover.[25] This theoretical writing received great attention in the 1980s and '90s, pointing the way for others to satirize science, and some visual artists joined in by creating parodies of the discourse of science. Eve Andrée Laramée, an artist based in New York, invited viewers into a laboratory equipped with irregular beakers etched with names like "dither" and "matter of chance" in her *Apparatus for the Distillation of Vague Intuitions* (plate 290). Measuring devices to determine progress on the "distillation" all operate by chance occurrence (such as a viewer's movement causing a shift in air current) or by the whim of the operator.

With Duchampian gusto and attention to detail, the American artist Matthew Ritchie has concocted a parody of the kind of map of the universe produced by cosmologists using components such as matter, force, and rate of expansion (plate 1). In place of these observable ingredients, the artist has imagined alternative elements and forces that fill his wall-size narrative about the Big Bang (plate 291). Ritchie's delight in bending the laws of physics is shared by many intel-

lectuals in today's art world; the curator who selected Ritchie's piece for Mass MoCA's *Unnatural Science* exhibition of 2000–2001 has noted the spoof approvingly: "Ritchie's continuing project represents a tireless effort to unravel all of the governing theories behind the existence of our universe, all the while in full cognizance of the absurdity of such a pursuit."[26]

MYSTICISM AND ART WITHOUT ABSOLUTES

The classical mystical outlook of the via negativa developed in reaction to the fundamental assumption of Greek science that knowledge comes from studying ideal entities—Pythagoras's numbers or Plato's forms, which reside in a heavenly realm of perfection. In the fifth century A.D., after this ideal realm had been adopted by Early Christian Neoplatonists as the domain of God-the-father, an Eastern Orthodox monk and mystic who wrote under the pseudonym Dionysius vigorously denied the possibility of human knowledge of the Absolute.[27] The cosmos can, according to Dionysius, be characterized only indirectly, by its lacks—it is incomprehensible, indescribable, and ultimately unknowable. Knowledge can be attained only by an inner journey—a via negativa—in which the seeker cleanses the mind of all preconceptions. Only then will the sacred truth of nature reveal itself.

Today the creative artist or scientist adopts this attitude in order to see the natural world afresh by approaching it without preconceived ideas. Searchers on such a journey retain their basic vocabularies—the artist's colors, the scientist's mathematics—just as Dionysius retained his ability to speak Latin, but they leave their conceptual frameworks behind. An artist might try to unlearn color theory so as to observe nature with a fresh eye, and an astronomer

291. Matthew Ritchie (American, born 1964), *Stacked*, 1998. Enamel on Sintra, acrylic and marker on a wall, c. 18 x 22 ft. (6.1 x 12.2 m). Courtesy Andrea Rosen Gallery, New York, and Southeast Center for Contemporary Art, Winston-Salem, North Carolina.

Ritchie has described his production of this model of creation: "The system works like this: There are forty-nine elements, divided into seven groups of seven. The seven groupings describe seven separate areas of operation in the system. Each element can appear in seven different ways depending on the context it is used in. Although the number of combinations is probably infinite, that is not the point, this is not a numerological system. The forty-nine elements are characters, with precisely defined functions in the story that is told by their interaction. This is the story of origins, of genesis and fall, as a metaphor for the construction of art."

might try to drop all assumptions about gravity when looking at data from a black hole. The kind of knowledge that results from this approach is no different from that gained by other avenues of inquiry; the gain is in the quality and the depth of knowledge—a new kind of art, an unexpected insight about black holes. The mystic or conceptual voyager intuits a new picture of reality. Travelers on the via negativa are also convinced that there are limitations to human knowledge, both in the extent to which the universe can be probed and in what the mind can conceive. The goal of conceiving of a unified cosmos has been abandoned.

To mystics like Dionysius it seemed presumptuous to give a name to the unknown—as if by naming and categorizing entities one gained control over them—hence the central mystical tenet: reality is ultimately indescribable. For Dionysius the via negativa culminated in illumination, which was "the darkness of unknowing."[28] Such a journey was modeled not after Pythagoras calculating numerical ratios in the bright Mediterranean sunlight but after Moses climbing to the mountaintop, where he became lost in the clouds.

Into the dark beyond all light
 we pray to come,
 through not seeing and not knowing,
to see and to know
 that beyond sight and knowledge,
 itself: neither seeing nor knowing.

Dionysius, fifth century A.D.

As with Dionysius's confession of his inability to describe what was most sacred to him, some artists in the postmodern era began to present their subjects indirectly, obliquely, in fragmentary form, and in darkness. Like mystics, the artists did not name their subjects but let them reveal themselves, showing humility before the unknown.

What distinguishes the postmodern mystical artist from earlier mystics is that for most educated people in the late twentieth and early twenty-first centuries, there is no transcendental realm beyond the given—there is no "Oneness" of the universe toward which to transcend. Rather than transcendence, the artists have focused instead on what is at hand—immanence, if you will—the artist's own self and the "other," by which is meant another person or object in the natural world.[29] Mystical postmodern art presents intense meditations on these inexhaustible topics; the art is mystical in the sense that it reveals the mystery of the commonplace experience: reflecting on oneself, looking into the eyes of another conscious being, touching an object.[30]

In the 1950s and '60s Joseph Beuys emerged in Germany as a mystical force opposed to Duchamp's cynicism by assuming the role of a shaman, a healer who used enchanted art to cure the ills of postwar German society. In high school Beuys had seriously studied the natural sciences, and he had considered a career as a pediatrician; he later described his sculpture as therapy, as "art ointment" and an "art pill." In 1940 the nineteen-year-old Beuys enlisted in the Luftwaffe and became a radio operator on combat aircraft. In the dark days of the war he formed his artistic outlook by reading popular works by German scientists—not the physicists of the moment, Einstein and Heisenberg, but the Romantic biology of Goethe and the Naturphilosophen views about a life force in all matter and an evolving consciousness as expressed by Rudolf Steiner. In 1941 Beuys especially found inspiration in a book that Steiner had written during World War I, calling for Germans to renew themselves by releasing the spiritual life force that had been submerged within them by the war (*Appeal to the German People and the Civilized World* [1919]).[31] Echoing Ernst Haeckel and the Naturphilosophen, Steiner had declared that the same creative life force propels both art and science, and he further insisted that in the reorganization of postwar German society the state should have no control over artists and scientists.

In 1943 Beuys was seriously injured when his plane was shot down in the snowy Crimea,

and he had a transformative experience of being cared for by nomadic Tartars. After the war he dedicated himself to becoming an artist who would help society heal its war wounds by releasing its creative potential. In the 1960s Beuys was briefly associated with Fluxus, but he felt that Duchamp's antiart attitudes poisoned the group—a view expressed in his performance *The Silence of Marcel Duchamp Is Overrated* (1964; Museum Schloss Moyland, Bedburg-Hau, Germany). Throughout the 1960s Beuys gathered pieces for a workstation from which to investigate the natural world, *Framework for an Absurd Wilderness: Working Place of a Scientist/Artist* (plate 292). This is not the pristine laboratory-studio of an heir to Enlightenment rationalism, such as Seurat or Mondrian; this is the messy den of an alchemist concocting a new language for the incomprehensible, indescribable, unknowable "absurd wilderness" of the postmodern era.[32]

292. Joseph Beuys (German, 1921–1986), *Framework for an Absurd Wilderness: Working Place of a Scientist/Artist*, 1961–67. Mixed media, 9 ft. 8 in. x 13 ft. 4 in. x 6 ft. 4 in. (2.9 x 4 x 1.9 m). Kaiser Wilhelm Museum, Krefeld, Germany. Helga and Walther Lauffs Collection.

Like a mystic on the via negativa, Beuys did not look for order; his shelves are filled with the tools of science—jars of chemicals, weights, a scale—but they are broken and rusted. Rather, in his Actions (the name he gave his performances) he fostered disorder, erasing images and words (*Noiseless Blackboard Erasers*, 1974; Ronald Feldman Fine Arts, New York) and scribbling diagrams during his public appearances (*Directional Forces, 100 Blackboards*, 1974–77; Neue Nationalgalerie, Berlin) to stimulate a new creative approach to images and words, which Beuys has described: "My path went through language, strangely enough; it did not start off from what is called artistic talent. As many people know, I started out studying science, and in so doing I came to a realization. I said to myself: Perhaps your potential lies in a direction that demands something quite different from the ability to become a good specialist in one field or another. What you can do is to provide an impetus for the task that faces the people as a whole. The idea of a people is linked in a very elementary way with its language."[33]

Beuys based his approach to making sculpture on Steiner's cosmology, but with a fundamental difference. Steiner had shared the common late-nineteenth-century view that all matter is conscious and is organized in a hierarchy of an evolving consciousness, from minerals to plants to animals, and then—through transcendent stages—to consciousness of the Absolute. Following Steiner, Beuys redefined sculpture as matter that, like an embryo, grows from within. But in Beuys's sculpture there is no Absolute; there is only the mystery of commonplace experience. For example, in the sculpture *Honey Pump at the Workplace* (plate 293), electric motors pump honey through transparent plastic tubes, expressing the flow of life and energy. The long tubes loop and twist throughout the space, forming a vast installation. Seeing honey and smelling honey, the viewer does not transcend to another spiritual level, but focuses

293. Joseph Beuys, *Honey Pump at the Workplace,* 1977. Installation for Documenta 6, Kassel, Germany.

on the mystery of life as symbolized in the honey flowing before his or her eyes.

Beuys derived the symbol of the bee from a lecture in which Steiner described the bee's transforming honey into beeswax as a symbol of creative force in nature. Beuys wanted to reawaken the creative spirit of all individuals, and after being famously fired from a faculty position in Düsseldorf for insisting that all rejected students could be his students, he further expanded his concept of sculpture to encompass a joint creative effort by people working together. In the socialist climate of the postwar decades, it was crucial to Beuys that *Honey Pump* not be assembled by alienated laborers in his absence but that he work side by side with a team of enthusiastic people, like worker bees, to create the honey-filled structure. In a 1975 interview he said: "Honey as such also used to be seen in a mythological context as a spiritual substance, so of course the bee was divine. There is the Apis [Latin for "bee"] cult. . . . My sculptures too are a kind of Apis cult. They are not to be understood as a statement about the biological processes in a bee hive but are meant to extend to the Apis cult, for example, which signifies socialism."[34]

Beuys was one of the last major artists in the West to find inspiration in a thinker within the German Idealist tradition. Artists who matured after World War II were drawn instead to philosophers and theologians who were critical of a scientific view of nature as knowable and as a unified whole. Indeed, some historians have noted parallels between the mysticism of Dionysius's via negativa and outlooks that dominated the postwar era—Existentialism, Zen Buddhism, Critical Theory, negative theology, and deconstruction. Although these outlooks have roots in nineteenth-century critiques of science, their widespread adoption by Western intellectuals dates to the decades following World War II.[35]

Existentialism arose in the late-nineteenth and early-twentieth centuries when philosophers such as Friedrich Nietzsche and Martin Heidegger recoiled at the grand scientific systems of thought that treat human beings as members of a species and therefore, in their opinion, overlook the uniqueness of each individual. They discarded generalizations and began their studies by giving a detailed description of the existence of concrete individuals. They declared that one creates one's essence through actions made by free choice, rather than being assigned an identity as the member of a group such as "middle-class women." The Existentialist emphasis on introspection led the French philosopher Jean-Paul Sartre to provide a theoretical foundation in his study of consciousness, *Being and Nothingness* (1943), in which he described consciousness (nothingness) as directed toward objects in the world (being). He also declared that what is unique about the mind of humans (as opposed to lower mammals) is that it is capable of reflecting on its own thought process—self-consciousness; for example, you can not only read this page but also contemplate your reading of it. Sartre's book appeared, along with his popular plays and novels, at a time when young intellectuals throughout the war-torn West were being drawn to the serenity offered by Eastern philosophy, especially the teachings of the late-sixth-century-

B.C. Indian Gautama Siddartha, who meditated and discovered a path to peace (nirvana), hence his title Buddha (Sanskrit for "Enlightened One"). It was especially Sartre's definition of consciousness as "nothingness" that has led scholars to point out the similarities of the Existentialist contemplation of consciousness to mystical experience of enlightenment.[36]

At the heart of Critical Theory, the school of philosophy established in Frankfurt in the 1930s, was Theodor Adorno's similar critique of the abstract reasoning used in German science. Like Dionysius's insistence on the ultimate unknowability of reality, Adorno stressed the inexhaustibility of the meaning of a concept. For example, any general definition of the word "woman" robs an individual woman of her sensuality and contingency. To rescue these human qualities from scientific (theoretical, abstract) analysis, he urged using a kind of dialectical method of inquiry, but not Hegel's process of reasoning by thesis and antithesis that leads toward an Absolute truth. In his treatise *Negative Dialectics* (1966), Adorno urged intellectuals to look ceaselessly for nuances of meaning and to raise objections to any conclusive definition. Adorno proclaimed that the modern artist is the best example of this method because the artist continually questions the nature of art and, with each new piece, redefines what art is.

294. Wolfgang Laib (German, born 1950), *Milkstone*, 1975. Marble covered with milk, 1 x 36 x 36 in. (2.5 x 91.4 x 91.4 cm). Courtesy of the artist and Sperone Westwater, New York.

Some philosophers and theologians have noted similarities between the via negativa and the method of deconstruction in postwar French philosophy. The tradition of Dionysius's mystical theology has also been taken up by postmodern theologians in their denial of total clarity and final certitude—negative theology—in which the parallelism of the via negativa to deconstruction is pronounced. While acknowledging the negative character of deconstruction, its author the French philosopher Jacques Derrida has insisted that his method—he continually shows differences and lacks in concepts that undermine claims of complete knowledge— is a skepticism, but not a source of mysticism.[37]

Wolfgang Laib is a striking example of an artist who matured after World War II and whose work is an intense celebration of life in all its immediacy. Born in Germany in 1950, Laib studied medicine at the University of Tübingen from 1968 to 1974, but he abandoned this career because he felt that clinical training gave him too narrow a view of nature and the human body. During his years at the university, Laib also took courses in Indian culture and Sanskrit, and he read widely in Buddhist texts. Since his childhood travels with his family in the Orient, where his father worked as a physician, Laib has considered India his spiritual home. In 1975 he redirected his energies to art and created his first *Milkstone* (plate 294), a square slab of white marble that has a superficial resemblance to a Minimalist sculpture. But Laib intends not to minimize but rather to maximize the symbolic associations of the stone, and to that end, he pours fresh milk on its smooth surface several times each day. The piece is about "the unknowable" that one approaches by the via negativa, as opposed to the classical goal of

exhaustive knowledge of the whole—the chemical analysis and the naming of nutrients—that one seeks in medical school. As Laib has stated: "The milkstones are a direct answer to what I left, to what I found milk and stone to be about. Milk is not what I was taught in hygiene. You can learn everything about this liquid but have no idea what it is."[38]

Laib makes his works of natural materials, and he treats nature as sacred in the sense of being of greatest importance to him; he is attuned not to the transcendental but to the life-giving substances at hand, such as milk, rice, and pollen. He lives a contemplative life close to nature in a rural setting: "I'm living very isolated outside of a small village, like on an island isolated from people and from society, but also from art and artists. . . . The monks of the Middle Ages lived in monasteries or as hermits in remote places, or in other parts of the world hermits and ascetics living in forests or caves in the mountains. . . . The trees and forests, the rocks and hills which surround me, they are so timeless, so independent and still so new every day."[39] In the summer he spends long hours in the fields gathering pollen from which to make his luminous floor pieces (plate 295), and at the close of each exhibition he carefully collects the vital powdery material into glass storage jars. His work is an unabashed celebration of life: "Milk or pollen is extremely beautiful, like the sun or the sky. And why be afraid of beauty? Recently so many artists, especially German artists, seem to think that art has to be as ugly and brutal as possible. Beauty is bourgeois—what a strange idea. It is my great fortune to participate in beautiful things."[40] Laib's work is not about science or influenced by science in any straightforward way. Instead, *like* science, it focuses intensely on the natural world, and he lets the materials reveal themselves in their rich complexity in ways that are in harmony with

295. Wolfgang Laib, *Pollen from Hazelnut Flowers*, 1985–86. Pollen, 10 ft. 6 in. x 11 ft. 6 in. (3.2 x 3.5 m). Courtesy of the artist and Sperone Westwater, New York.

THINKING ABOUT THEORY OF RELATIVITY

MIND AT REST

contemporary science. Indeed, Laib's work resonates with mystical strains in other areas of the postmodern intellectual landscape.

In the postmodern era there has also been widespread agreement throughout the sciences that knowledge of nature is inherently incomplete. The use of scientific methods that resemble the via negativa—in the sense of gathering data indirectly in fleeting, fragmentary bits—is nowhere more evident than in neuroscience. In the first half of the twentieth century most researchers studying the mind were divided between taking a strictly physical approach, as in neurology, or a psychological approach, as in psychoanalysis. The discovery in 1953 of rapid-eye-movement (REM) sleep, during which dreaming occurs, and the development in the 1950s of the first drug effective against a psychosis, chlorpromazine (trade name Thorazine) for schizophrenia—inspired post-1945 researchers to merge mental and physical approaches to the mind and brain into today's neuroscience. Computer models of the mind were tried extensively in the postwar decades (plate 296), but by the late 1960s they were being abandoned as too simplistic, as electric machine models had been renounced in Freud's day. By the 1980s neurologists, biologists, and psychologists were joining forces to create a complex model of the mind as a neurological,

296. A Princeton neurologist hooking Albert Einstein up to an electroencephalograph (EEG), a device that records the electrical activity of the brain, and a sample of the recording. "Recording Genius," *Life*, 26 Feb. 1951, 40.

The caption to the EEG recording reads: "GENIUS BRAIN of Albert Einstein produced this chart when the scientist was asked to think about problems of relativity, then to relax and make his mind become blank."

chemical, and evolutionary machine that is fully integrated with the subjective experience of the self.

A decade ago words like *mind* and *consciousness* were not used in scientific discourse because neurologists thought that because they described phenomena that could not be precisely measured, they were outside the purview of science. Today that attitude has shifted to the humbler stance of letting the elusive phenomena reveal themselves and suggest how best to approach them. Neuroscientists throughout the world are exploring the realm of consciousness by devising indirect ways to record phantom feelings. The human mind is composed of hundreds of billions of nerve cells, and Gerald Edelman and Guilio Tononi at the Neurosciences Institute in San Diego have demonstrated that every individual creates his or her own unique mental map. Their recordings of neurological activity in different subjects performing the same tasks reveal the startling differences (plate 298). In his series of paintings *Something from Sleep III* (plate 297), the American artist David Wojnarowicz symbolized the complex scientific

approaches to sleep and dreams that have characterized neuroscience since the 1980s. In all these works the artist merged several disciplines; in this example, Wojnarowicz's cosmic figure peers through a microscope while dreaming.

A century after Freud abandoned neurology in 1900 and founded psychoanalysis, during which the two fields have followed separate paths, the British neurologist Mark Solms is forging a truce between the two camps; the first issue of the journal *Neuropsychoanalysis*, which he coedits, appeared in 1999.[41] Militantly avoiding reducing one field to the other, these pathfinders are exploring the interface of mind and brain. In 1994 the first laboratory for "affective neuroscience" was established at the University of Wisconsin at Madison, where researchers have recorded neural activity correlated with subjects' reports of feeling happy (plate 299). The director of the laboratory, Richard J. Davidson, has expressed a particular interest in the Eastern mystical tradition and in how the state of a mystic's mind affects his or her body:[42] "We hope eventually to take techniques involved in various kinds of meditation out of their Buddhist context and apply them to secular training that may improve mental and physical health."[43]

One senses the complexity of human consciousness when entering a video installation by Bill Viola, which is like walking into another person's mind. Using the metaphor of psychological layers of meaning and memory, in one work Viola suspended a series of parallel veils from the ceiling of a large darkened room—a "black box" (plate 301). From opposite ends of the room the artist projected onto the veils two moving pictures of people walking: on the first veil the image is lucid; on the second it is slightly unclear, then blurry on the third, and so on. In the middle layers of this metaphorical psyche, one enters the darkest part of Viola's installation. Here hazy memories, coming from one side of the room-mind, merge with other vague recollections projected metaphorically from the other side. And each viewer is another walking figure, moving in and out of the darkness, merging with the ghosts from the past and casting shadows on the veils.

The Norwegian artist Odd Nerdrum has turned to the Old Masters in search of myths that capture the postmodern spirit. His is a barren landscape in which timeless figures are infused with mysterious powers and visions in *Untitled (Forbidden Painting)* (plate 300); Nerdrum gives the commonplace "untitled" the mystical sense of "unspeakable" with his subtitle: *Forbidden Painting*. The figure crouching on a rock at the left has a nocturnal vision; amid still and silent sleepers, a man hovers in the air. What is forbidden? Perhaps not only the viewer's being a hidden witness to the secret but also the artist's daring to embody the mystery in an icon—a forbidden painting.

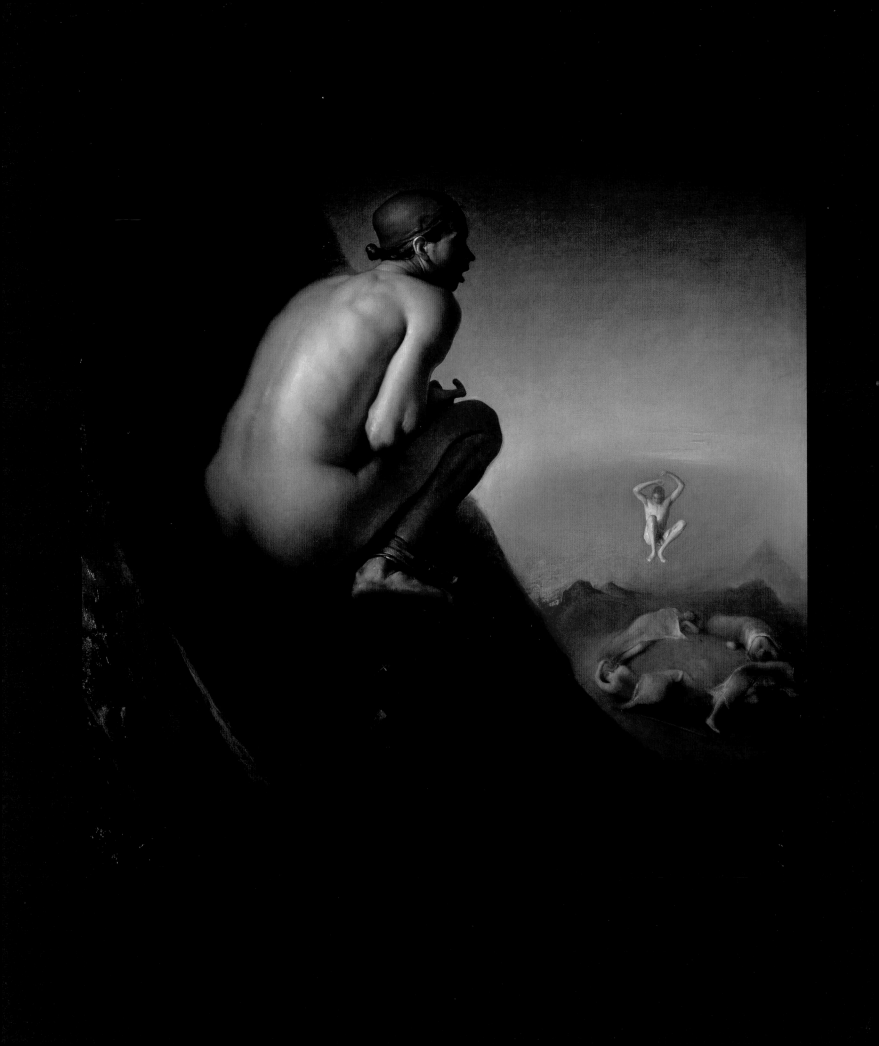

OPPOSITE
300. Odd Nerdrum (Norwegian, born 1944), *Untitled (Forbidden Painting)*, 1996. Oil on canvas, 68 x 65 in. (172.7 x 165.1 cm). Courtesy of the artist and Forum Gallery, New York and Los Angeles.

LEFT
301. Bill Viola (American, born 1951), *The Veiling*, 1995. Video and sound installation. Edition 1: collection of Marion Stroud Swingle. Edition 2: collection of the artist; courtesy Anthony d'Offay Gallery, London.

BELOW
302. The birth of a cosmic child, in *2001: A Space Odyssey*, 1968. Stanley Kubrick, director and coauthor of the screenplay with science fiction writer, Arthur C. Clarke.

A spiritual quest forms the plot of the 1968 science fiction film *2001: A Space Odyssey*, which was named for Homer's ancient tale of Odysseus's wandering in the Mediterranean Sea. In *2001* a spaceship sails through outer space toward Jupiter, carrying the young astronaut Dave and his companion, the computer HAL-9000. After their relationship takes a violent turn, Dave commands "Open the pod bay door, HAL"; when HAL refuses, Dave unplugs him. Now alone in the outer solar system, Dave travels to a black stone monolith via a fast-forward hallucination. The film ends as Dave, now white-haired and frail, is reborn as a child of the cosmos (plate 302).

A mystical approach to the heavens is implicit in James Turrell's installations about light and space. Raised in a Quaker home and observant enough to have been a conscientious objector during the Vietnam War, Turrell—despite his ten-gallon hat and laid-back L.A.

I discovered . . . The Cloud of Unknowing, the classic medieval text in the Christian tradition of the via negativa. . . . *I'm trying to address this issue of how, in a secular age, one works in a spiritual vein, and how one avoids the problem of simply labeling things in a way that tells the audience how to respond.*

Bill Viola, 1997

manner—has retained a Quaker outlook. The Society of Friends (the Quakers) believe that one finds guidance through silent meditation and discovering one's own "inner light."[44] Turrell's *Roden Crater* (plate 304) is infused with the overtones of the Quaker tradition, which is in sympathy with the via negativa: as in the voyage of Dionysius described above, this artist manifests in his work simplicity, humility before nature, and attunement to both darkness and inner light. "My interest in space and light," says Turrell, "came about the way it does for most artists— Friedrich, Vermeer, Turner, Constable, Rembrandt, Seurat, the Impressionists. Perception and light have always been the basic things."[45]

In 1972 Turrell began a monumental piece of environmental art in an extinct volcano, Roden Crater, near Flagstaff, Arizona, the first phase of which is presently being completed. The outside of the crater has not been changed, but within, the artist has carved out rooms with openings to the sky ("skyspaces," according to Turrell) with the goal of enhancing the viewer's experience of light, sound, and sky. Walking down an 864-foot-long tunnel into an elliptical room, the viewer hears echoes from afar and his or her heartbeat from within. Stone benches encourage viewers to lie on their backs and perceive the dome of the sky. In the Sun and Moon Room there stands a fifteen-foot-high monolith, with associations to sacred stones such as the obelisks that Egyptians dedicated to the sun god; the secular purpose of Turrell's monolith is to aid in observation of various solar and lunar events. Phase two of his project will create an opening through which to observe the summer solstice, as prehistoric man did at Stonehenge (plate 303).

The variety of art created by travelers on the via negativa underscores that abstract art is no longer the vessel for the spiritual that its early modern creators intended it to be. After the desecration brought by cynicism, if abstract art is to be used by a mystical postmodernist it must be reinvigorated, as in Laib's anointment of the marble slab with milk. In the last decade two senior American abstract painters, whose earlier work was associated with pure form and color, have imbued their work with spiritual overtones. Jules Olitski has symbolized the paths followed by Moses—out of bondage, to the mountaintop—in lush

OPPOSITE, TOP

303. James Turrell (American, born 1941), *Roden Crater*, begun in 1972 in the Painted Desert near Flagstaff, Arizona, interior view looking east—the direction of the rising sun—through a portal, high above a black stone monolith.

OPPOSITE, BOTTOM

304. James Turrell, *Roden Crater*, aerial view.

LEFT, TOP

305. Jules Olitski (American, born 1922), *Moses Path—Violet and Green*, 2001. Acrylic on canvas, 60 x 72 in. (152.4 x 182.9 cm). Courtesy of the artist.

LEFT, BOTTOM

306. Kenneth Noland (American, born 1924), *Nimbus*, from the *Mysteries* series, 2001. Acrylic on canvas, 48 x 48 in. (121.9 x 121.9 cm). Courtesy of the artist.

In classical and Christian art, a nimbus is a radiance, usually a bright circle (as in Noland's painting), that surrounds a deity and symbolizes sanctity. When Luke Howard first classified the clouds in 1803 (see plate 5), he borrowed the term *nimbus* to name a luminous rain cloud, beginning the secular association of the term with heavenly auras that Constable (see plate 12) and Noland employ.

303

hues laced with gold (plate 305). Kenneth Noland has given his floating circles of color a celestial association in his *Mysteries* series (plate 306).

The German Neo-Expressionist artist Anselm Kiefer has also been drawn to cosmic imagery in a kind of postmodern mysticism. In 1970 Kiefer was a student in Düsseldorf with Beuys, who inspired him to make art related to German history. In *Every Man Stands beneath His Own Dome of Heaven* (plate 308), Kiefer made an analogy between the relativity of perspective in politics (the man under "his own dome" gives a Nazi salute) with relative frameworks in cosmology (where there are many "domes" to pick from).

Kiefer's title *Essenz/Ek-sistenz* (Essence/ek-sistence; plate 281) derives from German philosophy, but it is telling that he did not look to Idealism, as his teacher Beuys did. Born in 1945, Kiefer matured in an intellectual climate in which Steiner's cosmology, with consciousness evolving toward an Absolute, had ceased being meaningful. In the founding text of German Existentialism, *Sein und Zeit* (Being and time, 1927), Heidegger invented terms to name various kinds of existence; *Ek-sistenz* is composed of *ek* (Greek for "of"), *sistere* (Latin for "to stand"), plus the German ending *enz* to make it a noun—and it means standing forth and existing authentically in the sense of taking direction only from within oneself and not following the path of others. Kiefer symbolized authentic existence by what is solid and clearly seen, the mountain on which he has written "Ek-sistenz" in bold strokes. In Existentialist thought the "essence" of something is a concept of it, which is always secondary to, and defined from, its

immediate existence (in Jean-Paul Sartre's dictum "Existence precedes essence"). Thus Kiefer has symbolized the always allusive, shifting "Essenz" of the self by writing it in brushstrokes that dissolve into the clouds. At the time Friedrich painted his *Wanderer above a Sea of Fog* (plate 2), natural philosophers were confident that they could know both the existence and the essence of the natural world with clarity—the Alpine mountain and the fog, symbolizing the Absolute, existed for them within a unified whole. Today that pantheist vision is gone, and Kiefer—like Dionysius moving into the dark beyond all light—awaits only incomplete knowledge of nature and human consciousness to be revealed to him in the fog.

This book began in the days of Romanticism, when "exploring the invisible" meant studying objects that could not be seen with the unaided eye. As bigger telescopes were pointed at the sky, and better microscopes focused on specimens, the invisible suddenly came into view and inspired artists to capture these strange new landscapes (plate 309). Today astronomers are focusing their attention on several phenomena that are "invisible" in a more profound sense. Outer space is littered with massive invisible objects—black holes—and one of the most confounding realizations in recent astronomy is that stars and galaxies are but a small fraction of the total mass of the universe. There is another kind of matter—dark matter— that gives off no radiation, no X rays, no visible light, no infrared glow, no radio waves. We have no way of recording it, but we know it is there—a lot of it, as much as 90 percent of the matter in the universe—only because it exerts gravitational force on the matter we can observe.

Cosmologists today generally agree that the universe began in a Big Bang when a single point exploded about 13 billion years ago and set the expansion of the universe into motion. There is less agreement about the fate of the universe, which depends on the total amount of matter in the universe and the laws of gravity. Depending on which assumptions about the amount of matter are correct, the cosmos may expand forever, its expansion may slow to a point where the force of gravity causes the universe to contract, or the cosmos may remain at an equilibrium, balanced between expansion and collapse. Cosmologists used to argue only about the amount of matter in the universe, assuming that Newton's law of universal gravity was unbreakable. But in 1998 astronomers announced that a force opposed to gravity, some unknown antigravity effect— a dark force—seems to be accelerating the expansion of the cosmos.

As we enter the twenty-first century, international teams of astronomers are exploring this bizarre dark matter and the strange dark force acting on it. Artists have begun a journey by a via negativa to explore the postmodern meanings of life, consciousness, and the universe. The modern vision of cosmic unity is gone, but as we begin to redefine art, science, and the spiritual for the postmodern era, we can find courage in the words of Einstein, who urged us to embrace the darkness: "The most beautiful experience we can have is the mysterious."

309. Cone Nebula (Planetary Nebula NGC 2264), 2002. Hubble Space Telescope. Advanced Camera for Surveys. Holland Ford, the ACS Science Team, and NASA.

This pillar of gas and dust is two light years tall, and is part of the Cone Nebula, located 2,500 light years from Earth in the constellation Monoceros.

Notes

Unless otherwise noted, all translations from the French are by the author and all from German, Russian, and Czech are by Silvia Vassileva-Ivanova.

Introduction

1. In this book I follow the lead of historians who have contemplated the visual arts in the context of science and technology. I was set on this search by reading Erwin Panofsky's classic essay *Perspective as Symbolic Form*, trans. Christopher S. Wood (New York: Zone Books, 1991) (originally published in 1924–25 as "Die Perspektive als 'symbolische Form'" [Perspective as "symbolic form"]), and by following the extensive discussion of perspective it inspired, recent notable contributions being Hubert Damisch, *The Origins of Perspective*, trans. John Goodman (Cambridge, Mass.: MIT Press, 1994), and James Elkins, *The Poetics of Perspective* (Ithaca, N.Y.: Cornell University Press, 1994). Panofsky's insight that Renaissance artists developed linear perspective not to imitate their visual experience but to express their concept of the world made me wonder why modern artists had abandoned it. This led me to study the history of science and drew me to writers on modern art who have a deep knowledge of the sciences, especially the French philosopher Maurice Merleau-Ponty and his rich mix of phenomenology and the physiology of perception, evident in his essay "Cézanne's Doubt" (1948), in *Sense and Non-Sense*, trans. H. Dreyfus and P. Dreyfus (Evanston, Ill.: Northwestern University Press, 1964), 9–25, and the historian of science Peter Galison and his discussions, in the Anglo-American analytic style, of logic and physics as they pertain to the arts, especially his essays "Minkowski's Space-Time: From Visual Thinking to the Absolute World" (in *Historical Studies in the Physical Sciences*, ed. R. McCormmach, L. Pyenson, and R. S. Turner, no. 10 [Berkeley and Los Angeles: University of California Press, 1979], 85–121) and "Aufbau/Bauhaus: Logical Positivism and Architectural Modernism" (*Critical Inquiry* 16, no. 4 [Summer 1990]: 709–52).

I have also been inspired by interdisciplinary exhibitions, especially those curated by Jean Clair, including *Wunderblock: Eine Geschichte der modernen Seele* (Wonderblock: A history of the modern soul) (1989), at the Historisches Museum der Stadt Wien, and *Cosmos: From Romanticism to the Avant-Garde* (1999), at the Montreal Museum of Fine Arts. I have profited from the wealth of recent detailed studies of the impact of the sciences on modern art, especially Linda Dalrymple Henderson's exemplary detective work on art of the early twentieth century in her books *The Fourth Dimension and Non-Euclidean Geometry in Modern Art* (Princeton, N.J.: Princeton University Press, 1983) and *Duchamp in Context: Science and Technology in "The Large Glass" and Related Works* (Princeton, N.J.: Princeton University Press, 1998).

2. I have benefited from the great recent attention given to scientific imagery by scholars working in the new field of visual culture. Barbara Maria Stafford's work stands out in this vast literature; especially interesting to me were her books *Voyage into Substance: Art, Science, Nature, and the Illustrated Travel Account, 1760–1840* (Cambridge, Mass.: MIT Press, 1984) and *Artful Science: Enlightenment, Entertainment, and the Eclipse of Visual Education* (Cambridge, Mass.: MIT Press, 1994).

3. On the topic of the human condition in modern culture, I have benefited from all of George Steiner's writings, especially his collection of essays, *In Bluebeard's Castle: Some Notes towards the Redefinition of Culture* (New Haven, Conn., and London: Yale University Press, 1971). Jacques Barzun's many chronicles of modern history have also instructed me, especially his essays in *The Use and Abuse of Art* (Princeton, N.J.: Princeton University Press, 1974). Although I do not share Steiner's and Barzun's low assessments of modern art, their descriptions of how they reached their pessimistic conclusions inform me profoundly. My endless search to understand twentieth-century artistic expressions of the human condition always leads me back into the labyrinthine mind of Donald Kuspit, from whom I have learned most from his essays "Considering the Spiritual in Contemporary Art," in *The Spiritual in Art: Abstract Painting: 1890–1985*, exh. cat., ed. Maurice Tuchman (Los Angeles: Los Angeles County Museum of Art; New York: Abbeville Press, 1987), 313–25, "Abstract Painting and the Spiritual Unconscious," in *The Rebirth of Painting in the Late Twentieth Century* (Cambridge, England: Cambridge University Press, 2000), 62–75, and his keynote address, "Reconsidering the Spiritual in Art" (2001), at the conference *Spiritualism in Art* organized by the School of Visual Arts in New York.

4. I follow here especially Robert Rosenblum in his book *Modern Painting and the Northern Romantic Tradition: From Friedrich to Rothko* (New York: Harper and Row, 1975).

5. I have greatly benefited from this popularization of science, having read widely in the vast literature published since 1970, especially the writings of Isaac Asimov, Gerald M. Edelman, Stephen Jay Gould, Stephen Hawking, Oliver Sacks, and Neil deGrasse Tyson. My Tuesdays are incomplete without reading the Science Times section of the *New York Times*.

1. Art in Pursuit of the Absolute: Romanticism

1. I am a member of the generations of students of this major accomplishment in Western thought who are grateful to W. H. Walsh for his lucid exposition of Kant's arguments in *Kant's Criticism of Metaphysics* (Edinburgh: Edinburgh University Press, 1975).

2. Before Schelling the seventeenth-century German mathematician and philosopher Gottfried Leibniz rejected the Cartesian dichotomy of mind and matter, arguing that at a deeper level of analysis all bodies are composed of tiny organisms with souls—monads.

3. See Hans Christian Ørsted, *The Soul in Nature*, trans. L. Horner and L. B. Horner (London: H. G. Bohn, 1852).

4. Oken, *Elements of Physiophilosophy*, trans. A. Tulk (London: C. and J. Adland, 1847); originally published in 1843 as *Lehrbuch der Naturphilosophie* (Handbook of nature philosophy).

5. For the impact of the natural sciences on German Romanticism, see Timothy F. Mitchell, *Art and Science in German Landscape Painting, 1770–1840* (Oxford, England: Clarendon Press, 1993).

6. According to Wieland Schmied (*Caspar David Friedrich*, trans. Russell Stockman [New York: Harry N. Abrams, 1992] 108), a contemporary of Friedrich, C. A. Böttiger, who reviewed the exhibition of the painting for *Artistisches Notizenblatt* (Mar. 1825), described the wrecked ship as one of Parry's, the *Griper* (which in fact did not sink). In a painting that is lost, Friedrich depicted the wreck of another ship, the *Hoffnung* (Hope), with which this painting is often confused. For the impact of

arctic explorations on artists of the era, see Chauncey C. Loomis, "The Arctic Sublime," in *Nature and the Victorian Imagination*, ed. U. C. Knoepflmacher and G. B. Tennyson (Berkeley and Los Angeles: University of California Press, 1977), 95–112. Frederic Edwin Church sailed along the coasts of Newfoundland and Labrador to paint the arctic landscape; the voyage was recorded by Church's traveling companion L. L. Noble in *After Icebergs with a Painter* (New York: D. Appleton and Co., 1861). For an overview of nineteenth- and twentieth-century artistic responses to the polar landscapes, see *Arktis Antarktis*, exh. cat. (Bonn: Kunst-und Ausstellungshalle der Bundesrepublik Deutschland, 1997).

7. See Richard Hamblyn, *The Invention of Clouds: How an Amateur Meteorologist Forged the Language of the Skies* (New York: Farrar, Straus and Giroux, 2001).

8. The complete German text of Goethe's poem "To the Honored Memory of Howard" (1820) is given in Kurt Badt, *John Constable's Clouds*, trans. Stanley Godman (London: Routledge and Kegan Paul, 1950), 12–13.

9. From Carus, *Neun Briefe über Landschaftsmalerei* (Nine letters on landscape painting) (1815–24); quoted and translated in ibid., 34.

10. From Goethe's letter to Carus, 20 Apr. 1822, which is reprinted in its entirety in the introduction by Dorothea Kuhn to Carus, *Neun Briefe über Landschaftsmalerei, geschrieben in den Jahren 1815–24* (Nine letters on landscape painting, 1815–24) (Dresden, Germany: Wolfgang Jess, 1955), 10.

11. They are called "metaphysics" (Greek for "after physics") because these topics followed physics in Aristotle's treatise on transcendental philosophy.

12. According to Henri F. Ellenberger, *The Discovery of the Unconscious Mind: The History and Evolution of Dynamic Psychiatry* (New York: Basic Books, 1970), 57–69. Anyone who has studied the history of the unconscious mind is grateful to Ellenberger for this classic study.

13. Franz Anton Mesmer, *Schreiben über die Magnetkur an einem auswärtigen Arzt* (Writings on magnetism to a faraway medical doctor) (Vienna: Joseph Kurzböck, 1775).

14. In Braid, *Neurypnology, or The Rationale of Nervous Sleep Considered in Relation with Animal Magnetism* (London: J. Churchill, 1843).

15. Honoré de Balzac was enthusiastic about mesmerism, which he presented favorably in *Ursule Mirouet* (1853). For interest shown by French realist painters in the unconscious mind, see Aaron Sheon, "Courbet, le réalisme français et la découverte de l'inconscient" (Courbet, French realism and the discovery of the unconscious), in *L'Âme au corps: Arts et sciences, 1793–1993* (The soul of the body: Arts and sciences, 1793–1993),

exh. cat., ed. Jean Clair (Paris: Réunion des Musées Nationaux; Gallimard, 1993), 280–99.

16. Carl Gustav Carus, *Psyche: Zur Entwicklungsgeschichte der Seele* (Psyche, on the history of the development of the soul) (Leipzig, Germany: Alfred Kröner, 1846), 83–86.

17. Ibid., 1.

18. Hartmann, *Philosophie des Unbewussten* (Philosophy of the unconscious) (Berlin: Duncker, 1869).

19. Burke, *A Philosophical Inquiry into the Origin of Our Ideas of the Sublime and the Beautiful* (London: R. and J. Dodsley, 1757).

20. For the impact of the natural sciences on Romantic landscape painting in Britain and America, see Lynn Barber, *The Heyday of Natural History, 1820–1870* (London: Jonathan Cape, 1980), Charlotte Klonk, *Science and the Perception of Nature: British Landscape Art in the Eighteenth and Nineteenth Centuries* (New Haven, Conn., and London: Yale University Press, 1996), Barbara Novak, *Nature and Culture: American Landscape and Painting, 1825–1875* (New York: Oxford University Press, 1995), and Rebecca Bedell, *The Anatomy of Nature: Geology and American Landscape Painting, 1825–1875* (Princeton, N.J.: Princeton University Press, 2001).

21. Goethe believed that he was proving Aristotle's ancient color theory (see chap. 7), which had long ago been discarded.

22. Such as by Martin Kemp in *The Science of Art: Optical Themes in Western Art from Brunelleschi to Seurat* (New Haven, Conn., and London: Yale University Press, 1990), 297–99. Besides Turner, other artists, especially in Germanic lands, have continued to consult Goethe's color theory; for twentieth-century examples, see John Gage, "Goethe in the Twentieth Century," in *Color and Meaning: Art, Science, and Symbolism* (Berkeley and Los Angeles: University of California Press, 1999), 193–95, and Wolfgang Paalen's article comparing Goethe and Newton on light, "Art and Science" (1942) in *Wolfgang Paalen's DYN: The Complete Reprint*, ed. Christian Kloyber (Vienna and New York: Springer, 2000). It is amazing to me that Goethe's color theory still commands a scientific audience: for example, see Michael J. Duck, "Newton and Goethe on Color: Physical and Physiological Considerations," *Annals of Science* 45 (1988): 507–19. After a detailed consideration of the opposed theories, Duck ends by declaring a tie: "Although Goethe failed in his bid to discredit Newton's *Opticks*, he was successful in exposing certain flaws in it—especially with respect to coloured shadows, coloured liquids and subjective spectra. Since Newton was concerned with the physics of light rather than its perception, these flaws are of minor importance" (519).

23. As detailed by Helmholtz in "On Goethe's Scientific Researches" (1853), in *Popular*

Lectures on Scientific Subjects, trans. E. Atkinson (New York: D. Appleton and Co., 1891) 39–59.

24. Ibid., 51.

25. Ibid., 54.

26. According to Constable in his letter to George Constable, 12 Dec. 1836, quoted in Badt, *John Constable's Clouds*, 50. Badt's thesis is that Constable got indispensable stimulus from the new science of meteorology. Louis Hawes has argued against scientific sources, saying that the artist was inspired instead by earlier art and direct observation of nature, in "Constable's Sky Sketches," *Journal of the Warburg and Courtauld Institutes* 32 (1969): 344–65.

27. Constable, letter of October 1821, the entire text of which is printed in C. R. Leslie, "Skies," *Crayon*, 11 July 1855, 26.

28. Emerson, "The Transcendentalist" (1841), in *The Collected Works of Ralph Waldo Emerson*, ed. Robert E. Spiller and Alfred R. Ferguson (Cambridge, Mass.: Harvard University Press, Belknap Press, 1971), 1:201, 207.

29. Cole, "Essay on American Scenery" (1836), in *American Art 1700–1960: Sources and Documents*, ed. John W. McCoubrey (Englewood Cliffs, N.J.: Prentice-Hall, 1965), 105.

30. See Barbara Novak, "The Meteorological Vision: Clouds," in *Nature and Culture*, 78–100.

31. Humboldt, *Cosmos*, trans. E. C. Otté (London: Henry G. Bohn, 1849), 1:3–4.

32. On the relation of Church's painting to Humboldt, see Albert Ten Eyck Gardner, "Scientific Sources of the Full-Length Landscape: 1850," *Bulletin of the Metropolitan Museum of Art* 4, no. 2 (Oct. 1945): 59–65, Stephen Jay Gould, "Church, Humboldt, and Darwin: The Tension and Harmony of Art and Science," in *Frederic Edwin Church*, exh. cat., ed. Franklin Kelly (Washington, D.C.: National Gallery of Art, 1989), 94–107, and Günter Metken, "*Heart of the Andes*: Humboldt's *Cosmos* and Frederic Edwin Church," in *Cosmos: From Romanticism to the Avant-Garde*, exh. cat., ed. Jean Clair (Montreal: Montreal Museum of Fine Arts, 1999), 60–66.

33. Darwin, diary entry, 28 Feb. 1832, *Charles Darwin's Diary of the Voyage of the H.M.S. Beagle*, ed. Nora Barlow (1933; reprint, New York: Kraus, 1969), 39.

2. ADOPTING A SCIENTIFIC WORLDVIEW

1. Today's estimates are closer to thirty feet.

2. Mantell, journal entry, 27 Sept. 1834, in *The Journal of Gideon Mantell: Surgeon and Geologist*, ed. E. Cecil Curwen (London: Oxford University Press, 1940), 125.

3. Hutton published his uniformitarian views in *Theory of the Earth* (Edinburgh, 1785).

4. For the popularization of geology, see Barbara Maria Stafford, *Voyage into Substance: Art, Science, Nature, and the Illustrated Travel Account, 1760–1840* (Cambridge, Mass.: MIT Press, 1984), and Rebecca Bedell, *The Anatomy of Nature: Geology and American Landscape Painting, 1825–1875* (Princeton, N.J.: Princeton University Press, 2001), 3–15.

5. See Edmunds V. Bunske, "Humboldt and an Aesthetic Tradition in Geography," *Geographical Review* 71, no. 2 (Apr. 1981): 127–46.

6. Durand owned all five volumes of Ruskin's *Modern Painters* (1843–60), according to an 1844 letter from John Durand to Asher B. Durand that is quoted in Bedell, *Anatomy of Nature*, 159–60 n. 10.

7. Ibid., 160 n. 36.

8. Asher B. Durand, "Letter," *Crayon*, 11 July 1855, 17.

9. For early high-altitude landscape photography, see F. Guichon, *Montagne: Photographies de 1845 à 1914* (The mountain: Photographs from 1845 to 1914) (Paris: Denoël, 1984).

10. For the photography on these expeditions, see François Brunet, "Geological Views as Social Art: Explorers and Photographers in the American West, 1859–1879," in *Cosmos: From Romanticism to the Avant-Garde*, exh. cat., ed. Jean Clair (Montreal: Montreal Museum of Fine Arts, 1999), 86–92.

11. On Darwin's metaphor, see Howard E. Grubber, "Darwin's 'Tree of Nature' and Other Images of Wide Scope," *On Aesthetics in Science*, ed. Judith Wechsler (Cambridge, Mass.: MIT Press, 1978), 121–39.

12. For a summary of recent opposition to Darwin (in connection with the August 1999 decision by the Kansas school board, followed by the reversal of its decision in March 2001, to remove from the state's science curriculum evolution by natural selection as an explanation of the origin of species), see James Glanz, "Darwin vs. Design: Evolutionists' New Battle," *New York Times*, 8 Apr. 2001.

13. On the popularization of Darwinian evolution in Britain, see David Roger Oldroyd, *Darwinian Impacts: An Introduction to the Darwinian Revolution* (Kensington, Australia: New South Wales University, 1980), and Alvar Ellegård, *Darwin and the General Reader: The Reception of Darwin's Theory of Evolution in the British Periodical Press, 1859–1872* (Chicago: University of Chicago Press, 1990).

14. Johann Caspar Lavater, *Physiogno-mische Fragmente* (Essays on physiognomy) (Leipzig, Germany, and Winterthur, Switzerland:

Weidmannc Erben, Reich, and Heinrich Steiner, 1775), 1:45.

15. Text by Erasmus Darwin on a 1783 engraving of Fuseli's painting; quoted in Nicolas Powell, *Fuseli: The Nightmare* (New York: Viking Press, 1972), 58–60.

16. The occasion is described, the historical record is summarized, and Huxley's recollection of his remarks (in a 9 Sept. 1860 letter to Frederick Dyster) is quoted in Adrian Desmond, *Huxley: From Devil's Disciple to Evolution's High Priest* (Reading, Mass.: Addison-Wesley, 1997), 278–79.

17. Ibid., 374–76, 500–501.

18. Released in New York on 11 Jan. 1908. *Motion Picture Herald* 2 (1908): 29.

19. See Susan Sheets-Pyenson, "Popular Science Periodicals in Paris and London: The Emergence of a Low Scientific Culture, 1820–1875," *Annals of Science* 42, no. 6 (Nov. 1985): 549–72; Bruno Béguet, ed., *La Science pour tous: Sur la vulgarisation scientifique en France de 1850 à 1914* (Science for everyone: On the popularization of science in France from 1850 to 1914) (Paris: Bibliothèque du Conservatoire National des Art et Métiers, 1990); and Bruno Béguet, ed., *La Science pour tous: Sur la vulgarisation scientifique en France de 1850 à 1914*, exh. cat. (Paris: Réunion des Musées Nationaux, 1994).

3. The French Art of Observation: A Cool Rejection of Darwin

1. On French attitudes toward natural selection, see Robert E. Stebbins, "France," in *The Comparative Reception of Darwinism*, ed. Thomas F. Glick (Austin: University of Texas Press, 1974), 117–67.

2. Louis Pasteur, "Chimie appliquée à la physiologie: Des générations spontanées," *Revue des cours scientifiques* 1, no. 21 (23 Apr. 1864): 257.

3. For a complete listing see Bruno Béguet, ed., *La Science pour tous: Sur la vulgarisation scientifique en France de 1850 à 1914* (Science for everyone: On the popularization of science in France from 1850 to 1914) (Paris: Bibliothèque du Conservatoire National des Art et Métiers, 1990), 70, 94–95.

4. Figuier, *La Terre avant le deluge* (The earth before the deluge) (Paris: Hachette, 1863), xiv.

5. Zola, quoted in Louis Trebor, "Chez M. Émile Zola," *Le Figaro*, 6 Mar. 1893, 2. "Musset" is probably the playwright Alfred de Musset. On the influence of Taine's positivism on realist writers and Impressionist artists, see Marianne Marcussen and Hilde Olrik, "Le Réel chez Zola et les peintres impressionnistes: Perception et représentation," *Revue d'histoire*

littéraire de la France 80, no. 2 (Nov.–Dec. 1980): 966–77.

6. Zola, preface to the second edition of *Thérèse Raquin* (1868), trans. William R. Trask (New York: Bantam Books, 1960), xx.

7. Bernard wrote *Introduction à l'étude de la médecine expérimental* (Introduction to the study of experimental medicine) (Paris: J. B. Baillière, 1865).

8. Émile Zola, "Une Nouvelle Manière en peinture: Édouard Manet" (1867), in *Realism and Tradition in Art: 1848–1900*, ed. and trans. Linda Nochlin (Englewood Cliffs, N.J.: Prentice-Hall, 1966), 74.

9. Ibid., 72.

10. For examples of physiognomy in the writings of Zola, Balzac, and others, see F. Baldensperger, "Les Théories de Lavater dans la littérature française," in *Études d'histoire littéraire*, 2 ser. (Paris: Librairie Hachette, 1910), 51–91; the author argues that Zola based his description of the characters in *Thérèse Raquin* on Lavater (89). See also Philippe Sorel, "La Phrénologie et l'art" (Phrenology and art) in *L'Âme au corps: Arts et sciences, 1793–1993)* (The soul of the body: Arts and sciences, 1793–1993), exh. cat., ed. Jean Clair (Paris: Réunion des Musées Nationaux; Gallimard, 1993), 266–79.

11. George Combe, *Notes on the United States of North America during a Phrenological Visit* (Edinburgh: Machlachlan, Stewart, and Company, 1841), 339.

12. *The Notebooks of Edgar Degas*, ed. Theodore Reff (Oxford, England: Clarendon Press, 1976), vol. 2, notebook 23 (1868–72), entry 44. My discussion of Degas's use of Lavater is based on Theodore Reff, *Degas: The Artist's Mind*, exh. cat. (New York: Metropolitan Museum of Art, 1976), 216–23, and Anthea Callen, *The Spectacular Body: Science, Method, and Meaning in the Work of Degas* (New Haven, Conn., and London: Yale University Press, 1995).

13. Trianon, "Sixième Exposition de peinture par un groupe d'artists" (1881), in Ruth Berson, *The New Painting: Impressionism 1874–1886: Documentation* (San Francisco: Fine Arts Museums of San Francisco, 1996), 367–68.

14. Ephrussi, "Exposition des artistes indépendants" (Exhibition of independent artists) (1881), in ibid., 336–37.

15. A distinction between primary and secondary qualities, which is essentially the difference between color in the world and color in the mind, was made by René Descartes, who began *The World, or Essay on Light* (1633), by proclaiming "In proposing to treat here of light, the first thing I want to make clear to you is that there can be a difference between our sensation of light (i.e., the idea that is formed in our imagination through the intermediary of our eyes) and what is in the objects that produces

that sensation in us (i.e., what is in the flame or in the sun that is called by the name 'light')" (*The World/Le Monde*, trans. Michael Sean Mahoney [New York: Abaris Books, 1979], 1). The distinction was given its classic formulation by the British philosopher John Locke in *Essay Concerning Human Understanding* (1690), book 2, chap. 8. Descartes's *Essay on Man* also included an elaborate, although untested, physiological explanation of vision, and Locke's *Essay* contained a description of vision as light corpuscles striking the retina.

16. Runge to Pauline Bassenge, Apr. 1803, *Philipp Otto Runge: Briefe und Schriften* (Philipp Otto Runge: Letters and writings), ed. P. Betthausen (Munich: C. H. Beckaq, 1982), 141.

17. According to Chevreul's son M. Henri Chevreul, in his introduction to *De la loi du contraste simultané des couleurs* (On the law of simultaneous contrast of colors) (1889; reprint, Paris: Léonce Laget, 1969), iv.

18. Laugel, *L'Optique et les arts* (Optics and the arts) (Paris: Germer Baillière, 1869), 7. Laugel was a well-known science journalist for the series *Bibliothèque de philosophie contemporaine*. Other presentations of the Young-Helmholtz-Maxwell three-receptor theory of vision that were available to Impressionist artists and writers include Helmholtz's own *On the Relation of Optics to Painting* (1871), in which he explained the relevance of his discoveries to the artist's task of depicting nature; a translation was printed as an appendix to von Brücke's *Principes scientifiques* (Scientific principles) (1878). In *La Lumière et les couleurs* (Light and colors) (Paris: Hachette, 1874), Amédée Guillemin, a founder in 1873 of the science periodical *La Nature*, quoted from Helmholtz's *Optique physiologique* (Paris: Masson, 1867), a French edition of *Handbuch der physiologischen Optik* (1856–67) (Handbook of physiological optics [1856–67]) in his discussion of vision, and critic Eugène Véron summarized Helmholtz as well as French experimental work on physiology in "La Peinture" in his *L'Esthétique* (Aesthetics) (Paris: C. Reinwald, 1883). The American chemist Ogden N. Rood based his *Modern Chromatics* of 1879 (New York: D. Appleton and Co.) on a Helmholtzian view of vision, as did the French critic Georges Guéroult in "Formes, couleurs, et mouvements" (Forms, colors, and movements) in the popular *Gazette des beaux-arts* 25, no. 2 (Feb. 1882): 165–79.

19. Taine, *L'Intelligence* (Intelligence), 9th ed. (Paris: Hachette, 1900), 161–62.

20. Ibid., 163.

21. "The whole technical power of painting depends on our recovery of what may be called the *innocence of the eye*; that is to say, of a sort of childish perception of these flat stains of colour, merely as such, without consciousness of what they signify, as a blind man would see them if suddenly gifted with sight." John Ruskin, *The Elements of Drawing* (London: Smith, Elder & Co., 1857), 5–6.

22. See Chevreul, "Complement des études sur la vision des couleurs" (Supplement to studies about seeing color), *Memoires de l'Académie des sciences*, 2nd ser., 41 (1879): 14, 15, 178ff, 248ff.

23. Helmholtz summarized his early results in vol. 1 of *Handbook* (1856).

24. Panofsky, *Perspective as Symbolic Form*, trans. Christopher S. Wood (New York: Zone Books, 1991); originally published in 1924–25 as "Die Perspektive als 'symbolische Form'" (Perspective as "symbolic form").

25. Aaron Scharf, *Art and Photography* (Baltimore: Penguin Press, 1968), 177.

26. Martelli's copy is preserved in an archive in the Biblioteca Marcelliana, Florence; see Norma F. Broude, "The Macchiaioli as 'Proto-Impressionists': Realism, Popular Science and the Re-shaping of *Macchia* Romanticism, 1862–86," *Art Bulletin* 52, no. 4 (Dec. 1970): 407 n. 24. In this article (406) Broude also translates Diego Martelli's lecture "Gli Impressionisti," first published as a pamphlet in Pisa, Italy, in 1880.

27. For the former view, see Scharf, *Art and Photography*, and for the latter see Kirk Varnedoe, "The Artifice of Candor: Impressionism and Photography Reconsidered," *Art in America* 68, no. 1 (Jan. 1980): 66–78.

28. Théodore Duret, "Les Peintres impressionnistes" (The Impressionist painters) (1878), in *Impressionism and Post-Impressionism, 1874–1904: Sources and Documents*, ed. and trans. Linda Nochlin (Englewood Cliffs, N.J.: Prentice-Hall, 1966), 7–10.

29. Duranty, *La Nouvelle Peinture: À propos du groupe d'artistes qui expose dans les Galeries Durand-Ruel* (The new painting: A group exhibition of artists at Galeries Durand-Ruel), ed. Marcel Guèrin (1876; reprint, Paris: Floury, 1946), 38–47, 53, 55. On Duranty and Guillemin, see Marianne Marcussen, "Duranty et les Impressionnistes, II," *Hafnia*, no. 6 (1979): 29.

30. Monet to Gustave Geffroy, in Geffroy, *Claude Monet: Sa vie, son temps, son oeuvre* (Claude Monet: His life, his times, his work) (Paris: G. Crès, 1922), 188–89.

31. For a detailed analysis of Monet's painting technique, see Robert Herbert, "Method and Meaning in Monet," *Art in America* 67, no. 5 (Sept. 1979): 90–108.

32. Laforgue, "Impressionism" (1883), in *Oeuvres complètes* (Complete works) (Paris: L'Age d'Homme, 1986), 3:330.

33. Ibid., 3:332.

34. On the biological décor of Haeckel's home in Jena, see Michael Huey, "Medusa Man," *World of Interiors* (Aug. 1999): 54–63. For Haeckel's influence on Art Nouveau design, see Erika Krausse, "Zum Einfluss Ernst Haeckels auf Architekten des Art Nouveau" (Ernst Haeckel's influence on Art Nouveau architecture), in *Die Natur der Dinge: Neue Natürlichkeit?* (The nature of things: The new naturalness?), ed. Olaf Breidbach and Werner Lippert (Vienna: Springer, 2000), 85–93.

35. Van Overloop, *Essai d'un théorie du sentiment esthétique* (Essay on aesthetics) (Brussels: Hayez, 1889).

36. Gallé, *Écrits pour l'art* (Writings on art) (1908; reprint, Marseilles, France: Laffitte Reprints, 1980), 154.

37. Mutationism was articulated by Alexis Jordan, a botanist in Lyons, coauthor with botanist Jules Fourreau of *Icones ad floram Europae* (Depictions of European vegetation) (1866–68); on this undercurrent in French biology, see Adrien Davy de Virville, "Le Jordanisme," in *Histoire de la botanique en France* (History of botany in France) (Paris: Société d'Édition d'Enseignement Supérior, 1954), 326–28. In 1883 Armand Clavaud wrote his *Fauna of Gironde* (Bordeaux, France: Société Linnéenne, 1881–84), in which he supported Jordan's view that species originated by abrupt jumps that produced freaks or odd combinations of characteristics (Gironde is the region that includes the city of Bordeaux). The origin of species by mutation was an unpopular theory that was continued by French botanists such as Charles Naudin in the late nineteenth century. After Mendel's laws of genetics were rediscovered in 1900, the Dutch botanist Hugo de Vries demonstrated that mutations could be explained by the ability of characteristics to vary independently. For a discussion of Darwinian aspects of the art of Redon, as well as Edvard Munch, Franz von Stuck, and others, see Barbara Larson, "La Génération symboliste et la revolution darwinienne" (The symbolist generation and the Darwinian revolution), in *L'Âme au corps: Arts et sciences, 1793–1993* (The soul of the body: Arts and sciences, 1793–1993), exh. cat., ed. Jean Clair (Paris: Réunion des Musées Nationaux; Gallimard, 1993), 322–41.

38. Redon to A. Bonger, May 1909, in *À soi-même* (To myself) (Paris: H. Floury, 1922), 19–20.

39. The influence of Clavaud and the microscope on Redon's work had been noted since André Mellerio's classic study, *Odilon Redon: Peintre, dessinateur, et graveur* (Odilon Redon: Painter, draftsman, and printmaker) (Paris: H. Floury, 1923); see Douglas W. Druick and Peter Kort Zegers, "In the Public Eye," in *Odilon Redon: Prince of Dreams, 1840–1916*, exh. cat., ed. Douglas W. Druick (Chicago: Art Institute of Chicago, 1994), 120–74, and Marco Franciolli, "Les Merveilles du monde invisible" (Marvels of the invisible world), in *Odilon Redon: La nature dell'invisible — La Nature de l'invisible*

(Odilon Redon: The nature of the invisible), exh. cat., ed. Manela Kahn-Rossi (Milan: Skira, 1996), 295–97.

40. Redon, *À soi-même*, 19. The titles of Clavaud's six publications between 1864 and 1884, and his eighty-five oral presentations to the Linnaean Society of Bordeaux, indicate that he worked exclusively on classifying plants of the Bordeaux region. Redon's remark about intermediary life led the biologist Curt Pueschel to raise with me the intriguing possibility that Clavaud may have studied a rare insect-eating plant (like the venus flytrap). But I determined that of the approximately eighty species named by Clavaud in the titles of his talks, none is carnivorous (per e-mail to me of 14 Nov. 2001 from Philippe Richard, conservator of the Bordeaux Botanical Garden). So the intermediary creatures that enchanted Clavaud were evidently all microscopic.

41. "Il aurait fallu le crayon d'Odilon Redon pour donner la vie à ces monstres"; according to Redon's wife, after Pasteur looked at Redon's *Origins* with great curiosity for a long time, he was prompted to make the remark when he was offered a sculpture by Carabin depicting fantastic creatures, which were presumably in a more traditional mythological style. Redon's wife relayed the anecdote to André Mellerio. Mellerio, *Odilon Redon*, 155. Before beginning his career in chemistry, Pasteur had academic training in drawing and was an accomplished draftsman; see René Vallery-Radot, "Pasteur Artiste" (Pasteur the artist), in *Pasteur inconnu* (The unknown Pasteur) (Paris: Flammarion, 1956), 162–74.

42. Huysmans, "Le Nouvel album d'Odilon Redon" (The new album by Odilon Redon), in *La Revue indépendante* (Geneva: Slatkine Reprints, 1970), vol. 2 (1885): 291.

4. German and Russian Art of the Absolute: A Warm Embrace of Darwin

1. See William M. Montgomery, "Germany," in *The Comparative Reception of Darwinism*, ed. Thomas F. Glick (Austin: University of Texas Press, 1974), 81–116.

2. As evidence that all animals have a common ancestor, Haeckel published drawings of the development of a human, a chicken, and a salamander in which the three embryos were strikingly similar; Haeckel, *Anthropogenie, oder Entwicklungsgeschichte des Menschen* (Anthropogeny, or the history of human development) (Leipzig, Germany: W. Engelmann, 1874). After reproducing them in biology textbooks for over a century, biologists determined in the 1990s that the drawings are either overinterpretations of data or outright fakes; see James Glanz, "Variations on an Embryo," *New York Times*, 8 Apr. 2001. See also James Hanken, "Beauty beyond Belief: The Art of Ernst Haeckel

Transcends His Controversial Scientific Ideas," *Natural History* 107, no. 10 (Dec. 1998–Jan. 1999): 56–58.

3. For the reception of Darwin in Russia, see Alexander Vucinich, *Science in Russian Culture* (Stanford, Calif.: Stanford University Press, 1970), 2:273–97; see also Vucinich, "Russia: Biological Sciences," in Glick, *The Comparative Reception of Darwinism*, 227–55.

4. K. A. Timiriazev, *Kratkii ocherk teorii Darvina* (Short essay on Darwin's theory) (1865; reprint, Moscow: Gos. izd-vo sel'khoz. lit-ry, 1953).

5. Darwin, *The Descent of Man, and Selection in Relation to Sex*, 2nd ed. (New York and London: D. Appleton and Co., 1874), 163.

6. Kovalevsky, quoted in Vucinich, "Biological Sciences," 229.

7. Kandinsky, "Reminiscences" (1913), in *Kandinsky: Complete Writings on Art*, ed. Kenneth C. Lindsay and Peter Vergo (Boston: G. K. Hall and Co., 1982), 1:362–63.

8. Fechner, *Zend-Avesta, oder über die Dinge des Himmels und des Jenseits vom Standpunkt der Naturbetrachtung* (Zend-Avesta, or about the subject of heaven and the other side from the standpoint of the contemplation of nature) (Leipzig, Germany: L. Voss, 1851). Fechner named his cosmology after "Zend-Avesta," a sacred text written by the Persian prophet Zoroaster in the sixth century B.C. that described the struggle between the forces of light and darkness.

9. Freud, "Beyond the Pleasure Principle" (1920), in *The Standard Edition of the Complete Psychological Works of Sigmund Freud*, trans. James Strachey (London: Hogarth Press, 1962), 18:8.

10. "Fechner's law" states that the minimal difference in intensity between two stimuli (in the physical world) that can be distinguished by the perceiving subject (in the psychological or spiritual realm) bears a constant relation to the percentage of the stimulus.

11. Fechner, *Vorschule der Aesthetik* (Introduction to aesthetics) (Leipzig, Germany: Breitkopf und Härtel, 1876), 15–17.

12. Ibid., 193–96.

13. Helmholtz, "Gustav Magnus: In Memoriam," in *Popular Lectures on Scientific Subjects*, trans. E. Atkinson (London: Longmans, Green, 1881), 2:1–25.

14. As done in Sixten Ringbom, *The Sounding Cosmos: A Study of the Spiritualism of Kandinsky and the Generation of Abstract Painting* (Abo, Finland: Abo Academia, 1970), and Maurice Tuchman, ed., *The Spiritual in Art: Abstract Painting, 1890–1985*, exh. cat. (Los Angeles: Los Angeles County Museum of Art; New York: Abbeville Press, 1987).

15. Bucke cited Whitman and the poem as examples in "From Self to Cosmic Consciousness," in *Cosmic Consciousness: A Study in the Evolution of the Human Mind* (1901; facsimile reprint, New Hyde Park, N.Y.: University Books, 1961), 51–68.

16. Translated by Konstantin Bal'mont as *Pobiegi travy* (Moscow: Kn-vo "Skorpion," 1911); Bucke's book was translated into Russian *(Kosmicheskoe soznanie)* in 1915.

17. See Linda Dalrymple Henderson, "Hyperspace Philosophy in Russia: Peter Demianovich Ouspensky," in *The Fourth Dimension and Non-Euclidean Geometry in Modern Art* (Princeton, N.J.: Princeton University Press, 1983), 245–55.

18. Ouspensky, *Tertium Organum: The Third Canon of Thought, a Key to the Enigmas of the World*, trans. Claude Bragdon and Nicholas Bessaraboff (New York: Alfred A. Knopf, 1968), 236.

19. Ibid., 230.

20. Böhme's publications include *Sechs theosophic Punkten* (Six theosophical points) (1620).

21. Steiner, "Haeckel, 'The Riddle of the Universe' and Theosophy," in *Three Essays on Haeckel and Karma* (London: Theosophical Publishing Society, 1914), 223.

22. Besant's publications include *Biblical Biology: A Contribution to Religious Non-Science* (London: A. Besant and C. Bradlaugh, 1884), and Annie Besant wrote *Light, Heat, and Sound* (London: Freethought Publishing Co., 1881). Besant and Charles W. Leadbeater together wrote *Occult Chemistry: A Series of Clairvoyant Observations on the Chemical Elements* (London: Theosophical Publishing, Co., 1908), and a manual explaining how to perceive auras and the vibrations in them that produce "thought-forms," in *Thought-Forms* (London: Theosophical Publishing Society, 1905). Leadbeater also published an illustrated book on auras, *Man Visible and Invisible: Examples of Different Types of Men as Seen by Trained Clairvoyance* (New York: John Lane, 1902). All these publications are a mix of real science and the supernatural; for example, Besant and Leadbeater's colorful illustrations of supernatural thought-forms are derived from diagrams of sound waves and electromagnetic waves in physics texts.

23. Endell, *Um die Schönheit* (About beauty) (Munich: Emil Franke, 1896), 9. The related idea of looking at nature in terms of its abstract structure motivated Endell's contemporary the Berlin botanist Karl Blossfeldt to create stunning photographs of stems, buds, and leaves on stark blank backgrounds; see Blossfeldt *Urformen der Kunst: Photographische Pflanzenbilder* (Art forms in nature: Photographs of plants), ed. Karl Nierendorf (Berlin: E. Wasmuth, 1928). Generations of mid-twentieth-century artists

were encouraged to continue looking at nature abstractly by the British biologist D'Arcy Thompson's *On Growth and Form* (Cambridge, England: Cambridge University Press, 1942).

24. Endell, *Die Schönheit der grossen Stadt* (Beauty of the big city) (Stuttgart, Germany, 1908), 44–45.

25. Malevich, *The Non-objective World* (Chicago: Paul Theobald and Co., 1959), 68.

26. Lipps, *Raumaesthetik, und geometrisch-optische Täuschungen* (Aesthetics of space, and geometrical optical illusions) (Leipzig, Germany: Johann Ambrosius Barth, 1897).

27. Lipps included a chapter on the subjective experience of musical harmony and discord in *Psychologische Studien* (Psychological studies) (1885).

28. For a detailed discussion of the origins of abstract painting in Munich in the decorative arts, see Peg Weiss, *Kandinsky in Munich: The Formative Years* (Princeton, N.J.: Princeton University Press, 1979), esp. "Emergence to Abstraction," 107–35.

29. See Christoph Kockerbeck, "Ernst Haeckels *Kunstformen der Natur* und die bildende Kunst des Art nouveau am Beispiel von Hermann Obrist" (Ernst Haeckel's *Kunstformen der Natur* and art nouveau painting as exemplified by Hermann Obrist), in *Ernst Haeckels Kunstformen der Natur und ihr Einfluss auf die deutsche bildende Kunst der Jahrhundertwende* (Ernst Haeckel's *Kunstformen der Natur* and its influence on German painting at the turn of the century) (Frankfurt am Main, and New York: P. Lang, 1986), 43–211.

30. Fuchs, "Hermann Obrist," *Pan* 1 (1895): 324.

31. Ibid., 321, 324.

32. Endell, three-part article in *Dekorative Kunst*: part 1, "Formenschönheit und Dekorative Kunst" (The beauty of forms and decorative art), vol. 1, no. 6 (Mar. 1898): 75–76; part 2, "Die Gerade Linie" (The straight line), and part 3, "Geradlinige Gebilde" (Straight-line images), vol. 1, no. 9 (June 1898): 119–25; the quote is from "Formenschönheit und Dekorative Kunst," 75–76.

33. See the epigraph to this chapter, from ibid., part 1, 75–76.

34. Endell, "Architektonische Erstlinge" (New architecture), *Dekorative Kunst* 3, no. 8 (May 1900): 314–15.

35. Rössler, "Das abstrakte Ornament mit gleichzeitiger Verwendung simultaner Farbenkontraste" (Abstract ornament used for color contrast), *Wiener Abendpost*, suppl. to no. 228 (6 Oct. 1903), n.p.

36. Rössler, *Neu-Dachau: Ludwig Dill, Adolf Hölzel, Arthur Langhammer* (Bielefeld,

Germany, and Leipzig, Germany: Velhagen & Klasing, 1905), 123.

37. Ibid.

38. Kulbin, *Chuvstvitelnost: Ocherki po psikhometree e klinicheskomu primeneniiu eia dannykh* (Sensitivity: Studies in psychometry and the clinical application of its data) (Saint Petersburg, Russia, 1907).

39. Kandinsky, "Whither the 'New Painting'" (1911), in *Kandinsky: Complete Writings on Art*, 1:98.

40. Ibid., 1:101.

41. Kulbin, *Chuvstvitelnost*, 151. Perhaps inspired by these associations, Kandinsky gave the triangle a prominent place in *On the Spiritual in Art* of 1912; one ascends a pyramid as one attains higher levels of spirituality.

42. Kulbin, "Free Art as the Basis of Life: Harmony and Dissonance" (1908), in *Russian Art of the Avant-Garde: Theory and Criticism 1902–1934*, ed. and trans. John E. Bowlt (London: Thames and Hudson, 1988), 13. Kulbin published another article, "Free Music," on the topic in *Der Blaue Reiter* (1912); translated into English in *The Blaue Reiter Almanac*, trans. Henning Falkenstein, ed. Klaus Lankheit (New York: Viking, 1965), 141–46.

43. On Kandinsky in Munich, see Peg Weiss, *Kandinsky in Munich*.

44. Kandinsky, "Form and Content," in *Kandinsky: Complete Writings on Art*, 1:87.

45. For biological imagery and evolutionary ideas in Russian avant-garde art, see Charlotte Douglas, "Evolution and the Biological Metaphor in Modern Russian Art," *Art Journal* 44, no. 2 (Summer 1984): 153–61, and Alla V. Povelikhina, *Organica: The Non-objective World of Nature in the Russian Avant-Garde of the 20th Century*, exh. cat. (Cologne, Germany: Galerie Gmurzynska, 1999). On the more general impact of science, see Patricia Railing, *From Science to Systems of Art: On Russian Abstract Art and Language, 1910–1920*, trans. C. Van Manen et al. (n.p. [England]: Artists' Bookworks, 1989).

46. D. G. Konovalov, *Religioznyi ekstaz v russkom misticheskom sektantstve* (Religious ecstasy in Russian mystical sectarianism) (Sergiev Posad, Russia: Troitse-Sergieva Monastery, 1908); Kruchenykh described the sectarians as sincere, religious people, who speak in unknown tongues when "filled with the Holy Spirit." "Novye puti slova" (New ways of words) (1913), in *Manifesty i programmy russkikh futuristov* (Manifestos and programs of the Russian Futurists), ed. Vladimir Markov (Munich: Fink, 1967), 67. In 1913 Kruchenykh published *Utinoe gniezdyshko durnykh slov* (The nest of a duck filled with evil words), in which he claimed that for the first time he and other writers gave the world poems, written in a free language

(zaumnom) that is beyond reason and universal (Saint Petersburg, Russia: EUY, 1913). Kruchenykh also published *Zaumnaia kniga* (Book beyond reason) (Moscow: Knigi Budetlian, 1915).

47. Malevich to Matiushin, summer 1913, archives of the Tretiakov Gallery, Moscow, f. 25, no. 9, sheets 11–12; quoted in Charlotte Douglas, "Beyond Reason: Malevich, Matiushin, and Their Circle," in Tuchman, ed., *Spiritual in Art*, 199. On the relation of Malevich to Khlebnikov, see Rainer Crone, "Malevich and Khlebnikov: Suprematism Reinterpreted," *Artforum* 17, no. 4 (Dec. 1978): 38–47.

48. On Malevich's use of mathematical symbols, see John Milner, *Kazimir Malevich and the Art of Geometry* (New Haven, Conn., and London: Yale University Press, 1996).

49. *From Cubism to Suprematism in Art, to the New Realism of Painting, to Absolute Creation* (Saint Petersburg, Russia: L. Ya. Ganzburg, 1915), trans. by Charlotte Douglas as an appendix to her *Swans of Other Worlds: Kazimir Malevich and the Origins of Abstraction in Russia* (Ann Arbor, Mich.: UMI Research Press, 1976), 110.

50. Matiushin, "Ne iskusstvo a zhizn" (Not art but life) (1923), translated by Christina Lodder in her *Russian Constructivism* (New Haven, Conn., and London: Yale University Press, 1983), 206.

51. Ibid. The State Institute was closed in 1929, but three years later Matiushin published a book of his color studies, which is similar to Chevreul's; *Zakonomernost izmeniaemosti tsvetochnykh sochetanii: Spravochnik po tsvetu* (The natural law of variability of color combinations: A color guide) (Leningrad and Moscow: Ogiz-Izogiz, 1932).

52. Malevich to Matiushin, 10 Nov. 1917, quoted in Evgenii Kovtun, "Suprematism as an Eruption of Universal Space," *Suprematisme*, exh. cat. (Paris: Galerie Jean Chauvelin, 1977), 27.

53. Malevich, "Suprematism as Non-objectivity" (1922), quoted and translated by Rainer Crone and David Moos in their *Kazimir Malevich: The Climax of Disclosure* (London: Reaktion Books, 1991), 8.

54. Malevich, *Non-objective World*, 68.

5. Loving and Loathing Science at the Fin de Siècle

1. There is critical writing about Seurat and science beginning in the 1880s showing that the Neo-Impressionists assembled under a banner of science because of the prestige of science and the useful information scientists provided artists: the key publications are Charles Henry, "Introduction à une esthétique scientifique

(Introduction to a scientific aesthetics)," *La Revue contemporaine* 2 (Aug. 1885), 441–69; Félix Fénéon, "Les Impressionnistes" (1886) in *Les écrivains devant l'impressionnisme* (Writers consider Impressionism), ed. Denys Riout (Paris: Macula, 1989), 393–405; William Innes Homer, *Seurat and the Science of Painting* (Cambridge, Mass.: MIT Press, 1964); Martin Kemp, *The Science of Art: Optical Themes in Western Art from Brunelleschi to Seurat* (New Haven, Conn., and London: Yale University Press, 1990), 306–22; and John Gage, "Seurat's Silence," in *Color and Meaning: Art, Science, and Symbolism* (Berkeley and Los Angeles: University of California Press, 1999), 219–27. There is also a trail of commentary alleging that the Neo-Impressionists misused scientific information: Louis Hayet (1887) in G. Dulon and C. Duvivier, *Louis Hayet 1864–1940: Peintre et théoricien du néo-impressionnisme* (Louis Hayet 1864–1940: Painter and theoretician of Neo-Impressionism), exh. cat. (Pontoise, France: Musée de Pontoise, 1991), 185; J. Carson Webster, "The Technique of Impressionism: A Reappraisal," *College Art Journal* 4, no. 1 (Nov. 1944): 3–22; Alan Lee, "Seurat and Science," *Art History* 10, no. 2 (June 1987): 203–26, and the response to Lee by Dana A. Freeman, *Art History* 11, no. 2 (June 1988): 150–55; John Gage, "The Technique of Seurat: A Reappraisal," *Art Bulletin* 59, no. 3 (Sept. 1987): 448–54. Others have stressed the link of science with the anarchist political outlook held by artists in Seurat's circle: Robyn S. Roslak, "The Politics of Aesthetic Harmony: Neo-Impressionism, Science, and Anarchism," *Art Bulletin* 73, no. 3 (Sept. 1991): 381–90, and John G. Hutton, *Neo-Impressionism and the Search for Solid Ground: Art, Science, and Anarchism in Fin-de-Siècle France* (Baton Rouge: Louisiana State University Press, 1994). In this literature I found Webster ("Technique") and Gage ("Seurat's Silence") the most helpful.

2. Rood, *Modern Chromatics with Applications to Art and Industry* (1879; facsimile reprint, New York: Van Nostrand Reinhold Company, 1973), 14; translated as *Théorie scientifique des couleurs et leurs applications à l'art et à l'industrie* (Paris: Librarie Germer Baillière, 1881).

3. Ibid., 140.

4. Fénéon, "Les Impressionnistes," 401–2.

5. Fénéon mentions optical mixtures demonstrated by "Maxwell's discs" in connection with Seurat's *La Grande Jatte*, in "Les Impressionnistes," 402–3. Pissarro said Seurat's sources included "the theory of colors discovered by Chevreul, the experiments of Maxwell, and the measurements of O. N. Rood," Pissarro to Durand-Ruel, 6 Nov. 1886, in L. Venturi, ed. *Les Archives de l'impressionnisme* (Archives of Impressionism) (Paris and New York: Durand-Ruel, 1939), 2:24.

6. The possible impact on Seurat has been discussed by Norma Broude in "New Light on Seurat's 'Dot': Its Relation to Photo-Mechanical Color Printing in France in 1880s," *Art Bulletin* 56, no. 4 (Dec. 1974): 581–89.

7. Blanc, *Grammaire des arts du dessin* (Grammar of composition) (Paris: Jules Renouard, 1867), 68.

8. Rood, *Modern Chromatics*, 275.

9. From Hayet's unpublished notebooks, c. 1886, quoted in Dulon and Duvivier, *Louis Hayet*, 185.

10. Rood, *Modern Chromatics*, 275.

11. Ibid., 140.

12. Blanc, *Grammaire*, 568.

13. Ibid., 568.

14. Hayet, notebook entry, 1897, quoted in Dulon and Duvivier, *Louis Hayet*, 185. For a recent example of the same misreading of Seurat's dots, see Lee, "Seurat and Science."

15. Fénéon, "Les Impressionnistes," 402.

16. Rood, *Modern Chromatics*, 149; the chart comparing the mixture of pigment on a palette with the mixture of light by rotating disk is on pp. 148–49.

17. Paul Bourget described Fechner's method of measuring sensations in a discussion of Impressionist work in "Paradoxe sur la couleur" (1881), in Riout, ed., *Les Écrivains devant l'impressionnisme*, 317; originally published in *Le Parlement*, 15 Apr. 1881. Jules Laforgue cited *la lois de Fechner* (Fechner's law) in "L'Impressionnisme" (1883), in *Oeuvres complètes* (Complete works) (Paris: L'Age d'Homme, 1986), 3:333, as did Félix Fénéon in a discussion of Signac's work, "Paul Signac" (1891), in *Félix Fénéon: Oeuvres plus que complètes* (Félix Fénéon: His works, which are more than complete) (Geneva: Dros, 1970), 1:198; originally published in *La Plume*, 1 Sept. 1891. Charles Henry was familiar not only with Fechner and Wundt but also with other leading German, British, and French researchers in the physiology of perception; Henry, "Introduction à une esthétique scientifique," 444. There were also French scientific publications on German psychophysics, such as Théodule Ribot's chapters on Fechner and Wundt in *La Psychologie allemande contemporaine: École expérimentale* (Contemporary German psychology: The experimental school) (Paris: Félix Alcan, 1885).

18. On Henry's attempt to formulate an aesthetics based on science, see Henri Dorra, "Charles Henry's 'Scientific' Aesthetic," *Gazette des beaux-arts* 74 (Dec. 1969): 343–56, and José A. Argüelles, *Charles Henry and the Formation of a Psychophysical Aesthetic* (Chicago: University of Chicago Press, 1972).

19. See epigraph to this chapter; letter to Maurice Beaubourg, 28 Aug. 1890, translated in Homer, *Seurat and Science*, 187.

20. The format matches a wood-block print owned by the artist, per Françoise Cachin, "Le Portrait de Fénéon par Signac: Une source inédite" (The portrait of Fénéon by Signac: An unpublished source), *La Revue de l'art*, no. 6 (1969): 90–91.

21. Cheney, *The Story of Modern Art* (New York: Viking Press, 1941), 191.

22. Richard G. Tansey and Fred S. Kleiner, *Gardner's Art through the Ages*, 10th ed. (New York: Harcourt Brace College Publishers, 1996), 2:989.

23. Arnason and Prather, *History of Modern Art*, 4th ed. (New York: Harry N. Abrams, 1998), 65.

24. See Michael F. Zimmermann, "Die 'Erfindung' Pieros und seine Wahlverwandtschaft mit Seurat" (Piero's discovery and its relation to Seurat), in *Piero della Francesca and His Legacy*, ed. Marilyn Aronberg Lavin (Washington, D.C.: National Gallery of Art, 1995), 268–301.

25. See Robert L. Herbert, *Seurat's Drawings* (New York: Shorewood Publishers, 1962).

26. For recent discussions of decadence in late-nineteenth-century art, see Patrick Bade, "Art and Corruption: Visual Icons of Corruption," in *Degeneration: The Dark Side of Progress*, ed. Edward Chamberlin and Sander L. Gilman (New York: Columbia University Press, 1985), 220–40, José Pierre, ed., *L'Universe symboliste: Décadence, symbolisme, et art nouveau* (The symbolist universe: Decadence, symbolism, and art nouveau) (Paris: Somogy, 1991), and Shearer West, "Degeneration," in *Fin de Siècle* (Woodstock, N.Y.: Overlook Press, 1993).

27. Goncourt, entry for 13 Feb. 1874, Edmond de Goncourt and Jules de Goncourt, *Le Journal des Goncourt: Mémoires de la vie littéraire* (Journal of the Goncourts: Memoirs of a literary life) (Paris: Bibliothèque-Charpentier, 1891), 5:112.

28. Aurier, "Les Isolés, Vincent van Gogh" (The isolated ones, Vincent van Gogh) (1890), in *Impressionism and Post-Impressionism 1874–1904: Sources and Documents*, ed. and trans. Linda Nochlin (Englewood Cliffs, N.J.: Prentice-Hall, 1966), 136, 139.

29. On bacterial infection and the visual arts in the late nineteenth century, see Barbara Larson, "Microbes and Maladies: Bacteriology and Health at the Fin de Siècle," *Lost Paradise: Symbolist Europe*, exh. cat., ed. Jean Clair (Montreal: Montreal Museum of Fine Arts, 1995), 385–93.

30. Quoted in Arne Eggum, "The Major Paintings," in *Edvard Munch: Symbols and Images*, exh. cat. (Washington, D.C.: National Gallery of

Art, 1978), 39.

31. I agree with Thomas M. Messer that the frequent reading of the bands in the sky of *The Scream* as a visualization of sound waves misses the point of this work; Messer, *Edvard Munch* (New York: Harry N. Abrams, 1985), 72. Also the bands resemble not sound waves (see plate 137), but stratus clouds (see plate 5).

32. Quoted in Ragna Stang, *Edvard Munch: The Man and His Art*, trans. Geoffrey Culverwell (New York: Abbeville Press, 1977), 31.

33. Nordau, *Degeneration* (New York: D. Appleton and Co., 1895), viii.

34. For French examples, see Oscar Reutersvärd, "The 'Violettomania' of the Impressionists," *Journal of Aesthetics and Art Criticism* 9, no. 1 (Sept. 1960): 106–10; for American examples, see Lynn Gamwell and Nancy Tomes, *Madness in America: Cultural and Medical Perceptions of Mental Illness before 1914* (Ithaca, N.Y.: Cornell University Press, 1994), 130–31.

35. On the cultural impact of entropy, see Stephen G. Brush, "Degeneration," in *The Temperature of History: Phases of Science and Culture in the Nineteenth Century* (New York: Burt Franklin & Co., 1978), 103–20, and Greg Myers, "Nineteenth-Century Popularizations of Thermodynamics and the Rhetoric of Social Progress," *Victorian Studies* 29, no. 1 (Autumn 1985): 35–66.

36. Clausius, 1868, quoted in Brush, *Temperature of History*, 61.

37. Spencer, *First Principles* (1862; reprint, New York: DeWitt Revolving Fund, 1958), 507.

38. *The Autobiography of Charles Darwin*, ed. N. Barlow (1870; reprint, retitled, of Charles Darwin, *Autobiography*, New York: Harcourt, Brace, 1958), 92.

39. Flammarion, *Astronomie populaire* (Popular astronomy) (Paris: C. Marpon and E. Flammarion, 1881), 101.

40. Wells, *The Time Machine* (1895; reprint, New York: Random House, 1931), 80.

6. Looking Inward: Art and the Human Mind

1. Huysmans, "L'Expositions des indépendants en 1880," *L'Art moderne* (Paris: Plon-Nourrit, 1883), 104.

2. Monet, recorded by Lilla Cabot Perry in "Reminiscences of Claude Monet from 1889–1909," *American Magazine of Art* 18, no. 3 (Mar. 1927): 120. In 1884 the Viennese ophthalmologist Carl Koller had discovered that cocaine could be used as a local anesthesia for cataract surgery, making the procedure safer and more endurable, and hence suddenly common in the late nineteenth century.

3. On Helmholtz's transformation of Kant's views on space, see Gary C. Hatfield, "Helmholtz: The Epistemology and Psychology of Spatial Perception," in *The Natural and the Normative: Theories of Spatial Perception from Kant to Helmholtz* (Cambridge, Mass.: MIT Press, 1990), 165–234.

4. My discussion of Cézanne was inspired by Maurice Merleau-Ponty's essay "Cézanne's Doubt" (1948), in *Sense and Non-Sense*, trans. H. Dreyfus and P. Dreyfus (Evanston, Ill.: Northwestern University Press, 1964), 9–25. Merleau-Ponty described Cézanne as having anticipated later (Gestalt) theories of spatial perception, but I think it is more accurate to understand both Cézanne and Gestalt psychologists as having a common source in Helmholtz. For related discussions, see Laurence Gowing, "The Logic of Organized Sensation," in *Cézanne: The Late Work*, exh. cat., ed. William Rubin (New York: Museum of Modern Art, 1977), 55–71, and the sections on Cézanne in Edwin Jones, *Reading the Book of Nature: A Phenomenological Study of Creative Expression in Science and Painting*, Series in Continental Thought, no. 14 (Athens: Ohio University Press, 1989).

5. See the epigraph to this chapter, which was one of several "opinions" of the artist recorded by Bernard and approved by the artist for publication in "Paul Cézanne" (1904), in *Conversations avec Cézanne*, P. Michael Doran, ed. (Paris: Macula, 1978), 36.

6. Cézanne to Emile Bernard, 15 Apr. 1904, *Correspondance*, ed. J. Rewald (Paris: B. Grasset, 1978), 296.

7. Helmholtz, *On the Relation of Optics to Painting* (1871), trans. E. Atkinson, in *Selected Writings of Hermann von Helmholtz*, ed. R. Kahl (Middletown, Conn.: Wesleyan University Press, 1971), 329.

8. See Edmond de Goncourt and Jules de Goncourt, *Journal des Goncourt: Mémoires de la vie littéraire* (Journal of the Goncourts: Memoirs of a literary life) (1891; reprint, Paris: Fasquelle, 1956), 3:594, 885, 932; see also G. Hahn, "Charcot et son influence sur l'opinion publique," *Revue des questions scientifiques*, 2nd ser., 6 (1894): 230–61, 353–59.

9. Gleizes and Metzinger, *Du Cubisme* (About Cubism) (Paris: Figuière, 1912), 36.

10. Raynal, *Quelques intentions du cubisme* (Some intentions of Cubism) (Paris: L'Effort Moderne, 1919), n.p.

11. Kahnweiler, *Der Weg zum Kubismus* (The way to Cubism) (Munich: Delphin, 1920), 40–41.

12. Ibid., 34.

13. By the first decade of the twentieth century, scientists too were responding to the Kant-Helmholtz legacy, and signs and symbols were becoming central themes in mathematics and linguistics. In Germany the work of Kurt Gödel founded the discipline of symbolic logic, and in France the linguist Ferdinand de Saussure examined the structure of spoken language. As these scholars examined the foundations of symbolic and verbal languages, Braque, Picasso, and Gris expressed the essence of pictorial language—mimesis.

14. Alfred H. Barr Jr., *Cubism and Abstract Art* (New York: Museum of Modern Art, 1936), 29–46, 77–92.

15. As has been demonstrated by Linda Dalrymple Henderson in *The Fourth Dimension and Non-Euclidean Geometry in Modern Art* (Princeton, N.J.: Princeton University Press, 1983).

16. Gris to Maurice Raynal, 3 Jan. 1922, Juan Gris, *Letters: 1913–1927*, ed. and trans. Douglas Cooper (London: privately printed, 1956), 135. Gris had just read Charles Nordmann's popularization of relativity theory, *Einstein et l'universe: Une Lueur dans le mystère des choses* (Einstein and the universe: A glimpse into the mystery of things) (Paris: Hachette, 1921). Gris expressed great admiration for Einstein and requested anything "by him or about him" to read. For arguments that Gris employed a mathematical system (the "golden section") to create his compositions, see William A. Camfield, "Juan Gris and the Golden Section," *Art Bulletin* 47, no. 1 (Mar. 1965): 128–33.

17. The term *simultaneity* was first published in reference to a Cubist work in 1912; see Lynn Gamwell, *Cubist Criticism* (Ann Arbor, Mich.: UMI Research Press, 1980), 50. On a related topic, some have argued that Henri Bergson's concepts of space and/or time, as well as those of Gustave Le Bon, have influenced Cubism; see Timothy Mitchell, "Bergson, Le Bon, and Hermetic Cubism," *Journal of Aesthetics and Art Criticism* 36, no. 2 (Winter 1977): 175–83, and Robert Mark Antliff, "Bergson and Cubism: A Reassessment," *Art Journal* 47, no. 4 (Winter 1988): 341–49.

18. Gleizes and Metzinger, *Du Cubisme*, 17; Alexandre Mercereau, "Introduction to an Exhibition in Prague" (1914), trans. Jonathan Griffin, in *Cubism*, ed. Edward F. Fry (London: Thames and Hudson, 1966), 134.

19. Poincaré, *La Science et l'hypothèse* (Science and hypothesis) (Paris, 1902), and *La Science et le methode* (Science and method) (Paris, 1908).

20. Kramár, *Kubismus* (Cubism) (Brno, Czechoslovakia: Nákladem Morav.-Slezské Revue, 1921), 31. This information was confirmed for me by Lenka Bydozovská of the Czech Academy of Sciences (e-mail of 13 Nov. 2001), who is author of "Prague," in *Central European Avant-Gardes: Exchange and Transformation, 1910–1930*, exh. cat., ed. Timothy O. Benson

(Los Angeles: Los Angeles County Museum of Art, 2002), 81–87.

21. Panofsky, *Perspective as Symbolic Form*, trans. Christopher S. Wood (New York: Zone Books, 1991), 153–54 n. 73; originally published in 1924–25 as "Die Perspektive als 'symbolische Form'" (Perspective as "symbolic form").

22. Giedion, *Space, Time, and Architecture: The Growth of a New Tradition* (1941; reprint, Cambridge, Mass.: Harvard University Press, 1967), 14.

23. Einstein to art historian Paul M. Laporte, 4 May 1946, trans. Max Gould, in Laporte's essay "Cubism and Relativity with a letter of Albert Einstein," *Art Journal* 25, no. 3 (Spring 1966): 246. Einstein also didn't appreciate Giedion's efforts; the German architect Erich Mendelsohn sent him a passage from *Space, Time, and Architecture*, which inspired Einstein to write a few lines of his renowned doggerel: "Some new thought isn't hard to declare / If any nonsense one will dare. / But rarely do you find that novel babble / Is at the same time reason-able"; Einstein letter to Mendelsohn, quoted and translated in Wolf von Eckhardt, *Eric Mendelsohn* (New York: George Braziller, 1960), 14.

24. Paul M. Laporte, "The Space-Time Concept in the Work of Picasso," *Magazine of Art* 41, no. 1 (Jan. 1948): 26–32; Panofsky, *Early Netherlandish Painting* (Cambridge, Mass.: Harvard University Press, 1953), 1:5, 362. Panofsky may have been especially interested in Einstein's cultural impact because by 1953 the two men were friendly colleagues at the American haven for refugee intellectuals, the Institute for Advanced Study in Princeton, New Jersey. Panofsky, for example, organized Einstein's seventieth-birthday celebration in 1949; see Jamie Sayen, *Einstein in America* (New York: Crown Books, 1985), 226.

25. Edgerton, *The Renaissance Rediscovery of Linear Perspective* (New York: Basic Books, 1975), 162.

26. Schapiro's many notes and essay drafts on the topic were compiled by Joseph Masheck into the essay "Einstein and Cubism: Science and Art," in *The Unity of Picasso's Art*, ed. Lillian Milgram Schapiro (New York: George Braziller, 2000), 49–149. I am grateful to George Braziller for bringing this material to my attention before it was published, so rich in insight and historical detail, when I was writing the first draft of this book.

27. Everdell, *The First Moderns: Profiles in the Origins of Twentieth-Century Thought* (Chicago: University of Chicago Press, 1997), 249; Miller, *Einstein, Picasso: Space, Time, and the Beauty That Causes Havoc* (New York: Basic Books, 2001), 239. For other recent examples, see Philip Courtenay, "Einstein and Art," in *Einstein: The First Hundred Years*, ed. Maurice Goldsmith, Alan Mackay, and James Woudhuysen

(Oxford, England: Pergamon Press, 1980), 145–57; Leonard Shlain, *Art and Physics: Parallel Visions in Space, Time, and Light* (New York: William Morrow, 1991); and Thomas Vargish and Delo E. Mook, *Inside Modernism: Relativity Theory, Cubism, Narrative* (New Haven, Conn., and London: Yale University Press, 1999).

28. Breuer and Freud, "Studies on Hysteria" (1893–95), in *The Standard Edition of the Complete Psychological Works of Sigmund Freud*, trans. James Strachey (London: Hogarth Press, 1962), 2:1–305.

29. See Jacqueline Carroy, "L'Hystértique, l'artiste et le savant," (The hysteric, the artist, and the scholar) in *L'Âme au corps: Arts et sciences, 1793–1993* (The soul of the body: Arts and sciences, 1793–1993), exh. cat., ed. Jean Clair (Paris: Réunion des Musées Nationaux; Gallimard, 1993), 446–57; Rodolphe Rapetti, "From Anguish to Ecstasy: Symbolism and the Study of Hysteria," in *Lost Paradise: Symbolist Europe*, exh. cat., ed. Jean Clair (Montreal: Montreal Museum of Fine Arts, 1995), 224–34; in the same volume, see also Jean Clair, "The Self Beyond Recovery," 125–36.

30. For an overview of images and ideas associated with modern notions of the mind, see *Wunderblock: Eine Geschichte der modernen Seele* (Wonderblock: A history of the modern soul), exh. cat., ed. Jean Clair (Vienna: Historisches Museum der Stadt Wien, 1989).

31. See Norma Lifton, "Thomas Eakins and S. Weir Mitchell: Images and Cures in the Late Nineteenth Century," in *Psychoanalytic Perspectives on Art*, ed. Mary Mathews Gedo (Hillsdale, N.Y.: Analytic Press, 1987), 247–74.

32. Albert Londe, "La Photographie en médicine," *La Nature* 2, pt. 2 (June–Nov. 1883): 215–18.

33. Joris-Karl Huysmans, *À rebours* (1884; reprint, Paris: Fasquelle, 1955), 86.

34. See Elaine Showalter, "Hysteria, Feminism, and Gender," in *Hysteria beyond Freud*, ed. Sander L. Gilman et al. (Berkeley and Los Angeles: University of California Press, 1993), 286–344.

35. S. Weir Mitchell, *Lectures on Diseases of the Nervous System, Especially Women* (Philadelphia: H. Lea's Son and Co., 1881), 218. This attitude was scorned in an account of a treatment for hysteria by one of Mitchell's patients, Charlotte Perkins Gilman, in *The Yellow Wallpaper* (Boston, 1899).

36. Marquis d'Hervey de St. Denys, *Les Rêves et les moyens de les diriger* (Dreams, and ways to direct them) (Paris: Amyot, 1867); for Freud's comments on this study, see Freud, *The Interpretation of Dreams* (1900), in *Standard Edition*, 4:13–14, 60–61.

7. WORDLESS MUSIC AND ABSTRACT ART

1. Goethe revived this ancient view in his book *Farbenlehre* (Theory of colors) (1810).

2. Kepler published his third law of planetary motion in *Harmonices mundi* (Harmony of the world) (1618); see D. P. Walker, "Kepler's Celestial Music," *Journal of the Warburg and Courtauld Institutes* 30 (1967): 228–50.

3. J. C. Meredith, ed. and trans., *Kant's Critique of Aesthetic Judgment* (1790) (Oxford, England: Clarendon Press, 1911), 210.

4. Hegel, *Aesthetics: Lectures on Fine Art*, trans. T. M. Knox (London: Oxford University Press, 1975), 2:933.

5. Runge, *Farben-Kugel* (Color sphere) (1810); see also *Philipp Otto Runge: Briefe und Schriften* (Philipp Otto Runge: Letters and writings), ed. P. Betthausen (Munich: C. H. Beck, 1982), in which Runge described music, mathematics, and spiritual faith as each being an expression of universal color and light (letter of Apr. 1803, 142).

6. In Gauguin's letter on the topic of synesthesia to Emile Schuffenecker, 14 Jan. 1885, in *Impressionism and Post-Impressionism 1874–1904: Sources and Documents*, ed. and trans. Linda Nochlin (Englewood Cliffs, N.J.: Prentice-Hall, 1966), 158–59.

7. Helmholtz, "The Physiological Causes of Harmony in Music" (1857), trans. A. J. Ellis, in *Selected Writings of Hermann von Helmholtz*, ed. Russell Kahl (Middletown, Conn.: Wesleyan University Press, 1971), 107.

8. On the origins of the theory of art for art's sake, see Rose Frances Egan, "The Genesis of the Theory of 'Art for Art's Sake' in Germany and in England," parts 1 and 2, *Smith College Studies in Modern Languages* 2, no. 4 (1921): 5–61; 5, no. 3 (1924), 1–33.

9. For a detailed account of the role of music in modern art, see Karin von Maur, ed., *Vom Klang der Bilder: Die Musik in der Kunst des 20. Jahrhunderts* (On the sound of painting: Music in the art of the twentieth century), exh. cat. (Munich: Prestel, 1985).

10. Kandinsky's note to his 1911 translation into Russian of Schoenberg's "On Parallel Octaves and Fifths," in the exhibition catalogue *Salon 2* (Odessa, Russia, 1911); reprinted in *Kandinsky: Complete Writings on Art*, ed. Kenneth C. Lindsay and Peter Vergo (Boston: G. K. Hall and Co., 1982), 1:93. On music in Kandinsky's art, see Peter Vergo, "Music and Abstract Painting: Kandinsky, Goethe, and Schoenberg," in *Towards a New Art: Essays on the Background to Abstract Art, 1910–1920* (London: Tate Gallery, 1980), 41–63.

11. According to Aleksis Rannit, *Mikalojus Konstantinas Čiurlionis: Lithuanian Visionary*

Painter (Chicago: Lithuanian Library Press, 1984), 52–54. On Čiurlionis's interest in combining astronomy, music, and art, see also Alfred Erich Senn, John E. Bowlt, and Danute Staskevicius, *Mikalojus Konstantinas Čiurlionis: Music of the Spheres* (Newtonville, Mass.: Oriental Research Partners, 1986).

12. See Dorothee Eberlein, "Čiurlionis, Skryabin, und der osteuropäische Symbolismus," in Maur, ed., *Vom Klang der Bilder*, 340–45.

13. On the music/color analogy in abstract film see Malcolm Le Grice, *Abstract Film and Beyond* (Cambridge, Mass.: MIT Press, 1977), and William Moritz, "Abstract Film and Color Music," in *The Spiritual in Art: Abstract Painting, 1890–1985*, exh. cat., ed. Maurice Tuchman (Los Angeles: Los Angeles County Museum of Art; New York: Abbeville Press, 1987), 296–311.

14. Quoted in Le Grice, *Abstract Film*, 18–19.

15. Ibid., 22.

16. Richter, "Principles of the Art of Motion" (1921), in *De Stijl*, ed. Hans Jaffé, trans. Mary Whitall (London: Thames and Hudson, 1967), 144–46.

17. Quoted in Magdalene Droste, *Bauhaus: 1919–1933* (Cologne, Germany: Taschen, 1993), 33.

18. Crumb, liner notes for *"Ancient Voices of Children" and "Music for a Summer Evening (Makrokosmos III),"* (New York: Elektra/Asylum/Nonesuch Records, 1987), compact disk.

19. Ibid.

20. Marcia Bartusiak summarizes the arguments for this view, and gives an overview of the current project to record and measure gravitational waves, in *Einstein's Unfinished Symphony: Listening to the Sounds of Space-Time* (Washington, D.C.: Joseph Henry Press, 2000).

8. The Culmination of Newton's Clockwork Universe

1. On the cultural impact of the discovery of X rays, see Bettyann Kevles, *Naked to the Bone: Medical Imaging in the Twentieth Century* (New Brunswick, N.J.: Rutgers University Press, 1997), especially the chapter entitled "X Rays in the Imagination: The Avant-Garde through Surrealism," 116–41.

2. *Motion Picture Herald* 2 (1908): 103, and 5 (1909): 23.

3. The art historian Albert Boime has identified the following objects: the moon, Venus, the constellation Aries, and a spiral nebula in *The Starry Night*, the constellation Aquarius in *Cafe Terrace at Night*, (1888; Kröller-Müller Museum, Otterlo, The Netherlands), and the Big Dipper in *Starry Night over the Rhône* (plate 169); Boime, "Van Gogh's *Starry Night*: A History of Matter and

a Matter of History," *Arts Magazine* 59, no. 4 (Dec. 1984): 87–103. Astronomers Donald W. Olsen and Russell L. Doescher have identified the moon, Venus, and Mercury in *Road with Cypress and Star* (1890; Kröller-Müller Museum, Otterlo, The Netherlands); Doescher, "Van Gogh, Two Planets, and the Moon," *Sky and Telescope* 76, no. 4 (Oct. 1988): 406–88. See also Charles A. Whitney, "The Skies of Van Gogh," *Art History* 9, no. 3 (Sept. 1986): 352.

4. Van Gogh to Bernard, June 1888, in *Vincent van Gogh: Letters to Emile Bernard*, trans. and ed. Douglas Lord (New York: Museum of Modern Art, 1938), 46.

5. Comte, "Cours de philosophie positive" (Course in positive philosophy) (1835), trans. Harriet Martineau, in *Auguste Comte and Positivism: The Essential Writings*, ed. Gertrud Lenzer (Chicago: University of Chicago Press, 1975), 130.

6. Van Gogh to Theo van Gogh, Sept. 1888, *The Complete Letters of Vincent van Gogh* (Greenwich, Conn.: New York Graphic Society, 1959), 3:56.

7. Ibid.

8. For a description of the painting in terms of physics, see A. D. Moore, "Henry A. Rowland," *Scientific American* 246, no. 2 (Feb. 1982): 149–61.

9. On the impact of time-lapse photography on Kupka and Duchamp, see Margit Rowell, "Kupka, Duchamp and Marey," *Studio International* 189, nos. 973–75 (Jan.–Feb. 1975): 48–51. On the impact of X-ray imagery on the artists, see Linda Dalrymple Henderson, "X-Rays and the Quest for Invisible Reality in the Art of Kupka, Duchamp, and the Cubists," *Art Journal* 47 (Winter 1988): 323–40. On a related topic, see also Linda Dalrymple Henderson, "Francis Picabia, Radiometers, and X-rays in 1913," *Art Bulletin* 71, no. 1 (March 1989), 114–23. On the general impact of science on Duchamp, see Linda Dalrymple Henderson, *Duchamp in Context: Science and Technology in "The Large Glass" and Related Works* (Princeton, N.J.: Princeton University Press, 1998).

10. Robert Delaunay, "Light" (1912), in *The New Art of Color: The Writings of Robert and Sonia Delaunay*, trans. David Shapiro and Arthur A. Cohen (New York: Viking Press, 1978), 81–82; first published in *Der Sturm*, no. 144–45 (Feb. 1913), trans. Paul Klee.

11. Boccioni et al., "Futurist Painting: Technical Manifesto" (1910), in *Theories of Modern Art*, ed. Herschel B. Chipp (Berkeley and Los Angeles: University of California Press, 1968), 290.

12. Balla to Alfred H. Barr Jr., 24 Apr. 1954, on the occasion of the purchase of the painting by the Museum of Modern Art in New York. The entire letter in Italian, with translation, is given in Susan Barnes Robinson, *Giacomo*

Balla: Divisionism and Futurism, 1871–1912 (Ann Arbor, Mich.: UMI Research Press, 1981), 83–84, 153.

13. Boccioni et al., "Futurist Painting," 289.

14. Ibid., 290.

15. Ibid., 296.

16. Umberto Boccioni, "Technical Manifesto of Futurist Sculpture" (1912), in Chipp, *Theories*, 300.

17. Ibid. Futurist thought was also informed by the French philosopher of evolution and science popularizer Henri Bergson, who is referred to in their manifestos; an Italian translation of a selection of Bergson's writing was published in 1909. For arguments that Bergson's view of time underlies Futurism, see Ivor Davies, "Western European Art Forms Influenced by Nietzsche and Bergson before 1914, Particularly Italian Futurism and French Orphism," *Art International* 19 (20 Mar. 1975): 49–55, and Brian Petrie, "Boccioni and Bergson," *Burlington Magazine* 66 (Mar. 1974): 140–47. In my opinion Futurist art was a straightforward attempt to visualize a three-dimensional object moving through real time; it is not necessary to bring in Bergson's philosophical views of internal and external time to account for work such as *Unique Forms of Continuity in Space* (plate 180).

18. Boccioni, "Peinture et sculpture futuristes" (Futurist painting and sculpture) (1914), in *Futurisme: Manifestes, Proclamations, Documents* (Futurism: Manifestos, proclamations, documents), ed. Giovanni Lista (Lausanne, Switzerland: L'Age d'Homme, 1973), 193–94.

19. Pound, *Blast* 1 (29 June 1914): 153.

20. Pound, "The Serious Artist" (1913), in *Literary Essays of Ezra Pound*, ed. T. S. Eliot (Westport, Conn.: Greenwood Press, 1979), 49.

21. Kandinsky, "Whither the New Art" (1911), in *Kandinsky: Complete Writings on Art*, ed. Kenneth C. Lindsay and Peter Vergo (Boston: G. K. Hall and Co., 1982), 1:98.

22. Ibid., 1:143.

23. Crookes, lecture to the British Association for the Advancement of Science, Sheffield, England, 1879, excerpted in E. E. Fournier d'Albe, *The Life of William Crookes* (London: T. Fisher Unwin, 1923), 284–90; see P. Zeeman, "Sir William Crookes, F.R.S.: The Apostle of Radiant Matter," *Scientific American*, suppl. to no. 1672 (18 Jan. 1908): 44–45.

24. Crookes, "Radiant Matter" lecture, 1879, quoted in Fournier d'Albe, *Life of William Crookes*, 290.

25. Kandinsky, "Reminiscences" (1913), in *Kandinsky: Complete Writings on Art*, 364, and Kandinsky, "On the Spiritual in Art" (1912), in ibid., 142.

26. Ibid. In 1956 the Kandinsky scholar Kenneth C. Lindsay first identified Kandinsky's

paintings of the four seasons (*Painting #198 [Summer]*, *Painting #199 [Autumn]*, *Painting #200 [Spring]*, and *Painting #201 [Winter]*) as having been commissioned by Edwin R. Campbell, whom the artist did not know ("Kandinsky in 1914 New York," *ArtNews* 55 [May 1956]: 32–33, 58). Due to a proofreading error in this publication, the titles of the four works became interchanged in the literature. The current owner of the four paintings, the Museum of Modern Art in New York, has recently renamed them *Panels for Edwin R. Campbell*. For the work reproduced here, I use Lindsay's title.

27. The drawing was published posthumously (as an illustration to a poem by Gustav Renner in a collection of his verse *Stella Peregrina* (Latin for "moving star") (Munich, 1917). The title *Dort fiel ein Stern* (There fell a star) is from a poem by Renner. I'm following Roberta J. M. Olson's suggestion that the artist may have intended the wandering star in the sky to be a comet; Olson, *Fire and Ice: A History of Comets in Art* (New York: Walker and Co., 1985), 113. In 1900 Kandinsky also painted a comet passing over a landscape (*Comet [Night Rider]*), 1900; Städtische Galerie im Lenbachhaus, Munich).

28. Paul Klee, *Tagebücher, 1898–1918* (Diary, 1898–1918), ed. F. Klee (Cologne, Germany: M. Du Mont Schauberg, 1957), entries 885, 253. On Klee and physics, see Sara Lynn Henry, "Form-Creating Energies: Paul Klee and Physics," *Arts Magazine* 52, no. 1 (Sept. 1977): 118–21.

29. Delaunay, "Light."

30. Marc, *Aphorisms* (1914–15), no. 35, quoted in Chipp, *Theories*, 180.

31. Translated by Norbert Guterman and quoted in *Franz Marc: Watercolors, Drawings, Writings*, ed. Klaus Lankheit (New York: Harry N. Abrams, 1960), 51.

9. EINSTEIN'S SPACE-TIME UNIVERSE

1. "One geometry cannot be more true than another; it can only be more convenient"; Poincaré, *Science and Hypothesis*, trans. W. J. G. (New York: Dover, 1952), 50. Craig Adcock has argued for the influence of this idea on Marcel Duchamp in "Conventionalism in Henri Poincaré and Marcel Duchamp," *Art Journal* 44, no. 3 (Summer 1984): 249–58.

2. Whitehead, "The Origins of Modern Science" (1925), in *Science and the Modern World* (New York: Free Press, 1967), 10.

3. On the popularization of relativity in Germany, see Lewis Elton, "Einstein, General Relativity, and the German Press, 1919–1920," *Isis* 77 (Mar. 1986), 95–103. For the reception of relativity within the German scientific community, see Lewis Pyenson, "The Relativity Revolution in

Germany," in *The Comparative Reception of Relativity*, ed. Thomas F. Glick (Dordrecht, The Netherlands, and Boston: D. Reidel, 1987), 59–111. This collection of essays also includes detailed coverage of the scientific reception of relativity throughout the West, including José M. Sanchez-Ron, "The Reception of Special Relativity in Great Britain," 27–58; Stanley Goldberg, "Putting New Wine in Old Bottles: The Assimilation of Relativity in America," 1–26; and Michel Paty, "The Scientific Reception of Relativity in France," 113–67.

4. *Vossische Zeitung* (Berlin), 15 Apr. 1919; this article is described, along with a picture of the illustration in the article, in Elton, "Einstein."

5. According to Gerald Holton, in "Einstein's Influence on Our Culture," in *Einstein, History, and Other Passions* (Woodbury, N.Y.: American Institute of Physics, 1995), 21 n. 29.

6. See Jeffrey Crelinsten, "Einstein, Relativity, and the Press: The Myth of Incomprehensibility," *Physics Teacher* 18 (Feb. 1980): 115–22.

7. "Dr. Albert Einstein," *Times* (London), 8 Nov. 1919.

8. Einstein's statement in the *Times* (London), 28 Nov. 1919.

9. Letter to the editor, *Times* (London), 15 Nov. 1919.

10. Eddington, *Space, Time and Gravitation: An Outline of the General Theory of Relativity* (1920; reprint, Cambridge, England: Cambridge University Press, 1968), 200–201.

11. Lockyer, quoted in "Lights All Askew in the Heavens," *New York Times*, 8 Nov. 1919.

12. Editorial, *New York Times*, 11 Nov. 1919.

13. Floyd Parsons, "Science and Everyday Life," *Saturday Evening Post*, 10 Mar. 1923, 157; Parsons also ominously noted that "if some German should happen to discover a way to artificially break up an atom" the energy unleashed could be "used by the Teuton to destroy their conquerors." "The Stupendous Possibilities of the Atom," *World's Work* 42 (May–Oct. 1921): 21. An example of the legacy of the American public's view of physics as incomprehensible is the Whitney Museum of American Art's 1958 catalogue of the exhibition *Nature in Abstraction: The Relation of Abstract Painting and Sculpture to Nature in Twentieth-Century American Art*, in which the curator, John I. H. Baur declared: "Only a very few of our artists . . . have been demonstrably stirred by the revolutionary concepts of science and have consciously interpreted them with intuitive pictorial equivalents. The difficulty is that most of these concepts are mathematical or intellectual or microscopic; they are beyond the reach of our sensory perceptions and daily experience; even to understand them becomes increasingly hard because of their complexity"

(New York: Whitney Museum of American Art, 1958), 7.

14. See, for example, the interview with the French astronomer Charles Nordmann, "Einstein expose et discute sa thèorie" (Einstein explains and discusses his theory), in the popular *Revue des deux mondes* 9 (1922): 129–66. On the French public's reaction to Einstein's 1922 visit, see Michel Biezunski's *Einstein à Paris: Le temps n'est plus...* (Einstein in Paris: Time is no longer...) (Saint Denis, France: Presses Universitaires de Vincennes, 1991); the author's thesis is that any difficulty that the French had in understanding relativity was inextricably linked to Einstein's persona, which was incomprehensible to the French because his wit and accessibility did not fulfill their expectations of a serious savant.

15. Einstein to Max Born, 4 Dec. 1926, in *Albert Einstein, Hedwig und Max Born, Briefwechsel, 1916–1935* (Munich: Nymphenburger Verlagshandlung, 1969), 129.

16. Einstein, "Religion and Science," *New York Times Magazine*, 9 Nov. 1930.

17. Freud, "The Future of an Illusion" (1927), in *The Standard Edition of the Complete Psychological Works of Sigmund Freud*, trans. James Strachey (London: Hogarth Press, 1962), 21:3–58.

18. Einstein to Eduard Büsching, 25 Oct. 1929, quoted in Max Jammer, *Einstein and Religion: Physics and Theology* (Princeton, N.J.: Princeton University Press, 1999), 51.

19. Einstein, "Religion and Science."

20. On the visual nature of Einstein's thought, see Gerald Holton, "On Trying to Understand Scientific Genius," in *Thematic Origins of Scientific Thought* (Cambridge, Mass.: Harvard University Press, 1973), 353–80; on Minkowski's geometric approach, see Peter Galison, "Minkowski's Space-Time: From Visual Thinking to the Absolute World," in *Historical Studies in the Physical Sciences*, ed. R. McCormmach, L. Pyenson, and R. S. Turner, no. 10 (Berkeley and Los Angeles: University of California Press, 1979): 85–121. On a related topic, many physicists have claimed that aesthetic considerations are central to their visualization of nature; for recent examples see the Chinese physicist Chen Ning Yang, "Beauty and Theoretical Physics," in *The Aesthetic Dimension of Science*, ed. Deane Curtin (New York: Philosophical Library, 1982), 25–40; the American physicist Anthony Lee, *Fearful Symmetry: The Search for Beauty in Modern Physics* (New York: Macmillan, 1986); the Indian physicist S. Chandrasekhar, *Truth and Beauty: Aesthetics and Motivations in Science* (Chicago: University of Chicago Press, 1987); the Chinese astrophysicist Fang Lizhi, "Form and Physics," *Partisan Review* 58, no. 4 (1991): 656–64. Informative overviews of the topic from a philosophical perspective are provided by editor

Judith Wechsler in her introduction to the collection of essays *On Aesthetics in Science* (Cambridge, Mass.: MIT Press, 1978), Gideon Engler, "Aesthetics in Science and in Art," *British Journal of Aesthetics* 30, no. 1 (Jan. 1990): 24–33, and James W. McAllister, "Scientists' Aesthetic Judgments," *British Journal of Aesthetics* 31, no. 4 (Oct. 1991): 334–41.

21. In a draft of his manuscript for "Space and Time" (1907), Minkowski wrote: "In truth, we are dealing with more than merely a new conception of space and time. The claim is that it is rather a quite specific natural law, which, because of its importance—since it alone deals with the primitive concepts of all Natural Knowledge, namely space and time—can claim to be called the first law of nature. This is a law for which . . . I will coin the expression the 'Principle of the Absolute World'"; trans. by Galison in his "Minkowski's Space-Time," 115–17.

22. On the role of pictures in the theory of relativity and quantum physics, see Arthur I. Miller, *Imagery in Scientific Thought: Creating Twentieth-Century Physics* (Boston: Birkhäuser, 1984).

10. Abstract Art with a Cosmic Perspective

1. Kupka, *La Création dans les arts plastiques* (Creation in the plastic arts) (1912–13; reprint, Paris: Diagonales, 1989), 207.

2. Ibid., 115.

3. Arp, catalogue essay for an exhibition at Galerie Tanner, Zurich (1915); the German text, translated here by Silvia Vassileva-Ivanova, was first published in Hans Arp, *On My Way: Poetry and Essays 1912–1947*, ed. Robert Motherwell (New York: Wittenborn, Schultz, 1946), 82, where the source of the text is not given; the text is identified as Arp's 1915 catalogue essay in *Das literarische Werk Hans Arps, 1903–1930* (The literary work of Hans Arp, 1903–1930), ed. Reinhard Döhl (Stuttgart, Germany: J. B. Metzlersche, 1967), 35.

4. Huelsenbeck [Charles R. Hulbeck], "Psychoanalytic Notes on Modern Art," *American Journal of Psychoanalysis* 20, no. 2 (1960): 60. Huelsenbeck completed a medical degree in neuropsychiatry at the University of Berlin in 1922.

5. Arp, "Jalons" (Highlights) (1950), in *Jours effeuillés: Poèmes, essais, souvenirs, 1920–1956* (Pruned days: Poems, essays, memories, 1920–1956) (Paris: Gallimard, 1966), 357.

6. Arp, *On My Way*, 82; Jakob Böhme, *Aurora, oder Morgenröte im Aufgang* (Dawn, or the rosy daybreak on the ascending path) (1634; reprint, Frankfurt am Main, Germany: Insel, 1992), chap. 22, no. 47. Arp's interest in Böhme has been noted by Jennifer Mundy in her essay

"Form and Creation: The Impact of the Biological Sciences on Modern Art," in *Creation: Modern Art and Nature*, exh. cat. (Edinburgh: Scottish National Gallery of Modern Art, 1984), 21.

7. Arp, "Forms" (1950), in *Jours effeuillés*, 360.

8. Kandinsky's biological sources have been catalogued by Vivian Endicott Barnett, "Kandinsky and Science: The Introduction of Biological Images in the Paris Period," in *Kandinsky in Paris: 1934–44*, exh. cat. (New York: Solomon R. Guggenheim Museum, 1985), 61–87.

9. Kandinsky, "Two Directions" (1935), in *Kandinsky: Complete Writings on Art*, ed. Kenneth C. Lindsay and Peter Vergo (Boston: G. K. Hall and Co., 1982), 2:779.

10. Calder, "Statement" (dated to the early 1930s), in *Museum of Modern Art Bulletin* 18, no. 3 (Spring 1951): 8. The artist has also acknowledged his adult visits to the planetarium (in ibid.), as well as his childhood delight in eighteenth-century armillaries; see the interview in Selden Rodman, *Conversations with Artists* (New York: Devin-Adair, 1957), 139.

11. Bayer, statement in *Herbert Bayer: A Total Concept*, exh. cat. (Denver: Denver Art Museum, 1973), 22.

12. Another example is Bayer's *Messages through the Atmosphere* (1942; private collection).

13. On mathematics and early abstract art, see Lucy Adelman and Michael Compton, "Mathematics and Early Abstract Art," in *Towards a New Art: Essays on the Background to Abstract Art 1910–20* (London: Tate Gallery, 1980), 64–89.

14. Discussions of the impact of Einstein's theory of relativity on the visual arts include Thomas Jewell Craven, "Art and Relativity," *Dial* 70 (May 1921): 535–39, and Betty Jean Craig, ed., *Relativism in the Arts* (Athens: University of Georgia Press, 1983), along with the examples cited in chap. 6 n. 27.

15. Ozenfant and Jeanneret, "Le Purisme," *L'Esprit nouveau* 4 (1921): 369–86; the quote is from page 386. Ozenfant attended lectures by Henri Poincaré and Henri Bergson while an art student in 1906, and he maintained a deep interest in science and mathematics throughout his career.

16. Paul Le Beq, "À propos des théories d'Einstein" (About the theories of Einstein), *L'Esprit nouveau* 7 (1921): 720.

17. Ozenfant, *Foundations of Modern Art*, trans. John Bodker (1928; reprint, New York: Dover Publications, 1952), 9–10.

18. Van Doesburg et al., "Manifesto I of De Stijl, 1918," trans. R. R. Symonds, in *De Stijl*, ed. Hans L. C. Jaffé (London: Thames and Hudson, 1970), 172–73.

19. Mondrian, "Neoplasticism in Painting" (1917), in Jaffé, *De Stijl*, 36.

20. See epigraph to this chapter. Van Doesburg, "Elementarism" (1926–27), in Jaffé, *De Stijl*, 213–14.

21. Van Doesburg, "Towards a Plastic Architecture" (1924), in Jaffé, *De Stijl*, 186–87.

22. Moholy-Nagy, *Vision in Motion* (Chicago: Paul Theobald, 1947), 279.

23. Escher letter to Dr. Wagenaar about Gestalt psychology, 16 Jan. 1953, quoted in *M. C. Escher: His Life and Complete Graphic Work* (New York: Harry N. Abrams, 1981), 68. Gombrich's article appeared in the *Saturday Evening Post*, 29 July 1961.

24. Malevich, "Suprematism, 34 Drawings: Vitebsk, 1920," quoted in Larissa A. Zhadova, *Malevich: Suprematism and Revolution in Russian Art, 1910–1930*, trans. Alexander Lieven (London: Thames and Hudson, 1982), 284.

25. Lissitzky, "Proun" (1920–21), in *El Lissitzky: Ausstellung* (El Lissitzky: Exhibition) (Cologne, Germany: Galerie Gmurzynska, 1976), 63. On mathematics in Lissitzky's work, see Y. A. Bois, "Lissitzky, Malevich, et la question de l'éspace," in *Suprematisme* (Paris: Galerie Jean Chauvelin, 1977), 29–46, Esther Levinger, "Art and Mathematics in the Thought of El Lissitzky: His Relationship to Suprematism and Constructivism," *Leonardo* 22, no. 2 (1989): 227–36, and Esther Levinger, "El Lissitzky's Art Games," *Neohelicon* 14, no. 1 (Dec. 1987): 177–91.

26. Lissitzky, "A. and *Pangeometry*" (1925), in *El Lissitzky: Life, Letters, Texts*, ed. Sophie Lissitzky-Küppers, trans. Helene Aldwinckle and Mary Whittall (Greenwich, Conn.: New York Graphic Society, 1968), 351.

27. Van Doesburg summarized his views in "Licht-en Tijdbeelding" (Light in film), *De Stijl* 5, no. 5 (1924): 59.

28. Richter, "Principles of the Art of Motion" (1921), trans. Mary Whitall, in Jaffé, *De Stijl*, 144–46.

29. The significance of collage in this regard is considered by Donald Kuspit in his essay "Collage: The Organizing Principle of Art in the Age of Relativity of Art," in Craig, ed., *Relativism in the Arts*, 123–47

30. Moholy-Nagy, *Vision in Motion*, 279.

31. Eisenstein, "The Filmic Fourth Dimension" (1929), in *Film Form: Essays on Film Theory*, ed. and trans. Jay Leyda (New York: Harcourt, Brace, 1949), 69–70.

32. On the influence of X-ray technology on Gabo, see John E. Bowlt, "The Presence of Absence: The Aesthetic of Transparency in Russian Modernism," *Structurist* 27–28 (1987–88): 15–22.

33. Gabo and Pevsner, "Realist Manifesto" (1920), in *Russian Art of the Avant Garde: Theory and Criticism, 1902–1934*, ed. and trans. John E. Bowlt (London: Thames and Hudson, 1988), 209.

34. Ibid., 212.

35. Ibid., 211.

36. Ibid., 211–12; the dots are in the original.

37. Taut, *Die Stadtkrone* (The city crown) (Jena, Germany: E. Diedrichs, 1919). The well-known author of *Abstraction and Empathy* (1908), Wilhelm Worringer, had published a book on the eve of World War I that made architects especially aware of the symbolism of the Gothic cathedral, *Problems of Form in Gothic Art* (1912).

38. Hans Maria Wingler, *The Bauhaus: Weimar, Dessau, Berlin, Chicago* (Cambridge, Mass: MIT Press, 1969), 78. Einstein and Gropius remained in contact regarding German politics and corresponded about the needs of mutual friends when World War II broke out; see letters from Einstein to Gropius, 18 Jan. 1939 and 18 Dec. 1940, in the Bauhaus-Archiv, Berlin.

11. SURREALIST SCIENCE

1. Soupault, "Origines et début du surréalisme" (The origins and beginning of surrealism), *Europe*, nos. 475–76 (Nov.–Dec. 1968): 4.

2. For a comparison of the layout and typography of the two periodicals, along with the debate between the editors, Pierre Naville and Benjamin Péret, about whether to adopt a scientific appearance, see Dawn Ades, *Dada and Surrealism Reviewed*, exh. cat. (London: Arts Council of Great Britain, 1978), 189–90.

3. The psychologists objected at their November 1929 meeting of the Société Médico-psychologique, a report of which was carried in the Parisian press. Proud to be viewed as a serious threat, Breton reprinted the report in his *Second Surrealist Manifesto*; André Breton, *Manifestes du surréalisme* (Surrealist manifestos) (Paris: Pauvert, 1962), 308.

4. See Frank J. Sulloway, *Freud, Biologist of the Mind: Beyond the Psychoanalytic Legend* (Cambridge, Mass.: Harvard University Press, 1979).

5. For a list of early publications on Freud in French, see Appendix II of William Ray Ellenwood, "André Breton and Freud" (Ph.D. diss., Rutgers University, 1976), 246–48.

6. Jean Goudal, "Surréalisme et le cinema" (Surrealism and cinema), *La Revue hébdomadaire*, 21 Feb. 1925, 349.

7. Buñuel, quoted in Francisco Aranda, *Luis Buñuel: A Critical Biography* (London: Secher and Warburg, 1969), 56.

8. Ernst's borrowings from *La Nature* are detailed by Charlotte Stokes in her essay "The Scientific Methods of Max Ernst: His Use of Scientific Subjects from *La Nature*," *Art Bulletin* 62, no. 3 (Sept. 1980): 453–65. For a sumptuously illustrated survey of natural science images in the work of Ernst and other Surrealists, see Karin Orchard and Jörg Zimmermann, eds., *Die Erfindung der Natur: Max Ernst, Paul Klee, Wols und das surreale Universum* (The discovery of nature: Max Ernst, Paul Klee, Wols and the Surreal universe), exh. cat. (Hannover, Germany: Sprengel Museum; Freiburg im Breisgau, Germany: Rombach Verlag, 1994).

9. Freud to André Breton, 1937, in response to the poet's request to Freud to join him in the publication of dream texts; the letter is reproduced in Breton, *Trajectoire des rêves* (The path of dreams) (Paris: GLM, 1938), 127.

10. Dalí, "L'Âne pourri" (The rotten ass), *La Surréalisme au service de la révolution* (Surrealism at the service of the revolution) 1 (July 1930): 10.

11. Lacan, *De la psychose paranoïque dans ses rapports avec la personalité* (Of the paranoid psychosis and its relation to personality) (Paris: Le François, 1932). Lacan's development of structuralist psychoanalysis dates after the Surrealist era, to the 1950s; in his revision of Freud, Lacan argued that Freud was wrong in claiming that the unconscious mind is fundamentally visual. Employing French structural linguistics, Lacan countered that "the unconscious is structured like a language"; "The Insistence of the Letter in the Unconscious" (1957), trans. J. Miel, in *Structuralism*, ed. J. Ehrmann (Garden City, N.Y.: Anchor, 1970), 103. By the time Lacan's theory had widespread influence on the visual arts (especially Conceptual art, beginning in the 1960s), his work had moved out of the psychiatric clinic and into academia, where today the pendulum has swung back to arguing for the visual nature of the unconscious; see Jean-François Lyotard, "The Dreamwork Does Not Think," trans. Mary Lydon, in *The Lyotard Reader* (Oxford, England: Blackwell, 1989), 19–55. For Lacan and Conceptual art, see *Dreams 1900–2000: Science, Art, and the Unconscious Mind*, ed. Lynn Gamwell (Ithaca, N.Y.: Cornell University Press, 2000), 45–49.

12. Jung, *Modern Man in Search of a Soul*, trans. E. F. C. Hull (1933; reprint, New York: Bollingen Foundation, 1966), 82.

13. Rothko, in Gottlieb and Rothko interview, WNYC, New York, 13 Apr. 1943, in *Abstract Expressionism: Creators and Critics*, ed. Clifford Ross (New York: Harry N. Abrams, 1990), 210.

14. His analyst, Joseph L. Henderson, unleashed a firestorm of criticism among mental health professionals and legal experts on medical ethics when, for personal gain, Henderson sold a group of drawings that Pollock had made for him as part of the artist's psychotherapy. In 1977 Pollock's widow, the artist Lee Krasner, lost a lawsuit against Henderson for violation of patient confidentiality; see Claude Cernuschi, *Jackson Pollock: "Psycho-analytic" Drawings* (Durham, N.C.: Duke University Press, 1992). For their part, many art historians became furious with their colleagues who "analyzed" Pollock; see especially Donald Kuspit, "To Interpret or Not to Interpret Jackson Pollock," *Arts Magazine* 53, no. 7 (Mar. 1979): 125–27, and William Rubin, "Pollock as Jungian Illustrator: The Limits of Psychological Interpretation," parts 1 and 2, *Art in America* 67, no. 7 (Nov. 1979): 104–23; no. 8 (Dec. 1979): 72–91.

15. Paalen, quoted in Christian Kloyber, introduction to *Wolfgang Paalen's DYN: The Complete Reprint*, ed. Christian Kloyber (Vienna and New York: Springer, 2000), ii.

16. Einstein, quoted in Wolfgang Paalen, "Inquiry on Dialectical Materialism" (1942), in *Wolfgang Paalen's DYN*. Paalen was fascinated enough with Einstein to try to capture him in a likeness; *Portrait of Einstein* (1940; Collection of Charles Bolles Rogers).

17. Breton, "Des tendances les plus récent de la peinture surréaliste" (The most recent trends in Surrealist painting), in *Surréalisme et la peinture* (Surrealism and painting) (New York: Brentano's, 1945), 152; in a note Breton defines "lithochroniques": "Certain surfaces, which we call *lithochroniques*, open a window on the strange world of the fourth dimension, constituting a kind of solidification of time (Sabato and Dominguez)."

18. Dawn Ades discusses Matta's interest in cosmology in *Surrealist Art: Bergman Collection*, exh. cat. (Chicago: Art Institute of Chicago, 1997), 189; Matta, in an interview with Max Kozloff, discussed morphology; *Artforum* 4, no. 1 (Sept. 1965): 23–26.

19. Matta, "Sensible Mathematics—Architecture of Time," *Minotaure*, no. 11 (Spring 1938): 43.

20. Matta has suggested his diverse sources: "To use a symbolic morphology or symbolic logic, I picture this non-Euclidean space." Matta, interview by Max Kozloff, 26.

12. THE ATOMIC SUBLIME

1. The recent literature includes Stephen Polcari, *Abstract Expressionism and the Modern Experience* (Cambridge, England: Cambridge University Press, 1991), and Martica Sawin, *Surrealism in Exile and the Beginning of the New York School* (Cambridge, Mass.: MIT Press, 1995).

2. Following popular custom, I use "nuclear" energy and "atomic" energy, "nuclear" bomb and "atomic" bomb interchangeably, although strictly speaking "atomic" is a misnomer. Changes that leave the atoms intact involve only

electromagnetic forces, but not nuclear forces. For example, when a piece of coal is burned producing heat and carbon dioxide, the atoms are rearranged (that is, molecular bonds are broken) and radiant energy is given off in the form of visible light and infared (heat) waves, but the atomic nuclei are unchanged and no nuclear energy is released.

3. Fermi, *Introduzione alla fisica atomica* (Introduction to atomic physics) (Bologna, Italy: N. Zanichelli, 1928).

4. On cosmic themes in second-generation Futurism, see Giovanni Lista, "The Cosmos as Finitude: From Boccioni's Cosmogony to Fontana's Spatial Art," in *Cosmos: From Goya to de Chirico, from Friedrich to Kiefer, Art in Pursuit of the Infinite*, exh. cat., ed. Jean Clair (Milan: Bompiani, 2000), 93–97, and Claudia Gian Ferrari, "The Idea of the Cosmos during the Second Phase of Futurism," in ibid., 99–103.

5. Marinetti et al., "Manifesto of Aerial Painting" (1929; signed by Marinetti, Balla, Benedetta, Dottori, Fillia, Prampolini, Somenzi, and Tato), in *Futurisme: Manifestes, proclamations, documents* (Futurism: Manifestos, proclamations, documents), ed. Giovanni Lista (Lausanne, Switzerland: L'Age d'Homme, 1974), 224.

6. In the opinion of the author, who holds a Class B skydiving license from the United States Parachute Association and has done about one hundred jumps from 1920s–'30s-style propeller monoplanes and biplanes, performed aerial acrobatics (loops, dives), and shot aerial photography (video).

7. Marinetti, "Manifesto of Aerial Painting," 225.

8. Ibid.

9. Einstein was affiliated with the Institute for Advanced Study in Princeton; see Jamie Sayen, *Einstein in America* (New York: Crown Books, 1985).

10. My discussion of art for the atomic age was inspired by Barnett Newman, "The Sublime Is Now," in *Tiger's Eye* 6 (Dec. 1948): 51–53, and Robert Rosenblum, "The Abstract Sublime," *Artnews* (Feb. 1961): 38–40, 56–68. See also John Golding's study of abstract artists who have pursued a vision of the Absolute that ends with the Abstract Expressionists' "abstract sublime"; *Paths to the Absolute: Mondrian, Malevich, Kandinsky, Pollock, Newman, Rothko, and Still* (Princeton, N.J.: Princeton University Press, 2000).

11. Barbara Cavaliere has argued that Newman expressed the sublime by using a precise mathematical system to lay out some of his paintings; see "Barnett Newman's 'Vir Heroicus Sublimis': Building the 'Complex Idea,'" *Artnews* 55 (Jan. 1981): 144–52.

12. Writing the year after Newman's death, Thomas B. Hess described the artist's interest in Spinoza based on his own conversations with the artist, in Hess, *Barnett Newman* (New York: Museum of Modern Art, 1971), 13–14; on the basis of interviews with the artist's widow, Annalee Newman, and his friends Tony Smith and Lawrence Alloway, Barbara Cavaliere reported the artist's frequent references to Spinoza, whom the artist held in high regard, in "Barnett Newman's 'Vir Heroicus Sublimus,'" 152.

13. Newman, "The Plasmic Image" (1945), in *Barnett Newman: Selected Writings*, ed. John P. O'Neill (New York: Alfred A. Knopf, 1990), 140.

14. Greenberg, review of Adolph Gottlieb exhibition (1947), quoted in *Barnett Newman: Selected Writings*, 161. To this day American critics deride Newman's quest for spiritual transcendence as "his verbose insistence that the paintings be grasped as sacred, quasi-religious epiphanies"; Michael Kimmelman, "Epiphany in a Vibrant Universe Depicting Nothing but Itself," a review of the Newman retrospective exhibition at the Philadelphia Museum of Art, *New York Times*, 12 April 2002.

15. Newman, response to Greenberg (1947, in *Barnett Newman: Selected Writings*, 163); the *Nation*, which published Greenberg's review, declined to publish Newman's response because the piece was too specialized for its readers; it was first published in Hess, *Barnett Newman*, 36–38.

16. Theodore Stamos and Adolph Gottlieb shared Rothko's interest; see Stephen Polcari, "The Intellectual Roots of Abstract Expressionism," in *Abstract Expressionism*, 31–56, and Jeffrey Weiss, "Science and Primitivism: A Fearful Symmetry in the Early New York School," *Arts Magazine* 57 (Mar. 1983): 81–87.

17. Gottlieb, in Gottlieb and Rothko interview, WNYC, New York, 13 Apr. 1943, in *Abstract Expressionism: Creators and Critics*, ed. Clifford Ross (New York: Harry N. Abrams, 1990), 212.

18. Murrow, broadcast of 12 Aug. 1945, *In Search of Light: The Broadcasts of Edward R. Murrow, 1938–1961* (New York: Alfred A. Knopf, 1967), 102.

19. "The force from which the sun draws its power has been loosened against those who brought war to the Far East"; statement by Truman in a White House press release, 6 Aug. 1945, in the Harry S. Truman Library, Eben A. Ayers papers. A facsimile of the document is posted at http://www.whistlestop.org/study_collections/bomb/small/mb10.htm.

20. "The Atomic Bomb: Its First Explosion Opens a New Era," *Life*, 20 Aug. 1945, 87B.

21. "Hiroshima Before, Hiroshima After," in ibid., 30–31.

22. Ibid., 25.

23. Ibid., 18.

24. *Life*, 19 Nov. 1945, 28.

25. Ibid., 27.

26. Ibid., 29.

27. Ibid., 34.

28. "The Bomb and the Man," *Time*, 21 Dec. 1945, 15–16.

29. See epigraph to this chapter; Barnett Newman, "The New Sense of Fate" (1948), in *Barnett Newman: Selected Writings*, 100.

30. Newman, "The Sublime Is Now," 53; Newman's statement was one of six made by artists responding to the *Tiger's Eye* editor's query, "What is sublime in art?" all of which were published together as "The Ides of Art," *Tiger's Eye* 6 (Dec. 1948): 46–57.

31. Barnett Newman, interview with British art critic David Sylvester for the BBC, 1965, in *Barnett Newman: Selected Writings*, 256.

32. Rothko, interview, in Selden Rodman, *Conversations with Artists* (New York: Devin-Adair, 1957), 93.

33. Ibid.

34. Arp, "Forms" (1950), in *Jours effeuillés: Poèmes, essais, souvenirs, 1920–1956* (Pruned days: Poems, essays, memories, 1920–1956) (Paris: Gallimard, 1966), 360.

35. "The Atomic Bomb," *Life*, 20 Aug. 1945.

36. Pollock, interview with William Wright (Pollock's neighbor in East Hampton, New York), 1951, broadcast on WERI, Westerly, Rhode Island, in 1951; in *Pollock: A Catalogue Raisonné*, ed. Francis V. O'Connor and Eugene Victor Thaw (New Haven, Conn., and London: Yale University Press, 1978), 4:248–51.

37. Pollock, from the narration of the film *Jackson Pollock* (1951), in *Theories of Modern Art*, ed. Herschel B. Chipp (Berkeley and Los Angeles: University of California Press, 1968), 548.

38. Eyewitness account recorded in Committee for the Compilation of Materials on Damage Caused by the Atomic Bombs in Hiroshima and Nagasaki, *The Impact of the A-Bomb: Hiroshima and Nagasaki* (1985), quoted in Rachelle Linner, *City of Silence: Listening to Hiroshima* (Maryknoll, N.Y.: Orbis Books, 1995), 19–20.

39. Fontana, "Manifiesto blanco" (White manifesto) (1946), in Lucio Fontana, *Catalogo generale* (General catalogue), ed. Enrico Crispolti (Milan: Electa, 1986), 1:33–37.

40. Fontana, quoted in Carla Lonzi, *Autoritratto* (Self-portrait) (Bari, Italy: De Donato, 1969), 169–71.

41. Fontana, "Technical manifesto" (1951), in *Lucio Fontana*, ed. Enrico Crispolti and Rosella Siligato (Milan: Electa, 1998), 174.

42. *Mario Merz*, exh. cat., ed. Marissa Merz and Harold Szeemann (Zurich: Kunsthaus, 1985), 202–3.

43. If a radioactive element has a half-life of 28 years, then after it decays for 28 years about 50 percent of the atoms will remain radioactive, after 112 years 6.25 percent will still be radioactive, and after 196 years its radioactivity will be negligible (.78 percent).

44. Newman, "Fourteen Stations of the Cross," in *Barnett Newman: Selected Writings*, 190.

13. The Disunity of Nature: Postmodern Art, Science, and the Spiritual

1. See John Dupré's classic study *The Disorder of Things: Metaphysical Foundations of the Disunity of Science* (Cambridge, Mass.: Harvard University Press, 1993). For leading voices that still proclaim unity, see Edward O. Wilson, *Consilience: The Unity of Knowledge* (New York: Alfred A. Knopf, 1998), and Brian Greene, *The Elegant Universe: Superstrings, Hidden Dimensions, and the Quest for the Ultimate Theory* (New York: W. W. Norton, 1999). In his 2002 book *A New Kind of Science* (Champaign, Ill.: Wolfram Media), Stephen Wolfram has argued that researchers seeking to discover the underlying unity of nature should not look for mathematical formulas but for simple rules—algorithms—which, like a computer, generate the complexity of the universe.

2. The epigraph is from their influential essay, "The Theory of Everything," *Proceedings of the National Academy of Sciences* 97, no. 1 (Jan. 2000): 28–31.

3. James Clerk Maxwell, "Science and Free Will" (1873), reprinted in L. Campbell and W. Garnett, *The Life of James Clerk Maxwell* (London: Macmillan, 1882), 434–44.

4. Ibid., 438.

5. Poincaré, in *La Valeur de la science* (The value of science) (1904; reprint, Paris: Ernest Flammarion, 1923), 200–211.

6. Jarry, "Exploits and Opinions of Doctor Faustroll, Pataphysician: A Neo-Scientific Novel," in *Selected Works of Alfred Jarry*, ed. and trans. Roger Shattuck and Simon Watson Taylor (London: Eyre Methuen, 1965), 173–256.

7. Jarry, "Concerning the Measuring Rod, the Watch, and the Tuning Fork: Telepathic Letter from Doctor Faustroll to Lord Kelvin," in ibid., 246–49.

8. Apollinaire, quoted in ibid., 14.

9. Duchamp, quoted in Pierre Cabanne, *Dialogues with Marcel Duchamp* (New York: Da Capo Press, 1971), 46.

10. Anne D'Harnoncourt and Kynaston McShine, *Marcel Duchamp*, exh. cat. (Philadelphia: Philadelphia Museum of Art, 1973), 264.

11. For an exhaustive account of the references, see Linda Dalrymple Henderson, *Duchamp in Context: Science and Technology in "The Large Glass" and Related Works* (Princeton, N.J.: Princeton University Press, 1998).

12. His notes were published as *The Green Box* (Paris, 1934).

13. Duchamp, "The Green Box" (1934), in *The Writings of Marcel Duchamp*, ed. M. Duchamp, M. Sanouillet, and E. Peterson (New York: Da Capo Press, 1989), 71.

14. Schrödinger, *Science and Humanism: Physics in Our Time* (Cambridge, England: Cambridge University Press, 1951), 7–8.

15. Quoted in Niels Bohr, *Atomic Physics and Human Knowledge* (Bungay, England: Richard Clay, 1963), v–vi. On parallels between modern art and physics, see Erwin Schrödinger's essay "Science, Art, and Play," *Philosopher* 13 (1935): 11–18.

16. C. P. Snow worked as a molecular physicist at Cambridge University for twenty years, and he was also author of an eleven-volume novel series, *Strangers and Brothers* (1940–70). Thus he was well acquainted with the practices of mid-twentieth-century science and literature that he described in *The Two Cultures and the Scientific Revolution* (Cambridge, England: Cambridge University Press, 1959), a book that touched off a heated debate about the alleged cultural breach he described. Snow was an enthusiastic supporter of Gamow's efforts to bridge the gap by explaining physics to the educated public through his short fiction.

17. The impact on literature has been especially well documented; see the books of N. Katherine Hayles, *The Cosmic Web: Scientific Field Models and Literary Strategies in the Twentieth Century* (Ithaca, N.Y.: Cornell University Press, 1984), *Chaos Bound: Orderly Disorder in Contemporary Literature and Science* (Ithaca, N.Y.: Cornell University Press, 1990), and Susan Strehle, *Fiction in the Quantum Universe* (Chapel Hill: University of North Carolina Press, 1993).

18. On Heisenberg's attitudes immediately after the German defeat, see the annotated transcript of his conversations, secretly recorded during the months that he was detained, along with other physicists from Nazi Germany, at "Farm Hall" in England. Jeremy Bernstein, ed., *Hitler's Uranium Club: The Secret Recordings at Farm Hall* (Woodbury, N.Y.: American Institute of Physics, 1996).

19. See John Powers, *Heisenberg's War: The Secret History of the German Bomb* (New York: Alfred A. Knopf, 1993). Our culture's continued fascination with Heisenberg is exemplified by Michael Frayn's *Copenhagen: A Play in Two Acts* (New York: Samuel French, 1998). An excerpt:

> HEISENBERG: Suddenly we were out of all the politics of Berlin. Out of the bombing. The war was coming to an end. There was nothing to think about but the reactor. And we didn't go mad, in fact. We didn't work all the time. There was a monastery on top of the rock above our cave. I used to retire to the organ-loft in the church, and play Bach fugues.
>
> MARGRETHE [Mrs. Niels Bohr]: Look at him. He's lost. He's like a lost child. [43–44]

On 6 Feb. 2002 the Niels Bohr Archive released an unsent letter from Bohr to Heisenberg, undated but probably written in 1957, that sheds new light on Heisenberg's post-1945 portrayal of himself as a pacifist who succeeded in sabotaging Hitler's efforts to build an atomic bomb. In reference to a wartime meeting between Bohr and Heisenberg in Copenhagen, which forms the dramatic centerpiece of Frayn's play, Bohr wrote that Heisenberg told him on that occasion that "everything was being done in Germany to develop atomic weapons." The letter is available at www.nba.nbi.dk.

20. Dalí, "Anti-Matter Manifesto," in *Salvador Dalí*, exh. cat. (New York: Carstairs Gallery, 1958), n.p.

21. Ibid. On 20 April 2002, a team of Canadian, American, and British scientists announced experimental results confirming beyond a doubt what had long been suspected: the neutrino has mass. The amount of mass is minute—for neutrinos it is still true that "the earth is just a silly ball" through which they pass undeterred—but neutrinos are so plentiful that their having even a speck of mass is very significant in explaining the structure of the universe. Details are available from the Canadian Sudbury Neutrino Observatory at www.sno.phy.queensu.ca.

22. Another artist who was influenced by Duchamp, Robert Rauschenberg, was not interested in science per se, but in technology (applied science). In 1966 he joined with the American engineer Johan Wilhelm (Billy) Klüver to form an organization to promote the collaboration of artists and engineers, Experiments in Art and Technology (E.A.T.). Klüver, who had a background in laboratory administration at Bell Telephone Laboratories, devoted himself full-time to the organization. In 1967 E.A.T. sponsored a competition for art-and-technology collaborations, and some of the winners were included in the 1968 exhibition *The Machine* at the Museum of Modern Art in New York, with the losers composing a high-tech Salon des Refusés at the Brooklyn Museum. In a review of the exhibition the critic Harold Rosenberg described the atmosphere as resembling a "Wonders of Science pavilion" at a world's fair;

quoted in Mary Lynn Kotz, *Rauschenberg: Art and Life* (New York: Harry N. Abrams, 1990), 135. E.A.T. received support from AT&T, IBM, and other corporations, and by 1969 it had six thousand artists and engineers signed up as members. In a similar effort, Maurice Tuchman and Jane Livingston produced the 1971 exhibition *Art and Technology* (Los Angeles County Museum of Art), which was the culmination of their ambitious scheme of arranging about eighty artist-in-residencies at major corporations, where the industry engineers and equipment provided technical support to realize the artist's conception. Thus were born Rauschenberg's *Mud-Muse* (1971), a nine-by-twelve-foot vat of mud that bubbled up in response to ambient sounds made by visitors to the museum, and Claes Oldenburg's undulating, four-story-tall *Giant Icebag* (1971). For overviews of modern art and technology see Peter Franscastel, *Art and Technology in the Nineteenth and Twentieth Centuries*, trans. Randall Cherry (New York: Zone Books, 2000), and Stephen Wilson, *Information Art: Intersections of Art, Science, and Technology* (Cambridge, Mass.: MIT Press, 2000).

23. Halley, "Notes on the Paintings" (1982), in *Peter Halley: Collected Essays, 1981–87* (Venice, Calif.: Lapis Press, 1988), 23. For other recent satirical approaches to abstract painting, see Mark Rosenthal, *Critiques of Pure Abstraction*, exh. cat. (New York: Independent Curators Incorporated, 1995).

24. It has been suggested that even Stella unconsciously expressed such associations in his most Minimalist work. In a catalogue to an exhibition of his Black Paintings, curator Brenda Richardson has exhaustively traced the references of Stella's titles of the works in this series, and noted that they are all linked with themes of death, madness, and cruelty; *Frank Stella: The Black Paintings*, exh. cat. (Baltimore: Baltimore Museum of Art, 1976). For example, the title of *Getty's Tomb* refers to a mausoleum, designed by Louis Sullivan in 1890, which stands in the Graceland Cemetery in Chicago. Stella's Black Paintings also include *Bethlehem Hospital* (1959; Collection of Mr. and Mrs. David Mirvish, Toronto), named for the hospital of St. Mary's of Bethlehem in London, an asylum for the insane better known as "Bedlam," and *Arbeit Macht Frei* (Labor liberates, 1959; Collection of the artist), which were the words of a slogan—suitable to a work camp—written over the entrance gate at Auschwitz.

25. For a French intellectual's vigorous defense of rational objectivity against cultural relativism, see Alain Finkielkraut, *The Defeat of the Mind*, trans. Judith Friedlander (New York: Columbia University Press, 1995). For a critical overview from an American perspective of the many publications in the 1980s and '90s on the "end of objectivity" in the laboratory, see Paul R. Gross and Norman Levitt, *Higher Superstition: The Academic Left and Its Quarrels with Science* (Baltimore: Johns Hopkins University Press, 1994). The assault on science, especially the

charge that scientists fabricate data based on their culturally determined sexist or racist attitudes, led Colin Macilwain, a Washington news editor of *Nature* magazine to lament in a 1994 editorial that scientists are "worried about a slow—Hollywood-assisted—erosion of their public image. The dedicated, white-coated researcher, laboring to save the planet from poverty and disease, risks being supplanted in the public mind by a money-grabbing, plagiarizing, con-artist." *Nature* 367 (6 Jan. 1994): 6.

26. Laura Stewart Heon's curatorial perspective is available at Mass MoCA's Web site: www.massmoca.org/press_releases/02_2000/2_14_2000.html.

27. The unknown writer borrowed his name from a Greek, Dionysius the Areopagite, whose conversion by Saint Paul was described in the New Testament (Acts 17:34) (hence Dionysius is often called "Pseudo-Dionysius"). I follow Bernard McGinn in calling him Dionysius; see McGinn, "Anagogy and Apophaticism: The Mysticism of Dionysius," in *Foundations of Mysticism*, vol. 1 of *The Presence of God: A History of Western Christian Mysticism* (New York: Crossroad, 1992), 157–82.

28. Pseudo-Dionysius Areopagite, *The Divine Names and Mystical Theology*, trans. John D. Jones (Milwaukee: Marquette University Press, 1980), 214.

29. On the complex meanings of the term, see Michael Theunissen, *The Other: Studies in the Social Ontology of Husserl, Heidegger, Sartre, and Buber*, trans. Christopher Macann (Cambridge, Mass.: MIT Press, 1984).

30. For a discussion of mystical themes in twentieth-century art and science, which includes excerpts of major texts, see Hans Dieter Zimmermann, *Rationalität und Mystik* (Rationality and mysticism) (Frankfurt am Main: Insel, 1981).

31. See Heiner Stachelhaus's biography, *Joseph Beuys*, trans. David Britt (New York: Abbeville Press, 1991), 16, 36.

32. My reading of Beuys was inspired by Donald Kuspit's "Beuys: Fat, Felt, and Alchemy," *Art in America* 68, no. 5 (May 1980): 78–89.

33. Beuys, lecture in the series "Talks on My Own Country," at the *Kammerspiele*, Munich, 20 Nov. 1985, quoted in Stachelhaus, *Joseph Beuys*, 65–66.

34. Beuys, interview with B. Blume and H. G. Prager in the beekeeping journal *Rheinische Bienenzeitung* (1975), quoted in Stachelhaus, *Joseph Beuys*, 57–58.

35. The similarities and differences between postmodern theology, negative theology, and deconstruction are laid out by Kevin Hart in *The Trespass of the Sign: Deconstruction, Theology, and Philosophy* (Cambridge, England: Cambridge University Press, 1989).

36. In 1951 the journal *Philosophy East and West* was launched by the University of Hawaii with a mandate to find common ground between the two traditions, and its first issue carried Van Meter Ames's essay "America, Existentialism, and Zen"; vol. 1, no. 1 (Apr. 1951). In 1956 the renowned Japanese scholar D. T. Suzuki compared Existentialism and Buddhism in "Existentialism, Pragmatism, and Zen," in *Zen Buddhism: Selected Writings of D. T. Suzuki*, ed. W. Barrett (1956; reprint, New York: Doubleday, 1996), 259–75. For an argument on the limitations of the comparison, see William Bossart, "Sartre's Theory of Consciousness and the Zen Doctrine of No Mind," in *The Life of the Transcendental Ego*, ed. E. S. Casey and D. V. Morano (Albany: State University of New York Press, 1986), 126–50.

37. "What I write is not a 'negative theology.'" Jacques Derrida, "Comment ne pas parler: Dénégrations" (1987), quoted in *Derrida and Negative Theology*, ed. H. Coward and T. Foshay, trans. K. Frieden (Albany: State University of New York Press, 1992), 77.

38. Laib, interview with Klaus Ottmann, 2001, *Journal of Contemporary Art*, available at www.jca-online.com/laib.html.

39. Laib, *LightSeed*, exh. cat., ed. Harald Szeemann (Tokyo: Watari-Um, 1991), 66.

40. Ibid., 60.

41. For a journal with an even broader, more multidisciplinary approach to the mind, see *Journal of Consciousness Studies*, which began publication in 1994, especially its two-issue feature "Art and the Brain," ed. Joseph A. Goguen, vol. 6, nos. 6–7 (1999), and 7, nos. 8–9 (2000).

42. In an indication of how mainstream such research has become, in 2001 the National Institutes of Health, which is the American government agency that funds medical research, awarded Davidson and the University of Wisconsin a 10.9–million-dollar grant to establish the Center for Mind-Body Interaction.

43. See press release for the conference *Transformations of Mind, Brain, and Emotion: Neurobiological and Bio-Behavioral Research on Meditation*, Laboratory for Affective Neuroscience, University of Wisconsin at Madison, May 2001, available at www.news.wisc.edu/packages/emotion. Speakers at the conference included neurologists, biologists, psychiatrists, and a Tibetan monk, the Dalai Lama.

44. Known in the United States for its pacifism and human rights activism, a political arm of the Friends (the American Friends Service Committee) won the 1947 Nobel Peace Prize.

45. Turrell, quoted in Michael Kimmelman, "Inside a Lifelong Dream of Desert Light," *New York Times*, 8 Apr. 2001.

CHRONOLOGY

	ART	SCIENCE	THE SPIRITUAL
1770s			1775 Mesmer, *Writings on Magnetism* 1775–78 Lavater, *Essays on Physiognomy*
1780s	1781 Fuseli, *The Nightmare*		1781 Kant, *Critique of Pure Reason*
1790s			1790 Kant, *Critique of Judgment* 1798 Schelling, *On the World Soul*
1800s		1800 Electric battery invented 1801 Young declares that light is a wave 1803 Howard, *Modifications of Clouds* 1809 Lamarck proposes evolution by acquired characteristics	1807 Hegel, treatise on Absolute Idea 1808 Goethe, *Faust* (Part 1)
1810s	1818 Friedrich, *Wanderer above a Sea of Fog*	1810 Goethe, *Theory of Colors* 1812 Cuvier, *Inquiry into Fossil Remains* 1814 Spectral lines in sunlight discovered	1810 Phrenology proposed
1820s	1821–22 Constable, *Cloud Studies* series	1821 Faraday proposes lines of force in an electromagnetic field 1825 Iguanodon named 1826 Lobachevsky formulates first non-Euclidean geometry	1825 Saint-Simon, *New Christianity*
1830s	1830 Cole, *Niagara Falls* 1836 Cole, "Essays on American Scenery"	1830s Achromatic microscope developed 1830–33 Lyell, *Principles of Geology* 1838 Schwann and Scheiden declare cell theory of life 1839 Chevreul, *On the Law of Simultaneous Contrast of Colors* 1839 First photographs exhibited	1835 Hegel, *Aesthetics*
1840s	1843 Turner, *Shade and Darkness* and *Light and Color*	1840 Agassiz, *Study of Glaciers* 1842 Extinct giant lizards named "dinosaurs" 1845 Humboldt, *Cosmos* 1846 Neptune discovered 1847 Boole introduces a two-value algebra	1841 Emerson, "Transcendentalist" 1843 Mill, *System of Logic* 1846 Carus, *Psyche* 1848 Marx and Engels, *Communist Manifesto*
1850s	1859 Church, *Heart of the Andes*	1850 Clausius declares entropy of the universe 1854 Riemann develops non-Euclidean geometry that describes a curved space 1855 Maury, *Physical Geography of the Sea* 1856 Neanderthal man excavated 1856–67 Helmholtz, *Physiological Optics* 1857 Helmholtz, "Physiological Causes of Harmony in Music" 1859 Darwin, *Origin of Species* 1859 Spectral "fingerprint" for each element discovered	1852 Comte, *Positivist Catechism* 1855 Whitman, *Leaves of Grass* (first edition included twelve poems)

ART	SCIENCE	THE SPIRITUAL	
1860 Baudelaire, *Painter of Modern Life*	1860 Maxwell introduces statistics to measure speed of gas molecules	1860 Fechner, *Psychophysics*	*1860s*
1861 Whistler, *Symphony in White, No. 1*	1862 Pasteur announces germ theory of disease	1862 Spencer proposes social Darwinism	
1863 Manet, *Déjeuner sur l'herbe*	1863 Chemical constitution of stars determined	1864 Lombroso, *Man of Genius*	
	1865 Mendel publishes laws of heredity	1865 Verne, *From the Earth to the Moon*	
	1868 Cro-Magnon man found	1867 Zola, *Thérèse Raquin*	
	1868 Life in the deep sea confirmed		
	1869 Mendeleyev, periodic table of elements		
1874 First Impressionist exhibition	1871 Darwin, *Descent of Man*	1870 Taine, *Intelligence*	*1870s*
1876 Monet, *Camille Monet in the Garden at the House in Argenteuil*	1871 Helmholtz, *On the Relation of Optics to Painting*	1870 Verne, *Twenty Thousand Leagues under the Sea*	
1876 Moreau, *Apparition*	1872 Darwin, *Expression of Emotion*	1873 Anorexia nervosa diagnosed	
1878 Duret, *Les Impressionnistes*	1872–76 HMS *Challenger* expedition to the deep sea	1875 Blavatsky founds Theosophical Society, New York	
	1876 Telephone patented in United States	1876 Fechner, *Aesthetics*	
	1879 Edison invents electric light bulb	1879 Wundt opens first institute for experimental psychology, Leipzig	
	1879 Rood, *Modern Chromatics*		
1880–81 Degas, *Little Fourteen-Year-Old Dancer*	1881–85 Pasteur and Koch develop vaccinations against anthrax and rabies	1882 Charcot uses hypnosis	*1880s*
1883 Redon, *Origins*	1882 Role of chromosomes in cell division suggested	1886 Krafft-Ebing, *Sexual Psychopathology*	
1884–86 Seurat, *La Grande Jatte*	1886 First expedition to the North Pole	1889 Janet proposes automatism as a path to the subconscious mind	
1884–1906 Cézanne, *Mont Sainte Victoire* series	1887 Michelson and Morley fail to measure absolute space		
1885 Henry, *Scientific Aesthetic*	1888 Hertz detects radio waves		
1886 Last Impressionist exhibition	1889 Neuron theory proposed		
1889 Van Gogh, *Starry Night*			
1889–1903 Gallé, *Deep Sea*			
1891 Monet, *Grainstack (Sunset)*	1895 Röntgen discovers X rays	1890s Charcot opens laboratory of physiological psychology, Paris	*1890s*
1893 Munch, *The Scream*	1896 Motion pictures shown publicly	1890s Gestalt psychology founded	
1893–95 Horta, *Tassel House*	1897 Electron discovered	1890s Pavlov performs experiments on conditioning	
1895 Obrist, *Whiplash*	1897 Marie Curie traces source of radioactivity to the atom	1892 Nordau, *Degeneration*	
1896 Jarry, *Ubu roi*	1898 Curies discover radium and polonium	1894 Lipps founds Psychological Institute, Munich	
1896–97 Endell, *Elvira Studio*		1893–95 Breuer and Freud, "Studies on Hysteria"	
1899–1904 Haeckel, *Art Forms in Nature*		1897 Wells, *Invisible Man*	
1900 Binet's entry portal and Gallé's retrospective at Exposition Universelle, Paris	1900 Mendel's laws rediscovered	1900 Freud, *Interpretation of Dreams*	*1900s*
1900 Schmithals, *Balls of Bacilli*	1900 Planck proposes quantum theory	1901 Bucke, *Cosmic Consciousness*	
1901 Kubin, *North Pole*	1901 First wireless telegraph sent	1907 Bergson, *Creative Evolution*	
1903 Méliès, *Trip to the Moon*	1902 Poincaré declares conventionality of geometry	1908 Poincaré, "Chance"	
1907 Cézanne retrospective, Paris	1903 Airplane invented	1908 Worringer, *Abstraction and Empathy*	
1907 *Triangle: Art and Psychology* show organized in Saint Petersburg	1905 Einstein publishes *Special Theory of Relativity*, proposes photon theory of light, and declares $E=mc^2$		
1908 Braque, *Houses at L'Estaque*	1907 Minkowski proposes theory of space-time		
1909 Balla, *Street Light*	1909 Peary reaches North Pole		
1909 Marinetti, *Futurist Manifesto*			

	ART	SCIENCE	THE SPIRITUAL
1910s	1911 First *Der Blaue Reiter* exhibition, Munich	1911 First chromosome map of genetic data proposed	1910–13 Russell and Whitehead, *Principia Mathematica*
	1911–20 Kupka, *Cosmic Spring*	1911–13 Hertzsprung and Russell diagram the main sequence of stars	1911 Ouspensky, *Tertium Organum*
	1912 Corra, manifesto "Abstract Cinema—Chromatic Music"	1911–13 Rutherford and Bohr propose solar system model of the atom	1913 Kruchenykh, *New Ways of Words*
	1912 Delaunay, *Windows*	1912 Leavitt discovers cepheid variable stars	1913 Steiner founds the Anthroposophical Society
	1912 Kandinsky, *On the Spiritual in Art*	1916 Einstein, *General Theory of Relativity*	1919 Breton and Soupault, *Les Champs magnétiques*
	1913 Boccioni, *Unique Forms of Continuity in Space*	1919 Rutherford transmutes nitrogen into oxygen	
	1913 Malevich, *Black Square*	1919 Solar eclipse confirms curvature of space in Einstein's non-Euclidean universe	
	1913–14 Picasso, *Card Player*		
	1914 Kandinsky, *Fugue*		
	1915 Malevich, manifesto *From Cubism to Suprematism*		
	1916 Arp begins using chance techniques		
	1919 Bauhaus opens		
	1919 Tatlin, monument to Third International		
	1919–21 Mies van der Rohe, studies for glass skyscrapers		
	1919–24 El Lissitzky, *Proun* series		
1920s	1920s Gabo begins kinetic, transparent sculpture	1924 Hubble demonstrates that there is a second galaxy in the universe, Andromeda	1920s–'30s School of Gestalt psychology centered in Berlin
	1920 Brancusi, *Beginning of the World*	1926 Schrödinger proposes electron cloud model of the atom	1921 Jung, treatise on archetypes and the collective unconscious
	1920 Kahnweiler, *The Way to Cubism*	1927 Heisenberg declares Uncertainty Principle	1924–25 Panofsky, "Perspective as 'Symbolic Form'"
	1921 Kramár, *Cubism*	1929 Astronomers agree there are hundreds of galaxies	1927 Heidegger, *Being and Time*
	1924 Van Doesburg, plans for four-dimensional architecture	1929 Hubble proves the universe is expanding	1928 Breton, *Nadja*
	1925 El Lissitzky, "A. and *Pangeometry*"		
	1927–48 Arp, *Cosmic Forms* series		
	1929 Marinetti, *Manifesto of Aerial Painting*		
1930s	1930s Escher begins optical illusion series	1930 Pluto discovered	1930 Einstein, "Religion and Science"
	1930 Calder, first mobile	1930–31 Existence of antimatter and neutrino proposed	1932 Lacan, thesis on paranoid psychosis
	1931 Dalí, *Persistence of Memory*	1932 Neutron discovered	1933 Jung, *Modern Man in Search of a Soul*
	1932 Magritte, *The Universe Unmasked*	1932 Radio waves from outer space recorded	1939 Einstein warns Roosevelt about atomic weapons
	1936 Man Ray publishes *Mathematical Object* series	1934 Chromosome map of a fruit fly completed	
	1938 Magritte, *Time Transfixed*	1934 Fermi bombards uranium with neutrons	
	1938 Man Ray, *Chance*	1935 First antibiotics (sulfa drugs) developed	
	1939 Dominguez, *Nostalgia of Space*	1939 Antibacterial agent in penicillin isolated	
		1939 Meitner and Hahn discover atomic fission	

ART	SCIENCE	THE SPIRITUAL	
1940–41 Miró, *Constellation* series	1940s Electronic computers developed	1943 Sartre, *Being and Nothingness*	*1940s*
1944 Matta, *Vertigo of Eros*	1942 Fermi accomplishes first nuclear chain reaction, Chicago		
1945 Fontana begins creating environmental art with light	1945 First uranium fission bomb detonated		
1947 Fontana, manifesto *Spazialismo*	1948 Gamow proposes Big Bang theory		
1947 Pollock begins drip paintings			
1947 Rothko begins floating rectangles of color			
1948 Newman begins *Zip* paintings			
1948 Newman, "New Sense of Fate" and "The Sublime Is Now"			
1950 Albers begins *Homage to the Square* series	1952 First hydrogen fusion bomb detonated	1950s Lacan develops structuralist psychoanalysis	*1950s*
1952 Baj and Dangelo, *Manifesto of Nuclear Painting*	1953 Structure of DNA molecule determined	1952 REM sleep discovered	
1954 Arnheim, *Art and Visual Perception*	1954 First fission-fusion bomb detonated	1952 First antipsychotic drug developed	
1954 Honda and Morse, *Godzilla*	1956 Existence of antimatter and neutrino confirmed	1953 Beckett, *Waiting for Godot*	
1958 Dalí, "Anti-Matter Manifesto"	1957 *Sputnik I* launched		
1958 Stella begins *Black Painting* series			
1958–66 Newman, *Fourteen Stations of the Cross*			
1961–67 Beuys, *Framework for an Absurd Wilderness*	1968 First human walks on the moon	1966 Adorno, *Negative Dialectics*	*1960s*
1965–66 Rothko, Rothko Chapel			
1968 Fontana, *White Labyrinth*			
1968 Kubrick, *2001: A Space Odyssey*			
1969 Merz begins *Fibonacci* numerical series			
1972 Turrell begins *Roden Crater*	1971 Black hole detected	1970s CAT scans of brain developed	*1970s*
1975 Kiefer, *Essenz/Ek-sistenz*	1978 First AIDS cases diagnosed in New York	1970s Derrida develops deconstruction	
1975 Laib begins *Milkstone* series		1970s Negative theology formulated	
1977 Beuys, *Honey Pump*			
1980 Wojnarowicz, *Something from Sleep*	1986 Halley's comet returns	1980s Magnetic resonance imaging (MRI) of brain developed	*1980s*
1980–82 Johnson, Crystal Cathedral	1987 Neutrinos recorded from an exploding star		
1995 Viola, *The Veiling*	1990 Hubble Space Telescope launched	1990s Edelman describes mental maps	*1990s*
1996 Bleckner, *In Sickness and in Health*	1992 Recordings of cosmic background radiation confirm Big Bang theory	1990s Solms forges neuropsychoanalysis	
1996 Nerdrum, *Forbidden Painting*	1993 Dark matter discovered	1994 Davidson opens Laboratory for Affective Neuroscience	
1999–2001 Noland, *Mysteries* series	1994 Hubble Space Telescope records conclusive evidence for existence of a black hole		
	1995 Hubble Deep Field discovers fifty billion new galaxies		
	1998 Dark force detected		
2000 Seidel and Kiefer, *Cosmos Poems*	2000 Chromosome map of a human being completed		*2000s*
2001 Olitski, *Moses Path*	2002 Neutrino is proven to have mass		

ACKNOWLEDGMENTS

I WROTE THIS BOOK in the haven of three fine institutions. Binghamton University of the State University of New York, where I am director of the art museum, encourages innovative intellectual pursuits under the leadership of President Lois B. DeFleur. It was there, in 1989, that I curated my first exhibition on a topic in art and science, *The Sigmund Freud Antiquities: Fragments from a Buried Past*, which I organized in cooperation with the American Psychoanalytic Association and the Freud Museum in London. My terrific museum staff has given their enthusiastic support to my subsequent series of exhibitions on themes linking the arts and sciences; my thanks go to the assistant director, Jacqueline Hogan; the installations designer, Jennifer Giza; the development director, Marcia Steinbrecher; and the research assistant, Mark Dellaquila. I am especially grateful to the curator and registrar, Silvia Vassileva-Ivanova, with whom I have worked most closely on art and science projects. Binghamton University's innovative "Science across the Curriculum" program, which was established with a National Science Foundation grant to promote the interdisciplinary teaching of science, has helped me expand the art museum's audience to include students in science and engineering. It has been exciting to work on joint educational ventures with the program's principal scientists, the chemist Wayne E. Jones and the biologist Anna Tan-Wilson.

One of America's oldest science institutions, the New York Academy of Sciences in Manhattan, opened its doors to me in 1994 to bring my art and science exhibition series to its landmark building, located near the heart of New York's museum mile. I have continued to this day, with one brief hiatus, to serve as the curator of this exhibition series, and I have been enriched by participating in the intense debates about science and culture that are at the intellectual core of the Academy. For his enthusiasm about displaying visual art in the halls of science, I am especially grateful to the president of the Academy's board of directors, the neuroscientist Torsten N. Wiesel, who shared the 1981 Nobel Prize in medicine and physiology for his research on the processing of visual information by the eye and brain—a topic that has been of seminal importance to modern artists since Claude Monet painted his first Impressionist landscape.

Having been educated in the humanities (a B.A. in philosophy and a Ph.D. in the history of art), by the early 1990s I was feeling the need to make a systematic study of the history of science in order to explore the links between art and science in more detail. At that point in my life the best way to do this was to teach it—so I designed for art students a two-semester course on modern art and science that included key discoveries in astronomy and physics in the fall semester ("The Expanding Universe"), and biology in the spring semester ("The Mystery of Life"). I am forever grateful to Robert Milgrom, cochair of Humanities and Sciences at the School of Visual Arts in New York, for approving my course proposal. Thus I began spending my

Saturdays teaching the history of science, trying to bring it alive for young artists in Manhattan. Now in my eighth year of teaching this course, I have a special place in my heart for all the art students who, driven by their curiosity, wouldn't let me go until antimatter or the genetic code made sense to them, or until they grasped what science has to do with art.

Before writing this book I benefited from discussions about my methodology and the organization of my manuscript with the paleontologist Stephen Jay Gould, whose recent death I mourn, and with the art critic Donald Kuspit. After I had written a draft, I received extensive and invaluable criticism from the following readers of the manuscript. On topics in astronomy and physics: the professor of physics at Binghamton University, who is also a musician knowledgeable about acoustics and harmony, Robert Pompi; and the director of the Hayden Planetarium at the American Museum of Natural History in New York, Neil deGrasse Tyson; on biology: the professor of biology and director of the Binghamton University electron microscope, Curt Pueschel; on chemistry: the dean of the College of Engineering and Physical Sciences at the University of Connecticut, who is also a collector of rare books and manuscripts in the history of alchemy and chemistry, Arthur Greenberg; on the history of art: my dear sister, the artist Jean Becker; the professor emeritus of art history at Binghamton University, Kenneth C. Lindsay; the art director of *The Sciences* magazine, which sadly ceased publication in 2001, Elizabeth Meryman; and the professor of art history at New York University, Robert Rosenblum; on philosophy: my former teacher, the philosopher John M. Vickers; and finally, on theology: my beloved brother-in-law, the German theologian Rolf-Walter Becker. And whenever I had a question about a text in ancient Greek, Latin, or Hebrew, or whenever a puzzle arose concerning a biblical reference or a German philosophical term, I could always count on getting a prompt and learned response from the pastor of the Evangelical Lutheran Church of Saxony, near Dresden, Germany—my nephew Jan-Peter Becker.

I am honored that Novartis Corporation, with headquarters in Basel, Switzerland, chose to put their fine name on an edition of this book. I am especially grateful to the President and CEO, Terry Barnett, and to the Head of Novartis Corporate Donations and Sponsoring, Thomas E. Prieswerk, who, from our first meeting in Basel, has been a steadfast source of advice and encouragement. I am also grateful to the College Art Association of America for awarding this book a grant from the Millard Meiss Publication Fund.

Like many art historians who spend their careers in art museums, I have been able over the years only to coauthor exhibition catalogues. Thus I was happy when the publisher of art books at Princeton University Press, Nancy Grubb, offered me the chance to publish an entire book in my own voice. It has been my privilege to work with Nancy and her expert team at Princeton: the production coordinator, Sarah Henry; the production editor, Devra K. Nelson; the production manager, Ken Wong; and the managing editor, Kate Zanzucchi. This book was edited with insight and care by Nancy Grubb, Suzanne Kotz, and Philip Reynolds; proofread meticulously by June Cuffner; and indexed beautifully by Kathleen M. Friello. The rich array of nineteenth- and early-twentieth-century science imagery was captured by the magician with a camera, Chris Focht, and the science diagrams were created by the wizard of cyberspace and President of Umbra Studios, my husband Charles M. Brown. Words fail to capture the talents of the designer, Joel Avirom, but the riveting appearance of this book speaks for itself.

Suggestions for Further Reading

Barzun, Jacques. *The Use and Abuse of Art*. Princeton, N.J.: Princeton University Press, 1974.

A historian of Western culture describes the role of the visual arts in the age of science, especially in the chapter "Art and Its Tempter, Science."

Bohr, Niels. *Atomic Physics and Human Knowledge*. New York: John Wiley and Co., 1958.

The coauthor of the solar-system model of the atom considers the philosophical implications of quantum physics.

Brusatin, Manlio, and Jean Clair. *Identità e alterità: Figure del corpo 1895–1995* (Identity and otherness: Picturing the body, 1895–1995). Exh. cat. Venice: La Biennale di Venezia; Marsilio, 1995.

A group of essays with art and science images (presented on the occasion of the Venice Biennale), related to changing views of the identity that is rooted in a person's body (such as age, race, or sexuality), and his "otherness." *Alterità* can also be translated "alterity," which is a psychiatric term that refers to a patient's feeling of estrangement from his social group due to physical difference.

Clair, Jean. *Wunderblock: Eine Geschichte der modernen Seele* (Wonderblock: A history of the modern soul). Exh. cat. Vienna: Historisches Museum der Stadt Wien, 1989.

A French art historian and director of the Musée Picasso in Paris, Jean Clair is today's leading curator of interdisciplinary exhibitions. Vienna was the site of this exhibition about modern concepts of the soul, the psyche, and the unconscious mind. The show was named for a childhood toy—a

Wunderblock—that was made of a piece of clear plastic over a black slate. A child would write on the block with a wooden stick; when the child lifted the clear page, the message would magically vanish, except, Freud noted, for a faint impression left on the slate, which he compared to the memory traces that remain imprinted on the modern soul.

———. *L'Âme au corps: Arts et sciences, 1793–1993* (The soul of the body: Arts and sciences, 1793–1993). Exh. cat. Paris: Réunion des Musées Nationaux; Gallimard, 1993.

Clair led an international team of curators in assembling scientific objects and artworks on themes related to the human spirit and mind, including anatomy, phrenology, neurology, evolution, dreams, and the soul.

———. *Éloge du visible: Fondements imaginaires de la science* (Elegy for the visible: Foundations of the imagination in science). Paris: Gallimard, 1996.

Musings on the scientific origins of abstract art by Clair.

———. *Cosmos: From Romanticism to the Avant-Garde*. Montreal: Montreal Museum of Fine Arts; New York: Prestel, 1999.

Explorations of earth and sky—geology, the artic, astronomy, and space travel—are the unifying themes of this exhibition of works that range from Francisco Goya's painting of a hot air balloon to a star map by Anselm Kiefer.

Einstein, Albert. *Ideas and Opinions*. New York: Crown Publishers, 1954.

A collection of Einstein's statements, full of wit, wisdom, and sadness, on topics including physics, culture,

politics, Germany, and the Jewish people.

Frankel, Felice, and George M. Whitesides. *On the Surface of Things: Images of the Extraordinary in Science*. San Francisco: Chronicle Books, 1997.

A collaboration between the chemist George M. Whitesides, who provides commentary, and the science photographer Felice Frankel.

Gage, John. *Color and Meaning: Art, Science, and Symbolism*. Berkeley and Los Angeles: University of California Press, 1999.

An art historian who is an expert on light and color employs his technical knowledge to expand the reader's understanding of artworks from all ages; especially notable is the chapter "Seurat's Silence."

Galison, Peter. "Aufbau/Bauhaus: Logical Positivism and Architectural Modernism." *Critical Inquiry* 16, no. 4 (Summer 1990): 709–52.

In this model of scholarly sleuthing, a historian of science links the Austrian logical positivist movement the Vienna Circle to the modernist architecture of the Dessau Bauhaus.

Gamwell, Lynn, ed. *Dreams 1900–2000: Science, Art, and the Unconscious Mind*. Ithaca, N.Y.: Cornell University Press, 2000.

A historian, an art critic, and a psychiatrist commemorate the centenary of the publication of Freud's *Interpretation of Dreams* (1900) with discussions of the impact of psychoanalysis on the visual arts; the book is illustrated with over one thousand artworks about dreams.

Gay, Peter. *Freud: A Life for Our Time.* New York: W. W. Norton, 1988.

A cultural historian describes the life and thought of Sigmund Freud in its rich intellectual context, including the ongoing debate about whether psychoanalysis is an art or a science.

Helmholtz, Hermann von. *On the Relation of Optics to Painting.* In *Selected Writings of Hermann von Helmholtz,* ed. Russell Kahl. 1871. Reprint, Middletown, Conn.: Wesleyan University Press, 1971.

Helmholtz's classic study of visual perception addressed to artists, especially landscape painters.

Henderson, Linda Dalrymple. *The Fourth Dimension and Non-Euclidean Geometry in Modern Art.* Princeton, N.J.: Princeton University Press, 1983.

An art historian traces the themes of the fourth dimension and non-Euclidean geometries, distinguishing three threads: science fiction, physics, and the occult.

_____. *Duchamp in Context: Science and Technology in "The Large Glass" and Related Works.* Princeton, N.J.: Princeton University Press, 1998.

Duchamp, master of witty complexity and clever obfuscation, has met his match in Henderson, who reveals his scientific sources and solves many of his puzzles in this monumental study of *The Large Glass.*

Holton, Gerald. *Einstein, History, and Other Passions.* Woodbury, N.Y.: American Institute of Physics, 1995.

A physicist and historian of science discusses the role of Einstein, as well as other leading scientists and key discoveries, in the general culture.

Kemp, Martin. "Seeing and Picturing: Visual Representation in Twentieth-Century Science." In *Science in the Twentieth Century,* ed. John Krige and Dominique Pestre. N.p. [Australia]: Harwood Academic Publishers, 1997.

An art historian discusses a century of science imagery, from X rays to subatomic particle tracings.

_____. *Visualization: The Nature Book of Art and Science.* Oxford, England: Oxford University Press, 2000.

A collection of essays by Kemp originally published in an art and science series in the British science magazine *Nature.*

Kemp, Martin, and Marina Wallace. *Spectacular Bodies: The Art and Science of the Human Body from Leonardo to Now.* Exh. cat. London: Hayward Gallery, 2000.

A well-illustrated five-hundred-year survey of pictures and models of the human body from anatomy, medicine, psychiatry, and the fine arts.

Klee, Paul. *Pedagogical Sketchbook.* Translated by Sibyl Moholy-Nagy. New York: Praeger, 1953.

This lovely little volume of Paul Klee's aphorisms on line and color is illustrated by his ink drawings of plants, animals, the earth, its atmosphere, and the heavens. The book is a reprint of Klee's *Pädagogisches Skizzenbuch,* which was first published in 1925 in a series of Bauhaus books edited by Walter Gropius. László Moholy-Nagy's original design of the book is retained in this translation.

Lipsey, Roger. *An Art of Our Own: The Spiritual in Twentieth-Century Art.* Boston: Shambhala, 1988.

A historian of ancient and modern mysticism, Lipsey is best known as editor of the papers of the great scholar of Indian art, Ananda Coomaraswamy, who was curator from 1917 to 1947 of the Indian section of the Museum of Fine Arts, Boston. Taking Wassily Kandinsky's *On the Spiritual in Art* (1912) as his starting point, Lipsey traces mystical themes in modern art, ending with Abstract Expressionism and Mark Rothko.

Orchard, Karin, and Jörg Zimmermann, eds., *Die Erfindung der Natur: Max Ernst, Paul Klee, Wols und das surreale Universum* (The discovery of nature: Max Ernst, Paul Klee, Wols and the Surreal universe). Exh. cat. Hannover, Germany: Sprengel Museum; Freiburg im Breisgau, Germany: Rombach Verlag, 1994.

An in-depth examination of the Surrealist concept of the natural world, which is especially rich in biological imagery.

Purcell, Rosamond Wolff, and Stephen Jay Gould. *Crossing Over: Where Art and Science Meet.* New York: Three Rivers Press, 2000.

A collaborative effort by a specialist in paleontology, Stephen Jay Gould, who provided commentary, and a photographer, Rosamond Wolff Purcell, who contributed pictures about natural history.

Schama, Simon. *Landscape and Memory.* New York: Alfred A. Knopf, 1995.

Beginning with the thesis that nature is a mythic cultural creation—"a text on which generations write their recurring obsessions"—the historian Schama illuminates modern attitudes toward nature through his exposition of well-chosen texts, from Susan B. Anthony's crusade to include a woman on Mount Rushmore to Anselm Kiefer's paintings of the tangled roots and dark woods of Germany.

Scottish National Gallery of Modern Art. *Creation: Modern Art and Nature.* Exh. cat. Edinburgh: Scottish National Gallery of Modern Art, 1984.

An array of artistic depictions of heaven, earth, creatures, and the human mind, accompanied by an essay by Robert Rosenblum, "Resurrecting Darwin and Genesis: Thoughts on Nature and Modern Art."

Snow, C. P. *The Two Cultures and the Scientific Revolution.* Cambridge, England: Cambridge University Press, 1959.

When Snow, a British novelist and molecular physicist, published this description of an alleged cultural breach between the sciences and the humanities, he touched off a debate that rages to this day.

Stafford, Barbara Maria. *Visual Analogy: Consciousness as the Art of Connecting*. Cambridge, Mass.: MIT Press, 1999.

In this study of visual analogies (things that look alike) a writer on visual culture, whose previous publications focused on imagery from the Enlightenment, casts her perceptive eye on modern and contemporary art, along with earlier images.

Steiner, George. *Language and Silence: Essays on Language, Literature, and the Inhuman*. New York: Atheneum, 1967.

Literary scholar George Steiner's consideration of the many ways in which language has ceased to communicate discursive content, especially his essay "Retreat from the Word," is relevant to the defensive, incommunicado stance assumed by certain abstract artists who experience the scientific culture as alien terrain.

———. *In Bluebeard's Castle: Some Notes towards the Redefinition of Culture*. New Haven, Conn., and London: Yale University Press, 1971.

Steiner presents a penetrating view of modern culture, with a profound pessimism that is summarized by the book's epigraph: "We seem to stand, in regard to a theory of culture, where Bartók's Judith stands, when she asks to open the last door on the night."

Tuchman, Maurice, ed. *The Spiritual in Art: Abstract Painting, 1890–1985*. Exh. cat. Los Angeles: Los Angeles County Museum of Art; New York: Abbeville Press, 1987.

A rich collection of essays and images, some of which support the curator's thesis that spiritual themes in abstract art have an occult origin.

Waddington, Conrad. *Behind Appearances: The Natural Sciences and Twentieth-Century Painting*. Edinburgh: Edinburgh University Press, 1969.

A British geneticist considers the impact of biology and physics on modern painting.

Zimmermann, Hans Dieter. *Rationalität und Mystik* (Rationality and mysticism). Frankfurt am Main: Insel, 1981.

A German theologian presents mystical themes in key texts by twentieth-century artists, scientists, and intellectuals, including Wassily Kandinsky, Franz Kafka, Werner Heisenberg, Martin Buber, and Ludwig Wittgenstein.

INDEX

light and color theories; Neo-Impressionism; spectrum

color organ, 157–58

Combe, George, 65

Comte, August, 30–31, 172; *Positivist Catechism*, 30–31

conceptual art, 276

Constable, John, 26, 302; cloud studies, 26, 309n.26; *Cloud Study*, pl. 12

Constructivism, 224; Russian, 238

Corra, Bruno, 158; "Abstract Cinema— Chromatic Music," 158; *The Rainbow*, 158–60

cosmic consciousness, 98–100

Crali, Tullio, *Looping*, 261, pl. 260

Crippa, Roberto, 276; *The Creation of the World*, pl. 276

Critical Theory, 294–95

Crookes, William, 186, 188–89

Crumb, George, *Makrokosmos III*, 161

Cubism, 107, 134–40, 157, 204; Analytic, 135, 137–38; and cognition, 138; introduction of, 134, 139; name of, 134; and organization of the mind, 129; and relativity theory, 138–40, 315n.17; Synthetic, 135, 137–38; and transparent planes, 177–78

Curie, Irène, 259, 263

Curie, Marie Sklodowska, 185, 187, 259

Curie, Pierre, 185–86, 259

Cuvier, Georges, 33, 54, 90; *Inquiry into Fossil Remains*, 36; and origin of species, 57, 61

cynicism: contemporary, 290, 302; Duchampian, 288–89, 292; Greek, 282

Dada, 210

Dahl, Johan Christian, *A Cloud and Landscape Study by Moonlight*, 18, pl. 6

Dalí, Salvador: "Anti-Matter Manifesto," 288; *The Chromosome of a Highly Colored Fish's Eye . . .*, 287, pl. 287; *The Enigma of Hitler*, 287; *Intra-atomic Equilibrium of a Swan's Feather*, 284–85, pl. 284; *Metamorphosis of Narcissus*, 248, pl. 248; "Paranoid-critical Interpretation of the Obsessive Image *The Angelus* by Millet," 248; *The Persistence of Memory*, 287, pl. 197; and Buñuel, *Un Chien Andalou*, 245

Dalton, John, 163

Dangelo, Sergio, and Baj, *Manifesto of Nuclear Painting*, 276

Dante Alighieri, 31, 261; *The Banquet*, 260; *Divine Comedy*, 260

dark matter, 306

Darwin, Charles, 29, 66, 95; and *Beagle* voyage, 29, 40–41, pl. 26; *The Descent of Man*, 33, 95; on entropy, 125; evolution theory of, 9, 33, 40–44, 48, 70, 74, 129, 131, 138; *The Expression of the Emotion in Man and Animals*, 140, pls. 126, 127; and natural selection, 40–42, 48, 54, 58, 89; *On the Origin of Species*, 9–10, 41–42, 84, 98; —French translation of, 58–61; —German translation of, 93–94; —Russian translation of, 95. *See also* evolution, Darwinian theory of; natural selection

Darwin, Erasmus, 42

Darwinism, social, 121, 124

Davidson, Richard J., 299

deconstruction, 294–95

Degas, Edgar, 45, 65, 73, 122; *Criminal Physiognomies (Émile Abadie and Michael Knobloch)*, 65–66, pl. 51; *Criminal Physiognomy (Paul Kirail)*, 66; *Little Fourteen-Year-Old Dancer*, 66, pl. 52; *Place de la Concorde (Vicomte Lepic and His Daughters)*, 73

Delacroix, Eugène, 67, 115, 117; *Expulsion of Heliodorus*, 67

Delaunay, Robert, 178; "Light," 178–79, 191; *Simultaneous Contrasts: Sun and Moon*, 163, 179, pl. 151; *Simultaneous Windows* series, 179, 191; *Windows*, 178, pl. 173

Derrida, Jacques, 295

Descartes, René, 14–15, 18, 93; *Compendium Musicae*, 150; *Essay on Man*, 311n.15; *The World, or Essay on Light*, 310n.15

De Stijl, 224, 226–27

Dickens, Charles, 65; *Bleak House*, 35

Diogenes, 282, 288

Dionysius, 291–92, 295, 306, 323n.27

Dirac, Paul, 288

Doesburg, Theo van, 226–30, 233; *Composition II*, 226; *Construction in the Fourth Dimension of Space-Time*, 229, pl. 227; *Contra-composition of Dissonances XVI*, pl. 226; "Element-arism," 207, 227; "Towards a Plastic Architecture," 229; "The Will to Style," 229

Dominguez, Oscar, 255–56; *Nostalgia of Space*, 256, pl. 255

Dottori, Gerardo, 260; *Apotheosis of Flight*, 263; *Dynamic Forces*, 261, pl. 262; *Reds and Greens*, 261, pl. 263

Dova, Gianni, 276

Duchamp, Marcel, 283, 288–89, 292–93, 318n.1, 322n.22; *Bride Stripped Bare by Her Bachelors, Even (The Large Glass)*, 283; *Musical Erratum*, 283; *Nude Descending a Staircase (No. 2)*, 177; *3 Stoppages Étalon*, 283, pl. 282

Duchenne de Boulogne, Guillaume; *Mechanism of Human Facial Expression*, 141

Durand, Asher B., 38, 310n.6; *Rocky Cliff*, 38, pl. 24

Duranty, Edmond, 74

Duret, Théodore, 74

Durrell, Lawrence, 199

Eakins, Thomas: *Professor Henry A. Rowland*, 176, pl. 170; *Retrospection*, 142, pl. 130

Eddington, Arthur S.: *The Expanding Universe*, 218; *Space, Time, and Gravitation*, 198–99

Edelman, Gerald, 298, pl. 298

Eggeling, Viking, 234; *Diagonal Symphony*, 160

Ehrenberg, C. G., *Infusion Animals*, 46, 77, 243, pls. 15, 37

Ehrenzweig, Anton, 231; *The Hidden Order of Art*, 231

Eiffel Tower, 167, 179, 240

Einstein, Albert, 9, 18, 185, 195–205, 227, 240, 254, 281, 292, 306, 316nn. 23–24, 320n.38, pl. 296; conservation of mass-energy, law of, 195; and cosmic religion, 202–4, 266; and gravity waves, 161; and nuclear fission, 265–66; quantum theory of radiation, 195; relativity, general theory of, 195; relativity, special theory of, 138–39, 195; *Relativity: The Special and General Theory, a Popular Exposition*, 94, 198; "Religion and Science," 203, 266; and space-time cosmology, 10, 138–39. *See also* space-time, Einsteinian

Eisenstein, Sergei, "The Filmic Fourth Dimension," 235

electrical/electronic technology: generators, 165; lights, 180, 186; motors, 165; radios, 222, 273; storage batteries, 68; vacuum tubes, 186, 188. *See also* film; telegraph; telephone

electricity: and Art Nouveau line, 80, 163; of the body, 64; and the brain as machine, 130, 144, 297; currents of, 67–68, 186; and the mind, 20; and the nervous system, 68; and therapy, 20; and the unconscious, 129. *See also* electrical/electronic technology; electromagnetism

electromagnetism, 165, 179, 205, 226, 312n.22, pls. 154–55; and atoms, 163, 204, 207; discovery of, 15; and electromagnetic radiation, 221; electromagnetic spectrum, 164–68, 175–76; and Malevich, 107; and Theory of Everything, 265

Emerson, Ralph Waldo, 27, 38; *Nature*, 28

Endell, August, 100, 102, 157, 211; and abstract decoration, 102–4, 163, 204; "The Beauty of Form and Decorative Art," 93; Elvira Photography Studio, 102, pls. 88, 89

Enlightenment, the, 9, 13, 66, 93, 281, 293; and German Idealism, 13, 18; and music, 150

environmental art, 276

Ernst, Max, 243–45, 248; *Boophilic Plantation of Hyperborean Ultramarine*, pl. 243; *Configurations*, 245, pl. 245; *Day and Night*, 245–47, pl. 247; *Farcical Hydropic Parasitic Plantation*, pl. 244; *The Inside View*, 245; *Natural History*, 243

Escher, M. C., 231–32; *Other World*, pl. 233

ether, 16, 21, 195

Euclid, 73, 282; *Elements of Geometry*, 202, 224. *See also* geometry

evolution, biblical account of, 33, 40, 61

evolution, Darwinian theory of, 29–30, 33, 41–45, 48, 64–65, 74, 83, 90, 94, 97, 124, 127, 138, 155, 244; and cosmic evolution, 108, 256; evolutionary aesthetics, 77; and evolution of artists and poets, 107–8, 232; in France, 65, 91; in Germany, 93–94, 96; and mind or consciousness, 54, 97–100, 107, 109, 292–93, 297, 305; opposition to, 41–45, 310n.12; and origin of species, 57, 311n.37; popularization of, 48, 93–95; and psychological evolution, 100; in Russia, 95–96, 107; satirical cartoons on, 42, pls. 27, 31; and spiritual evolution, 54, 98; and spontaneous generation, 58, 90–91; and structure

of the mind, 131; and vision, 70. *See also* Darwin, Charles; natural selection

Existentialism, 294, 305–6

Expressionism, German, 98

Fauvism, 134

Fechner, Gustav Theodor, 96–98, 100–101, 118, 129, 144, 312nn. 8 and 10, 314n.17; *Introduction to Aesthetics*, 97; *Psychophysics*, 97, 102–4

Fénéon, Félix, 114; "The Impressionists," 112, 117; "Paul Signac," 120

Fermi, Enrico, 259–65, 277, 288

Fibonacci, Leonardo, 276–77

Figuier, Louis, 61; *Earth before the Deluge*, 61, pls. 20, 50, 164; *Les Mystères de la science*, pl. 49; *Les Nouvelles conquêtes des sciences*, pl. 138

Fillia, Luigi Colombo, *Terrestrial Transcendence*, 261

film: abstraction in 158–60, 233–35; and the dream state, 245; electromagnetic forces in, 167; and the fourth dimension, 235; and microscopy, 48, 210, pls. 40, 203; and quantum physics, 233, 235; and Surrealism, 245, 257; X rays in, pl. 172

Filonov, Pavel, 108; *Formula of Spring*, pl. 93

Fischinger, Oskar, 160; *Radio Dynamics*, pl. 149

Flammarion, Camille, 61; *The End of the World*, 111, 125; on entropy, 125, pl. 113; *Le Monde avant la création de l'homme*, pls. 3, 119; *Les Merveilles célestes*, pl. 168; *Popular Astronomy*, 157, pls. 33, 113, 139, 166

Fluxus, 288, 293

Fontana, Lucio, 274–75, 288; *Black Environment*, 276; *Buchi* series, 275; *Spatial Concept*, 275; *Spatial Concept: "Waiting,"* pl. 274; *Spatial Environment with Black Light*, 275; and Spazialismo, 276; *Structure*, 275, pl. 275; *Tagli* series, 275; "Technical Manifesto," 275; *White Labyrinth*, 276, pl. 277

force lines, in art, 182, 191, 205, 260, 275

Forester, Thomas, *Researches about Atmospheric Phenomena*, 26

fossils, 33–37, 48, 58, 95–96, pls. 16, 21, 85

fourth dimension, 139; and film, 235; Ouspensky and, 99; as spiritual, 99; time as, 139, 207, 227–29, 255, 275

Freud, Sigmund, 140, 144–47, 290, 297, 299; "Beyond the Pleasure Principle," 97; and case history of Anna O., 141–42, 147; *The Future of an Illusion*, 202; *The Interpretation of Dreams*, 58, 94, 138, 144–47, 243–44; *On Dreams*, 94, 244; "Project for a Scientific Psychology," 144; and sexuality, 249; "Studies on Hysteria," 142; and the unconscious mind, 129, 144, 243–44, 287, 320n.11. *See also* psychoanalysis; unconscious mind

Friedrich, Caspar David, 93, 122, 265, 302; *Abbey in Oakwood*, 16; *Monk by the Sea*, 21, 272; and pantheism, 14–17; *The Polar Sea*, 16, 125, 308n.6, pl. 4; and the soul, 21, 272; *Times of Day*, 16; *Wanderer above a Sea of Fog*, 13–14, 18, 21, 306, pl. 2

Fuseli, Henry (Johann Heinrich Füssli), 42; *The Nightmare*, 42, pl. 29

Futurism, 107; Italian, 158, 179–82, 205, 236, 260, 275; manifestos of, 179–80, 182, 261; Russian, 182

Gabo, Naum, 224, 236; *Kinetic Construction: Standing Wave*, 236, pl. 236; *Translucent Variation on a Spheric Theme*, 236, pl. 237

Gall, Franz Joseph, 65, 68

Gallé, Émile, 77, 86; *Deep Sea*, 86, pl. 77; *Hand*, 86, pl. 76; Pasteur vessel, 86; *Sea Dragon*, 86; "Symbolic Decor," 87

Galvani, Luigi, 20

Gamow, George, 224, 285, 322n.16; *Mr. Tompkins in Paperback*, 284, 286, pls. 283, 286

Gauguin, Paul, 152

Gauss, Carl Friedrich, 233

genetics: chromosomes, 210, 287; DNA, 287; genes, 209–10; Mendel's laws of, 41, 89, 209, 311n.37; RNA, 88, pl. 78

geology, 36–38, 40; and evolution, 33, 48, 61; and Earth's crust, 36–40, 88, pls. 20, 21; and glaciers, 36, pl. 22

geometric art, 10, 236; and non-Euclidean geometry, 224–37, 267. *See also* architecture, geometric; De Stijl; Suprematism

geometry: Euclidean, 73, 131–32, 195–96, 205, 207, 224–25; non-Euclidean, 73, 99, 131, 139, 205, 207, 224–25, 230,

236, 255, 266–67, 286; and
Surrealism, 255–57, 320n.20. *See also*
geometric art

germs/microbes, 77, 88–90, pl. 32; and art,
89–90, 127; and disease, 45, 48, 77,
89–90, 121. *See also* microorganisms;
microscope

Giedion, Sigfried, *Space, Time, and
Architecture*, 139, 316n.23

Ginna, Arnaldo, 158; *The Rainbow*, 158–60

Gleizes, Albert, 134, 225; and Metzinger,
About Cubism, 139

Gödel, Kurt, 315n.13

Goethe, Johann Wolfgang von, 16, 22, 100,
292; and clouds, 17–18; "Cloud
Poems," 17, 19; color theories of,
24–26, 45, 309nn. 21–22, pl. 11;
Faust, 16; *The Metamorphosis of Plants*,
16; "The Shape of Clouds According to
Howard," 17; *Theory of Colors*, 24

Gogh, Theo van, 154, 175

Gogh, Vincent van, 122, 124, 154; *Cafe
Terrace at Night*, 317n.3; *Starry Night*,
171, 317n.3, pl. 165; *Starry Night over
the Rhône*, 175, 317n.3, pl. 169

Gombrich, Ernst, "How to Read a Painting,"
232

Goncharova, Natalia, 182

Gottlieb, Adolph, 250, 266–67

Greenberg, Clement, 254, 266

Gris, Juan, 315n.13; and Cubism, 135–38,
224; and relativity theory, 138,
315n.16; *The Table*, 136, pl. 124

Gropius, Walter, 240–41, 320n.38;
Bauhaus, Dessau, 240–41, pl. 242

Grunow, Gertrude, 160

Guillemin, Amédée, 61, 311n.18; *The Forces
of Nature*, pls. 154, 185; *Le Monde
physique*, pls. 10, 42–44, 101, 137,
142, 145, 156, 162; *Light*, 74

Gull, William, 141

Haeckel, Ernst, 94, 98–101, 131, pls. 63,
83; *Art Forms in Nature*, 77, 95, pls.
60, 66, 68, 82; and Darwinism, 94,
312n.2; and evolving consciousness,
100, 250, 292; and experimental psy-
chology, 98; *General Morphology*, 94;
and panpsychism, 100, 104; *Report on
the Scientific Results of the Voyage of
HMS* Challenger, 84, pls. 62, 66, 68,
73

Hahn, Otto, 264

Halley, Edmond, 22–23

Halley, Peter; *Two Cells with Conduit and
Underground Chamber*, 289–90

Hanslick, Eduard, *The Beautiful in Music*,
151–52

harmony, 149–54, 157, 160, 179; of the
spheres, 149–50, 157, 161; physiologi-
cal causes of, 152–54

Hartmann, Eduard von, 74; *Philosophy of
the Unconscious*, 23

Hayet, Louis, 115, 117

H-bomb, 277–78

Hegel, Georg Wilhelm Friedrich, 74, 95,
254; and Absolute Spirit, 16, 21, 30,
295; *Aesthetics*, 151–52; and mes-
merism, 21

Heidegger, Martin, 294; *Sein und Zeit*, 305

Heisenberg, Werner, 204–5, 265, 284–87,
292, 322n.19, pl. 283

Helmholtz, Hermann von, 25–26, 74, 98,
176, 290; and cognition, 136–37; on
colored light, 112–15, 117, pl. 99; and
conservation of energy, 124, 196;
Handbook of Physiological Optics, 57,
70–71, 94, 130, 311n.18; and hearing,
theory of, 152–55; and mind and physi-
ology of perception, 93, 130–31, 135,
138, 140, 144, 179; *On the Relation of
Optics to Painting*, 94, 133, 311n.18; on
optics, 66, 68–70, 72–74, 93, 129, 142,
311n.18; "The Physiological Causes of
Harmony in Music," pl. 141; *Recent
Progress of the Theory of Vision*, 94, pl.
53

Henry, Charles, 118, 163, 314n.17; aesthetic
protractor, 118, pl. 109; color wheel of,
118–20; *Introduction to a Scientific
Aesthetic*, 118, pl. 109; and X rays, 163

Herschel, William, 165, 171

Hertz, Heinrich, 165–67, 188

Hertzsprung, Ejnar, 191–93, pl. 192

Hervey de Saint-Denys, Léon, marquis d',
144, pl. 118

Hindemith, Paul, *Die Harmony der Welt*, 161

Hitler, Adolf, 265, 284, 287, 322n.19

Hölzel, Adolf, 102; abstract ornament, pl.
90

Hooke, Robert, cells in cork, 47, pl. 35

Horta, Victor, 45, 101; Tassel House, 80,
pl. 67

Howard, Luke, 303; *Essay on the
Modifications of Clouds*, 17, 26, pl. 5

Hubble, Edwin, 213; Hubble's law, 218,
224, 252; *Realm of the Nebulae*, pl. 213

Hudson River School, 28, 38

Humboldt, Alexander von, 28–29, 37;
Cosmos, 29, 94; *Personal Narrative*, 29

Hutton, James, 36

Huxley, Thomas, 43–45, 93, 203, pl. 30

hygiene, 77, 122; and art, 45, 89

hypnosis, 21, 134, 141, 147

Idealism, German, 10–11, 31, 95, 281, 288,
294, 305; and Coleridge, 23; and Kant,
13, 18–19, 129, 225; and pantheism,
16, 23; second-generation, 13–14,
18–19

Impressionism, 54, 57, 66, 73–74, 111–12,
120–21, 129–32, 138, 179, 204, 302;
and light theories, 66–67, 73–74, 91;
and passive mind, 130; and photogra-
phy, 73–74

installation art, 138, 293, 299; of Fontana,
275–76, 288, pl. 275

Iwai, Toshio, *Piano—As Image Media*, 161,
pl. 134

Jackson, John Hughlings, 131

James, William, *The Varieties of Religious
Experience*, 99

Janet, Pierre, 122, 140–41, 147, 243–44

Jarry, Alfred, 282–83; pataphysics, 283;
Ubu roi, 282–83, 288

Johnson, Philip, 241; Crystal Cathedral,
Garden Grove, 241; and Mies, Seagram
Building, New York, 241

Joliot, Frédéric, 259, 263

Jordon, Alexis, 311n.37

Jugendstil, 9, 95, 98, 102, 104, 129, 157,
177, 182; and abstraction, move to,
101, 136, 151; and analogy of music
and color, 157; biomorphic shapes in,
48, 189, 209, 218; and invisible forces,
54; and panpsychism, 207; and pan-
theism, 14. *See also* Art Nouveau

Jung, Carl, 243, 249–50; *Modern Man in
Search of a Soul*, 250; *The Psychological
Types*, 250

Kahlo, Frida, 254

Kahnweiler, Daniel-Henry, 134–35, 137,
139; portrait by Picasso, 134; *The Way
to Cubism*, 135

Kandinsky, Wassily, 95, 104, 151, 188–91,
211, 218–19, 260; and the Absolute, 15,
98; and abstraction in art, 96, 104, 157,
189, 204; and analogy of music and
color, 157; at Bauhaus, 109, 218; and
Der Blaue Reiter, 104; drawings from

PICTURE CREDITS